William Blake's art has traditionally been interpreted in terms of his poetry, under the assumption that his designs are visualizations of his own poetic myth. In this innovative study, Christopher Heppner constructs a new assessment and interpretation of Blake as illustrator of texts other than his own. Such topics as Blake's handling of human figures and the signifying power of their gestures, his relationship to Michelangelo, and his attitude towards perspective and the conventions of pictorial representation are brought to bear on the 1795 color prints, the illustrations to Young's *Night Thoughts*, and the illustrations to the Bible. Heppner concludes with an extended reading of *The Sea of Time and Space* which differs markedly from previous approaches to the work. A large number of illustrations, including a color plate section, accompanies this new interpretation of a complex artist.

Reading Blake's designs

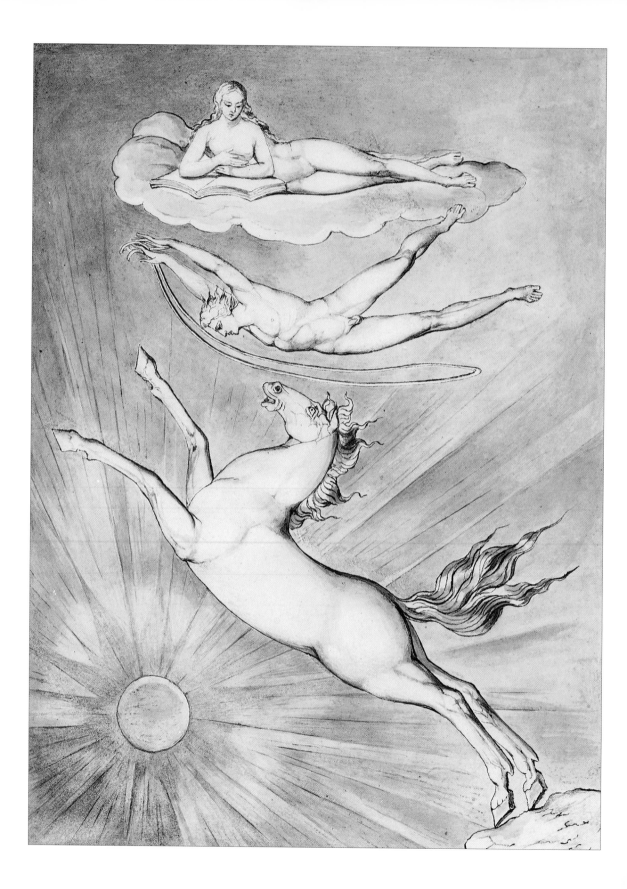

Reading Blake's designs

CHRISTOPHER HEPPNER *McGill University*

Published by the Press Syndicate of the University of Cambridge
The Pitt Building, Trumpington Street, Cambridge CB2 1RP
40 West 20th Street, New York, NY 10011–4211, USA
10 Stamford Road, Oakleigh, Melbourne 3166, Australia

First published 1995

Printed in Great Britain at the University Press, Cambridge
Design/typography by Dale Tomlinson using QuarkXPress/Monotype Dante
Origination/film-output by Kestrel Digital Colour, Chelmsford

Frontispiece: William Blake, *As if an Angel Dropped down from the Clouds* (B 547: 6)

A catalogue record for this book is available from the British Library

Library of Congress cataloguing in publication data

Heppner, Christopher.
Reading Blake's designs / Christopher Heppner.
 p. cm.
Includes index.
ISBN 0 521 47381 0
1. Blake, William, 1757–1827 – Criticism and interpretation.
2. Blake, William, 1757–1827 – Catalogs.
I. Blake, William, 1757–1827. II. Title.
NC978.5.B55H46 1995 741.6'4'092 – dc20 95–30341 CIP

ISBN 0 521 47381 0 hardback

TO FRITZ AND GRETE HEPPNER,

FOR HAVING TAKEN ME

IN TIME TO ENGLAND'S GREEN

AND PLEASANT LAND.

Contents

Color plates

Illustrations

Preface

A book must explain and justify itself in the reading, if at all, unless it requires a preliminary discussion of the theory upon which it is based. The present text builds its theory as it goes along, and so I shall here offer only a few definitions of its exclusions, aims, and strategies. The focus here is the Blake who worked to become visible as a history painter, producing a large body of imagery in the pursuit of that aim. I have thus more or less excluded the illuminated poetry, though the book dips into that territory from time to time to make specific points.

History painting, as Blake understood it, has two centers: the first is the expressive body; and the second the story itself, the historical, mythological or poetic incident that underlies the narrative component of the image. These two interact to produce the imagery that constitutes the painting. The eighteenth century split the first into two closely related areas that it called "design" and "expression"; the second it called "invention," while the term "composition" described the art of combining both into a unified whole.

Some of the difficulty we experience in reading Blake's images arises from problems he had in integrating these several points of origin into fully communicative pictures. There is a problematic area of interaction between a visually oriented art based on the human body as the fundamental unit of meaning, and a deeply literary art based on texts which provide the narrative syntax determining the relationship between figures in a design. In theory, the two combine to enact a representation of human action, the central object of imitation in the humanistic theory of history painting. Stothard illustrates the hope that a perfect marriage is possible, for instance, in recommending that students copy the "Raphael Bible" because the artist showed "the dependence of one figure upon another, in the incident, or, as it might be called, the argument of his picture. The graceful union that pervades the whole, whilst every part is varied according to the character, or circumstances that marks every individual scene."[1] Stothard praises Raphael's success in combining the expressiveness of individual figures with the coherence and intelligibility of the "argument" they combine to tell. I shall argue that it was just such integration that Blake sometimes found difficult. The distinction between the two major parts of this book is intended to foreground a sometimes troublesome area within Blake's paintings.

The first part of the book consists of three chapters that deal with Blake's handling of the human bodies that mediate meaningful narrative. One of the questions raised is just how explicit and stable is the meaning that we can

attribute to a particular body. Recent criticism has employed the term *pathos formulae*, often in a softened sense, as a way of talking about the meaning of Blake's figures. In Chapter 1, that phrase is returned to the meaning that Aby Warburg originally gave it, and then used as a tool with which to interpret some key situations in Blake's developing art. The reading of Blake's figures is problematized by rethinking the respective contributions of codified accounts of expressive meaning on the one hand, and context on the other.

The second part explores Blake's process of invention, in order to define how he goes about creating a meaningful design using a known story or body of poetic imagery. After a chapter that attempts an overview of how Blake understood the process of pictorial invention, Chapters 5, 6, and 7 focus on the large color prints, the illustrations to Young's *Night Thoughts*, and the Bible; not a complete account of Blake's output, but enough to suggest the extent and methods of his work. Another chapter looks at the problem of Blake's handling of perspective, using that term in a wide sense to cover aspects of his use of the conventions of visual representation upon a flat plane. The last chapter offers an extended reading of *The Sea of Time and Space* which is included both for the interest of the painting itself – it is one of the most complex and highly finished paintings Blake left us – and as a justification of the arguments made throughout the book. My reading depends heavily on arguments made in earlier chapters, and in turn is designed to support them. A theme running through this second half of the book is that Blake is nearly always more responsive to the texts from which he starts – or towards which he points – than has been generally understood, and that an identification of those texts can be enormously helpful.

The book moves between the discussion of specific designs and more general topics, in the belief that practice and theory belong together, though theory is too abstract a term for the issues I take up here; it might be more accurate simply to say that I am concerned with how as well as what Blake's designs mean. However, I have used Chapters 3, 4, and 8 to explore general issues at greater length than is comfortable while focusing on specific designs. The attitude taken here towards the relation between practice and theory is analogous to that between what Clifford Geertz calls "thick description" and the kind of "Theoretical formulations [that] hover so low over the interpretations they govern that they don't make much sense or hold much interest apart from them."[2]

The focus on meaning implies that this book does not attempt to deal with all aspects of Blake's art. That focus, however, reflects Blake's own; many of his comments describe his art as almost linguistic in its intelligibility: "Painting, as

well as poetry and music, exists and exults in immortal thoughts",[3] and "The Beauty proper for sublime art, is lineaments, or forms and features that are capable of being the receptacles of intellect."[4] This book is, I hope, sympathetic to the hierarchy of Blake's own values.

Among the several continuous or recurring topics in these chapters is a questioning of the received view that Blake usually illustrates his own mythology rather than the nominal subject of a design. I adopt – and I hope justify – the premise that Blake interacts energetically with the texts he chooses to illustrate even when he departs widely from them. To give a Blakean reading of a design means not simply to map it onto the Procrustean bed of the outlines of his poetic mythology, but to become aware of the critical angle at which his thought processes intersect those of a text that proceeds from a perspective other than his own.

One aim is thus to recover some of the contexts in relation to which Blake's work came into being. Though Blake's methods and conclusions are often profoundly original, he nevertheless continually uses the materials available within his own culture as the medium through which he works, because he has no choice if he wishes to be understood, and because it is an integral part of his own culture. Thus Blake's well-attested regard for Ovid plays a large role in my reading of *The Sea of Time and Space*; the fact that Blake sees the world very differently from Ovid does not lessen the poet's value for him.

I have made much use of the writings of Fuseli. Previous commentary on Blake's art has been more interested in Reynolds, prompted by the presence of Blake's antithetical annotations, but Fuseli was an acknowledged friend, and close to Blake's perspective on many issues; Blake's written comments and artistic practice are often illuminated by being placed beside Fuseli's writings. In spite of some earlier comments and Carol L. Hall's book,[5] the articulateness of Fuseli's mind is still one of the underutilized resources of Blake scholarship.

At moments in this book I may appear to be maintaining incompatible positions. On the one hand, I hold that Blake's figures and designs must be read carefully for the information they contain, and make the point that criticism has overlooked important details in his designs – the Hebrew lettering around the hem of the man in red in *The Sea of Time and Space* (dealt with in the last chapter) is just one example. On the other hand, I maintain that the meaning of a design lies largely in the context – which usually means text – with which it interacts, and that too has often been downplayed by criticism. The thrust of this book is that we must pay attention to both, that any adequate commentary must

account for all of the significant details in a design, and also for the relationship between those details and the context from which they originate or to which they refer. The two demands are complementary rather than incompatible, though at any given moment I may have failed to balance them satisfactorily.

The book may also appear at times to come perilously close to contradiction in maintaining that the true determinants of the structure of Blake's pictures are intellectual, while occasionally, as in the discussion in Chapter 7 of those illustrations of the Bible claimed to refer to the Seven Eyes of God, allowing that one of the determinants is a formal quest for visual balance. Again I do not think there is a contradiction; the power of intellectual determinants is not crushed by allowing that formal determinants are at play also. Intellectual structures must be made at least partly visible in order to exist within a design at all; once visible, formal structures inevitably become at least potentially relevant.

The book also attempts to balance respect for Blake's statements that his designs contain explicit meaning with respect for his suggestions that meaning is the product of an interaction between artist and reader/viewer, and thus subject to continual revision and recreation. This opens up into the large spaces of contemporary theories of meaning; all that I can realistically do in a book like this is recognize the difficulty, and hope that my drive towards specifying meanings retains an awareness that meaning is never fully determinate or final. Chapter 3 is an explicit recognition of some aspects of the problem within Blake's own practice, but Humpty Dumpty is a figure who haunts the book as a whole. I accept his ghostly presence with the feeling that any attempt at exorcism would be more damaging than helpful.

Acknowledgments

My thanks to the Social Sciences and Humanities Research Council of Canada for a grant which gave me the time to finish this book, and to the research assistants who helped, particularly William Donoghue, who eased the belated leap forwards into writing at a computer. Martin Butlin kindly read an earlier version of Chapter 5; his knowledgeable and keen eye saved me from several errors, and caused me to rethink various issues, though I fear he may not agree with everything written here, and errors of fact and judgment that remain are my own. He also deserves special thanks for much helpful information about sources for photographs. Robin Hamlyn of the Tate Gallery gave me a good afternoon in the study room and the detail photograph of *The Body of Christ Borne to the Tomb*. Robert N. Essick gave me the English version of Gert Schiff's entry on *Hecate* from the catalogue of the Tokyo exhibition, and helpful suggestions that prompted further thinking about details of *The Sea of Time and Space*.

I thank the Keeper of Arlington Court for allowing me to examine *The Sea of Time and Space* outside regular hours, and Louise M. A. Rose, Senior Assistant Archivist of North Devon Record Office, for making a search of the papers of Arlington Court, though the search found no reference to the painting.

The Lawrence Lande Blake Collection in the Department of Rare Books and Special Collections at McGill has been a continually useful resource, and the collections and staff of The Henry E. Huntington Library, the British Library, and the Warburg Institute have been invaluable on a regrettably more occasional basis.

Incorporated into the book are revised versions of previously published essays: "Reading Blake's Designs: *Pity* and *Hecate*," *Bulletin of Research in the Humanities*, 84 (1981); "Blake as Humpty-Dumpty: The Verbal Specification of Visual Meaning," in *Word and Visual Imagination*, eds. K. J. Höltgen, P. M. Daly, and W. Lottes (Erlangen, 1988); "Blake's 'The New Jerusalem Descending': A Drawing (Butlin #92) Identified," *Blake: An Illustrated Quarterly*, 20: 1 (Summer 1986); "The Good (In Spite of What You May Have Heard) Samaritan," *Blake: An Illustrated Quarterly*, 25:2 (Fall 1991); "The Chamber of Prophecy: Blake's 'A Vision' (Butlin #756) Interpreted," *Blake: An Illustrated Quarterly*, 25: 3 (Winter 1991–92). I thank the editors for permission to present the material here in revised form.

Maggie Kilgour, Mette Hjort and Paisley Livingston, Rachel Gamby and Hugh Roberts, Peter Ohlin, and Jeremy Walker, among others, have provided friendship and encouragement. Now I shall have a book to give to them in small recompense for those received and anticipated.

Key to references

David V. Erdman's *The Complete Poetry and Prose of William Blake* (University of California Press, 1982) is the source for quotations from Blake's written works; page references are given parenthetically, e.g. (E 42). Wherever possible, references to Blake's paintings and drawings are made to the catalogue (not illustration) number in Martin Butlin's *The Paintings and Drawings of William Blake*, 2 vols.(Yale University Press, 1981), abbreviated to, for example, (B 452). For consistency and ease of reference, I have used the titles found in that work even where I have suggested others as more appropriate. All information about a painting that is not specifically noted should be assumed to come from the relevant entry in Butlin. References to both Young's text and to Blake's illustrations of that text are made to John E. Grant, Edward J. Rose, Michael J. Tolley, and David V. Erdman, *William Blake's Designs for Edward Young's "Night Thoughts,"* 2 vols. (Oxford University Press, 1980) by the number there assigned to each page of Blake's watercolors (e.g. NT 48).

The following abbreviations are used in the notes:

AB	*Art Bulletin*
AH	*Art History*
BIQ	*Blake: An Illustrated Quarterly*
BM	*Burlington Magazine*
BN	*Blake Newsletter*
BRH	*Bulletin of Research in the Humanities*
BS	*Blake Studies*
CLQ	*Colby Library Quarterly*
DNB	*Dictionary of National Biography*
ELN	*English Language Notes*
HLQ	*Huntington Library Quarterly*
JEGP	*Journal of English and Germanic Philology*
JHI	*Journal of the History of Ideas*
JWCI	*Journal of the Warburg and Courtauld Institute*
MLQ	*Modern Languages Quarterly*
MP	*Modern Philology*
N & Q	*Notes and Queries*
PQ	*Philological Quarterly*
SiR	*Studies in Romanticism*

Blake and the signifying body

The pathos of formulae

The basic unit of meaning in history painting is the human body, the agent of intentional action. The first part of this book will look at Blake's developing theory – insofar as that is available to us – and practice of designing such bodies. That theory and practice can best be understood through the mediation of a brief and schematized account of the history of Western thought on the subject.

Antiquity is the single most influential source for Western work in the creation of thinking and acting bodies, but antiquity itself appears already divided as it confronts the Western artist. It presents on the one hand the great masterpieces of antique sculpture, several of them incomplete torsos, and on the other it offers the written formulations of the rhetoricians, which describe exact manual gestures to drive home very specific points. From these two sources the West derived two rather different, though overlapping and interconnected, systems of expression. One can describe the system derived from the sculptural remains as intuitive, natural, and torso-focused, and the system derived from the formulations of the rhetoricians as explicit, artificial, and limb-oriented: the systems offer themselves to a variety of oppositional terms. What I call the intuitive, natural system is based on actual observation of bodies and bodily expression, though that is always culturally mediated, and its articulation in art subject to the secondary mediation of schemata of the kind discussed by E. H. Gombrich in *Art and Illusion*.[1] The artificial system based on the rhetoricians was originally designed to assist an orator in communicating thought and feeling while talking, and sometimes became virtually a parallel vocabulary, a gesture to accompany each word spoken. In the language current in the eighteenth century, the first system was composed of natural signs;[2] the body becomes the expressive system of the soul through a kind of Gestalt isomorphism – relaxed, heavy limbs "mean," or better are, depression, calm, or whatever the context suggests. The second system was in eighteenth-century language composed largely of artificial signs, codified by such writers as Bulwer and Le Brun.[3] In practice, any gesturing body created by an artist will contain elements of both. The painter usually attempted to reduce or abolish the distance between these two modes; the natural, observed feeling tone of a body was moved in the direction of greater articulateness, while the artificially coded gesture taken from a rhetorical textbook was partly naturalized to appear

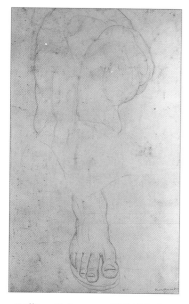

1. William Blake, copy of *The Belvedere Torso* (B 115v); *c.* 1779–80(?)

more spontaneous. The opposition I have described, though much mediated in practice, was widely understood in the seventeenth and eighteenth centuries,[4] and offers a basis on which to organize a discussion of Blake's thinking and working in the area.

Michelangelo and Poussin are the two figures in modern art who best instantiate this opposition as it appeared to Blake and his time. Both were enormously indebted to antiquity, but to different aspects thereof. Fuseli said of Michelangelo that "he scattered the Torso of Apollonius in every view, in every direction, in groups and single figures, over the composition of the Last Judgment."[5] The figure referred to is the sculpture most commonly known as The Belvedere Torso (illus. 1), also known as Hercules and the Torso of Michelangelo, since the great sculptor was said to have admired it, and to have learned some secret of composition from it.[6] Blake followed Fuseli and history in ascribing unique power to this torso, and referred to it, with a playful rhetoric, as "perhaps... the only original work remaining" of the Asiatic Patriarchs who created "those wonderful originals called in the Sacred Scriptures the Cherubim" (E 531). That a torso without arms or head, and with only stumps for legs, could be taken as the best representative of the appeal that antiquity had for the greatest artist of the Renaissance shows the power possessed by the idea that expression was focused in the exact tonality of the muscles of the trunk, and radiated out into the limbs and head from that organizing center; Blake defined strength as "accumulation of power to the principal seat, and from thence a regular gradation and subordination" (E 545). The expressive power of such a figure is dependent on the viewer's ability to achieve an intuitive muscular empathy with the body. The various interpretations given to the piece – that it had originally represented Hercules resting, caressing Hebe, etc. – played a powerful role in shaping the response of viewers throughout history, but these responses were also based on a meaningful play of tension and relaxation discernible in the muscles. That implies that a great deal of anatomical knowledge has entered into the creation of a body capable of arousing such feeling in a viewer. Michelangelo's art was always understood as a continuation of this aspect of antique tradition.

Poussin's debt to antiquity, while equally large, is differently focused. Blunt, in discussing Poussin's artistic theory, comments that while Rubens turned to "what can be called the baroque works in late Greek and Roman sculpture, such as the *Belvedere Torso* or the *Barberini Faun*, Poussin instinc-

tively turns to models of a more classical type."[7] Poussin avoided just that aspect of classical influence which had most appealed to Michelangelo, and chose instead that which is most explicitly articulate. Blunt records that Poussin was a serious reader of Quintilian, and that "In one of his notes… he quotes almost verbatim from Quintilian's *Institutio oratoria* on the subject of gesture."[8] Poussin was perfectly conscious of the drive towards an almost verbal articulateness represented by such work, and wrote to Félibien that "Just as the twenty-four letters of the alphabet are used to form our words and to express our thoughts, so the forms of the human body are used to express the various passions of the soul and to make visible what is in the mind."[9]

This drive towards the totally articulate was inherited by Le Brun, who learned an interest in the representation of expression through Poussin during his years in Rome, where he arrived in 1642 to join his great compatriot. Le Brun, grounding his theory on the philosophy of Descartes as well as on the practice of Poussin, made the eyebrows the central indices of the feelings of the soul, which in Descartes's theory came into contact with the body in the pineal gland just behind and below the eyebrows. Norman Bryson, basing his account of Le Brun as I am basing my own largely on the unpublished thesis of Jennifer Montagu, writes that "Le Brun reduces the face to a few basic semaphoric units,"[10] using a linguistic metaphor of legibility that I shall adopt for my own argument here. Le Brun's interest in his *Conférence sur l'expression générale et particulière* was focused on the face, but he also made some remarks on significant gestures that fit in with Poussin's use of the traditions of Roman oratory as the basis for his expressive theory. Le Brun's remarks describe movements of the limbs, especially the arms and hands, supporting Bryson's use of semaphore as the metaphor through which to describe this approach to bodies as signifying systems.

The actual practices of Michelangelo and of Poussin overlap a good deal, and the opposition made here between intuitive, trunk-centered bodily expression and an explicitly coded system using the mobile features of the face and the limbs and, especially, the hands, cannot be other than the marking out of the extreme limits of a field. Traces, or more, of the one pole always appear in any practice based primarily on the other. But the distinction was recognized by artists close to Blake, and I shall turn to the writings of Fuseli, a good friend of Blake's for a number of years, who articulates an awareness contemporary with Blake's.

6

In his *Lectures*, Fuseli makes a clear distinction between the two different types of expressive system outlined above. The distinction is coded in the terms "Nature" and "tradition," and is first expounded in the context of a discussion of classical art: "The passions which tradition had organized for Timanthes, Aristides caught as they rose from the lips of Nature herself."[11] The distinction is repeated in Fuseli's *Aphorisms*: after praising the "expression of the ancients" for a power that "from the heights and depths of the sublime, descended and emerged to search every nook of the human breast" (another image of power originating from a center and moving outwards to inform the periphery), he goes on to command the viewer to "Distinguish between the hero and the actor; between exertions of study and effects of impulse."[12] This fundamental distinction between natural expression and traditional code, impulse and study, becomes the basis for a recurring distinction between, on the one hand, ancient art and its Renaissance offspring, particularly that of Michelangelo and Raphael, and on the other the art of seventeenth-century France.

According to Fuseli, Michelangelo learned most of what he knew by copying the ancients and by working with actual human bodies, both dead and alive. In the process he recreated the language of natural feeling: "in the Last Judgment, with every attitude that varies the human body, [he] traced the master-tract of every passion that sways the human heart."[13] In the Sistine ceiling he created the "single figures of the Prophets, those organs of embodied sentiment."[14] Fuseli praises the Cartoon of Pisa as "the most striking instance of the eminent place due to this intuitive faculty among the principal organs of invention."[15] Michelangelo created bodies that express feeling with an unquestionable, inevitable naturalness. Fuseli is equally explicit about Raphael, who possessed an "intuition into the pure emanations of nature."[16] Though Fuseli's phrases about Michelangelo might seem to echo Poussin's words in the letter to Félibien cited above, Fuseli sees a large difference between the two artists.

In writing about French painting of the seventeenth century, Fuseli adopts a quite different vocabulary, consistently associating such art with both the theater and the academy. In the "Introduction" to his *Lectures* he suggests that the works of Cicero, "but chiefly his Orator and Rhetoric Institutions… might furnish the classic scenery of Poussin with figures,"[17] making Blunt's point long ago. Fuseli then describes briefly the "complete system of rules" composed by the French critics, which he sums up with:

"What can be learned from precept, founded on prescriptive authority, more than on the verdicts of nature, is displayed in the volumes of De Piles and Felibien"; it is a schooling which results in a "technical equality, which borders on mediocrity."[18] Fuseli expressed his dislike of Le Brun with particular forcefulness.[19]

Poussin is identified with this movement; though steeped in the antique, he "not only with the utmost ardour adopted, but suffered himself to be wholly absorbed by the antique. Such was his attachment to the ancients, that it may be said he less imitated their spirit than copied their relics and painted sculpture."[20] The result of such an uncreative and secondary process – copying the body rather than imitating the spirit – can be seen in "Poussin's extolled picture of Eudamidas [which] is another proof of the inefficacy to represent the enthusiasm of sentiment by the efforts of art."[21] When Fuseli writes that the French artists generally allow their "expression [to be] dictated by the theatre," it is in the context of their questioning of "Michael Angelo's right to the title of a painter"; Fuseli contrasts the "fierceness of [Michelangelo's] line" with something merely rhetorical and not deeply felt in the work of the French artists.[22] His views are an articulation of those always implicit and sometimes explicit in the whole century, and Blake was in a good position to have access to them at the source.

A more recent commentary on bodily expression, also set out as an opposition between two ways of coding feeling, continues the distinction traced here. Over a period of many years, Aby Warburg developed the concept to which he gave the name *pathos formula*. Warburg coined the term to identify gestures from classical art that embodied Dionysiac and primeval passion and were adopted by Renaissance artists as a kind of superlative to assist in the heightening of the expression of intense feeling. His thinking on the subject began with a girl, or "Nympha" as he came to call her, carrying a basket of fruit in Ghirlandajo's *Birth of St. John the Baptist*. Warburg identified her source as classical, and interpreted her as representing "the eruption of primitive emotion through the crust of Christian self-control and *bourgeois* decorum."[23] In his later thinking, Warburg likened the borrowing of such powerful classical figures to the linguistic formation of a superlative from a root quite different from that of the original adjective.

Attractive though they are to the artist, Warburg describes a danger in such formations:

> Wherever the artist's choice sprang from a real urge to use the maximum
> of expressive power that a human figure can yield, it was artistically
> justified and aesthetically successful. But what if the adaptation of this
> highly charged language of passion were only the consequence of fashion
> or superficial sensationalism? In that case it would land the artist in that
> theatrical gesticulation which we generally associate with the Baroque...
> There is thus an inherent danger in the artistic use of superlatives which
> only the greatest master can escape. A Michelangelo may use them
> without fear, but a minor artist succumbs too easily to their lure.[24]

In Warburg's later view, these *pathos formulae* carried a powerful and often
tragic charge of primeval religious experience, and the artist who used them
was always in danger of falling into a hollow, inflated theatricalism, though
Warburg does suggest that artists learned to tame these *formulae* by such
devices as the inversion of their meaning, giving as an example a sarcopha-
gus representing maenads tearing a leg from Pentheus, which Donatello
used as a schema for the representation of the healing of a broken leg.[25]

There is a difference between the oppositional structures outlined by
Fuseli and Warburg. For Fuseli, theatricalism is the opposite of the natural
power of classical invention; for Warburg, it is a danger inherent in its use,
or rather misuse. Fuseli sees the other, for Warburg more recent and *bour-
geois*, pole of the dichotomy as also having its origins in antiquity, in Timan-
thes and the rhetoricians But there is also a deep similarity: both see a
distinction between the powerful feeling expressed in classical figures, and
the more restricted, codified, and genteel figures of later art, and both see
Michelangelo as an intermediary, a modern artist strong enough to be able
to use classical figures without any danger of being, as Poussin was, "wholly
absorbed." We can take Fuseli's splendid phrase "organs of embodied senti-
ment" as representing the one pole of our model, and his "expression dictated
by the theatre" as representing the other. The latter phrase comfortably
accommodates such codifications as Le Brun's and Bulwer's, which indeed
did maintain a two-way contact with the theater.[26]

Warburg's language has found its way into discussion of Blake's art in
recent years. Much recent work on the meaning of figures in Blake's designs
has used the term *pathos formula* as a way of talking about the meaning of
the repeated gestures which occur in Blake's art. Bo Lindberg was the first
to make significant use of the term, and Jenijoy La Belle and especially Janet
Warner have developed the approach.[27] The phrase has sometimes been used

as if it meant simply the use of a conventional – or for that matter deeply archetypal – bodily gesture as a sign for a specific form of emotional energy. I shall take my representative definition from an essay by Jenijoy La Belle:

> Aby Warburg's concept of *pathos formulae*, recently used by Bo Lindberg in his study of the Job designs, is helpful in understanding the process of initial imitation and subsequent transformation operating here. A *pathos formula* may be described as a limited range of body configurations and placements of the human form in space which communicates a definable range of mental and emotional states. These *pathos formulae* form an important part of the language of motifs in Western art, from the Renaissance to at least the nineteenth century.[28]

This repeated use of the term *pathos formula* in discussion of Blake's system of bodily expression has had both helpful and unhelpful consequences. It has helped to focus awareness of the meaningfulness of gesture, of the presence of something approaching the status of a signifying code. But it has also weakened potential awareness of the history of Blake's continuing search for communicative and powerful modes of expression, and has tended to background the importance of context and detail in defining the total meaning of a specific gesture, though the essay by La Belle from which I have quoted is sensitive to this danger, and helpful in showing a clear awareness of both origin ("initial imitation") and change ("subsequent transformation").

The concept of *pathos formulae* has also sometimes led to a diminished awareness of the differences between types and sources of meaning, so that Warner, for instance, can imply the existence of a unified, internally consistent "pictorial language," a "visual vocabulary," and writes of "the great continuity of visual symbol" which existed in such forms as emblem books and the manuals of the mythographers. Warner refers to the Neoplatonic foundations of Blake's concept of art, reinforcing the connotations of words like "archetype," though she acknowledges that "for Blake, the language of visual images is man-made, not God-given, and the visual symbols as he recognized them have not the static nature associated with Platonic eternal form."[29] Though I accept many of the specific readings to which Warner's approach leads her, and will make analogous readings myself, there is a danger that readers will assume that there is indeed a coherent, univocal visual language, agreed upon by all artists, that Blake used, and which can in turn be used to decipher his images. The real state of

things is more complex and equivocal, as the brief history given above indicates, and the following discussion will begin an exploration of that complexity, following the model of a dialectic that moves towards a never quite achieved synthesis.

II

Blake's serious work on the problem of designing expressive bodies probably began with the copying of plaster casts of antique statues in Pars's drawing school.[30] The print of *Joseph of Arimathea Among the Rocks of Albion*, copied from a figure by Michelangelo, testifies to his continuing interest in learning from the great artists of the past during his apprenticeship with Basire, upon completion of which he was admitted to the Royal Academy in October 1779 as a promising young artist who was already a trained engraver.[31] He rapidly made himself visible by exhibiting a painting in 1780, *Death of Earl Goodwin* (B 60), which earned him a comment on its "good design and much character" in a review by his friend Cumberland.[32] He exhibited two more drawings at the Academy in 1784: *A Breach in a City, the Morning after a Battle* (B 188), and *War unchained by an angel, Fire, Pestilence, and Famine following* (B 187). In the same year Flaxman recorded that a Mr. Hawkins, in addition to commissioning several drawings, was attempting to raise a subscription to send Blake to finish his studies in Rome, a project which, fortunately or unfortunately, did not come to fruition. Blake's association with the Academy culminated in 1785 with the exhibition of *The Bard, from Gray* (B 160), and the three watercolors of the story of Joseph and his brothers (B 155–57). This won him a mention in an anonymous review in the *Morning Chronicle and Daily Advertiser*, but was his last appearance at the Academy for fourteen years.

This was a pivotal period in Blake's career. He had married in 1782. His first volume of poetry, *Poetical Sketches*, had been printed, though not published, in 1783. He had made a very promising beginning as a history painter while a student at the Academy. By 1785 there were thus openings in several directions, which offered tempting but for the moment inconclusive possibilities. There was also a wife to support. It was a time in which both to sum up the past and map out the future. The Joseph series belongs at the apex of this period.

If we consider these early designs as a group, some aspects of Blake's immaturity as a visual artist become apparent, despite Cumberland's compli-

2. William Blake, *Robinson Crusoe Discovers the Footprint in the Sand* (B 140r, *c.* 1780–85)

mentary notice. If we look at the *Death of Earl Goodwin*, and at other designs such as *The Keys of Calais* (B 64, *c.* 1779), *Joseph of Arimathea Preaching to the Inhabitants of Britain* (B 76r, *c.* 1780), and *Moses Staying the Plague* (B 115r, *c.* 1780–85), we find rather crudely drawn figures, with bodies held rigidly, and the feeling or intention articulated through stiff and repetitive gestures of arm and hand.

These gestures certainly depend upon codified systems such as that of Le Brun, and I offer an example taken from these early designs: Le Brun describes the formula for "Admiration" in the following way: "this… Passion may be expressed by a person standing bolt upright, with both Hands open and lifted up, his Arms drawn near his Body, and his Feet standing together in the same situation."[33] Blake's *Robinson Crusoe Discovers the Footprint in the Sand* (B 140r, *c.* 1780–85; illus. 2) could have been drawn as an illustration of just this description.

Such gestures are usually intelligible if we recognize and have access to the relevant code-book. But their intelligibility is by no means total or unequivocal in all cases, and does not defend them from the charge of being repetitive, mechanical, and, to repeat a phrase by Fuseli quoted above, "founded on prescriptive authority, more than on the verdicts of nature." There are also some gestures in Blake's early vocabulary that, with small variations, become disturbingly all-purpose. An arm and hand held straight out with pointing finger seems to indicate exhortation in *Joseph of Arimathea Preaching* (B 76r, *c.* 1780);[34] arms and hands held straight upwards accompany the swearing of an oath in *The Children of Israel Receiving the Ten Commandments from Moses* (B 114, *c.* 1780–85); arms held straight out and a little upwards seem to indicate a gestural version of performative utterance in *Moses Staying the Plague* (B 115r, *c.* 1780–85). Saul sends off David in *Saul and David* (B 118r, *c.* 1780–85) with a gesture uncomfortably close to that with which Goliath challenges that same David in *Goliath Cursing David* (B 119Ar,

c. 1780–85). The repetitive and unsatisfactory quality of these gestures is not much alleviated by the discovery of a code that partly governs their meaning, while nevertheless allowing very similar gestures to hold quite different meanings in different contexts.

To return to Bryson's metaphor of semaphoric signs, there is indeed a quality resembling the Morse code in these gestures of the arms and hands, largely isolated from the torso as a potentially organizing and energizing center of communicative power. Arms and legs seem moved into position as if they belonged to a puppet manipulated by an external master, rather than moving from an inner intelligence and motivation.

It is likely that Blake and Blake's friends were aware of these weaknesses. The chief intent behind an artist's desire to go to Rome in Blake's day was to win knowledge of the deep workings of the human body from the great works of antiquity, and from the masterpieces of modern art, most specifically Michelangelo and Raphael. The attempt by Blake's friends to send him there in 1784 failed, for unknown reasons,[35] but we can guess their motives, and we can also guess that Blake would have welcomed the opportunity to deepen and enrich his art. If he could not go to Rome, however, Rome could come to him. He could try to learn power from the great works of antiquity and their modern incarnation in Michelangelo. The reproductive print, which engaged so much of his own working life, could become a partial substitute for the sea passage he could not afford. Blake energized a dialectical process that would attempt to bring together two different expressive systems within his own art.

III

With the recent discovery of the preliminary sketch for *Joseph's Brethren Bowing before him,*[36] we now have sketches for all three of the Joseph designs which were exhibited at the Royal Academy in 1785, and this affords an unusual opportunity to explore the process that led Blake from sketch to finished design, and to win insight into some of the problems he was working through at this key moment in his career, when a bright future as a historical painter still seemed a possibility. In the interests of the narrative of my own argument, I shall reserve the design that comes first in the Genesis story, *Joseph's Brethren Bowing before him,* for consideration after the other two have been discussed. We do not know the actual chronological sequence in which Blake worked on the designs.

3. William Blake, *Joseph Ordering Simeon to be Bound*, sketch (B 158)

4. William Blake, *Joseph Ordering Simeon to be Bound*, finished version (B 156)

In the case of *Joseph Ordering Simeon to be Bound*, there is not a great difference between sketch (B 158; illus. 3) and finished design (B 156; illus. 4). In the finished design, Joseph himself has become more fluid, his upper body lowered and his legs pushed further back so that more of his weight appears to rest on his arms, as if to emphasize that in the passionate suffering of this moment his body is unable to support itself. One could read this as symptomatic of a deepening awareness of the whole body on Blake's part, of a better feeling for the interaction of muscle tone with gravity. The man binding Simeon, who looks directly at Simeon's averted face in the sketch, now looks down at the hands he is binding, which gives greater variety to the

14

gazes in the design, and reduces the number of personal interactions in order to foreground those that are central to the narrative. The largest change is in the arms and hands of the remaining brothers. In the sketch, there are three similarly raised hands in a row among those at the back, and another in the front row of kneelers. In the finished design, the raised hand of the kneeler has been brought down to shoulder level, and the fingers clasped around the other hand; the raised hands of the standees have also been dropped, except for one which now loosely covers part of its owner's face, as if shielding him from the painful event taking place. In all, the changes suggest that some good artist friend saw Blake's sketch, and gave him valuable advice on how to curb the repetitiveness of those all-purpose gestures, and on how to invent gestures that are more spontaneous and specific to an individual body. Given Blake's close and active association with several artists at just this time, that may indeed be exactly what happened.

In the case of *Joseph Making himself Known to his Brethren*, we possess two preliminary sketches, with a marked change of style between the two. In what appears to be the earlier (B 159v; illus. 5), Joseph and Benjamin move to embrace each other with identically raised and straight arms, while the other brothers are less well defined, displaying a good deal of repetition in

5. William Blake, *Joseph Making himself Known to his Brethren*, first (?) sketch (B 159v)

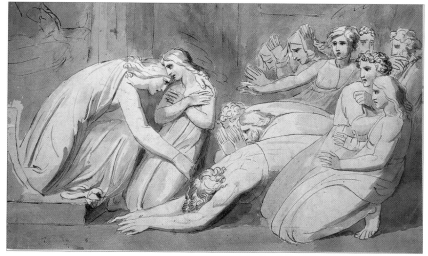

15

6. William Blake, *Joseph Making himself Known to his Brethren*, second(?) sketch (B 159r)

both the faces and the hands, the latter raised in a gesture representing sur-
prise, dismay, or alarm. What appear to be the younger, because beardless,
brothers at the center of the design lean forwards with hands before their
faces, in a posture described by Le Brun: "In Veneration the Body will be
yet more bent than in Esteem, the Arms and Hands almost joined, the
Knees bent to the ground, and, in short, all the Parts of the Body will
express a profound Respect."[37]

In what must be the second version (B 159r; illus. 6), Blake has chosen a
slightly different moment, and shows Joseph leaning upon and embracing
Benjamin, who is made smaller to indicate youth. But while the gestures of
these two have now been clearly distinguished, the other brothers present a
virtual forest of identically raised and outstretched hands. While Joseph

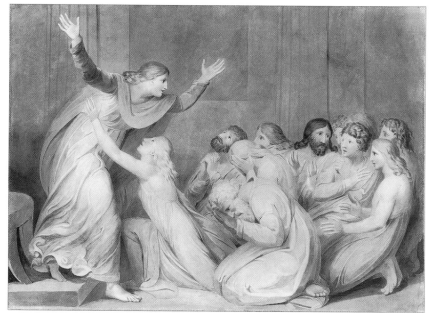

7. William Blake, *Joseph Making himself Known to his Brethren*, finished version (B 157)

16

has become more individually expressive, Benjamin seems to illustrate yet another of Le Brun's gestures: "in the Action that expresses Faith the Body may be almost prostrate, the Arms folded and joining the Body, the Hands crossed one upon another, and the whole Action must shew a profound Humility."[38] Blake was obviously dissatisfied with his first version, but this second try still suffers from a dry conventionality.

The finished drawing (B 157; illus. 7) is substantially changed. The repetitive groupings of brothers have been broken up, and more variety has been given to the heads and, especially, the arms and hands. We now have differentiated gestures: ashamed hands covering faces, hands clasped to implore, hands raised and apart in wonder. Benjamin himself is now more or less full size, and rises from kneeling to embrace Joseph, who steps forward with arms uplifted as if about to embrace all of his brothers or, as Le Brun puts it, with "Arms lifted up, and the Hands open" to express "Ravishment or Extasy."[39] The changes made in this design show Blake working to increase the variety and expressiveness of his figures, while remaining within the conventional codes of conveying feeling.

The recently rediscovered sketch for the remaining painting of the series, *Joseph's Brethren Bowing before him* (illus. 8), shows tendencies similar to those manifested by the other sketches, but with a difference. In compar-

8. William Blake, *Joseph's Brethren Bowing before him*, sketch

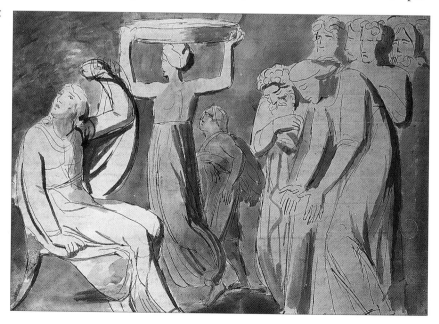

ison with the sketches for the other designs, an attempt has been made to individualize the mass of brothers – the two foremost are clearly separated into the young man close to us, unbearded, with arms down in submission, and the older, bearded brother, with arms crossed on his breast in contrition. Behind these two is a group of heads which do little more than fill in a corner of the design.

The remainder of the space is filled by two very different figures. In the center is an obviously classically inspired female servant in a gracefully *contrapposto*[40] position holding a flat basket on her head. She is quite extraordinarily similar to the "Nympha" in Ghirlandajo's painting of the *Birth of St. John the Baptist* in Florence, who stimulated Warburg's first explorations of *pathos formulae*.[41] The source of the figure is very probably the similar figure on the right in Poussin's *Triumph of Flora*, which was available in prints by Horthemels and Fessard and others (illus. 9).[42] This painting, like most of Poussin's, was done while he was in Italy, and so might have been influenced either by Ghirlandajo's painting or by its classical source; Poussin was quite capable of using the antique in its more natural and intuitive aspect, Fuseli's critique notwithstanding. Blake evidently thought highly of Poussin, especially of the early paintings, among which this painting belongs, and it is probable that he owned prints of some of these paintings;

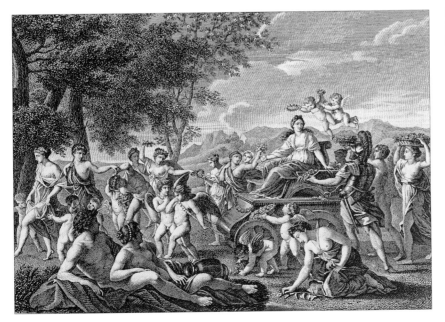

9. Poussin, *Triumph of Flora*, engraving by Sebastien Le Roy, Chataigner and Niquet

18

it was during this period that Poussin made the most numerous borrowings from the antique.[43] The connection leading from a classical original and/or Ghirlandajo's figure through Poussin to Blake cannot be traced with complete certainty, but it is intriguing to think of Blake's figure as springing from the very source of Warburg's concept of *pathos formulae*.

To the left of this figure is Joseph, seated on a chair with his arm and robe swept up to hide his averted face, in a gesture based on the classical statue of Niobe, as Bindman points out.[44] Blake's figure is probably based on some version of Perrier's well-known print, the central figures of which were re-engraved by Boitard for Spence's *Polymetis* (illus. 10).[45] Wilson's *Niobe* was based on the same Perrier print, and was in turn reproduced in what became a famous print by Woollett.[46] Blake copies almost exactly the orientation of the figure in these prints, making it likely that one of these versions, rather than a plaster cast, was his model.

In choosing this figure for his original, Blake has taken one of the most famous bodies created by antiquity, often attributed to Praxiteles or Scopas, though there were later doubts about this, and chosen by Shelley as "probably the most consummate personification of loveliness with regard to its countenance... that remains to us of Greek Antiquity."[47] Blake has adapted this powerful figure in ways that illustrate how much the meaning of a body can be shifted by modifications of gesture and change of context. Spence describes her actions like this: "She is sheltering her youngest daughter... with her own garments, and with her very person: for she bends over her, as willing rather to receive the wound herself, than to lose her favorite child."[48] Blake has left the upper half of the body largely unchanged, but has raised the upper arm so that the hand is above the head, and has slightly altered the angle of the head. The figure is now seated, so that its resistive energy is much reduced, and the lower arm, though not greatly different in outline, now rests on a chair instead of shielding a child, resulting in a degree of limpness; what had been a moving gesture is reduced to empty superfluity. The awkwardly turned head of the original, usually explained as a gaze turned towards the avenging Apollo in the sky,[49] now records a troubled act of self-concealment. The act of giving protective shelter focused on the child in the original has been shifted upwards and inwards by the raising of the upper arm, and is now centered on the face itself. The gesture now represents a guarding against the self-betrayal of a revelation of visible feeling.

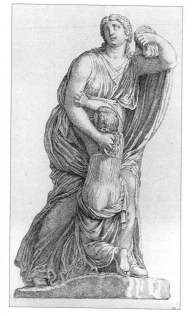

10. Boitard, engraving after Perrier's print of Niobe, from Joseph Spence, *Polymetis* (1755)

In revising the sketch for the finished design (illus. 11), Blake has made changes of several kinds. He has reversed the design from right to left, except for the servant girl, who remains facing to the left; the result is to isolate Joseph more effectively, since the girl now has her back to him. Joseph's lower hand has been raised from his chair to his breast, to give an apparently superfluous hand something useful to do by emphasizing the intensity of inheld feeling. The upper hand has been brought down a little closer to the head to sharpen the gesture of concealment. These changes reduce the closeness of the reference to the Niobe original, and improve the fit of the figure in its new context. The reversal of the servant girl in relation to the other figures has reduced her *contrapposto* by hiding one of her legs behind Joseph, and she becomes a less powerful figure as a consequence. Blake seems to have worked very deliberately to reshape the two classically inspired figures of Niobe and the servant girl in order to reduce both their power and their difference from his other figures. They now fit his own narrative more specifically and precisely.

Blake also did some work on the remaining bodies. The other brothers have been more highly characterized. The first two have not been changed a great deal, but the remaining brothers have been given a variety of hair color, beards, facial expressions, and colored garments, to reduce the effect

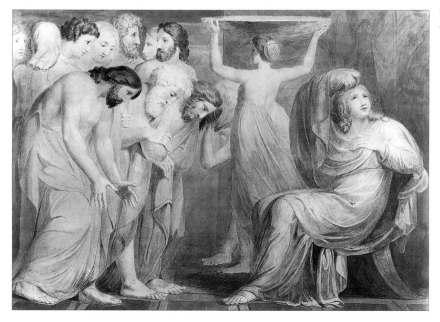

11. William Blake, *Joseph's Brethren Bowing before him,* finished version (B 155)

19

of their being an undifferentiated mass, though they have not quite been shaped into a community of totally articulate individuals.

The changes made between the sketch and the finished drawing give us a brief narrative of Blake's work in expanding his vocabulary of expressive bodies. He went to antique models, particularly for the key figure of Joseph. In doing so, however, he succumbed in some degree to the precise danger pointed at in different ways by both Fuseli and Warburg. Though Joseph was intended to be the center of emotional interest, his powerful gesture did not quite fit the context, and co-existed uncomfortably with the rather uninterestingly coded figures of his brothers. The free strength of the servant girl had no obvious relationship to the drama governing the design, though it attracted an undue amount of the viewer's attention and interest. The girl and Joseph were true *pathos formulae* in the sense defined by Warburg, with all of its implications of a potential lack of harmony with the surrounding figures.

Blake sensed this, or had it pointed out to him by a friend, for in revising the sketch he has worked from both sides to diminish the distance between these two very different kinds of figure. The mass of brothers has been animated, and the classical origins and power of the food-server and Joseph have been toned down; a conscious effort has been made to absorb them into the fabric.

Bindman, in commenting on the Joseph series, notes that "the self-conscious reference to classical prototypes" may reflect the influence of Barry.[50] This is very likely – Barry was elected professor of painting to the Royal Academy in 1782, and may well have had a direct influence on Blake's work at this time. Blake's reminiscence that "Barry told me that while he Did that Work – he Lived on Bread & Apples" (E 636) certainly implies a personal relationship. But Bindman's comment does not suggest the kind of active search that I am proposing here, for which the next chapter will offer further evidence.

The search was driven by Blake's dissatisfaction with the conventional gestural systems coded by Le Brun and others, and by his active and conscious attempt to find more powerful and individual sources for bodies expressive of human emotion. The Joseph series is the record of one moderately successful attempt by Blake to strengthen his art, though it bears within its history traces of a struggle with the power and freedom of the classical figures to which he has turned. The series also bears witness to the

fact that at this moment in his career, Blake's ability to invent intellectually interesting versions of a story had run ahead of his ability to create fully satisfying bodies through which to express that story. There was more work to do.

To call the Joseph series one small step in a substantial campaign would suggest too explicitly an overt narrative, as if this were a war with a definite beginning, middle, and end. In practice, the situation is less clear-cut. The conflict between different modes of representing the passions, and the shift from one towards the other, are continuous processes in Blake's career, and though the Joseph series is a significant moment in those processes, it in no way represents a final turning point or consummation; those processes went on, and the shifts went backwards as well as forwards. In *A Vision of The Last Judgment*, written in 1810, Blake entreats his viewers to "attend to the Hands & Feet to the Lineaments of the Countenances they are all descriptive of Character" (E 560), as if still, or again, invoking Le Brun-like codes, and Warner has shown Blake using gestures based on *Chirologia* in the illustrations to *The Book of Job*, the first designs for which were made *c.* 1805–1806 (B 550).[51] Blake never ceased to find utility in the coded systems of the academies, and indeed the evidence suggests that after the powerful experiments of the 1790s he increasingly returned to the more explicitly codified gestures of his earlier work. Though he would have been pleased to have the intelligibility of his figures recognized, he would have been less happy to have received congratulations on the formulaic quality of his art, from which he was making determined efforts to escape while continuing to find them invaluable.

The desire to expand and strengthen his ability to create powerful and expressive bodies continued, particularly in the 1790s, and took him more and more towards Michelangelo, whose work he saw as an extension of the work of antiquity; he refers to "Rafa[e]l Mich Angelo & the Ancient Sculptors" (E 562) as if they formed a unified tradition. The next chapter will isolate that relationship, focusing on the problems inherent in the acts of copying and borrowing.

"Michael Angelo Blake"

Blake's love of, and indebtedness to, Michelangelo is apparent and joyfully confessed. The relationship was seen and remarked upon by friends and contemporaries, to the point of the identity implied by Charles H. Tatham's request to Linnell in 1824: "Can you engage Michael Angelo *Blake* to meet us at yr. Study, & go up with us?"[1] Much has been written on the relationship, but there is room for a review within the specific context of Blake's quest for an expanded and more powerful vocabulary of expressive bodies. The focus will be on Blake's encounters with Michelangelo during the 1780s and 1790s, when the relationship was at its most intense and fruitful. The chapter will deal with the question of just how Blake saw Michelangelo, and with the problems involved in borrowing such powerful bodies, which are identical with those incurred in borrowing from the antique.

Blake's view of the Florentine should be situated in the context of previous views. Those were based on Vasari, who surprisingly was not fully translated into English until 1850, though an abbreviated version was available in William Aglionby's *Painting Illustrated in Three Diallogues... Together with the Lives of the Most Eminent Painters* (London, 1685). Vasari gives an extremely brief account of the Sistine ceiling – "There are in it many Stories, beginning from the Creation of the World to the flood; and then following on to most of the remarkable Stories of the Old Testament, adorned besides with *Sybils* and *Prophets*"– and then, having disposed of that matter, summarizes his view of Michelangelo: "The Work in general is the extreamest perfection of the Art for *Shortnings*, diversity of *Dresses*, *Airs* of the Heads, and noble <u>Invention</u>."[2]

This view is developed further in the account of the *Last Judgment*:

> he chose that Subject as the hardest to succeed in since it consists most in showing the true proportions of the hardest of Subjects; which is, the Humane Body Naked, and that in the most difficult Aptitudes [*sic*], with the strongest affections and passions in the World, full of the greatest variety imaginable. In all which he has showed himself to be the greatest master in the World.[3]

This interpretation of Michelangelo is continued by Aglionby himself in the *Three Diallogues*, in which he describes the Florentine as "the greatest *Designer* that ever was, having studied Naked Bodies with great Care; but he

aiming always at showing the most difficult things of the Art, in the contorsions of Members, and Convulsions of the Muscles, Contractions of the Nerves, &c."[4]

This view of Michelangelo as the great designer of the human body became the basis for the way in which the next century saw him. Du Fresnoy, for instance, wrote of Michelangelo that "He knew not the artifice of light and shadow; but he designed more learnedly, and better understood all the knittings of the bones, and the office and situation of the muscles, than any of the modern Painters."[5]

To come to writers a little closer to Blake, the Richardsons pass rapidly under the Sistine ceiling, reporting difficulty in seeing enough to justify full comment: "But for the Histories painted at the top of all I could not well judge of them as to That particular [i.e. state of preservation], or any other; for they are small figures, at a great height, and the Chapel has not over much Light."[6] They then pause uncomfortably before the *Last Judgment*: "There is indeed a great Variety of Attitudes of a Human Body, in which is seen profound Skill in Anatomy, as the Authors who so extravagantly commend this Picture say: This would have been a good Character for a Drawing-Book, but is a very Improper one for such a Subject as the Last Judgment."[7]

The perception of Michelangelo's work as a "Drawing-Book" of the sublime nude was continued through the century. Reynolds, for instance, wrote that Michelangelo "considered the art [of painting] as consisting of little more than what may be attained by Sculpture; correctness of form, and energy of character."[8] Another version of this view appears in Barry, who writes of Michelangelo that "He had formed himself very much upon the famous torso, and other ideal statues of antiquity. These were certainly perfect and happy representations of the characters they were intended for, but could never with any propriety be converted to the general use he made of them."[9] Implicit in these statements is the idea that Michelangelo was not truly a history painter, but a creator of powerful individual figures that did not interact in the narrative ways appropriate to history; they resisted full integration because they were based on the remains of antiquity, which were too powerful and individual to allow total incorporation into new situations. This, I shall maintain, is equally true of Blake, who, though capable of creating powerful single bodies, sometimes had trouble articulating them together through a convincing visual syntax into genuinely interac-

24

tive groups. To copy Michelangelo, even successfully, was not to solve all the problems confronting a beginning painter of history.

A major shift in the perception of Michelangelo begins at the turn of the century with Fuseli, who describes the painter as "the inventor of epic painting, in that sublime circle of the Sistine chapel."[10] In discussing the genre of *"epic* or sublime" painting, Fuseli describes the "aim of the epic painter [as being] to impress one general idea." In support of that thesis Fuseli provides five pages of commentary on the "divine series of frescoes, with which... Michael Angelo adorned the lofty compartments of the *Capella Sistina.*"[11] Fuseli describes the "one general idea" as "*theocracy* or the empire of religion, considered as the parent and queen of man; the origin, the progress, and final dispensation of Providence, as taught by the sacred records." This perspective (the word is meant literally as well as figuratively – Fuseli is said to have spent whole days on his back looking at the frescoes)[12] enables the construction of an organized reading of the whole ceiling. This is the moment when, without ceasing to be seen as the great draftsman of individual human forms, Michelangelo also became visible as the inventor of epic painting, of complex and profoundly programmed histories.

But even Fuseli, despite the grasp of the program of the ceiling as a whole shown in his "Third Lecture," puts his stress on "the powers it displays in the single figures of the Prophets, those organs of embodied sentiment,"[13] supporting the statement with finely differentiated readings. Fuseli also maintained the traditional view that it was Raphael who was the master of dramatic painting, the depiction of interaction between figures: his particular skill lay in the subordination of "both fact and maxim to the agent, his character and passion." Thus in the cartoon of Paul on the Areopagus, the various characters are perfectly fitted to the scene: "The assembly, though selected with characteristic art for the purpose, are the natural offspring of place and moment."[14]

Fuseli's account of the program of the Sistine ceiling received some acknowledgment; John Opie, for example, referred to the account's "unparalleled ingenuity" and "inimitable eloquence."[15] But it did not change the current view overnight, and in the first book on Michelangelo written in English, published in 1806, Richard Duppa, though he refers to Fuseli's account in a note, gives a much sketchier account of the ceiling, and poses the existence of any consistent program as still a question:

"Whether there was any regularly digested plan of theocracy in this assemblage of pictures is not known, as no contemporary supplies us with any information."[16] He echoes the Richardsons' discomfort with the *Last Judgment*: "It must be admitted, however, that an indiscriminate application of one character of muscular form and proportion, makes the whole rather an assemblage of academic figures, than a serious well studied historical composition."[17] Duppa was not going to be railroaded into what he perceived as a modernist revision of the traditional view.

Understanding of Michelangelo is consistent over two centuries: whatever the final estimate of his genius, all acknowledged that at its heart lay an unrivaled ability to draw the human body. He was without question the greatest designer since the ancients, whom he rivaled in power, but he lacked something in the related areas of individualizing figures for specific purposes, and of representing them in genuinely dramatic interaction.

II

Blake's own comments on Michelangelo are less extensive than one could wish. Most of them come from rather late in his career, and are therefore less secure guides to his early thinking than is his practice at the time. Most of Blake's extant comments praise the Florentine art of outline at the expense of the Venetian art of color. The word "outline" is closely connected with the word "design" or "disegno,"[18] and as one might expect, Blake's more specific comments on Michelangelo focus on the drawing of human bodies. In 1799 Blake defends his art against Trusler's criticism with the claim that "I have therefore proved your Reasonings ill proportioned which you can never prove my figures to be. They are those of Michael Angelo Rafael & the Antique & of the best Living Models" (E 702). We get another interesting glimpse in the *Descriptive Catalogue* of 1809. There Blake claims that "if one of Rafael or Michael Angelo's figures was to be traced, and Correggio's reflections and refractions to be added to it, there would soon be an end of proportion and strength" (E 548). In both these statements Blake understands Michelangelo as the designer of individual bodies, of exemplars of the "Human Form Divine," not as the inventor of complex historical programs.

Blake's opinion was based on what we would now regard as very inadequate evidence. He knew Michelangelo only, or at least principally, through prints,[19] a fact which is the subject of a delightful anecdote related

by Cunningham:

> "We hear much," said Phillips [who was painting Blake's portrait] "of the grandeur of Michael Angelo; from the engravings, I should say he has been over-rated; he could not paint an angel so well as Raphael."
> "He has not been over-rated, Sir," said Blake, "and he could paint an angel better than Raphael." "Well, but" said the other, "you never saw any of the paintings of Michael Angelo; and perhaps you speak from the opinions of others; your friends may have deceived you." "I never saw any of the paintings of Michael Angelo," replied Blake, "but I speak from the opinion of a friend who could not be mistaken." "A valuable friend truly," said Phillips, "and who may he be I pray?" "The arch-angel Gabriel, Sir," replied Blake.[20]

In addition to engravings, copies are another possible source of visual information about Michelangelo, though the relevance of such copies for Blake is difficult to assess. There was, for instance, a copy by da Sangallo of *The Cartoon of Pisa*, also known as *The Battle of Cascina*, in the Earl of Leicester's collection at Holkham Hall. Blake may also have been occasionally misled by mistaken attributions. There was, for instance, an outline print of Bronzino's *Allegory of Love* dated 1813 and annotated "Drawn by W. P. Sherlock from the Original Picture, by Michael Angelo Buonarotti."[21] Paley, in his essay on the Truchsessian Gallery and its impact on Blake, refers to "a Last Judgment attributed to Michelangelo and a 'Scuola di Michel Angelo' triptych showing Angels attending the Virgin, her nativity, and her death."[22] Paley speculates that a "'Scuola di Michaelangelo' *Last Judgment*... might have left an impression on Blake's first Last Judgment, executed in 1805 for Blair's *Grave*,"[23] but as he points out, not many of the pictures in the gallery can be traced, and this speculation must therefore remain speculation.

With a very few such possible exceptions, Blake knew Michelangelo through the medium of engravings, for the most part of individual figures. When Blake described himself as "Looking over the Prints from Raphael & Michael Angelo in the Library of the Royal Academy" (E 639), it was to series of prints like those of the Ghisis[24] that he was referring, and significantly the episode seems to belong to those early formative years at the Academy.

In absorbing Michelangelo in this way, Blake was sharing in the fate common to all who had not made the pilgrimage to Italy. The state of informa-

tion about Michelangelo generally available in Blake's time is well repre-
sented by a *Prospectus* announcing a print made of *The Cartoon of Pisa* by
Schiavonetti, and published in London in 1808 by William Miller. The
Prospectus states that "Detached groups and figures have been engraved
from this design by Marc Antonio, Agostino Veneziano, &c. but the whole
has never before been published. The rescuing from obscurity this justly
celebrated work will, it is presumed, be acceptable to all, who truly admire
the higher style of Art."[25] The *Prospectus* catches the tone of a period in
which England, prompted by Fuseli's account of the program of the Sistine
ceiling, was coming to a new appreciation of the larger aspects of Michelan-
gelo's paintings, but still thought of him principally in terms of "Detached
groups and figures."

To know Michelangelo through engravings is to possess a markedly lim-
ited knowledge. The great majority of the available engravings were of sin-
gle figures, often not named, and Blake's known copies from Michelangelo
are precisely of such single, unidentified figures. There were prints avail-
able of *The Last Judgment*, of the paintings of the Pauline Chapel, and also of
the major episodes from the Sistine ceiling; there was even an outline print
of the whole ceiling by Cunego.[26] These prints generally reproduce figures
on too small a scale to be of serious interest to an artist who wished to learn
how to draw a figure in a particular pose, though as we shall see later in this
chapter Blake may have used an engraving of *The Last Judgment* to help cre-
ate figures for *The Book of Urizen*; even small reproductions of figures by
Michelangelo had some value. As a result, Michelangelo appears in sharp
focus primarily as the designer of individual human bodies, often isolated
from any apparent environment or context. The medium of the print
helped to create and maintain the universal view of Michelangelo.

Another consequence of knowing Michelangelo only through engrav-
ings is that drawings become as significant as large-scale paintings; the two
are reduced to apparent equality in the process of translation into the
medium of the print. This reinforces the long tradition of respect for
Michelangelo's drawings, most forcefully expressed perhaps by the
Richardsons: "In his Drawings 'tis certain *Michael Angelo* is seen to greater
Advantage as a painter than in the *Capella Sistina*, or anywhere else."[27]
Blake borrowed motifs from well known and often engraved drawings as
freely as he borrowed them from the great paintings, as we shall see.[28]

Having sketched in a little of the Michelangelo that Blake knew, we can

look more closely at some of the specific uses that he made of his forebear, keeping in mind the importance of the drawings, and of engravings of single figures.

III

To trace the uses made by one artist of the work of another poses as many problems for the commentator as does the use made by one poet of another. It can vary from the casual borrowing of an attitude to the protracted struggle with a strong precursor made familiar to us by Harold Bloom. In the present case it can be difficult to disentangle Michelangelo from the remains of classical art – to make use once more of Fuseli's fine statement, Michelangelo "scattered the Torso of Apollonius in every view, in every direction, in groups and single figures, over the composition of the Last Judgment."[29] That mingled freight entered deeply into Fuseli's own art, and we should expect to find the same mixture in Blake.

The earliest copy from Michelangelo of which we have knowledge is the first version of the print that Blake later reworked and named *Joseph of Arimathea Among the Rocks of Albion* (illus. 12). On the only surviving copy of the first state Blake has written "Engraved when I was a beginner at Basires from a drawing by Salviati after Michael Angelo," which implies a date *c.* 1773. No known drawing answers to Blake's description; Leo Steinberg has identified the source as an engraving by Beatrizet, without explaining how Blake came to be mistaken in his own attribution.[30]

Since we are not certain about Blake's source – that drawing by Salviati may have existed, though Essick persuasively suggests that Blake's "drawing" probably means "engraving of a drawing"[31] – we must be tentative in commenting on what Blake may have added. In Michelangelo's fresco, the figure that Blake copied is surrounded by others; Beatrizet's engraving shows just one isolated figure. Probably Blake first made, as Essick suggests, "a kind of school exercise assigned by the master after one or two years of apprenticeship." One can guess that at this stage there would have been no background, or only sketchy indications; the point of the exercise would have been to copy the figure and in so doing learn something of the old master's skill at handling the human body.

At some later point, Blake looked again at his old engraving and thought of an interpretation which could be added to it. He revised it, and engraved the following text: "This is one of the Gothic Artists who Built the Cathe-

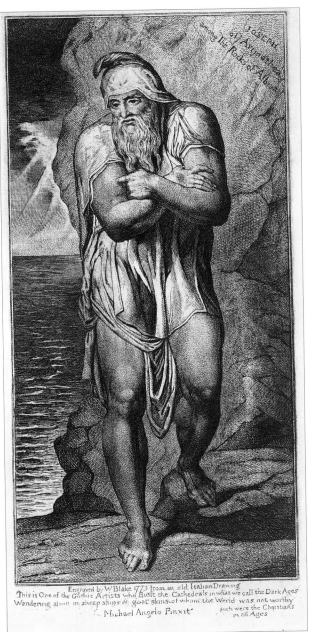

drals in what we call the Dark Ages Wandering about in sheep skins & goat skins of whom the World was not worthy; such were the Christians in all Ages." This text, as Damon points out,[32] comes largely from Paul's description of the early martyrs: "They were stoned, they were sawn asunder, were tempted, were slain with the sword: they wandered about in sheepskins and goatskins; being destitute, afflicted, tormented; (Of whom the world was not worthy:) they wandered in deserts, and in mountains, and in dens and caves of the earth" (Hebrews 11: 37–38).

Blake has taken key phrases from this tribute to the suffering of faithful witnesses and transferred them to the story of the legendary missionary and builder of a church of boughs. The resultant text is a composite which unites the suffering of Paul's witnesses with the creativity of Joseph of Arimathea as spreader of the Gospel and builder of churches; there is a tension within Blake's text between the language of martyrdom and that of heroic building. This new, complex text is applied to Joseph at a particular moment of his career; he has arrived "among the rocks of Albion" to start the great work of transforming a barren and hostile environment. How does this textually determined meaning react upon the figure that Blake first copied so many years earlier?

12. William Blake, engraving, *Joseph of Arimathea Among the Rocks of Albion*

In its original context, Michelangelo's figure walks towards the viewer, having already passed the terrible act in process to his right, the crucifixion of Peter upside-down. To quote De Tolnay, "the personages of the fresco do not directly participate in the action. They are there like unintentional witnesses who have come from every point on the horizon, and go past, moved and resigned before the committed crime."[33] The powerful arms of the figure Blake engraved are folded, as if to repress their potential energy. The downcast face and short, unenergetic stride suggest a troubled but for the moment impotent witness; we cannot guess at what he may do when he

finally moves out of sight. The heavy, burdened stride remains the domi-
nant feature of the figure in the new context; the figure resists the imposi-
tion of the heroic and creative meanings ascribed to it by the new texts.

The origins of Michelangelo's burdened witness explain this resistance.
Steinberg states that the figure "recalls statues of Barbarian captives," as
Haskell and Penny confirm.[34] Steinberg goes on to say that "Though the
heroic solitude and finality of Michelangelo's figure separates it from the
antique prototypes, its formal associations betray an elective affinity with
the captive state. The captive as symbol of his human condition came read-
ily to Michelangelo." This fits well with the suffering aspect of Blake's
Joseph, but less well with the heroic and creative aspect of his work, to
which the text points. The further possibility that the figure represents one
of Michelangelo's self-portraits may or may not have occurred to Blake, but
in either case the point made here would be unaffected.

Blake is again having trouble with a *pathos formula*, this time one taken
from Michelangelo, though based ultimately in classical art – a true *pathos
formula* in Warburg's sense. As if in implicit affirmation of the gap between
figure and text, Blake has engraved the words "Michael Angelo Pinxit"
beneath the design. This is the normal way in which an engraver reproduc-
ing a painting credited the original creator, but the traditional phrase also
emphasizes the separateness of Michelangelo's figure from Blake's text.
Blake has asked a figure originally created to represent the power of suffer-
ing witness to signify now both tormented martyr and heroic builder, and
the task is a little too much. Michelangelo's great figure refuses to merge
totally into the new context, and continues its heavy walk through time
essentially unaltered by the subscribed text. The attempt to take over and
use for a new purpose a figure from the past has won only partial success.
Blake's partial failure echoes exactly what some had seen as Michelangelo's
own failure to turn figures from the antique to his own specific purposes.

A slightly later instance of copying from Michelangelo is the series of
seven drawings, dated *c.* 1785 by Butlin, that Blake made from Adam Ghisi's
small book of engravings of figures from the Sistine frescoes. These have
been reproduced and well discussed by Jenijoy La Belle,[35] but a few things
are worth emphasis in the present context.

One is that Ghisi presents Michelangelo's masterpiece as a series of dis-
crete figures isolated in space rather than as parts of an immense icono-
graphic program. La Belle points out that in the one case where Blake has

added a legend, "The Reposing Traveller," the form of the "g" suggests that Blake added the words many years after making the drawing.[36] Blake appears again to have used Michelangelo initially as a high quality drawing book, and then later found a use for one of the figures that was appropriate to the posture and feeling of the design, but had no relationship to the program controlling the original, a program possibly unknown to Blake. In this case the text fits the figure comfortably enough; borrowing a figure is much easier where there is no need to adapt it to a complex new context.

IV

In all the instances of copying or borrowing figures discussed so far – the Niobe original of Joseph, and the Michelangelo originals which became Joseph of Arimathea and "The Reposing Traveller" – Blake is doing exactly the kind of borrowing that Reynolds recommends to students in his last "Discourse" as a follow-up to an exercise in simply copying figures directly from Michelangelo:

> The next lesson should be, to change the purpose of the figures without changing the attitude, as Tintoret has done with the Sampson of Michael Angelo. Instead of the figure which Sampson bestrides, he has placed an eagle under him, and instead of the jawbone, thunder and lightening in his right hand; and thus it becomes a Jupiter. Titian, in the same manner, has taken the figure which represents God dividing the light from the darkness in the vault of the Capella Sestina, and has introduced it in the famous battle of Cadore, so much celebrated by Vasari; and extraordinary as it may seem it is here converted to a General, falling from his horse.[37]

In another Discourse, Reynolds comments that "he, who borrows an idea from an antient, or even from a modern artist not his contemporary, and so accommodates it to his own work, that it makes a part of it, with no seam or joining appearing, can hardly be charged with plagiarism."[38]

Fuseli also approved of just such adaptive borrowing, and like Reynolds, insists on the necessity of a full integration of the borrowed figure into its new context:

> Far from impairing the originality of invention, the unpremeditated discovery of an appropriate attitude or figure in the works of antiquity, or of the great old masters after the revival, and its adoption, or the apt

transposition of one misplaced in some inferior work, will add lustre to a performance of commensurate or superior power.[39]

However, such an attempt to be an artist of "commensurate or superior power" with the ancients and Michelangelo created an intense anxiety of influence, attested by Fuseli's well known drawing of "The Artist moved by the magnitude of antique fragments."[40] It is part of Blake's strength and originality, and perhaps also professional naiveté, that he could claim, without apparent anxiety, that his figures were "those of Michael Angelo Rafael & the Antique & of the best living Models" (E 702) with no suggestion that there might be a problem in thus claiming simultaneously both equality with, and dependence upon, the great masters of the past.

For Reynolds and Fuseli the copying of a figure from an earlier artist, and its adaptation to a new and different context, is part of the process of learning and practicing the art of painting. Both lay stress on the need for a total taking over of the borrowed material; "no seam or joining" should appear, and the borrower should adapt the material so thoroughly that it should join with his own in "a kind coalition." The meaning of the borrowed figure is, as Reynolds and Fuseli understand it, totally determined by the new context created around it, though there may be a faint "lustre" of power and skill that communicates itself to those viewers able to recognize the original.

Blake, in the early acts of copying discussed so far, was following the accepted procedures for learning his craft. That the copying amounts to a deliberate program is attested by the comment in the margin of his copy of Reynolds: "To learn the Language of Art Copy for Ever. is My Rule" (E 636). By the criteria for successful borrowing outlined by both Reynolds and Fuseli, Blake has had a little trouble in making his borrowed figures seem completely at home in their new environment. Niobe and Michelangelo's suffering witness resist full integration into their new environments precisely because they have a specificity of meaning born from those original contexts that causes them to resist accommodation to Blake's new and different frame; their very strength becomes a kind of weakness.

In the cases discussed so far, Blake has taken over figures without any attempt to import the meaning of the original contexts as well; he has used classical sculpture and Michelangelo precisely as drawing books of the heroic nude, borrowing simply "an appropriate attitude or figure" without concern for how such figures had been used originally.

It is possible, however, to understand and use the act of borrowing very differently. Hogarth, for instance, made conscious and ironic use of famous paintings as a form of quotation; mordant wit arises from the recognition of gestures taken from Leonardo's *Last Supper* in the very different atmosphere of *The Election Feast*. The witty allusion here is underlined by Hogarth's attachment of a motto which reads: "He that dippeth his hand with me in the dish, the same shall betray me."[41] This is analogous to the art of allusion as practiced by a poet like Pope, who often made sure that an allusion would not be missed by citing the relevant text in a footnote; Hogarth accomplished the same end by the text subscribed to his design.

Reynolds was famous, or notorious, for similar practices, though in ways that are more varied and, sometimes, ambiguous. He was capable of such conscious quotation as a painting of young Master Crews in the attitude of Holbein's *Henry VIII*, which bears out Walpole's claim on behalf of Reynolds that "a quotation… with a novel application of the sense has always been allowed to be an instance of parts and taste" – in short, of wit.[42] Such a work assumes the viewer's collaboration in recognizing the source of the quotation, and hence the dissonance of contexts which generates the wit.[43] But Reynolds was equally capable of borrowing figures without any such ironic allusion being intended; when he painted *The Death of Dido*, taking the pose of the central figure directly from a painting of Psyche by a follower of Giulio Romano, there is very little sense of witty paraphrase, as Wind observes.[44]

There is a danger of naiveté in any attempt at a simple taxonomy of the different relationships that are possible between the elements involved in a visual borrowing, but I propose the following distinction. Reynolds and Fuseli describe what I shall call an "adoptive" model, in which the old context is discarded and the borrowed figure is fully taken up into its new family, its meaning understood as completely controlled by the new context. It is the degree of control which determines the success of the borrowing.

Walpole, on the other hand, describes a model that I shall call "parodic," using that term in the older sense of any relationship between an original image and its later adapted variant in which both are felt to retain a partial independence while entering into lively interaction within the new context. This model demands specific signs, often verbal as in the example cited from Hogarth, that awaken and shape our perception of the relationship. The distinction between these two models, though clearly not

34

absolute, has pragmatic utility, and I shall use it to discuss a recent account of Blake's use of Michelangelo which I believe fails through a misunderstanding of the nature of Blake's borrowings from Michelangelo. Blake, I shall maintain, was an "adoptive," not a "parodic," borrower.

Leslie W. Tannenbaum has discussed Blake's borrowings from Michelangelo in *The Book of Urizen*, and has made the Walpolian or parodic argument that "each borrowed figure contributes to the meaning of that book either directly or through the ironic juxtaposition of that figure's original context with the new context created by Blake."[45] Specifically, the suggestion is made that Blake uses figures adapted from the demonic side of Michelangelo's *Last Judgment* to show that the world Urizen creates is itself a hell, that his creation is "an inverted apocalypse, an anti-creation." Tannenbaum's argument assumes that Michelangelo's original figures are still present below or within Blake's adapted ones, although "their recognition... is initially obscured" because Blake has reversed, rotated, or modified them.[46] I believe this view represents a misunderstanding of Blake's mode of borrowing from Michelangelo.

13. William Blake, Plate 14 of *The Book of Urizen*; Urizen

The first figure discussed by Tannenbaum is the Urizen of Plate 14 (illus. 13). He writes that the figure suggests "an inversion of Michelangelo's God creating order out of chaos on the Sistine Chapel ceiling."[47] This sounds initially reasonable, though Tannenbaum's argument implies a fairly close figural resemblance that must continue through the semantic inversion if we are to interpret the one figure as a transformation of the other. Yet Tannenbaum simultaneously claims that the figure of the Urizen of Plate 14 is based on one of the devils dragging a soul down to hell in Michelangelo's *Last Judgment* (illus. 14); Blake, he writes, has borrowed the torso and legs of this figure, rotating them through ninety degrees. This "visual quotation" shows that "although Urizen, from his own point of view appears to be a hero, the Eternals identify him as a demon."[48]

This claims for the same figure both a general, programmatic resemblance to Michelangelo's God and a specific, though partial, figural resemblance to the body of a devil. Yet neither kind of resemblance is close, and there is in fact another figure in Michelangelo's *Last Judgment* which is at least as close to the Urizen of Plate 14 as is Tannenbaum's demon, and that other figure is floating up to Heaven to join the saved (illus. 15). The viewer who knows Michelangelo well must thus choose between two possible allusions that point in opposed ethical directions.

There is a better explanation of the resemblance between Blake's Urizen and the torso and legs of both of Michelangelo's figures, one saved and the other damned. Blake found in these figures a useful visual schema for the representation of a body in an aerial rather than terrestrial condition, free from the bonds of gravity. That schema can apply equally to the damned and the saved; it has no inherent ethical value for either Michelangelo or Blake. The content of Blake's act of borrowing was simply the schema of a floating torso and legs, not the programmatic context described by Tannenbaum. Blake has again used Michelangelo as a "Drawing-Book" of the sublime nude, but with a new way of controlling the potential power of an original figure: to put it crudely, he has cut it in half and transplanted only a portion. The original context has been made inoperative by that extractive surgery.

It remains true, however, that something of the atmosphere of the *Last Judgment* does pass into Blake's designs; there are not many contexts in which human bodies become freed from gravitational bonds. Blake, in addition to borrowing a visual schema for the depiction of a body freed from gravity, has also borrowed something of the style and manner of Michelangelo's depiction of the final cataclysm. The act of borrowing asserts a claim of kinship at a very general level also; both artists are venturing into the far spaces of a concrete imagining of apocalyptic realms, and Michelangelo's is a good hand to hold in that flight.

Tannenbaum goes on to suggest that there is a "principle of satiric inversion" operating in some cases, so that a figure rising from the ground in the Resurrection (illus. 16) is transformed into an image of the Urizen of Plate 9 (illus. 17), who "rather than rising from the dead, has actually created death by burying himself as he flees the wrath of the Eternals";[49] the argument is analogous to Warburg's suggestion that Renaissance artists learned to control the power of classical *pathos formulae* by inverting their significance. *The Book of Urizen*, 5: 3–11 and 5: 20–23, are cited as the texts that support this reading of the plate:

14. Michelangelo, *Last Judgment*, detail from print by Leonard Gaulthier (1561–1641) after Martin Rota; a devil dragging a soul down to hell

15. Michelangelo, *Last Judgment*, detail from print by Leonard Gaulthier (1561–1641) after Martin Rota; a figure floating up to heaven

Sund'ring, dark'ning, thund'ring!
Rent away with a terrible crash
Eternity roll'd wide apart

36

16. Michelangelo, *Last Judgment*, detail from print by Leonard Gaulthier (1561–1641) after Martin Rota; figure rising in the Resurrection

17. William Blake, Plate 9 of *The Book of Urizen*; Urizen

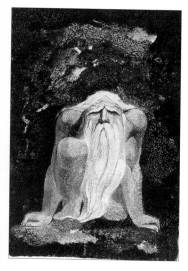

Wide asunder rolling
Mountainous all around
Departing; departing; departing:
Leaving ruinous fragments of life
Hanging frowning cliffs & all between
An ocean of voidness unfathomable.
. . .
To the deserts and rocks He ran raging
To hide, but He could not: combining
He dug mountains & hills in vast strength,
He piled them in incessant labour.

(E 73)

The selection of these texts leads Tannenbaum to interpret the design as showing Urizen forming a grave for himself, "which becomes the created universe."[50]

This text, however, with its emphasis in the last lines cited on Urizen's actively structuring activity, accords ill with the design, which shows a figure barely able to maintain or perhaps slowly enlarge the space of its own existence against a crushing pressure, felt most acutely in the smooth curve of the line separating body from rock, which pushes the head down almost to a level with the shoulders. Tannenbaum has allowed his interpretation to be unduly swayed by the original context of the figure which he has taken to be Blake's source, and this has led him both to an insensitive reading of the design itself and to what I believe is a mistaken choice of grounding text.

Mitchell, coming to the design from a more Gestalt-oriented perspective, lists it among the "substantial number of plates constructed on the schemata of the circle and rounded arch [that] convey a primary feeling of intense contraction, withdrawal, and enclosure," and places it among the earth plates in his separation of the designs "in terms of the dominance of particular elements."[51] In a more extended comment he describes the design as "one of the literal depictions of burial alive" which are "notable for their images of resistance and Sisyphus-like endurance, which provide a powerful counterthrust to the crushing stones around them. In plate 9 Urizen has come about as close to turning into stone as possible, and yet Blake had him say, in his caption for the separate print of this plate, 'Eternally I labour on' [E 673]."[52]

This is perceptive commentary based on an accurate response to the

design itself. Accepting the thrust of Mitchell's description, we can sharpen it a little by recontextualizing the design. Blake describes Urizen as fighting through, and in the process creating, the four elements in his search for a "world of solid obstruction":

First I fought with the fire; consum'd
Inwards, into a deep world within:
A void immense, wild dark & deep,
Where nothing was: Natures wide womb

And self balanc'd stretch'd o'er the void
I alone, even I! the winds merciless
Bound; but condensing, in torrents
They fall & fall; strong I repell'd
The vast waves, & arose on the waters
A wide world of solid obstruction. (E 72)

The design under discussion can best be understood as representing the final stage of this sequence, and thus as belonging to, and completing, a series of four designs which show all the stages of this progress.[53] Mitchell's association of this figure with the element of earth is confirmed when we connect it with the appropriate text.

The meaning of Blake's figure is decided not by the original context of the figure that may have been its source, but by the new contexts, visual and textual, that Blake has created around it. On this occasion Blake has adapted a powerful figure with success, and its new meaning fits convincingly. The strength of Blake's poetic conception has helped him to create a controlling context that enables him to incorporate a whole figure from Michelangelo without suffering indigestion.[54]

The discussion of this figure points to the need to make a distinction between the simple outline of a figure and the gesture that figure is interpreted as making. In the case of the Urizen of Plate 9 there is indeed a similarity in outline between Michelangelo's figure and Blake's. But Michelangelo's figure is making a gesture towards freedom, pulling free from the earth, which still holds fast to his right leg, while Blake's is being crushed by the rocks above, and is straining upwards with his shoulders to maintain his existence against their weight. The outlines of the figures are similar, but the gestures they are perceived as making are very different,

and must be read through the associated text or context. Outline and shape are static concepts, gesture an inherently dynamic one. Similarity of outline is no guarantee of similarity of meaning, and to borrow the shape or outline of a figure is not necessarily to borrow the original context of meaning, since the gesture understood as being made may be radically altered by the new context.[55]

In general, Tannenbaum has tried too hard to interpret Blake's figures as if they were a response to the program behind Michelangelo's art. Michelangelo's *Last Judgment* has shaped the illustrations of *The Book of Urizen* in ways both less and more specific than those described by Tannenbaum. Blake, in inventing figures who explore and create a world of torment, drew support from Michelangelo's portrayal of contorted and weightless figures. Michelangelo helped him to imagine figures who move in a space that they themselves seem to create, freed from the constraints of gravity, and provided some specific schemas for bodies. But Blake was still thinking of Michelangelo as the great designer of individual bodies, as the drawing-book of the nude, not as the inventor of large and complex programs, and it is a mistake to read these borrowed figures as if they carried with them a large freight of specific allusional meaning.

Borrowing figures from Michelangelo was only one of Blake's ways of strengthening his power to create expressive figures, though a major one. It did not end his struggles to control the power of *pathos formulae*; Michelangelo was no easier to deal with than the art of antiquity upon which he based his own. A long-term goal was to learn to think and design like, rather than after, Michelangelo; copying and borrowing were only steps towards the realization of that ambition.

V

One cause of the difficulties that Blake encountered lay in the fact that many of Michelangelo's figures were both subtle and strong in their incarnation of feeling; they resisted both explicit interpretation and easy transplantation. But some bodies lent themselves more readily to such acts. Michelangelo had created at least one allegorical drawing that contained figures with an explicit significance visible upon their surface, so that a borrower was virtually obliged to import meaning as well as form, though this limited such borrowing to contexts which put into play the specific quality or power incarnate in the figure.

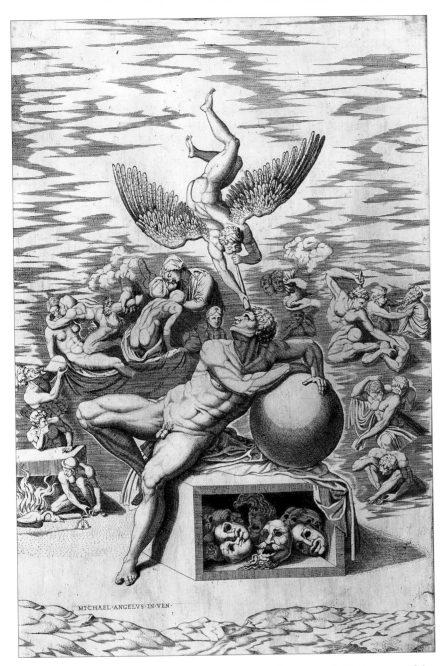

18. Michelangelo, engraving of his drawing, *A Dream of Human Life*

 Irene H. Chayes has drawn our attention to the powerful influence of the two central figures in Michelangelo's allegorical drawing *A Dream of Human Life* (illus. 18).[56] These figures played a large role in Blake's depictions of the apocalyptically descending trumpeter in his illustrations to Young's *Night Thoughts* and Blair's *The Grave*, and what Chayes calls his Renovated Man, the figure who rises from a half-recumbent posture to symbolize the possibility of an awakening in such works as Plate 21 of *The Marriage of Heaven and Hell*, and Plate 6 of *America*.[57] These particular bodies of Michelangelo's did carry a strong, stable charge of inherent meaning, clearly specified by the allegorical nature of Michelangelo's design. Borrowing these figures

was not a matter of adapting a body to a new situation but of creating a comparable situation in which a version of the figure could be appropriately used.

Though *A Dream of Human Life* has had a shaky recent history, and several critics of the last century have excluded it from the canon, Hartt in his monograph on Michelangelo's drawings firmly includes it.[58] The relevant facts for the present discussion are that it was universally attributed to Michelangelo in the centuries before Blake, and that it was available in several engravings. It was even singled out by Fuseli in the discussion of allegory in his "Fourth Lecture":

> In that sublime design of Michael Angelo, where a figure is roused by a descending genius from his repose on a globe, on which he yet reclines, and with surprise discovers the phantoms of the passions which he courted, unmasked in wild confusion flitting round him, M. Agnolo was less ambitious to express the nature of a dream... than to impress us with the lesson, that all is vanity and life a farce, unless engaged by virtue and the pursuits of mind.[59]

A much larger claim than the one made by Chayes can in fact be made for the influence of this drawing on Blake's art. Apart from the central figures of the trumpeter and the Renovated Man that Chayes has discussed, one can see the influence of several more of these "phantoms of the passions" on Blake's designs. The graphic images of Lust in action may have acted as precedent and justification for some of the explicitly erotic drawings in the manuscript of *The Four Zoas*. The miser's money-bag appears, without the presumably deliberate scrotal appearance of Michelangelo's bag, in the drawing of Avarice in *Night Thoughts* 115. A version of the masks appears in a comparable context in *Night Thoughts* 114. The bald or skull-capped figures who enact Lust and Anger appear in Plate 2 of *Europe*, the first plate of Blake's engraving for *Leonora*, and *Night Thoughts* 84, where they again act out Anger.[60]

Perhaps even more significant than these relationships is that between Blake's various figures of Despair and the hunched figure with his head between his knees in *The Dream of Human Life*.[61] Warner suggests possible sources and parallels: "Blake's hunched Despair figures are frontal, like Ripa's or Jesse of the Sistine Ceiling, as distinguished from the semi-profiled figure of Durer's *Melancolia I*. They differ from the tradition in that

they have an exaggerated slump or huddle."[62] The figure of Despair in *The Dream of Human Life* is much closer to Blake's figures than is any of the analogues mentioned by Warner, and is very probably the source for Blake's many variations on this visual theme; the one that approaches Michelangelo's most closely appears in *Night Thoughts* 105 illustrating "Mind" in prison. The closest connections between the drawing and the *Night Thoughts* illustrations occur in a specific portion (Nos. 84–115) of the illustrations, as if Blake had had recourse to the drawing during a particular stage of the production of the designs.

It is scarcely an exaggeration to claim that Blake took more motifs from this one drawing than from the whole of the Sistine ceiling – another reminder that the Michelangelo known to Blake through engravings was not the one known to us, but the Michelangelo accessible through engravings that put drawings on the same level as major frescoes.

In his various borrowings from this drawing Blake has been faithful to the meanings that he read in the figures themselves. Michelangelo's figures are without visual context other than that provided by their companion figures, with whom they co-exist rather than interact, with the exception of the central three. Their meanings are relatively self-contained, and much less dependent upon contextual detail than is usual; the figures are readily available for extraction and removal into new situations.

Blake's numerous borrowings from this one drawing show that he was strongly attracted to the most highly specified of Michelangelo's invented bodies. Blake sought out the great sculptor to deepen his own capacity to create bodies more powerful than those constructed upon the quasi-Morse codings of Le Brun and others, but he nevertheless wanted bodies that would convey specific and legible meaning. He had not turned his back upon the desire to communicate in explicit ways, though he was in search of figures that diffused meaning more completely throughout the whole body, that did not isolate hands and face from the torso to which they were attached.

This suggests that Blake was potentially interested in constructing a quasi-lexicon of the passions at work, though in the style of Michelangelo rather than of Le Brun; Warner uses something of this kind of language, though in the context of what Blake learned from various traditions.[63] If one works through the listing of "Ten Frequent Forms" appended to her essay on "Blake's Use of Gesture,"[64] several facts stand out clearly in the

42

context of a discussion of Blake's use of Michelangelo. One is that of the ten, only number 3, "The head-clutching falling male," number 5, "The nude male, seated, legs apart, looking upward," and number 9, "Hunched figures with knees drawn up, front view," have a substantial relationship to Michelangelo, and of those, numbers 5 and 9 derive from *A Dream of Human Life*. Of the remaining seven, number 1 – various versions of outstretched arms – is too widespread to be readily traceable; number 2, "The flying figure, back view, springing upward, one leg bent, one arm higher, usually nude, female, and wingless" has been traced to Fuseli by Warner in her book;[65] number 4, "The corpse," is again too widespread and general to be traceable; number 6, "The bent old man with staff and windblown garment" has not been traced; number 7, "Female figures imitating the stance of a traditional Venus" comes from classical art; number 8, "Bent-over kneeling figure, often a woman, apparently grieving, side view" is perhaps a relative of the figure traced through Fuseli to Donatello by Chayes;[66] and number 10, "The worm-serpent-dragon complex" is outside the humanly focused scope of this chapter. Michelangelo is represented in these repeated and favorite forms, but less overpoweringly than one might have anticipated. Blake has not simply accumulated a series of "embodied sentiments" from the works of Michelangelo available to him, or indeed from other exemplars of the "languages of art," but has invented his own. There is thus an unresolved tension between Warner's thesis that Blake based his art on well known tradition, and her inability to find sources for many of his "Ten Frequent Forms."

The allegorical figures of *A Dream of Human Life*, and other analogous designs, were of substantial use to Blake, but they were also limited in number and applicability, and their very explicitness made them difficult to integrate into designs involving complex interactions. Borrowing from Michelangelo thus ran between the Scylla of unmanageably powerful figures who resisted transplantation into situations for which they had not been designed, and the Charybdis of figures limited in their usefulness by their very explicitness. The most powerful side of Michelangelo's art went into the creation of some of the figures for poems such as *The Book of Urizen*, while a parallel process of producing explicitly coded and original figures continued in another arena to be explored in the following pages.

VI

Besides using the allegorical figures of *The Dream of Human Life*, Blake moved towards inventing his own analogous figures, and there is one very significant drawing in which we can see him at this very task. The matter of attribution has to be dealt with first, however. The two-sided drawing, now at Harvard, is currently called "Various Personifications" (B 214r and 214v; illuss. 19 and 20), and was first discussed by Erdman in the original edition of his facsimile of *The Notebook of William Blake*,[67] in which he attributed the drawings and their captions to Blake. In a revised edition of the *Notebook*, however, Erdman contended that the drawings "were evidently sketched by D. G. Rossetti, ca. 1860, from Blake's *NT* [*Night Thoughts*] watercolors," listing in support of his theory a number of resemblances between the drawing and those watercolors.[68] In his catalogue, Butlin restored the drawing to Blake, dating it *c.* 1793–94, but in countering Erdman's misattri-

19. William Blake, drawing, "Various Personifications" (B 214r)

Within the drawing, handwritten labels read:
Listlessness
Study
Cruelty
Severity
Distress
Misery
Mischief
Projection

20. William Blake, drawing,
"Various Personifications" (B 214v)

bution minimized the relationships between the drawing and the *Night Thoughts* watercolors, though he did recognize a few, particularly that between the figure labeled "Avarice" (one of the figures copied from Michelangelo's *The Dream of Human Life*) and *Night Thoughts* 115.[69]

Essick's review of Butlin confirmed the attribution to Blake.[70] There remains a problem with the titles beneath the individual figures, which Butlin describes as written in a hand that "bears some general resemblance to the lettering on certain of Blake's later prints... [but] does not seem to be Blake's," though he acknowledges that the title "Cruelty" is written in a hand "more fluid and Blake-like than usual." Whoever wrote those titles was evidently privy to Blake's intentions in creating the figures, for they are convincing in virtually every case, and several of the titles match exactly with phrases or words in the text of Young's *Night Thoughts* which Blake illustrated with closely corresponding figures.

In his initial consideration of the drawing, Erdman gave a short list of similarities between figures in the drawing and the *Night Thoughts* illustrations, but this list was very imperfect, and was emptied of significance by the subsequent claim that the sketches were made by Rossetti. The situation was then complicated by Butlin's denial that Erdman's analogies were substantial. Because Butlin was clearly correct in reassigning the drawing to Blake, and Essick, in confirming Butlin, did not pursue the possible relationship with *Night Thoughts*, Blake scholars were allowed to assume that

Butlin's virtual dismissal of that relationship was also justified, which is not the case.

Now that the drawing has been firmly established as Blake's, we can reopen the question of its relationship to his other work on a more solid basis; there are in fact many meaningful connections. I apologize for the rather abbreviated nature of my argument here; the reader can pursue the connections made through the references given. I shall indicate which connections are noted by Erdman, and will give short texts from the relevant passages in Night Thoughts to indicate the close connection between the names given to the figures in the drawing and the related illustrations to Young's poem.

The figure named "Idleness," as Erdman noted, is almost identical to the figure in NT 47, illustrating the line "Not, blundering, split on Idleness, for ease." The large untitled figure at the center of the verso of the Harvard drawing is very close to the figure of NT 85. The figure titled "Distress" is close to a figure in NT 96, illustrating "Smitten Friends": "For us they languish, and for us they die." The figure of "Avarice," as already noted, is very close indeed, though reversed, to the figure in NT 115, illustrating "Ambition makes my Little, less." The figure of "Joy," also noted by Erdman, has arms in exactly the position of the figure in NT 128, illustrating "Christian Joy's exulting wing." The figure of "Despair" has a clear relationship to despairing figures in NT 159 and 316. The figure of "Listlessness" is reasonably close to the figure of NT 279, illustrating "Possession, why more tasteless than Pursuit?" And the figure called "Misery," again as noted by Erdman, is virtually identical in posture to the figure howling in "the Dragon's subterranean Den" in NT 312.

This list of eight close relationships between figures in the Harvard drawing and the Night Thoughts watercolors omits one problematical relationship. The figure titled "Indolence" is close to, though reversed from, the figure expressing horror at a ghost in NT 523 (illus. 21). "Indolence" has a wide open mouth, which could signify a yawn, but could also express horror. The gesture of hands raised to the sides of the head is not too far from the gesture of the figure titled "Despair," though it could alternatively represent a relaxing stretch. This might suggest that the writer of the title was indeed someone other than Blake, who has on this occasion misunderstood Blake's intention. I think it more likely, however, that we are once again confronted with the fact that posture is not univocally descriptive of feeling and intention.

46

The analogies detailed above, which overlap only slightly with Erdman's original list, establish a firm connection between this drawing and Blake's *Night Thoughts* drawings. In addition, Erdman lists a number of connections with emblems in the Notebook; though he confesses that some of these are "not close," a few hold firmly. One figure titled "Joy" and the unnamed flying figure are close to figures in the emblem on page 47 of the Notebook; the figure titled "Doubt" is very close indeed to the emblem on page 95 of the Notebook, which in turn became Plate 2 of *The Gates of Paradise* of 1793, glossed as "Doubt Self Jealous Watry folly" in the later version, *For The Sexes* (E 268); and the figures titled "Cruelty" and "Mischief" are related both to

21. William Blake, illustrations to Young's *Night Thoughts*, 523; a figure expressing horror at a ghost

the figure on page 97 of the Notebook and to the foremost assassin in Blake's 1799 painting of *Malevolence* (B 341).

The drawing thus has close connections with Blake's work from 1793 to 1799, with a particularly close relation to the *Night Thoughts* drawings of 1795–97. That there are sometimes erased variants beneath the figures in the drawing, and differences, sometimes minor and sometimes quite substantial, between a figure in the drawing and the corresponding figure in the *Night Thoughts* illustrations, suggests the priority of the drawing; it would be likely that Blake, having invented a figure to embody a feeling, would modify it in adapting it to the particulars of a specific situation.

The likeliest explanation of the origin of the drawing is that Blake, faced with the massive project of illustrating the *Night Thoughts*, realized that he had some serious work to do in the area of articulating feeling and thought through expressive bodies. He had long ago absorbed standard codifi-

cations for expressive gestures, with results that were sometimes flat and repetitive. He had also worked to absorb and adapt more powerfully individual bodies from classical art and from Michelangelo, with interesting but not always completely successful results.

Now he embarked on the project of developing his own lexicon of embodied sentiments. There is a relationship to Michelangelo, but it is not as close as one might have expected. The figure named "Weariness" bears some likeness to the copy Blake had made earlier of the Aminadab Lunette, that at some later date Blake titled "The Reposing Traveller." But unlike Aminadab, the Harvard figure has parallel calves, elbows resting on knees, and hands supporting the head – an image of total failure of energy supporting itself by inert bones rather than wearied muscles. Blake had learned to think in the language of the body, and has here successfully derived "the body or outward form" of a man from his "Poetic Genius" or intuition of an organizing state of feeling (E 1).

The figure named "Study" has a distant kinship with the Jeremias of the Sistine ceiling, but Blake's figure is more intensely absorbed in his book. The figure of "Misery" has some similarity to the image of Despair in Michelangelo's *The Dream of Human Life*, and "Luxury" is in a posture that recalls the newly created Adam of the Sistine ceiling – a graphic demonstration of how an alteration in the arms and the turn of the head and neck can alter the significance of a body. Finally, the figure named "Despair" has some resemblance to one of the souls being shipped to hell in Michelangelo's *Last Judgment* (illus. 22), though Blake has made his figure more violently expressive, both hands pressing down on the back of his neck, and elbows high in the air.

That leaves approximately thirty-five figures that seem to be Blake's own inventions; I am deliberately indefinite since some may have sources that I have not traced. Blake invented most of these figures, and as we have seen used a fair number of them in his work. He was teaching himself to think and design more or less like Michelangelo rather than after Michelangelo; or we could say, with Blake, that he had to "Create a System, or be enslav'd by another Man's" (E 153).

Contemporary critical comment on Blake's most widely known work, the illustrations for Blair's *The Grave*, offers evidence on the point. Fuseli, in the "Remarks" included in the first edition, comments that "The groups and single figures on their own basis... frequently exhibit those genuine

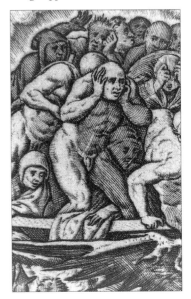

22. Michelangelo, *Last Judgment*, detail from print by Leonard Gaulthier (1561–1641) after Martin Rota; a soul being shipped to hell

and unaffected attitudes, those simple graces which nature and the heart alone cannot dictate, and only an eye inspired by both, discover."[71] Here is "Michael Angelo *Blake*" indeed, working in Fuseli's view not on Michelangelo but like Michelangelo, showing mastery in the creation of single figures and small groups.

Perhaps unwilling to disagree explicitly with Fuseli on a technical judgment, the generally hostile reviewer for the *Antijacobin Review* of November 1808 admits of "The Day of Judgment" that "Mr. Blake's knowledge of drawing, and of the human figure, is better displayed by this, than any other of his designs; and he has executed some very difficult foreshortenings with great success."[72] The review in the *Monthly Magazine* for December 1808 agrees that "there is considerable correctness and knowledge of form in the drawing of the various figures."[73] It was these recent comments that Blake had in mind when he claimed in *A Public Address* that "Mr. Blake's Inventive Powers & his Scientific Knowledge of Drawing is on all hands acknowledged" (E 571). The language in which the eighteenth century spoke of Michelangelo lies behind all of these comments, though the connection is not made explicit until the anonymous author of the "Biographical Sketch of Robert Blair," added in the 1813 edition of *The Grave*, writes: "The Painter who produced the designs is allowed to possess great powers; his pencil, imbued with the fiery genius and bold correctness of a *Michael Angelo*, is directed by the boundless imagination of a Dante."[74] Blake's contemporaries on this occasion described him as a draftsman who had absorbed some of Michelangelo's power to create expressive bodies.

Judging from the figures in the Harvard drawing, however, and from his other work, Blake's handling of bodily expression was rather different from Michelangelo's. Much of the subtle power of Michelangelo's figures arises from the interplay between tension and relaxation, an interplay that depends upon a profound understanding of the workings of the human body to communicate exact states of feeling and intention. Blake's limited knowledge of anatomy made this way of communicating meaning relatively inaccessible to him. Only relatively, because he knew enough, and had seen enough, to attempt such effects, with success on occasion. But for the most part Blake's effects arise from simple and strong lines, and from almost exaggeratedly expressive gestures, and that is the style of the figures of the Harvard drawing. The figures are intended to communicate strongly and clearly, but not with an excess of subtle shading.

VII

To focus the difference between the two artists, I shall compare their respective handling of similar subjects, and have chosen Michelangelo's *The Creation of Adam* from the Sistine ceiling (illus. 23) and Blake's *Elohim Creating Adam* (B 289; illus. 24) for discussion. The fact that the earlier design was one of the obvious sources for Blake's gives a more than arbitrary connection between the two.

Michelangelo's *The Creation of Adam* shows God almost touching Adam's left index finger with his own right index finger. If we were to pinpoint the moment in Genesis chosen for representation, it would be the phrase "breathed into his nostrils the breath of life" (2: 7), though Michelangelo has changed the biblical metaphor for the actual giving of life. God is represented as moving and supported in a magenta cloak which wraps over a host of subsidiary figures; three chunkily powerful ones seem to support his weight from below, while a goodly number of smaller and more youthful figures that De Tolnay identifies simply as putti and Genii[75] crowd around the upper part of the protected space. God's left arm goes over the shoulders of a figure usually interpreted as Eve or the "idea" of Eve, or sometimes as Mary,[76] while his left hand rests upon a child usually interpreted as Christ.

The problem of showing the energies that activate the mechanism of flight has been solved by giving them a human form, a solution that only puts things off one further stage – how do *these* human forms fly? – but leaves God free to create, and suggests his control over and partial identity with a numerous offspring of emanations that complete his being. God's musculature is surprisingly relaxed; the muscles of his leg and right arm are substantial, but exhibit no signs of hypertension, and his right and active hand appears powerful but relaxed except for the reaching-out index finger, upon which his eye is concentrated. The acute bend in his left index finger shows that the figure of Christ is being used for support; there is active transmission of weight through hand and finger. Metaphysical relationship has been incarnated in physical interaction. The final result is a complex combination of self-moving energy and assisted flight, of action and dependency. This is continued in the indications of interplay between this whole moving system and the surrounding air; the billowing of the cloak implies that the air through which it is moving is partly responsible for its shape, God's hair and beard show the movement of air through them, as does the

50

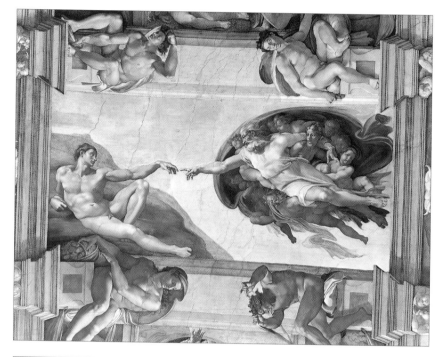

23. Michelangelo, *The Creation of Adam*, from the Sistine Chapel

24. William Blake, *Elohim Creating Adam* (B 289), color print

green sash that flows below the figures. These movements appear relatively gentle; this is not a whirlwind act to which we are witness through a strobe-light flash, but the relaxed act of power certain of its aim, and suspended in a kind of timeless present moment.

Adam raises himself partly from the ground as he reaches his left hand – he receives where God gives – almost to touch God's finger, though a small space is left to generate tension and anticipation. His body is relaxed: Montégut writes of "La molle attitude de son corps."[77] The relaxation can be seen in the bend of his right hand, and the superbly handled line that goes from his neck to his left shoulder, dipping sharply before the deltoid to indicate the relaxation of the trapezius. His face too is relaxed, without the frown lines of concentration that appear over God's raised eyebrow. De Tolnay writes that "His largely modeled gigantic body seems to be made of clay (Genesis 2: 7) and to be animated bit by bit at the approach of the divine cloud: slowly life trickles through his limbs."[78] That is not quite accurate; life is already present in the raised knee, the tilted and responsive head, and the raised arm, though the great body has not yet been fully charged with energy. I prefer Fuseli's description: "in the Creation of Adam, the Creator borne on a group of attendant spirits, the personified powers of Omnipotence, moves on toward his last, best work, the lord of his creation: the immortal spark, issuing from his extended arm, electrifies the new-formed being, who tremblingly alive, half raised, half reclined, hastens to meet his Maker."[79] But that, good though it is, is also not quite right; Adam is not "tremblingly alive," nor does he hasten. Fuseli has charged the scene with his own excess of hyperdramatic energy, and has distorted the deep, though anticipatory and responsive, calm of Adam's body as Michelangelo painted it.

The feeling in the scene is a product of both the feeling tone incorporated in the bodies that act out the event and of the interaction between their different tonicities. Its meaning resides at the almost cellular level of muscle tone, felt weight of limb, and energy charge of gesture. It is around these constants that one can then fill in theories about such matters as the identity of the figures beneath God's left arm.

Blake's *Elohim Creating Adam* is quite closely related to Michelangelo's painting, though C. H. Collins Baker has made the plausible suggestion that another direct visual source is the figure of Skiron, the southeast wind, as illustrated in both Stuart and Revett's *Antiquities of Athens* and Dalton's

Antiquities and Views in Greece and Egypt.[80] That the influence of such different styles as those of archaic Greek art and Michelangelo can be traced in the same figure in Blake's work is clear proof that he does not simply adopt one man's style, but incorporates elements into his own mix.

Blake's print chooses as focus the phrase just before that chosen by Michelangelo for the basis of his design: "And the Lord God formed man of the dust of the ground" (Genesis 2:7). Unlike Michelangelo's figures, Blake's do not look at each other; each is absorbed in his own fate, the one condemned to create, the other to be created. Michelangelo shows a moment of wondrous opening; Blake a moment in a necessary fall, a creation which is simultaneously a constriction.

Blake has imagined his deity as a self-powered flying creature, though the wings are attached in a totally non-functional way, and are folded upwards in a manner that precludes their providing any lift at this moment. While we cannot expect Blake to become a Leonardo for the sake of one design, we can feel discomfort at the manner of the attachment of the wings to the shoulder of the deity. The vanes that grow directly out of the deltoid muscle point backwards with the feathers they control, and are thus totally separated from the bone that seems to rise upwards and carry the main flight feathers. Blake has shown vanes that look like tendons on the joint of the further wing, as if he were quite unclear about the actual mechanism which transfers energy from muscle to feathers in bird flight. Blake has failed singularly in the task of imagining a flying human from the perspective of an aeronautical engineer taking bird flight as his model. Blake had no interest in that perspective – that would have put him squarely into Newton's world. The wings have a sculpted magnificence that rhetorically asserts rather than visually justifies the flying powers of this god. It never occurred to Blake that this figure would actually need these wings in order to fly; flight is built into the conception of the figure; the wings are there to denote splendor and power, not to provide lift. Michelangelo's meanings, I have tried to show, are fully incarnate in his bodies; they have really and truly taken on flesh. Blake's meanings are rhetorically asserted in a way designed to short-circuit the need for full ocular demonstration.

The figure of Elohim himself is, as others have noted, strangely trunkless, as if the shoulders were attached directly to the hips. His right hand is quite inadequately attached to the wrist, as if it had been re-attached by a careless surgeon after an accidental amputation. Adam's left wrist appears

broken, as does his left ankle. We are dealing with a colored print, not a painting, but there is evidence of detail touching up in ink, and we are justified in holding Blake responsible for the final result. The basis of the design is rhetoric, not anatomy. Elohim's face is stern, the brow wrinkled, the mouth open; the face, when put against the rather comic faces illustrating Le Brun, participates in "Astonishment," "Fright," "Fear," "Dejection," and "Pain."[81] Adam's face records a very similar feeling, though with a more resigned sorrow. Both have their mouths open in a gesture made familiar by the argument of Lessing's *Laocoön*, which cites Winckelmann's analysis of Laocoön's open mouth as uttering only an "anxious and subdued sigh," not "a terrible scream."[82] We can imagine a deep groan as the appropriate auditory image to accompany the open mouth of Adam in Blake's design.

We could spend a long time on the worm/serpent, the rays of light energy emanating from the solar disk behind the deity, and the clouds at the top of the design. But my purpose here is not to attempt a complete reading of the design, but to point at the deep differences between Blake's way of signifying and Michelangelo's. The latter incorporates meaning in fully developed bodies whose very muscle tone communicates subtle feeling by kinaesthetic empathy. Blake's design invites much more explicit forms of analysis that move towards the finding of texts that will support commentary on the forms and images in the design. This is the natural impulse of a viewer when faced with images that resist reading in purely visual terms; we would not want to hang an interpretation on an apparently broken wrist, and offer the suggestion that Adam has just received a severe beating, because our knowledge of the Blakean context persuades that this would be a gross mistake. But a body with a similarly distorted wrist in a design by Michelangelo would elicit just such interpretive motions; we would attempt to understand just why the body showed such a dislocation.

Blake's print invites us to respond with admiration for its originality, its strength, and the power of its imagining; it invites us to interpret its explicit images – the hand reaching for the lump of clay, the serpent/worm winding around the body of Adam, the wings of Elohim – but it does not ask us to respond in detail to the exact tension in each muscle. Blake said that we should "attend to the Hands & Feet to the Lineaments of the Countenances they are all descriptive of Character & not a line is drawn without intention

& that most discriminate & particular" (E 560), and that is just my point. It is the hands and feet and lines of the countenance (one can almost see the *Chironomia* hands and Le Brun faces) that Blake spontaneously thinks of as the carriers of meaning, just those parts of the body associated with what I have called, after Bryson, semaphoric modes of encoding meaning – just what Michelangelo was supposed to inoculate against by showing ways of making an entire body communicative. Blake is not being fair to himself in saying this – his best figures do communicate with their whole bodies – but he is being true to the deepest and most constant thrust of his art. Michelangelo was beyond and outside his reach.

To become really like Michelangelo, Blake would have had to become someone else, which would have meant becoming a lesser artist. He would have had to learn anatomy in a serious way; he would have had to spend years in life class, which he thought of as a death class, bodies arranged in unnatural and static attitudes, moved like robots at the will of another.[83] Blake's most powerful figures express extreme feeling, in which the whole body is involved, and in which the limits of the Le Brun kind of coding are overcome without such coding being entirely left behind. Some of these bodies are inspired by Michelangelo, and one can say that figures like the howling Los of *The Book of Urizen*, Plate 7 (illus. 25) are as near as he ever got to the style of the Florentine, though even there he only approached those more extreme aspects of Michelangelo that found expression in the *Last Judgment*, and Blake's bodies are always simplified and exaggerated in their expression of feeling when compared to those of his predecessor.

Blake's expressive style is an unstable mix of Le Brun and the other codifiers with more than a dash of schema learned from Michelangelo in particular, all this well mixed with his own readiness to short-circuit anatomical precision in favor of a kind of emotional hyperbole that is an early form of expressionism. Michelangelo was good to learn from, but there were limits to what Blake was capable, or even truly desirous, of learning, and he left himself free to develop his own style of expression, which has its successes and its failures. Blake at his best is the artist of strong assertion, the rhetoric of the gesture that does not depend for its effect upon a response to subtle indications of muscular tension or body language. It is an art that is almost allegorical in Fuseli's sense, and almost linguistic in its assertions that always point towards a definite meaning, though characteristically without quite defining that meaning. It is an art finally very differ-

ent from that of Michelangelo, though Blake needed his great predecessor to help him break through to the freedom to be himself.

25.William Blake, Plate 7 of *The Book of Urizen*; Los howling

Humpty Dumpty Blake

At various moments in the last two chapters a question has surfaced that needs to be addressed more directly and extensively. That question is whether an organized and expressive body has a stable, univocal meaning, or should be understood as supportive of a range of potential meanings, one or more of which is activated by the specific context, often in the form of an associated text or title. That is the view suggested in previous discussion, and it will be explored further here.

The issue is well articulated in *Through the Looking Glass*. Alice, doing her best to keep a footing amidst Humpty Dumpty's rough and arbitrary handling of the language that she had innocently supposed they shared, protests in her politely interrogative way: "The question is… whether you *can* make words mean so many different things." To which Humpty Dumpty replies firmly, "The question is… which is to be master – that's all," answering his own question by defining "impenetrability" as he has just used it: "I meant by 'impenetrability' that we've had enough of that subject, and it would be just as well if you'd mention what you meant to do next, as I suppose you don't mean to stop here all the rest of your life." As Alice reasonably replies, "That's a great deal to make one word mean."[1]

Blake, in commenting on his rival Stothard's handling of Chaucer's Plowman, protested more vigorously than Alice: "How spots of brown and yellow, smeared about at random, can be either young or old, I cannot see. It may be an old man; it may be a young one; it may be any thing that a prospectus pleases" (E 540). In contrast, Blake expressed confidence in the ability of his own more explicit "lineaments" to define "character and expression" on their own (E 540); the figures in his own visual works were, in his view, clear and univocal containers of meaning. In practice, however, Blake too attached titles, texts, and "necessary" (E 552) accounts to his visual images, as if in recognition that they did not always communicate unaided all that he wished them to, that even *his* images might need interpretation by a "prospectus." And on the other hand Humpty Dumpty, staunch defender of the theory of semantic malleability though he was, recognized the reality of resistance and limits: "They've a temper, some of them – particularly verbs, they're the proudest – adjectives you can do anything with, but not verbs."[2] The two theories of meaning, though

diametrically opposed to each other, in practice give at least limited recognition to the claims of the other party.

The present chapter will explore the ground between those two theories, and test the degree to which in Blake's work the meaning of a figure can be shaped, or reshaped, by an attached or associated text; it will also explore the degree to which explicit "lineaments" can offer a bad-tempered resistance to such manipulation. It will consider both Blake's practice and those occasional comments of his which are susceptible to theoretical interpretation.

I shall look first at a gesture that plays a prominent role in *The Sea of Time and Space* (B 803), in part as a way of clearing a little of the ground for the reading of that painting in the last chapter, and in part as a way of determining whether it is possible to interpret an action solely through the gesture with which it is made, without considering also the whole context, an understanding of which must include an interpretation of the gesture – the hermeneutic circle, in other words, from which there is no escape. At various points in this book I appeal to codifications of gesture by Le Brun and others in interpreting a design, but such appeals are only occasionally definitive, and usually need support from an interpretation of the whole design to which they contribute.

The gesture to be considered is that of the veiled woman at the center of the painting (illus. 26), whom I shall not attempt to identify at this point. There seems at first sight to be a strong similarity between her and the woman who represents Evening in Blake's illustration of the following lines from Cowper's *The Task* (B 809; illus. 27):

> one hand employ'd
> In letting fall the curtain of repose
> On bird and beast, the other charg'd for man
> With sweet oblivion of the cares of day.[3]

The figure in that design, made around 1820–25, has her hands stretched in the same apparent contrast between up and down as the woman in *The Sea of Time and Space*. A closer look, however, shows that her lower hand carries a poppy stem to denote "sweet oblivion," while her upper hand lifts a veiling "curtain," evidently in order to let it fall; the act of holding is shown by the closing of the index finger upon the thumb. Neither hand

26. William Blake,
*The Sea of Time
and Space* (B 803);
detail

27. William Blake, *Evening*, illustrating
Cowper's *The Task* (B 809)

actually points, and the apparent similarity between the two figures dissolves upon close consideration. In *Evening*, a gesture which initially appears to denote contrast actually records a semantic duplication of two versions of sleep, "repose" and "oblivion"; the veil and the poppy, though coded as an apparent opposition of up and down, function as virtual synonyms. The associated text profoundly changes our first intuitive response.

There are other close analogues to the posture of the woman in *The Sea of Time and Space*. One, as John Beer has noted, is that of the woman in *Donald the Hammerer* (B 782), but the situation illustrated there is complex and uncertain enough that I shall pass over it and move to consider the gesture made by both Sense and Reason, imaged as Eve and Adam respectively, in *NT* 119 (illus. 28), who "show the Door [of a church in Blake's design],/Call for my Bier, and point me to the Dust." The hands pointing in an opposition of up and down indicate complementary destinations, "[Church] Door" and "Dust," immortality and death, the final stage of the dialectic of soul and body.

The same gesture is found again in Blake's illustration to Dante's *Purgatorio*, Canto I: 22–66 (B 812: 71);[4] Virgil explains that he has shown Dante all the guilty people in hell, and now intends to show him the spirits in purgatory. The gesture here indicates past origin and future destination, successive stages in a continuing journey. In both these designs we can see, because we have the governing texts, what the gesture means.

There are thus three designs in which there occur female figures portrayed in a gesture almost identical to that made by the woman in *The Sea of Time and Space*, and different syntactical models can be drawn from them in the light of their full context. The first resolves itself into a duplication of meaning: up and down mean versions of the same thing, sleep. The second model uses the pointing hands and arms to point to different locations, Church and Dust, that encode a powerful dialectic. The third model establishes difference within similarity; past (hell) and future (purgatory) are parts of a continuing voyage of discovery. The conclusion must be that identity of body positions is not by itself sufficient ground for assuming identity of meaning. Most gestures are not univocal, but depend upon context for their sense. Different syntaxes may lie hidden beneath what appear to be the same lexical items, to consider a gesture as analogous to a word for a moment, and may activate different lexical meanings. The woman in *The Sea of Time and Space* will have to be interpreted in the light of a reading of the whole design.

(10)

To play Life's subtle Game, I scarce believe
I still survive ; and am I fond of Life, 130
Who scarce can think it possible, I live?
Alive by Miracle! or, what is next,
Alive by *Mead!* If I am still alive,
Who long have bury'd what gives Life to live,
Firmness of Nerve, and Energy of Thought.
Life's Lee is not more *shallow*, than *impure*,
And *vapid*; *Sense*, and *Reason* show the Door,
Call for my Bier, and point me to the Dust.

 O thou great Arbiter of Life and Death!
Nature's immortal, immaterial Sun! 140
Whose all-prolific Beam, late call'd me forth
From Darkness, teeming Darkness, where I lay
The Worms inferior, and, in Rank, beneath
The Dust I tread on, high to bear my Brow,
To drink the Spirit of the golden Day,
And triumph in Existence ; and could'st know
No Motive, but my Bliss ; and hast ordain'd

A

28. William Blake, illustrations to
Young's *Night Thoughts*, 119; Sense and
Reason, imaged as Eve and Adam

Janet Warner has attempted to account for differences of meaning within the same gesture by using the model of polarization, suggesting that a gesture has both "a regenerative and a demonic aspect,"[5] but that simple oppositional model does not account for the variations of meaning traced for the gesture analyzed above. There is no substitute for the process of working through the syntax that governs the action of a design. This is not a categorical denial that univocal gestures exist in Blake's work; some gestures, for the most part simple ones that have been coded by such systems as those of Le Brun, do indeed seem to have a stable meaning. But it is dangerous to depend only on a reading of a gesture in interpreting a picture; the meaning assigned must be supported by a reading of the whole context.

II

The remainder of this chapter will have something of the structure of a deliberate experiment, in that I have chosen as test cases some of the designs to which Blake attached more than one title or text in the process of publishing them on several occasions separated by a number of years. I have not attempted to be exhaustive, but have, I hope, chosen representative and interesting examples. The hypothesis governing the experiment is that the attachment of different titles or texts to fundamentally the same design shows that Blake did indeed consider the meaning of at least some of his images to be malleable within limits, to be definable and redefinable by attached texts rather than fixed immutably within the image itself. The image becomes the site of a process of meaning production, rather than simply a container of established meaning.

One such figure has already been discussed in the first chapter, where I showed that the figure Blake copied from Michelangelo for his *Joseph of Ari-*

60

29. William Blake, engraving, *Our End is come*, 1793

mathea among the Rocks of Albion offered a degree of resistance to the meanings imposed by the added text, and insisted, verb-like, on something of its original meaning in spite of the texts now associated with it, which asked the viewer to read it in a different light.

The first design to be considered here is the print that first appeared with the title *Our End is come* and the date 1793 (illus. 29).[6] The print shows a crowned king in the center, a noble of some age wearing scale armor and holding a spear on the left, both bearded, and a man bearing a large sword on the right, naked except for a robe that hangs from his left arm. The large upright sword and the robe imply that Blake is already thinking of him as executioner, as he will identify him in a later version, since the sword was an acknowledged attribute of the executioner as an ideal figure of the execution of justice:

> Her [Justice's] chief and faithful Minister,
> Squire CATCH, the Law's great finisher,
> Bore not th'imaginary Sword,
> But his own Tools, an Ax and Cord.[7]

The three figures stand closely huddled together and framed by a wooden doorway; all are caught in the same tight situation, though strongly distinguished in age and function. All three look outwards in various forms of dismay: the king has his hands to his head and an expression of open-mouthed anguish as he looks out just to the viewer's left; the noble faces obliquely to our left, grimly resolute; the executioner's face expresses fear as he looks over his shoulder to our extreme left. Each expresses a different response, and is focused on a different spot. The motivation behind the responses can be guessed at on the basis of the distinctions in their social status and function: the king is unarmed, and has the most to lose; the noble has physical power, armor, and battle experience, and is prepared to defend his privileges; the executioner is young and naked, though armed, and does not wish to die for a political structure of which he is merely an agent.

Erdman appropriately connects the title with Blake's poem *America*, also dated 1793, which warns the "Angels & weak men" who govern England that "their end should come, when France reciev'd the Demons light" (E57).[8] However, the dress of the figures in the design is clearly medieval, and since the title offers itself as the present tense utterance of the three figures, this

sets up a cognitive dissonance with the imprint, "Publishd June ⁵: 1793 by W Blake Lambeth," which establishes 1793 as a historical moment relevant to an interpretation of the print as a whole, a moment when an apocalyptic end to the established hierarchy of king and nobles appeared a real possibility.

The meaning of the print arises in the first place from the interaction between the parallelism of the figures, reinforced by the common fate indicated by the words Blake has used as title, and the hierarchical differentiation signified by the marks of rank and function of each figure. That meaning is framed within a vague historical past, while the contrast between that and the date of the print sets up another layer of meaning; the feudal order of kingship is about to fall before the advent of a more modern form of government, republicanism.

The design appears next in the form of a color print, but since there are no attached or associated texts in that state I shall move on to consider its next appearance in a state dating from c. 1793–96, though unfortunately this state is known only from descriptions – no extant copy has been found. The design itself appears not to have been much changed, but the former brief title has been replaced by a new text that reads, "When the senses are shaken / And the soul is driven to madness Page 56." The reference is to the "Prologue, Intended for a Dramatic Piece of King Edward the Fourth" in the *Poetical Sketches* of 1783.⁹

The line that Blake has quoted becomes clearer if we put it back into its context in the "Prologue":

> When the senses
> Are shaken, and the soul is driven to madness,
> Who can stand? When the souls of the oppressed
> fight in the troubled air that rages, who can stand?
> When the whirlwind of fury comes from the
> Throne of God, when the frowns of his countenance
> Drive the nations together, who can stand? (E 439)

This implies that it is the oppressors whose souls have been driven to madness by the irresistible power of the now raging oppressed, who come like a whirlwind from the throne of God. In the print the lines used as title or text describe the figures in the design, the oppressors, as showing signs of incipient madness as their guilt intensifies their fear before the onslaught of righteous anger now released.

62

It is impossible now to decide what Blake's intention might have been in writing the "Prologue," though I suspect that when he wrote it in the late 1770s or early 1780s he saw parallels between the civil wars of Edward's reign and his adventures in France, and George III's relations with his American colonies, which terminated in a kind of civil war; both France and America strove for freedom from English domination. Hume concluded his account of Edward's reign with this summary: "All the glories of Edward's reign terminated with the civil wars, where his laurels too were extremely sullied with blood, violence and cruelty."[10] Blake might have been interested in showing George and his ministers in a similar light. He did not write that play, but he did take lines from the "Prologue" for the print he designed in the 1790s, and even gave a page reference so that an owner of the print could look up the original context for the lines.

This context introduces the angrily prophetic voice that speaks the whole of the "Prologue," a voice that condemns "The Kings and Nobles" before the throne of God. That speaker, in his wish for a "voice like thunder," associates himself with the voice of God as expressed through the people, and becomes part of the total rhetoric with which the print addresses us, inviting us to apply the print to the situation prevailing during the print's appearance in the 1790s. Blake, in adding this text, has also added specificity to our understanding of the print.

Blake reissued the print once more, after 1800, when he made substantial changes in the design (illus. 30). There are now spiring flames which ascend on both sides, largely blotting out the wooden doorway; the destruction threatened in the previous version has begun. Apocalypse is now.

There are changes also in one of the figures. The one on our right, the executioner, has been considerably aged by the addition of heavy lines to the face. He has also been given a typically Blakean tight-fitting garment, visible chiefly in the hems around neck and calves. The folds of a robe are still visible on the right. These changes reduce the differences which previously marked this figure off from the other two. He has also been given a laurel wreath. Essick speculates that this introduction of a classical motif is "in accord with Blake's attacks, in the last two decades of his life, on classical civilization."[11] One could gloss Essick's comment with Blake's words from *On Virgil*: "Virgil in Eneid Book VI, line 848 says Let others study Art: Rome has somewhat better to do, namely War and Dominion" (E 270). The youthful, frightened executioner has become a much more formidable figure.

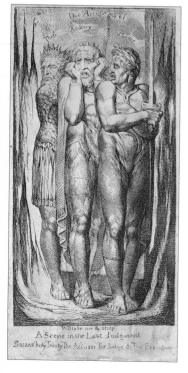

30. William Blake, engraving, *The Accusers of Theft Adultery Murder, c.* 180(?)

The text is now much more extensive and in several distinct parts. At the top, within the frame of the design, are engraved the words "The Accusers of Theft Adultery Murder," each accusation appearing directly over the head of the figure indicated. Below the frame of the design and the imprint, which now reads "W Blake inv & sculp," without place or date, appears the explanatory text "A Scene in the Last Judgment / Satans holy Trinity The Accuser The Judge & The Executioner." These texts give us much new matter to consider.

The text engraved above the heads of the figures defines them as equal, co-ordinated but differentiated agents of a single act, accusation. There may be an implied sequence in the three accusations, moving from least to most serious, but the governing syntax seems to suppress the possibility of realizing that sequence in favor of an equalizing parallelism. The juxtaposition of classical and medieval in the dress of the figures transposes the scene into the timeless world of allegory; the act of accusation is imaged as continuous and perpetual.

The text engraved below the frame of the design, "A Scene in the Last Judgment / Satans holy Trinity The Accuser The Judge & The Executioner," while confirming the fundamentally non-historical setting (the Last Judgment is a moment when all times become contemporary with each other), asks us to see the relationship between the figures in a different way, as both hierarchical and sequential. In this syntax, the first function, the Accuser, swallows up within itself all three figures and functions differentially defined by the upper text, which made all three figures into accusers. The two remaining accusers are reassigned functions as the Judge before whom an accuser lays a charge, and the Executioner who carries out the sentence passed by the Judge. The two texts, upper and lower, cannot therefore be easily reconciled. Is it possible to see both forms of syntax – parallel and sequential – simultaneously, or do we have a complex version of a classically ambiguous Gestalt figure, duck or hare but never, at the same moment, both?

There is one more text to consider before that question receives an answer, the identification of the three hierarchical functions listed in the lower text as "Satans holy Trinity." This focuses them as a parody of the Father, Son, and Holy Ghost of Christian theology. Presumably the king is Father and Judge, the noble the Son and Accuser, a demonic negative of Jesus as forgiver, and the executioner a parody of the Holy Ghost. Blake

was not a Trinitarian, and does not offer us an explicit and non-parodic model of the internal relationships within the Trinity. But the profound syntactic ambiguity of a relationship in which three separable modes of being are yet understood to constitute one total entity provides a semantic space within which both differentiated parallelism and sequential hierarchy can find a home. The identification of the figures as a parody of the Trinity thus offers a mediation between otherwise non-overlapping and irreconcilable structures.

The situation can be summed up by saying that the texts associated with the design have three primary functions. The first is to remove ambiguity by identifying figures specifically; in the last state of the print we know that the figure on the right is an executioner, and not just a warrior carrying a sword in a fashion that leads us to suspect that he might represent an executioner. The second is to articulate relationships between figures in a manner more precise than is possible to the design alone; in the first state of the print we know only that the three figures are together in a common situation, not how they are related to each other. The third is to apply the relationship thus defined to a specific situation, usually contemporary, outside the frame of the design. The full meaning of the design is thus as much the production of its associated texts as of the design itself. Humpty Dumpty had a point, though there was reason too in Alice's doubts. It looks as if Blake felt a stronger urge to specify meanings verbally as the years passed, and even to change them, within limits. This may have been partly a manifestation of the tempting demons that led him to continually revise his work until it had been "bruised and knocked about" (E 548), but it was also a sign of a gradual change in Blake's understanding of the roots of visual meaning. If the meaning of a figure can be reassigned by a text, meaning is more firmly in the camp of language than in that of the naked visual image.

III

Further evidence of the impulse to specify meanings beyond those that arise naturally from within a design itself can be found in the series of emblems which first appear as sketches in the Notebook, where they are accompanied by quotations from various poets. These were subsequently published in 1793 as a series called *For Children: The Gates of Paradise*. Here the emblems have brief legends engraved beneath them. Some time after 1805 Blake reissued the emblems with the changed direction, *For the Sexes*,

with minor changes to the designs, expanded legends, a prologue, a difficult poem called "The Keys of the Gates," and an epilogue: all in all, a much more complex textual accompaniment. I shall discuss just two emblems, the "Frontispiece" and emblem 11.

When the design for the "Frontispiece" first appeared in the Notebook, it was accompanied by the words "What is Man that thou shouldst magnify him & that thou shouldst set thine heart upon him Job," though a cancel line had then been drawn through all except the first three words.[12] The sketch shows a caterpillar eating its way along the edge of a leaf and a chrysalis with a baby's face with closed eyes.

The partly cancelled text from Job goes on to define man as a worm that will eventually "sleep in the dust" (Job 7: 21), and the caterpillar and chrysalis could be interpreted as offering alternative answers to Job's despairing question "What is Man" – he is a worm, or he is an immortal soul (butterfly, psyche) temporarily wrapped in a mortal cocoon. But there is also another way of reading the design: the two figures together could be read as constituting a single, complex, and sequential answer: man is born into the natural world as a caterpillar, but as he feeds upon the world and transforms it into his own substance, he builds a palace of eternity (the babe within the cocoon) upon the ruins of time and the natural world (the eaten leaf), to use the language of the "Proverbs of Hell." The possibility of inferring these different readings implies that the relational syntax governing the design is not sufficiently explicit to be univocal in meaning; the attached question seems simply to point towards the ambiguity. This is not necessarily a bad or unintended result, but it is changed by Blake's subsequent work on the emblem.

The design reappears as the frontispiece to *For Children: The Gates of Paradise* (illus. 31) with a few minor changes. The shape of the leaf the caterpillar feeds on has been altered, and the caterpillar's position changed so that it now overshadows the sleeping chrysalis. The sun is now evidently shining from the upper right-hand side, so that the chrysalis-baby's face is bathed in sunlight. The text reads "What is Man!" – Job's despairing question turned into an outcry by the exclamation mark.[13] Blake is subtly altering the text as well as the design.

When the emblem is republished in the 1800s in *For the Sexes: The Gates of Paradise* (illus. 32), the shading of sunlit areas has been intensified. To the exclamatory question "What is Man!" Blake has added the couplet "The

31. William Blake, *For Children: The Gates of Paradise*, 1793; frontispiece

32. William Blake, *For the Sexes: The Gates of Paradise*, c. 180(?); frontispiece

Suns Light when he unfolds it/Depends on the Organ that beholds it." This changes the context of Job's question from existential agony to idealist epistemology. As a result, the viewer of the design is much more conscious of the play of light, and of the difference between the caterpillar's eye – without visible iris or pupil, bent down in blind absorption in the act of feeding – and the eyes of the chrysalis-baby, closed, dreaming, and facing the sunlight. The added lines have reshaped our perception, and the design changes subtly as figure and ground shift their boundaries. The couplet encourages us to see the two figures as representing alternative ways of seeing; the syntax of choice is made dominant over the now faded possibility of the syntax of sequential development. One pole of the ambiguous syntax present in the original design has been realized, the other suppressed.

The couplet describing this emblem in the "Keys" produces yet another shift. "The Catterpiller on the Leaf/Reminds thee of thy Mothers Grief" does not pursue the epistemological concerns of the subscribed couplet, but rather asks us to see the emblem as one of a series of designs that trace the divine comedy of life on this earth. The very fact that the "Keys" are presented as a continuous poem, though indexed with numbers corresponding to the relevant emblems, persuades us to read the emblems with a stronger sense of continuity and interdependence.

The key itself is enigmatic, presenting us with an analogy between the natural and human worlds. The caterpillar is related to the worm of the last emblem of the series: they are both mediators between death and life, and between these limits the drama of sexual generation is played out. The caterpillar feeds on the leaf, and then becomes the chrysalis from which finally arises the human babe-butterfly. The "Mothers Grief" that it repeats ("Reminds" in the "Keys," but "Repeats," i.e. tells, signifies to the viewer, in *Auguries of Innocence* [E 491]) is the grief of one who gives up her substance to that which feeds upon her, so that the latter can grow to surpass and supplant her. Life organized in sequential (sexual) generations has a bitter sweetness.

The couplet from the "Keys" has reshaped our perception once again, this time by transforming the syntax that relates the forms in the design to each other from the presentation of alternatives – caterpillar blindness or chrysalis dreaming – to an acceptance of sequence – leaf, caterpillar, chrysalis, butterfly/babe. No deep contradiction is involved, since present-tense alternatives can be rearranged to form a sequence.

The shift in the perceived logic underlying the design is analogous to the tension between the logical structures implied by the several texts attached to *The Accusers*, which also apply both parallel / differentiation and hierarchy / sequence to the same design. Blake could clearly see both synchronic and diachronic interpretive possibilities in his designs, and felt quite comfortable articulating meaning along either axis. The design functions as a starting point for the activity of producing meaning, rather than as a container of meaning completed within itself.

I shall take one more example from *The Gates of Paradise*, emblem 11. The version in the earlier series *For Children* (illus. 33) is very close to the original Notebook sketch, and bears the same inscription, "Aged Ignorance." In this version, the old man's clipping of the wing of the Eros-like youth appears in the context of a history of desire, traced from the moon-aspiring youth of emblem 9, "I Want! I Want!" through the drowned man of emblem 10, to the present image, in which desire is going to be cut down to size. The closed, bespectacled eyes of the old man cannot see the sun ("Ignorance"), and he therefore feels he must clip the wing of the youth who steps rapidly onwards and appears to greet the dawning sun, towards which his face is turned, by raising his right hand. Ignorance, unable to see, wishes the whole world to be as incapable as itself.

33. William Blake, *For Children: The Gates of Paradise*, 1793; emblem 11

34. William Blake, *For the Sexes: The Gates of Paradise*, c. 180(?); emblem 11

When the design was reissued in *For the Sexes* (illus. 34) there were slight changes. The tree was darkened, the sun given a strong outline, and the winged youth given boyish genitals. More significantly, a new text, "Perceptive Organs closed their Objects close," has been added below the title "Aged Ignorance." This new text connects the emblem with the epistemological focus of the "Frontispiece," and attempts to transform our understanding of the winged youth from the image of desire restrained into an image representing any object of perception. The bespectacled ancient's eyes by closing produce a corresponding change in the youth, the object of their now blind perception, by removing his wings. Once again an added text attempts to shift our understanding of a figure.

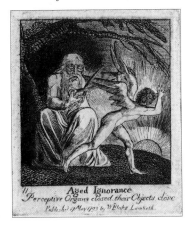

The direction of this shift is assisted by the gloss in the "Keys," which reads "Holy & cold I clipd the Wings / Of all Sublunary Things." Again, we are asked to see the youth as an object of the perception of the old man, who has become the narrator. But can we really accomplish this? We can assist the attempt by remembering such Blakean texts as the Devil's question from *The Marriage of Heaven and Hell*, "How do you know but ev'ry Bird

that cuts the airy way,/Is an immense world of delight, clos'd by your senses five?" (E 35), and the Fairy's promise in *Europe* to show "all alive / The world, when every particle of dust breathes forth its joy" (E 60). These texts also invite us to see each particle in the world as "a Man / Human formd" (E 712), but there is a wide gulf between a text which invites us to see the world as human, and a design which asks us to see a human body as representing the whole world of perceptual objects.

In fact, no commentator on the emblem to date has crossed this gulf. Mary Lynn Johnson has probably given this emblem more thought than any other critic, and here are her key identifications: "Aged Ignorance may be seen as fusing the complex interrelationship of Faith and Sense with the ideas that Time destroys Love and that true old age arrives when vision fails," and, of the youth, "he embodies the idea of love as well as of spiritual vision."[14] This is good comment, but it does not deal directly with the added texts, in part because the focus of Johnson's discussion is the relationship between Blake's design and earlier emblems.

In this case Blake's text has provided interpretive instructions which commentators have been unwilling to follow, for at least two reasons. One is the difficulty, already discussed, that we have in accepting in a design Blake's use of the human body as a metaphor for anything and everything in the universe seen as "Human formd." It is almost impossible to see the youth as one of the "Sublunary Things"; the conventions of iconography and the history of visual representation in general cannot easily be overcome by a brief text. Our eyes and brains insist upon seeing a human form as an active center of meaningful intention, not as a mere object of perception; my last chapter will pursue this theme further.

The other reason is the difference in structure between the design and the text added below. The design shows an old man restraining a youth with one hand and clipping his wing with the other, while the youth tries to continue his journey – the lift of his rear heel shows that he is still trying to step forward. The text added below the design, "Perceptive Organs closed their Objects close," appears to describe two separate acts in the form of two intransitive verbs, the one act immediately triggering the other. Interpretation will suggest that the closing of perceptual objects is a function as well as a consequence of the closing of perceptive organs, but the difference in syntax between the forcible transitive action of the design and the intransitive verbs of the text makes it difficult to apply the text directly to the

design. The text in the "Keys," on the other hand, though on a separate plate, does follow the syntax and imagery of the design, and it is possible that commentators would have been readier to see the design as Blake asks us to if the position of the two added texts had been reversed; proximity is a form of power. But, as in the case of *The Accusers*, differences in syntax between a design and an added text suggest that Blake's later textual thoughts move in ways rather different from those embodied in the original designs; he was quite prepared to reassign the meaning of a figure to suit his changed or deepened understanding of one of his own structures.

There are two issues here that point towards a decreasing reliance by Blake on the inherent expressiveness of bodies as he grew older. The first is Blake's apparently increasing readiness to use a body in a metaphorical sense. I have given the example of the winged youth in "Aged Ignorance" who is used as a metaphor for anything and everything in the universe seen as "Human formd." That is a radical example, but consider Blake's own commentary, dating from 1810, on his lost painting of *The Last Judgment*. There his most characteristic way of attaching a verbal meaning to a visual figure is by the word "represents," as in "The figure dragging up a Woman by her hair represents the Inquisition… The Man Strangling two Women represents a Cruel Church" (E 557–58). It is perhaps unfair to judge a lost painting by the surviving drawings, but the version held by the National Gallery, Washington (B 645), appears to be very close in design, and the figures described are clearly visible on the right-hand side of the drawing. Though the figures are vivid and expressive, the identifications given obviously go far beyond anything that could be derived from them by a textually uninstructed viewer. The figures have become almost counters in an interpretive game in which Blake invites the viewer to join: "The Ladies will be pleasd to see that I have represented the Furies by Three Men & not by three Women It is not because I think the Ancients wrong but they will be pleasd to remember that mine is Vision & not Fable The Spectator may suppose them Clergymen in the Pulpit Scourging Sin instead of Forgiving it" (E 557). The language here is playful and hypothetical, frankly accepting the fact that these meanings are attached to figures but in no way permanently reside within them. Meaning has become a game of metaphorical extension, steered by the verbal context supplied. But in the process, Blake's language, with its "pleasd to remember" and "may suppose," has come uncomfortably close to his scornful comment on Stothard's Plowman,

with which this chapter began: "It may be an old man; it may be a young one; it may be any thing that a prospectus pleases." The two statements were written within a year of each other, so the apparent shift of opinion cannot be explained as a change produced over time. Blake appears to have been reluctant to admit the existence of the Humpty Dumpty within his own artistic practice.

The second issue is what one might describe as Blake's gradual but by no means steady shifting of the locus of meaning from nouns to syntax. By that I mean a shift from the powerfully expressive bodies of the 1790s, the period of the 1795 large color prints and *The Book of Urizen*, with their strong and often isolated bodies, to a more textually oriented sense of the true locus of meaning in a design. The 1790s seems to have been the period of Blake's most intense involvement with the body-centered art of Michelangelo, and significantly it was also the period of his most intense concern with his own illuminated poetry. There was no radical or sudden change, and I have already cited the illustrations to Blair's *The Grave* (1805–1806) as a work that was identified by Fuseli and others as having firm roots in the art of Michelangelo. But increasingly, as the examples explored in this chapter show, Blake surrounds his images with texts that point to the relationship *between* figures as controllers of much of the meaning of a design. The figures themselves become almost ciphers, 0s to be given definition by the texts that are attached.

Metaphor and syntax are both terms that imply a linguistically based view of visual meaning, and Blake's art was moving in that direction. Such a view implies that a specific body does not carry with it a constant or univocal meaning, but rather a range of possible meanings, one or more of which is activated by the syntax of the design as a whole, or by an associated text. Gestures are always meaningful, but not always univocal, and their potential meanings must be narrowed and focused by the total context. That seems increasingly to have become Blake's view, and his practice seems to run more or less parallel with his thinking on the subject. In some ways this can be regarded as a betrayal of the possibilities Blake found in the art of Michelangelo in the last decade of the eighteenth century, as a betrayal of the artist that Blake might have become and indeed for a while was. But it can also be regarded as a victory for the poet that Blake always was, and as a recognition of the fact that he never would or could become an artist of the kind or stature of Michelangelo. The illuminated poems, and designs like

some of the large color prints, go far towards justifying Blake as one of the great artists that England produced – though perhaps it would be truer to acknowledge that Blake produced himself. D. H. Lawrence's comment that Blake "does handle the human body, even if he sometimes makes it a mere ideograph"[15] sums up nicely the mix of iconoclastic energy and rough handling that typifies Blake's approach. He never quite became the Stothard he castigated, but perhaps he might finally have learned a little sympathy for the latter's alleged assignment of arbitrary meanings to bodies.

There is one last and uncomfortable point to consider. Does the growing dependence upon a text to provide a focused meaning for a body in Blake's art mean that critics, including myself, suffer under the burden of having imposed upon them the same freedom to define meaning by attaching an interpretive text? Do we too play the game of providing meaning by attaching a "prospectus"? Beyond a certain point, and in some circumstances, we do; we have little choice in the matter, whether or not we subscribe to postmodern theories of signification. At moments in the following chapters I shall take issue with a traditional interpretation, or with a particular critic's reading of a design. At such moments I assert my "prospectus" against that of others, claiming that mine is better. I would like to think that I have taken care to articulate the various contexts that help to define Blake's designs, that I have looked closely at the details of a design, and that therefore my readings have weight and substance. But one must admit that risk enters the scene, that interpretation is never certain or exact, that some aspects of a design are finally undecidable. This chapter has argued that Blake himself was capable of changing the meaning of a design by changing the text with which he accompanied it. We are in much the same relationship to such designs, and cannot escape both the responsibility and risk that go along with such a position.

The syntax
of invention

"What Critics call The Fable"

The second part of this book will deal with what the eighteenth century called "Invention," as distinct from the focus on "Design" of the first part, though the discussion of Blake's use of the words "represent" and "suppose" at the end of the last chapter bridges the apparent discontinuity; the way in which figures are conceived to mean is dependent upon the kind of "Invention" in which they act.

One could wish that Blake had left us more in the way of explicit commentary on what he himself understood by history painting or, as he usually calls it, "Historical & Poetical" invention (E 526, 529, 771). *A Descriptive Catalogue* of 1809 is of considerable help, though its usefulness is diminished by Blake's preoccupation with his war against oil painting and its practitioners. Something, however, can be made of what he writes in commenting on individual paintings in the exhibition, and in scattered comments elsewhere.

In *A Descriptive Catalogue*, Blake gives a mythical account of the origin of the visual arts by describing the extant Greek sculptures as copies from Asiatic originals, excepting "the Torso" as the one possible surviving original – just that work which Fuseli had claimed as the foundation of the art of Michelangelo. He says of these "originals" that "some were painted as pictures, and some carved as basso relievos, and some as groupes of statues, all containing mythological and recondite meaning, where more is meant than meets the eye." They are described as containers of verbally coded information – that which does not meet the eye cannot be visually coded – and in this they are like the Sculptures of Los's Halls, which in spite of the static implications of their name have the narrative ability to tell "every pathetic story possible to happen" (E 161). In the very act of declaring the power of visual images, Blake undermines their authority by leaving their exact nature indeterminate, and by revealing the dependence of their meaning upon words implicitly contained within them.

In another comment, Blake suggests that he saw painting as radically independent, the equal of poetry in its own separate realm: "Poetry consists in these conceptions; and shall Painting be confined to the sordid drudgery of facsimile representations of merely mortal and perishing substances, and not be as poetry and music are, elevated into its own proper sphere of invention and visionary conception?" (E 541). The unexpected

reference to music suggests an art of pure expression, no longer tied to narrative or even the human body. But Blake's practice does not confirm that hint, and the subsequent statement that "Painting, as well as poetry and music, exists and exults in immortal thoughts" implies that he is thinking of textually supported or supportive music, like Handel's *Messiah*, which is capable of containing "thoughts." Again painting is implicitly a mode of thinking.

In a third passage, Blake writes that the "Vision" that structures *A Vision of The Last Judgment* is identical with what "Critics call The Fable" (E 554). This suggests that Blake, in addition to believing in the ultimate derivation of the arts from a common source, also believed in a more specific homology between epic poetry and true history painting. The word "Fable" when used in this sense belonged to the theory of epic poetry and tragedy, and Blake's comments would lead one to expect that theory to have relevance to his conception of his own visual art; that would be in accord with the accepted theory of history painting, which saw it as analogous to epic and tragedy in literature, and dependent upon that literature for its subjects.[1]

When Reynolds in Discourse IV wrote that "Invention in Painting does not imply the invention of the subject; for that is commonly supplied by the Poet or Historian," he was simply expressing that orthodox theory. Blake, however, responded to what he interpreted as a limitation of the power and freedom of historical painting by protesting that "All but Names of Persons & Places is Invention both in Poetry & Painting" (E 650), apparently reasserting the fundamental equality of the two arts. But "Names" necessarily belong to the world of language; once again a statement that aims at re-establishing the two arts upon an equal footing implicitly acknowledges the priority of language.

Blake's words also invoke a now largely forgotten but once enormously influential theory of epic invention, the calling up of which will enable us to refocus some often overlooked aspects of Blake's understanding of his own visual art. That theory is embodied in Le Bossu's *Treatise of the Epick Poem*, and the gist of it goes like this:

> The first thing we are to begin with for Composing a *Fable*, is to chuse the Instruction, and the point of Morality, which is to serve as its Foundation, according to the Design and End we propose to ourselves... In the next place this *Moral Truth* must be reduc'd into Action, and a general Action

must be feign'd in Imitation of the true and singular Actions [that illustrate the point chosen]... then [the Poet] should look for the Names of some Persons (to whom a parallel Action has either truly or probably happen'd) in *History*, or some well-known *Fables*: And lastly, he ought to place his Action under their Names. Thus it will be really feign'd and invented by the Author, and yet will seem to be taken out of some very ancient *History* and *Fable*.[2]

This at first sight rather startling theory won both fame and then later notoriety in the eighteenth century. It remained a central reference point for the whole period, and many writers comment on it. It was translated into English and "reprinted in abbreviated form no less than thirteen times after 1725 with translations of [Pope's] Homer." Dryden summarizes it in his *Parallel of Poetry and Painting*. Addison appears to refer to it in his influential discussion of *Paradise Lost*. Pope uses it with respect in the prefaces to his versions of Homer, and with disrespect in the preface to *The Dunciad*. Hugh Blair picks it up for his *Dissertation on Ossian*, but mocks it in *Lectures on Rhetoric*. Kames attacks it. In fact, it achieved such widespread familiarity that an examination of the influence of French criticism in England during the period concludes that Le Bossu's definition and skeletal outline of the sequence to be followed "were used as critical schedules for almost all concrete examinations of narrative poems during the next hundred years."[3]

Even Blake's friendly enemy Hayley shows respect while dismissing it:

Though Bossu is called "the best explainer of Aristotle, and one of the most learned and judicious of modern critics," by a writer for whose opinion I have much esteem, I cannot help thinking that his celebrated Essay on Epic Poetry is very ill calculated either to guide or to inspirit a young Poet. The absurdity of his advice concerning the mode of forming the fable, by chusing a moral, inventing the incidents, and then searching history for names to suit them, has been sufficiently exposed.[4]

The theory is not un-Blakean if well considered, since it gives great credit to the originality of the poet, who only *appears* to borrow his subject from tradition; in fact, the whole theory is articulated in order to meet the objection that a poet who finds his story in history or fable invents nothing, and does not merit the name of poet or maker.[5]

There is no explicit evidence that Blake read Le Bossu, but given his references to Pope's translation of Homer, and his wide acquaintance with

eighteenth-century thought, it is extremely likely that he knew the theory well.[6] The statement that "All but Names of Persons & Places is Invention" is specific enough to support that view, though Blake's interpretation of what this means is undoubtedly different from Le Bossu's. Where the critic insists that the epic poet begins with a "point of Morality," Blake starts from what he calls a "visionary conception" (E 541). However, Blake's phrase clearly describes the key notion of a conception that is formed *before*, and then determines, the choice of action and character.

There is another specific point on which Blake seems to show a knowl-edge of Le Bossu, though again there is disagreement as well as agreement between the two, as one would anticipate. Le Bossu argued that "'tis not at all necessary that the Hero of a Poem should be a good and vertuous Man," since one can be *"morally bad*... and... *Poetically good."* Le Bossu's intent is clear: a footman can "be *morally bad*, because he will be a dissembling, drunken, cheating Rascal, and he will be *Poetically good*, because these bad inclinations will be well exposed";[7] this idea too was particularly associated with Le Bossu and the epic. Blake's version is that "Goodness or Badness has nothing to do with Character" (E 269); the comment comes in the little work *On Homer's Poetry* – it was thinking about epic that called forth the remark. Blake's annotations to Boyd's "Historical Notes" on Dante take the relation between morality and epic narrative further in a direction not incompatible with Le Bossu.

Blake takes something like Le Bossu's account of epic invention very much for granted, and uses it as a backdrop against which to construct his own "Style of Designing," which though "a Species by itself" (E 701) bears a generic relationship to Le Bossu's. This should not be surprising; Blake saw himself as a history painter, and the theory of such painting in the eigh-teenth century was largely a product of French thought.

Le Bossu's theory involves a triple articulation: poets begin with a moral truth of their own choosing or devising, then invent an action that will tell that truth, and finally look for named characters in history or poetry in whom to embody that action, with the result that the action will be "really feign'd and invented by the Author, and yet will seem to be taken out of some very ancient *History* and *Fable."* This freedom to appropriate also car-ries with it a responsibility: "if those whose Names are borrow'd have done any known Actions, the Poet ought to make use of them, and to accommo-date these true Circumstances to his own Design."[8] Accommodation goes

both ways; the artist may change the circumstances, but must also be ready to reshape his own action to fit the chosen cover story, and is "frequently oblig'd to suit himself to the Dispositions of his Matter: which is found to be true, especially in the Composition of the *Episodes*, which are made after the General Personages are singulariz'd by the Imposition of the Names."[9]

Le Bossu extends his theory to the visual arts: "Art teaches the *Engraver* to form his Design first, to fansie the Postures, and the Proportions he would give his Personages; and afterwards to look out for Materials that are proper to receive that which he has imagin'd."[10] The theory enters the discussion of painting in Blake's time both through the analogies always pursued between history painting and literature, and through such texts as Barry's definition of his aims in creating the series of six paintings for the Great Room of the Society of Arts, Manufactures, and Commerce at the Adelphi, which he described as illustrating "one great maxim of moral truth," a phrase clearly derived from the tradition defined by Le Bossu. Barry also builds a bridge between Le Bossu and Blake: "The principal merit of Painting as well as Poetry, is its address to the mind; here it is that those Arts are sisters, the fable or subject, both of the one and the other, being but a vehicle in which are conveyed those sentiments by which the mind is elevated, the understanding improved, and the heart softened."[11]

Fuseli, whose lectures again afford parallels to what Blake might have thought but did not write, had a well known antipathy to French neo-classical criticism based on rule and precept. His writings, however, show a sympathy with some of Le Bossu's basic tenets, though it must be borne in mind that Le Bossu's views were so widespread in the eighteenth century in discussions of epic narrative that it is difficult to pin down specific relationships. Consider, however, these statements from Fuseli's Third Lecture on "Invention": in epic painting, "the visible agents are only engines to force *one* irresistible idea upon the mind and fancy," and "For as in the epic, act and agent are subordinate to the maxim, and in pure history are mere organs of the fact."[12] The definition of invention implied here is essentially Le Bossu's, despite Fuseli's declared hostility.

Werner Hofmann gives a fascinating example of a triple-layered process of invention in outlining an exercise developed by Fuseli and the sculptor Banks, "the object of which was to sketch figures round a series of five arbitrarily placed points indicating the position of head, hands and feet." This exercise led to some extraordinarily contorted bodies, which it appears Fuseli

related to a variety of iconographical prototypes; the figure in *A Captive*, for instance, reappears somewhat changed as *Prometheus*. Hofmann concludes:

> It therefore seems justifiable to suspect that this wide range of variations in fact conceals Fuseli's own "philosophical ideas made intuitive, or sentiments personified" [a phrase from a previously quoted letter by Fuseli]. Fuseli uses countless heroes from mythology or literature to symbolize the fundamental tragic elements of human behaviour: jealousy and faithlessness, evil abuse and violence, mental confusion and the longing for salvation, the desire for power and the instinct for submission.[13]

Such "sentiments personified" are embodied in and identified as figures taken from history or poetry: "such protagonists as Prometheus and Siegfried, Lady Macbeth and Melusine provide the 'heroic mask.'"[14] Or, as Fuseli himself put it in a review of his own *Theseus Receiving the Thread from Ariadne*, using words reminiscent of the phrase from Blake with which this discussion began, "Mythology can claim little of this performance besides the name. Its sentiment springs in every age, and dwells in every breast."[15]

The crucial function of names preoccupied Fuseli, who goes beyond Le Bossu's notion of the priority of moral subject over historical name by denigrating works which depend for their effect upon the names attached to the figures, and by correspondingly valorizing works which communicate without historical or poetic identifications. He argues, for instance, that the Laocoön would "rouse our sympathy more forcibly, and press the subject closer to our breast, were it considered only as the representation of an incident common to humanity," and not looked at in the light of its associated name.[16] Fuseli continues the discussion in the next lecture:

> The Madonnas of Raphael; the Ugolino, the Paolo and Frances of Dante; the Conflagration of the Borgo; the Niobe protecting her daughter; Hæmon piercing his own breast, with Antigone hanging dead from his arm, owe the sympathies they call forth to their assimilating power, and not to the names they bear: without names, without reference to time and place, they would impress with equal energy, because they find their counterpart in every breast, and speak the language of mankind.[17]

This implies that Fuseli thought of names as detachable, even optional; like Le Bossu, he claimed to regard them as the last, and least important, part of the act of invention.

But one should not miss the countercurrent of anxiety running through Fuseli's writing on this topic. He is perpetually haunted by the danger of unintelligibility: "the condition that each work of art should fully and essentially tell its own tale, undoubtedly narrows the quantity of admissible objects";[18] without names, some subjects will be unintelligible, and should therefore be avoided. Even in asserting the intrusiveness of names, Fuseli betrays anxiety over the intelligibility of his chosen examples by adding a note to his listing of Hæmon and Antigone: "The group in the Ludovisi... absurdly misnamed Pætus and Arria, notwithstanding some dissonance of taste and execution, may with more plausibility claim the title of Hæmon and Antigone."[19] In practice, Fuseli feels a need to reduce "dissonance" and increase the "plausibility" of his reading by assigning appropriate names chosen from commonly known sources: inappropriate names hinder perception and understanding, appropriate ones assist. In this case, history has not supported Fuseli's choice; Haskell and Penny, who miss his note in their listing of commentary on the piece, tell us that the subject "is now agreed to be a Gaul who stabs himself having already killed his wife to prevent her from falling captive."[20]

Fuseli writes strongly about the superfluousness of attached names, and approvingly of Raphael's "intuition into the pure emanations of nature" and Michelangelo's "Prophets, those organs of embodied sentiment," as if adequately conceived and executed figures should articulate their meaning without any assistance from known names and stories. But in practice he placed his own figures under known names, with extremely few exceptions,[21] and for good reason. It does make a difference to one's response if one identifies the protective woman as a mother, Niobe, defending her child against a virtually omnipotent adversary, or sees in the limply dead woman the heroic and self-sacrificing figure of Antigone. Names do alter cases, and intelligibility must always have a powerful verbal component. Fuseli's comments focus on individual figures – "organs of embodied sentiment," "pure emanations of nature"; discussion of interactive episodes always calls forth from him a desire to assist recognition and interpretation by placing an action under known names. The whole issue is a very important one, with major consequences for the reading of many of Blake's designs.

I have spent some time on Fuseli to make clear that the general issues involved are by no means peculiar to Blake, and that the influence, however mediated, of Le Bossu's theories of epic invention was deeply felt in the

artist for whom Blake had the greatest respect, and from whom he learned the most. Let us now look more closely at Blake's own theory and practice of the art of invention.

II

There is a widespread opinion that Blake illustrates his own myth more or less directly even in those designs produced for independent display. However, his statement that "All but Names of Persons & Places is Invention both in Poetry & Painting" has as its necessary corollary that names are *not* invention, that they belong to the realm of publically accessible data. In practice, Blake, like Fuseli, places virtually all his public designs under known names and stories, with extremely few exceptions,[22] and it is part of the project of this book to recover a few of the lost names that should be attached to those designs, and to deal with the relationships set up between those names with their attached stories, and the Blakean "Vision" or "Fable" that they incorporate. The relation of these "Fables" to Blake's own mythology is a related but separable issue; one can probably assume that there will be a connection, but also that it is unlikely to take the form of a direct correspondence, and that an interpreter will have to work through the names and their attached stories in order to understand the particular shape that Blake's "Vision" has taken when embodied in a specific "Fable."

The most complete accounts of the process of invention as Blake understood it are to be found in the entry in the 1809 *A Descriptive Catalogue* for the unfortunately lost painting *The Ancient Britons*, and in *A Vision of The Last Judgment*, dating from 1810; both documents represent a mature stage of Blake's thinking.

The account of the invention of the subject of *The Ancient Britons* begins with the statement that "The three general classes of men who are represented by the most Beautiful, the most Strong, and the most Ugly, could not be represented by any historical facts but those of our own country, the Ancient Britons; without violating costume" (E 542). Blake begins with his "Moral" or central theme, and uses the key word "represented" to describe its incarnation within specific historical figures; the word indicates the less than inevitable choice involved – other historical figures might conceivably have been as suitable under other circumstances. The figures belong to history, if we include the legendary history of England in that category, as Blake did, following Milton (E 543).

Mona Wilson showed long ago that Blake's structure is based upon material to which he was doubtless directed by William Owen Pughe, and Arthur Johnston has now provided further details. The key passage exists in two forms, one as Triad 85 in the first Series, printed in the *Myvyrian Archailogy of Wales* in 1801, and the other as Triad 83 in the Third Series. I give Edward Williams's translation of the latter:

> Three Men only escaped from the Battle of CAMLAN: MORFRAN son of TEGID, who was so horribly ugly that all thought him a Devil from Hell, and fled away from him; SANDDE OF ANGEL FORM, who was so extremely beautiful and of such benign looks that no man would lift up a hand against him, believing him to be an Angel from Heaven; and GLEWLWYD GAFAELFAWR (*Grey-Grim of mighty grasp*) who was of such giant size and strength, that none had the courage to stand before him, but all fled away with terror from him: except these three, not one escaped from the Battle of CAMLAN.[23]

Blake has turned this, or something very like it, into the following lines, written out as triads:

> In the last Battle that Arthur fought, the most Beautiful was one
> That return'd, and the most Strong another: with them also return'd
> The most Ugly, and no other beside return'd from the bloody field.
>
> The most Beautiful, the Roman Warriors trembled before and worshipped:
> The most Strong, they melted before him and dissolved in his presence:
> The most Ugly they fled with outcries and contortion of their Limbs.
> (E 526)

The nicely differentiated responses of the Romans are based upon the Welsh account, though Blake has heightened the passivity of the warriors before the Beautiful to active worship, and has made the terrified response to the Strong more picturesque by describing it as a dissolution. The changes make the responses of the Romans more graphically visual, one of the chief aims of the process of invention.

The existing text has been modified to become a better container for one of Blake's own structures:

> The Strong man represents the human sublime. The Beautiful man represents the human pathetic, which was in the wars of Eden divided into

male and female. The Ugly man represents the human reason. They were originally one man, who was fourfold; he was self-divided, and his real humanity slain on the stems of generation, and the form of the fourth was like the Son of God.

(E 543)

Thus we have an "Action" and names taken from legendary history and used by Blake as the cover story for a *"Moral Truth"* of his own, the myth of the human sublime, pathetic and reason, and the way in which one of them was divided. This is evidently a version of the myth of the Four Zoas, though its closest analogue in Blake's poetry is this passage that appears only on the unique proof of the frontispiece to *Jerusalem*:

There is a Void, outside of Existence, which if entered into
Englobes itself & becomes a Womb, such was Albion's Couch
A pleasant Shadow of Repose calld Albions lovely Land

His Sublime & Pathos become Two Rocks fixd in the Earth
His Reason his Spectrous Power, covers them above
Jerusalem his Emanation is a Stone laying beneath[.]

(E 144)

This is not the usual form of the Four Zoas, and actually sounds more like the structure Blake invents in *Milton*, in which Rintrah plays the role of the Sublime and Palamabron that of Pathos. This is a reminder that Blake's myths are not static, fixed entities, but are responsive to the varying structures of successive poems; to apply these myths as ideal entities directly to Blake's visual art is to ignore the kinds of differentiation that he himself introduced between his poems. Blake has a mythologizing imagination before he has a specific myth, and is capable of reshaping a wide range of material without merely duplicating the forms of his own mythology, itself a variable structure.

The invented action articulates a more or less unique version of Blake's myth under the guise of an adaptation of the legend: "this Picture... supposes that in the reign of that British Prince, who lived in the fifth century, there were remains of those naked Heroes, in the Welch Mountains" (E 543). This legendary history is chosen as that most appropriate to the myth: "The three general classes of men who are represented by the most Beautiful, the most Strong, and the most Ugly, could not be represented by any historical facts but those of our own country, the Ancient Britons; without

violating costume" (E 542). Blake has followed exactly the process outlined by Le Bossu; two key words are "supposes" and "represented," both descriptive of the embodying of a myth in a historical account. Blake's language here is the professional language of the history painter; "costume" is used in its more technical sense: "not only the Story, but the Circumstances must be observ'd, the Scene of Action, the Countrey, or Place, the Habits, Arms, Manners, Proportions, and the like, must correspond. This is call'd the observing *the Costûme*."[24] Blake wanted to be taken seriously as a history painter, and used the language of that art more than is sometimes recognized.

Blake is thinking of history in terms of a poetic understanding of its overall pattern and direction, of its characteristic repetitions:

> In this Picture, believing with Milton, the ancient British History, Mr. B. has done, as all the ancients did, and as all the moderns, who are worthy of fame, given the historical fact in its poetical vigour; so as it always happens, and not in that dull way that some Historians pretend, who being weakly organized themselves, cannot see either miracle or prodigy; all is to them a dull round of probabilities and possibilities; but the history of all times and places, is nothing else but improbabilities and impossibilities; what we should say, was impossible if we did not see it always before our eyes.
>
> (E 543)

This offers a sophisticated theory of history as a kind of superior fiction, shaped by the strong organization of a poetic consciousness that insists on seeking and creating meaning; one can read in Blake's language an updated version of a Christian providential history overwriting a merely aesthetic action described in the languages of Aristotle's poetics and Hume's critique of miracles.

The fit between Blake's originating "Moral" and the given action and names, adapted though they are, is not perfect; there is an awkwardness in making the Ugly man the representative of "human reason," and then glossing that as "incapability of intellect" (E 543, 545). A little Blakean interpretation can extricate us (and Blake) from the first apparent contradiction – we need not look far for evidence about his negative view of reason – but it is not so easy to understand why Blake then describes him as acting "from love of carnage, and delight in the savage barbarities of war" (E 545). Is this the act of even a Blakean reason? Moreover, the three together seem at least for the time of this battle to have succeeded in rolling back the Romans,

who are one of Blake's recurrent symbols of love of war and empire: "Let others study Art: Rome has somewhat better to do, namely War & Dominion" (E 270). Love of war has just succeeded in defeating love of war; allegorical invention is a tricky, two-edged weapon.

We have here an analogue in the sphere of invention to the only partially successful adaptation we saw in Blake's borrowing from Michelangelo's figure from the crucifixion of Peter. There is a gap, an awkwardness, between the original conception and the new use to which Blake has put it; new meanings do not always fit quite comfortably into old bottles.

Another aspect of the process of invention is also at work. The three figures are modeled on classical sculpture: the Beautiful man on Apollo, the Strong man on Hercules, and the Ugly man on the Dancing Faun.[25] Blake says that he has "resolved to emulate those precious remains of antiquity," with the result that "his ideas of strength and beauty have not been greatly different" (E 544). He seems to have been successful, since Seymour Kirkup described the figures to Lord Houghton in 1870 as reminding "one of Hercules, Apollo, and Pan";[26] evidently all three figures bore some visible similarity to their originals, though it is possible that Kirkup was remembering Blake's text more vividly than the picture.

The third figure is problematical, however, at this level too. The Dancing Faun, the model for the Ugly man, was interpreted as showing "thoughtless, pleasing folly" in the eighteenth century,[27] and though one can appreciate the irony of the choice of this figure as the model for "human reason," it is hard to reconcile with "love of carnage"; Blake has changed the usual associations of the figure substantially. One would love to be able to see what he actually painted, since it is risky to speculate on a lost painting, but it is hard to reconcile the Dancing Fawn with the sheer bloody-mindedness that Blake's text attributes to a figure based upon him.

Blake's account of this painting reveals an awareness of a process of invention that accords closely with Le Bossu's account. A structure of Blake's own devising (but one itself derived from extant mythology, and apparently adapted for the specific case) is folded into an account of an action belonging to the legendary history of England, and that action has in turn been articulated through figures visualized through the mediation of "Greek statues" deriving from the "wonderful originals" of the "Asiatic Patriarchs." There are a few awkwardnesses in the fit between these layers of invention, and it is precisely at these points that we can see the process most clearly.

A very similar account of a complex articulation appears in one of Blake's epic poems. One could claim this for *Milton* and *Jerusalem* as wholes, but I have in mind a specific moment. In *Milton* Blake writes that "the Three Heavens of Beulah" were beheld by Milton during his lifetime "In those three females whom his Wives, & those three whom his Daughters / Had represented and contained" (*Milton* 17: 1–2, E 110). These lines indicate a threefold articulation: the Heavens were made visible in the females who in turn were "represented" by his wives and daughters. Of the three terms used here – Heavens, females, wives / daughters – only the last can be located and named within history as conventionally understood. Blake's "represented" stands for essentially the same meaning as Le Bossu's "placed under," though the critic would doubtless have had difficulty in following the poet at this point.

The whole of *A Vision of The Last Judgment* is another exercise in invention of the kind described – or prescribed – by Le Bossu. Blake's statement that "The Last Judgment is an Overwhelming of Bad Art & Science" (E 565) is an embodiment of a Blakean "Vision" within an existing narrative structure. The words "represent" and "suppose" are again keys to Blake's articulation of the relationship between levels or stages of that process of incarnation. The reader / viewer of that work is invited to participate in a game that reverses the process in order to arrive at Blake's conception:

> The Ladies will be pleasd to see that I have represented the Furies by
> Three Men & not by three Women It is not because I think the Ancients
> wrong but they will be pleasd to remember that mine is Vision and not
> Fable The Spectator may suppose them Clergymen in the Pulpit Scourg-
> ing Sin instead of Forgiving it[.]
>
> (E 557)

This commentary opens up the spaces between Le Bossu's moral, action, and historical or poetic names, the three levels of his sequential account of the process of invention, and makes those spaces not so much sequential as interrelated in the game of producing a meaning which is always in play and never at a final stand. This playfulness is far removed from Le Bossu's seriousness, but it uses analogous structures.

In the passage quoted above, Blake has taken the moral issue of accusation and has placed it under the poetic name of the three Furies, in order to give it "a name and a habitation" (E 125), a recollection from *A Midsummer Night's Dream* that illustrates his consciousness of invention as a form of

imaginative play. The traditional scourges of the Furies qualify them as images of accusation; a familiar structure is turned to a new use, and given a new sex, so that the viewer needs to be alerted by a text to the identity underlying the transformed figures. There is a whole body of story built on the three Furies to which Blake desires his viewers to have access in order to give substance to these otherwise empty figures. In Le Bossu's terms, the action invented to illustrate Blake's chosen moral has been accommodated to accord, up to a point, with poetic history. But Blake has also accommodated that history to his invention, and has made the Furies into males, in order to forward his critique of patriarchal religion. The viewer, initiated into this invention by the text which Blake has described as "necessary,"[28] is invited to join the game; the phrase "may suppose" highlights the optional or provisional nature of any such specific identification. The production of meaning in "the sports of intellect" (E 196) is a continual process in which both artist and viewer must play an active role, and in which attached texts or names are as important as the figures in the design.

Blake's comments on his own process of invention testify to his sense of the existence of spaces between layers of the process of incarnation of meaning in a design, between initiating kernel and finished and received image. His word "represents" points to spaces and relationships between layers of the design seen as a semiotic system; the word "suppose" points to the space between the completed sign system and the viewer's activity in receiving and playing with that system. It is as if Blake had taken Le Bossu's narrative of invention and given it a good shake, respecting its central insight into the relationship between moral kernel, action, and name or chosen protagonist, but rejecting its strictly one-way flow in favor of a continual interplay between free creativity and existing stories and characters.

In practice, Blake uses existing poems or narratives as the substance in which he embodies his ideas (one has to take care to avoid language suggesting the cuckoo or parasite in discussing these relationships), and even his most apparently uncompromising statement of the independence of painting was made in the context of a design based on a poem by Gray:

> Poetry consists in these conceptions; and shall Painting be confined to the sordid drudgery of facsimile representations of merely mortal and perishing substances, and not be as poetry and music are, elevated into its own proper sphere of invention and visionary conception? No, it shall not be so! Painting, as well as poetry and music, exists and exults in immortal thoughts.
> (E 541)

This passage, read in context, implies that the "proper sphere" of pictorial invention is that inspired by great poetry; the visionary artist maps out a structure of his own upon an existing poetic or narrative structure, inventing a design that uses the existing text as the embodying vehicle for a new vision, which will have some relationship to the existing text, but one that will have to be determined in each case.

The remainder of this book will look at Blake's practice of the art of invention with a particular eye to tracing the relationships between his own thoughts or "Visions" and the stories or images he has used as their embodying cover, or has used as a point of origin for development. In some cases I shall suggest new originary texts; Blake, like Fuseli, had a desire to be understood, and very few of Blake's designs, apart from the illuminated poems, do not involve some public story that we need to recognize before we can fully comprehend what he is doing, though his meaning is never fully defined by identifying that story.

III

In the remainder of this chapter I shall look at a few works by Blake, chosen to illustrate various facets of the process of invention. I shall deal first with the three illustrations to the story of Joseph that were considered from a different perspective in Chapter 1. The three designs were exhibited together in the Royal Academy in 1785, and should be able to teach us something about Blake's practice as a history painter at this early stage of his career.

One way of focusing what Blake is doing is to look at the iconographic history of the Joseph story, one that appealed to a great many artists. Louis Réau comments that Joseph's place in art was in medieval times due "exclusivement" to his being considered from Tertullian on as a figure of Christ,[29] but this changed. Among the early engravers, three of those singled out by Blake as "great Masters in Painting and Designing" (E 567), H. Aldegrever, Lucas van Leyden, and Hans Sebald Beham, illustrated the Joseph story. Favorite episodes were Joseph explaining his dreams to his brothers, Joseph being lowered into the pit, and Joseph fleeing from Potiphar's wife. Raphael's Loggia series prompted various engravings illustrating Joseph explaining his dreams to his brothers, Joseph sold, Joseph fleeing from Potiphar's wife, and the finding of the cup in Benjamin's sack. Jacopo Pontormo illustrated Joseph listening to a petitioner, Joseph with his wife and

son, and Jacob blessing his sons. Pigler's list shows that in the seventeenth and eighteenth centuries the favorite subjects were Jacob's response to Joseph's bloody robe, Joseph and Potiphar's wife, Joseph in prison interpreting his fellow-prisoners' dreams, and the finding of the cup in Benjamin's sack. A little less popular, but still frequent, were the episodes of Joseph explaining his dreams, Joseph being sold, Joseph interpreting Pharaoh's dreams, Joseph distributing corn, Joseph receiving his father and brothers in Egypt, and Jacob blessing Joseph's sons.[30] Dreaming, sexual scandal, and family relationships were deemed to offer more dramatic human material than the typology of Joseph in the well or in prison.

Viewed against this background, Blake's series of designs appears deliberately undramatic, except for the final revelation. Blake has accepted the repeated appearance of a rather undifferentiated cast of brothers as a price worth paying (though as I showed earlier he made some attempts to reduce the cost) for the dramatic focus and continuity that it helped him impose upon a complex story; Joseph's concealment and subsequent revelation of his identity have been made into the single continuing plot of the sequence.

In the first design, *Joseph's Brethren Bowing before him* (B 155; illus. 11), Joseph turns aside and shields his face in a gesture based upon Genesis 42: 7: "And Joseph saw his brethren, and he knew them, but made himself strange unto them." In the second, *Joseph Ordering Simeon to be Bound* (B 156; illus. 4), Blake has merged two successive moments in the narrative into one by splitting Joseph's actions and giving one of them to a servant to perform: where Genesis 42: 24 says "And he turned himself about from them, and wept; and returned to them again, and communed with them, and took from them Simeon, and bound him before their eyes," Blake shows Joseph turned away and wringing his hands in anguish, while a servant simultaneously performs the act of binding. Just as condensation and splitting are, in Freud's account, major elements in dream production, so are they tools employed by the inventor in translating from one medium to another. In this case, the splitting has freed Blake to concentrate on the deep feeling within Joseph while his brother is bound; Joseph again communes with himself as he turns from his brothers in what looks like sorrowful prayer. Blake has put some pressure on the narrative in order to accommodate his chosen intent, but has remained faithful to its broad lines.

In the final drawing of the series, *Joseph Making himself Known to his Brethren* (B 157; illus. 7), Blake follows Genesis 45: 14–15: "And he fell upon his brother

Benjamin's neck, and wept; and Benjamin wept upon his neck. Moreover he kissed all his brethren, and wept upon them: and after that his brethren talked with him." The design combines these several actions into one complex event. It shows Benjamin reaching up from his kneeling position to embrace Joseph, the other brothers raising their heads in mingled fear and hope or bowing them in confession of guilt, while Joseph moves towards and looks out over them, his arms reaching forwards in an aerial embrace to encompass them all. Blake has combined in one design Joseph's special embrace of Benjamin and his general reconciliation with all of his brothers; Joseph has finally appeared clothed in his real feelings. The story of Joseph as Blake has reshaped it is the narrative of a test applied from a place of concealment, leading to self-revelation and atonement when the testing has achieved its purpose.

Blake has embodied his "Fable" in an "action" focused entirely on the story of Joseph and his brothers; there is no Jacob, no Pharaoh, no Potiphar's wife, no wife and sons, merely a bare minimum of ancillary figures such as the servant carrying food in the first design and the jailer chaining Simeon in the second. The biblical narrative has been stripped to reveal what Blake saw as a deep kernel of meaning in the story that lent itself to the tripartite structure he had in mind. The most obviously typological moments, such as Joseph's descents into the pit (Genesis 37: 24) and the prison (Genesis 39: 20), and his feeding of the Egyptian multitude (Genesis 47: 12–19) are passed over, as are such overtly dramatic moments as the episode of Potiphar's wife and the finding of the cup in Benjamin's sack. Blake has constructed a very specific narrative out of a complex story that contains a great number of possible paths for interpretive shaping.

Blake's version almost suggests that he had been reading Luther's commentary. Luther, in annotating the moment chosen by Blake for his first design (Genesis 42: 7), writes that Joseph is playing "a wonderful kind of game with them, but a game that humbles them greatly, trains them, and brings with it important and serious results."[31] Joseph's aim is "to put their penitence to the test and thus to drive them to acknowledge their sin and the mercy of God." Of the binding of Simeon, Luther writes that it was to "lead him to a knowledge of his sin," and of the final episode (Genesis 45: 1–15) he writes that "Here he absolves them from their sin" and that "Moses paints a very delightful picture of the embrace of Joseph and Benjamin."[32] Though Blake demonstrates some knowledge of Luther,[33] it is not likely

that he had read this commentary; it should, however, occasion no surprise that the readings of two great Protestant visionaries contain similarities.

Blake is not simply "illustrating" the story of Joseph, any more than he is telling a story purely of his own invention, or directly embodying his own myth, which almost certainly did not exist at this date; he is recasting a familiar narrative into a particular shape. It is impossible to say whether Blake decided to create designs that would show the workings of a restorative act of forgiveness (between brothers, to intensify the drama), and chose the story of Joseph as the most appropriate body in which to incarnate that action, or whether Blake, while re-reading and thinking about the story of Joseph for the twentieth time, suddenly saw the material for an interesting version of it. Fortunately, we do not need to make that decision before responding.

Blake's way of framing the story brings out what could be considered peculiarly Blakean values. Those values, however, are founded on a deep and perceptive reading of this and other episodes of the Bible. A kind of benevolent circularity is at work; the Bible narrative generates thoughts and values that then find expression in a transformed vision of one of those originary episodes. Are we to call those values Blakean or biblical? With such a text, Blake's work is as much interpretive as it is inventive, and reception and critique become facets of a single process.

There is one significant detail in *Joseph Ordering Simeon to be Bound* that poses further questions about Blake's shaping of the story, particularly in the light of the analogies between his and Luther's ways of thinking about it. In the background of what appears to be the prison where Simeon is bound (see Genesis 42: 16, 19) appear several large serpents. They suggest that Simeon is in a hell created by his own envious selfishness, and that his binding and release by Joseph is a narrative metaphor for his release from his own selfhood by the Joseph/Jesus of imagination. There is a hint of the traditional typology present here, but it has been reshaped in Blake's own image.

IV

The next design has been chosen because it raises interesting questions relating to the issue of names discussed above. It is an ink and wash drawing titled by Butlin *A Crowned Woman Amid Clouds with a Demon Starting Away* (B 92; illus. 35),[34] and dated c. 1785–90, just after the Joseph series. The subject

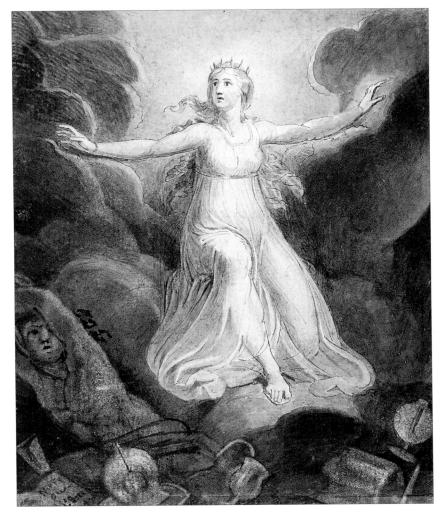

35. William Blake, *A Crowned Woman Amid Clouds with a Demon Starting Away* (*The New Jerusalem Descending?*) (B 92)

of the drawing was for a long time obscured by the failure to see that the signs that follow the raised arm of the figure in the bottom left-hand corner spell the word "GOG." Once the name is read as an identification of the same kind as the names attached to some of the figures in Blake's *Epitome of James Hervey's "Meditations Among the Tombs"* (B 770), interpretation can begin. The name follows the outline of the figure to which it refers, as do the names in the Hervey painting. From that discovery the rest of the interpretation might be expected to flow easily, but it does not, and an exploration of the reasons will take us deeper into Blake's process of invention.

Accepting Blake's identification of the male figure as Gog, we must identify the context and the moment. Gog appears significantly in two places in the Bible. In Ezekiel 38–39, the prophet is told by the word of the Lord to prophesy against Gog, "the chief prince of Meshech and Tubal," who with his "army... all of them clothed with all sorts of armour, even a great company with bucklers and shields, all of them handling swords," will "come like a storm... like a cloud to cover the land," threatening to "carry away silver and gold, to take away cattle and goods"; this "shall be in the latter days." But the Lord also promises that Gog and his bands will fall, and be given to "the ravenous birds of every sort, and to the beasts of the field to be devoured." The second major reference to Gog is in Revelation 20: when the thousand years during which Satan is bound come to an end, Satan "shall be loosed out of his prison, And shall go out to deceive the nations which are in the four quarters of the earth, Gog and Magog, to gather them together to battle"; but finally "fire came down from God out of heaven, and devoured them."

Blake has imaged Gog as he is described in Ezekiel. The somewhat miscellaneous hardware at the bottom of the design – one can make out a goblet, a helmet, and what look like a sword handle and a shield – derives from the description of Gog and his army with bucklers, shields, swords, and the spoils of silver and gold which they will loot. Both spoils and weaponry are pictured as discarded in Gog's hasty flight.

This identification of the named figure in the design, however, does not account for the woman descending from the clouds. Her meaning is partially accessible to an innocent eye; she is clearly descending, since her left leg is bent underneath her at the knee, so that she cannot have any upward moving energy, and she does not yet seem to have reached a stable resting position. In addition, the body of the "Demon" moves and leans towards the left in a way that implies that the female figure is descending and displacing him from the center of the design.

But we need more than that; we need a name and an identity. They are recoverable through a recognition of the analogy between the contexts of the account of Gog in Ezekiel and that in Revelation. The account of Gog in Ezekiel is followed by an extended revelation to the prophet of the dimensions of the temple of the Lord, described in chapters 40–47. The account of Gog and Magog in Revelation leads directly to the Last Judgment and the descent of "the holy city, new Jerusalem, coming down from God out of

heaven, prepared as a bride adorned for her husband" (Revelation 21: 2). There is thus a powerful structural analogy between the temple of Ezekiel and the bridal city of Revelation, which Blake has used to visualize the New Jerusalem as a woman descending to put to flight Gog and his already vanished army. Blake has connected the prophecies of Ezekiel and John by shifting from the language of one to that of the other within a single design.

The woman in the design is Blake's first visual representation of Jerusalem, the bridal city who is the true type of Ezekiel's vision of the temple of the Lord. The crown is a sign of that married state, in accord with the symbolism of the "crown that none can take away" in *The Book of Thel* (E 5), where it functions as a token of the sacred marriage between "he that loves the lowly" and the Clod of Clay, a marriage in turn modeled on the sacred marriages of the Bible recorded in Revelation and elsewhere.

The relationship between the two halves of the analogy can be expressed as a form of typology, as the ratio between a "house of Israel" built with stone and measured out with a reed (Ezekiel 40: 4–5), and the fully humanized vision of John, for whom the truest image of the human community, "the holy city" (Revelation 21: 2), is a human body. Architecture becomes a type of the sacredness of the human body in a way that we shall see repeated in a design to be discussed in Chapter 7.

Commentators on the Bible had already made much of the relationship between the two prophecies. The Protestant reformers recharged the discussion of biblical prophecy by asserting that the Papacy was the Antichrist, and by using that to give typological unity to their interpretations of, primarily, Daniel and Revelation. The Gog of Ezekiel was seen as a related figure, and there are a number of significant comments that constitute one historical context for Blake's design and support his joining of elements from the Old and New Testaments. Joseph Mede, for instance, in his widely read comments on Revelation, described Gog and Magog as the "counter-type" of the Gog of Ezekiel.[35] David Pareus, in another widely read commentary, also saw a relationship between the two prophecies: "The sense is thus: Like as of old *Gog* and *Magog* invaded the Holy Land with very great Armies… *So Satan being loosed* at the end of the thousand fatall years, shall raise up against the Church a new *Gog* and *Magog*, that is, most cruell adversaries."[36] The two commentators differ in their historical identifications, but both see the relationship between Ezekiel and Revelation as analogical and typological.

This view became standard, and can be found in many commentaries closer to Blake's own time. Matthew Henry, for instance, writes that "These chapters [Ezekiel 40–47] are the more to be regarded, because the last two chapters of the *Revelation* seem to have a plain allusion to them, as *Rev.* 20 has to the foregoing prophecy of Gog and Magog."[37] William Lowth recognizes that "The New Testament copies the style of the Old," and exemplifies this by explaining that "St. John in the Revelation, not only describes the heavenly sanctuary by representations taken from the Jewish Temple, Rev. XI.19. XIV.17. XV.5, 8. but likewise transcribes several of Ezekiel's expressions, Rev. IV.2, 3, 6. XI.12. XXI.12, & XXII.1, 2."[38] Lowth reads Ezekiel's temple as a figure of its antitype, the new Jerusalem. There was a large body of influential commentary to support Blake's bridging from Ezekiel's vision of Gog to Revelation's vision of the descent of the new Jerusalem.

Blake has brought the two parts of a typological structure into a newly imagined unity that is nevertheless in keeping with previous commentary. The prophets were poets, and a poet was also a prophet. In *All Religions are One* (1788), he treats "the Jewish & Christian Testaments" as being equally "An original derivation from the Poetic Genius," which is "every where call'd the Spirit of Prophecy" (E 1), and the whole of Blake's work confirms that Ezekiel and Isaiah in particular always commanded the greatest respect. Blake felt justified in combining statements from both "The Jewish & Christian Testaments" into one poetic vision of the victory of freedom and truth over tyranny and blindness. Blake's "maxim" fuses perfectly with the existing language of prophecy, which he can further extend into his own times.

Typology was applied to the understanding of history in the late seventeenth and eighteenth centuries, and indeed the difference between the two testaments was sometimes expressed as the difference between prophecy and history, or shadow and substance: "The new and old Testaments are one book... In the first we have the type and shadow, in the second the antitype and substance: What in the first volume is prophecy, in the last is history and matter of fact."[39]

The signs of approaching radical change in the 1780s brought about a large increase in the application of scriptural prophecy, particularly Revelation, to contemporary history. The immediate trigger was the American War of Independence; as early as 1772 Joseph Priestley wrote that the devel-

oping crisis in America looked like the beginning of the end of the world: "Every thing looks like the approach of that dismal catastrophe... I shall be looking for the downfall of Church and State together. I am really expecting some very calamitous, but finally glorious, events."[40] The 1780s saw the exhibition of such paintings as Benjamin West's *Death on a Pale Horse*, Barry's *Elysium, or the State of final Retribution*, and Lowe's *The Deluge*.[41]

Commentators had also been impressed by the text of Daniel 7: 19–28 that identified the ten horns of the fourth beast as "ten kings that shall arise," and King James himself had identified these, and the horns of Revelation 17, as the kings of Europe.[42] This made it easy to see these horned beasts as images of Antichrist, and thus associated with Gog and Magog. The power of the European kings had been badly shaken by the creation of the American Republic, and there were many prophetic statements that pointed forward to the French Revolution and the downfall of the European monarchies. By 1794 Priestley was identifying the crowned heads of Europe with the horns of the beast in Revelation, and declaring that "the execution of the king of France is the falling off of the first of these horns; and... the nine monarchies of Europe will fall one after another in the same way."[43]

Blake's drawing can be interpreted as extending its typology to contemporary history in just this manner; the exposure of the Old Testament to the revisionary criticism of the New Testament implied in the juxtaposition of the Gog of Ezekiel with the New Jerusalem of Revelation also extends to the instantiation of the prophetic type of Revelation in contemporary and anticipated events, which become the true antitype of the events recounted prophetically and symbolically in Revelation. As Korshin puts it, "In theological terms, the events in France had been predicted by Old and New Testament prophecies; in secular terms, history was to be seen as a series of predictive structures; and in figural terms, the prophetic types of Scripture were now having or about to have their long-awaited antitypes."[44] The truly prophetic moment is the present, in which prophetic metaphor is incarnated in living flesh and blood.

Blake's practice of invention has here taken a step beyond the relatively conservative handling of a text found in the Joseph series, and has embarked upon a much freer kind of creativity. But the new invention is still firmly "placed" under well known names, and takes much of its intelligibility from the texts pointed to by those names. Blake might at one point

have hoped that viewers would recognize those names; the "GOG" written in suggests that either through intuition or experience he discovered that he had been overly optimistic. The name follows the curve of the body to which it refers, as if attempting to pictorialize the letters, to reduce the potential disharmony between acting bodies and alphabetically coded information; the attempt at harmonization recognizes the tension in trying to reduce it.

The confounding of Gog by the descent of the New Jerusalem is the visionary and apocalyptic Fable that gives depth to the design; without those names we have simply *A Crowned Woman Amid Clouds with a Demon Starting Away*, a design not seen as meaningful enough to have drawn any commentary at all. Having recognized that Fable, we can if we wish proceed to allegorize it into a variety of contexts, as Blake himself did years later when he wrote that "Jerusalem is called Liberty among the Children of Albion" (E 203). But the visionary Fable is the root of any meanings built upon it; as Blake wrote in another but related context, "Tell me the Acts, O historian, and leave me to reason upon them as I please" (E 544). The "Acts" are the articulation of the Fable, and they are the acts of figures bearing significant names, on this occasion drawn from the Bible.

In an interesting essay, Nicholas P. Negroponte makes the point that a wink from a friend across the table at a dinner party could be described in the language of information theory as representing one bit. Yet that one bit could in fact carry an enormous freight of information; if asked, you might need more than 100,000 bits to explain the contents of the message to a stranger. Behind such a wink lies a huge body of shared information and experience, which enters into both the initial coding and the subsequent decoding of that one-bit wink. A name attached to a figure in a design functions in a similar way. If I know that the name of a figure is Gog, I already know a great deal, and can put that knowledge to use in interpreting the design. The attachment of a name, title or text makes smart viewers out of dumb ones, richly complex designs out of apparently simple ones. As Negroponte points out, "we cannot isolate thoughts about channel mode and capacity – flat estimates of how much information can travel how fast – from the computational resources at the ends of the network."[45] A name or title enormously increases the computational resources of the viewer of a design.

Blake's statement that "All but Names of Persons & Places is Invention

both in Poetry & Painting" means not only that Blake sees the epic poet and the history painter as pursuing essentially the same ends, but also that he accepts the need for the painter to make use of known figures and stories through which to communicate his message, while claiming the recognized right of the inventor to change and add to the known narrative. Without a recognition of those names and stories, the viewer can respond only to the energy exchanges visible in the design, which are not always explicit enough to support a clear interpretation. In the absence of the information which would help make smart viewers, commentators on Blake's designs have often succumbed to a stream of association triggered by the recollection of passages from his poetry.

The results have not always been a success. Examples are *Hecate*, which was not only misread but fundamentally mis-seen for a century, and the host of readings of *The Sea of Time and Space*, none of which command much confidence, and which identify the central figures in a bewildering variety of ways. We have to learn how to reconstruct the texts and names that underlie Blake's designs, and to understand better the ways in which he incorporated his meanings within them.

V

Blake added the subtitle "Poetical and Historical Inventions" to the 1809 *A Descriptive Catalogue*, a title he used again in a letter to Dawson Turner in 1818 in describing his large color prints (E 771). I shall not here attempt to define the distinction implied between those two terms, but shall turn to a design that is unmistakably on the "Poetical" side. If the last design discussed has suffered from not having any title attached, this one could be said to suffer from having too many. In the catalogue it is introduced with the following text: *"A Spirit vaulting from a cloud to turn and wind a fiery Pegasus – Shakspeare. The Horse of Intellect is leaping from the cliffs of Memory and Reasoning; it is a barren Rock: it is also called the Barren Waste of Locke and Newton"* (E 546).

The painting thus described (B 658) has disappeared, but there is a watercolor dated 1809 that would seem to be very close in composition (B 547: 6; illus. 36); that watercolor will stand in for the lost painting in the following discussion.[46] The risk involved in making that substitution would seem a small one, since Blake usually kept the basic features of a design when repeating it.

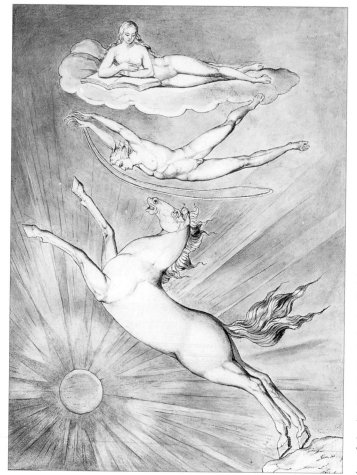

36. William Blake, *As if an Angel Dropped
down from the Clouds* (B 547: 6)

The first title is derived from *I Henry IV*. Here is the speech from which Blake has abstracted the words of his title, a report from Vernon to Hotspur of what he has seen of the "new" Hal and his allies:

> All furnish'd, all in arms;
> All plum'd like estridges that with the wind
> Bated, like eagles having lately bath'd,
> Glittering in golden coats like images,
> As full of spirit as the month of May,
> And gorgeous as the sun at midsummer;
> Wanton as young goats, wild as young bulls.
> I saw young Harry with his beaver on,
> His cushes on his thighs, gallantly arm'd,
> Rise from the ground like feather'd Mercury,
> And vaulted with such ease into his seat
> As if an angel dropp'd down from the clouds
> To turn and wind a fiery Pegasus,
> And witch the world with noble horsemanship.[47]

The words describe not a scene on stage, but images designed to persuade Hotspur to take Hal seriously.

Blunt points out that Blake's choice of subjects from Shakespeare includes this, "the only passage quoted in full by Burke."[48] That statement, though suggestive, is ambiguous, since Burke also quotes Milton's account of Death as Satan meets him, and the description of Satan in his "original brightness," both of which subjects Blake also illustrated.[49] Despite Blunt's "full," Burke omits two lines that refer to Hal's armor, "Glittering in golden coats like images," and "His cushes on his thighs, gallantly arm'd," though he keeps the initial "All furnished, all in arms."[50] This omission corresponds so well to the omission of all reference to armor in Blake's design that it is likely that Blake's attention was indeed drawn to this passage by Burke; he would have found it given as an example of those "many descriptions in the poets and orators which owe their sublimity to a richness and profusion of images, in which the mind is so dazzled as to make it impossible to attend to that exact coherence and agreement of the allusions, which we should require on every other occasion."[51] Blake was not dazzled, but has taken steps to simplify the profusion of images, helped by Burke's omissions.

Despite Blake's disagreement with Burke on the nature of the sublime, he nevertheless had respect for the notion itself, and may have accepted Burke's choice of examples as more valid than his arguments. Vernon's lines had much to offer as a starting point for an exercise in the sublime, and so we should expect to find a focus on the "lineaments, or forms and features that are capable of being the receptacles of intellect" (E 544) characteristic of Blake's approach to the visual sublime, which is always opposed to merely external power, as exemplified in a warrior culture.[52] The omission of all reference to armor demilitarizes Vernon's imagery, and facilitates Blake's redirection of the passage to a celebration of the imagination's sublime power and freedom of flight.

From Vernon's lines Blake has formulated a "Vision" or "Fable" pointed at by the words *"The Horse of Intellect is leaping from the cliffs of Memory and Reasoning"*; there is no hint here of Blake's monomyth, but rather a free fantasia on Blakean themes. This "Vision" has been articulated in an action created by selecting from Vernon's luxury of images, focusing on the last lines. The gesture of a newly focused energy leaping into action is accepted, but given a totally new context; the figures that embody that action are based on the vehicles of Vernon's images, put together into a new shape.

The "angel," whom we would expect to be clothed, has been transformed into a nude *"Spirit."* He has neither the feathered feet of Mercury nor the wings of an angel, though his dropping down from the clouds looks like a controlled form of flight. Vernon's exaggeration, his "As if," has become literal in the act of being visualized.

Pegasus, a not very important image in Vernon's lines, has become central to the design, and perhaps surprisingly lacks the traditional wings; as an image of human intellectual energy, he too must appear in his proper form, though he still possesses the power of flight. Flight is the result of the energy he represents, not of something added or external to his nature.

Blake's title transforms an inconspicuous feature of both Vernon's speech and the design into semantic prominence by converting it into the formidably negative sounding *"cliffs of Memory and Reasoning."* This is a long way from the "ground" from which Hal rises in Vernon's speech, but there remains a link: the ground is something left behind in the act of exerting the freedom of intellectual flight. The coda to Blake's text, *"it is also called the Barren Waste of Locke and Newton,"* applies the fable to a specific philosophical context, taking names from history in which to instantiate the action.

The woman is a transformation of Vernon's bewitched world, watching in fascination Hal's newly demonstrated virtuosity in riding. That world has become a Muse (inspirer and consumer both) absorbed in the new creation brought into being by Pegasus's poetic leap into space; we can imagine her poring over a text compounded of Shakespeare's poetry and Blake's design, the product of the horse's hoof-strike.

The sun is also taken from Vernon's lines, though it is no longer merely a sign of "gorgeous"-ness. The sun has become an image of the energy of the natural world, surpassed by the leap of intellect, as the imagination surpasses the military power of Hal. The horse, in leaping over the sun, has succeeded where Pegasus failed.

Blake's design visualizes the vehicles of Vernon's similes, taking elements which are parallel descriptors of Hal in the text and putting them into narrative interaction with each other. Vernon's images have been transformed into a Blakean "Fable" about the horse of Intellect and the wasteland of Locke and Newton through an action focused on the myth of Pegasus, which mediates between Vernon's imagery and Blake's textually assigned meaning. The design implies that we are on top of a mountain – presumably Mount Helicon; the implication is seconded by the Muse-like woman at the top of the design poring over a book. But simultaneously Blake's text identifies the mountain top as a *"barren Rock"*; there are no signs of the poetic fountain of Hippocrene raised there by the horse's hoof. In focusing on the energetic initial movement of the horse, Blake is maximizing the contrast between the ground left behind and the flight itself; rather than transforming the barren ground as is suggested in the myth, Blake's horse simply leaves it behind.

We can find a few analogues to the imagery of this design in Blake's letters of approximately the same time. He writes to Hayley that "My fingers Emit sparks of fire with Expectation of my future labours" (E 709), and to Flaxman that "In my Brain are studies & Chambers fill'd with books & pictures of old which I wrote & painted in ages of Eternity. before my mortal life & whose works are the delight & Study of Archangels" (E 710). Blake, so to speak, is horse and rider as one creative unit, and the woman in the design is one of those archangels, the ideal consumers of the artist's product. In another letter he writes that "Nothing can withstand the fury of my Course among the Stars of God & in the Abysses of the Accuser My Enthusiasm is still what it was only Enlarged and confirmd" (E 720); here Blake is

Pegasus himself. These letters date from 1800 to 1802, and it is very possibly during this period that Blake made the original version of the painting we are considering; he says in *A Descriptive Catalogue* that "This Picture was done many years ago, and was one of the first Mr. B. ever did in Fresco" (E 546), which would seem to date it around 1799, though the exact meaning of the word "Fresco" is uncertain.[53]

There is no visible horizon, so that it is not possible to fix our point of view exactly; if the horse has leaped over the sun, the action is taking place above any possible horizon, though that uncomfortably implies a mountain top at approximately the level of the sun. Here is the true sublime as Blake would define it; mere space, including the pull of gravity, has been overcome by the energy of poetic creation. The vertical stacking and separation of the figures of the design against a more or less blank background abolish the potentially ordering power of perspective rules; the figures can only be articulated together through an implicit text that provides the syntax needed to impose relationship between separate and independent parts.

This leads to one final question about the design; can we, or should we, impose a more distinct identity on the male "*Spirit*"? The obvious answer is that the widespread use of Pegasus as a metaphor for the power of poetry[54] has enabled Blake to bypass the male figures originally associated with the mythical Pegasus in favor of a more modern appropriation of the story. The rider here is the poetic faculty itself, truly a "*Spirit*." The mythical structure reflected in the language of the original persists, but in an updated transform, equally as public as the original, and developed from it. Blake can allow himself freedom without totally abandoning the original myth, taken over from Shakespeare's text, that underlies the design.

Milton invoked the same understanding of the myth in the invocation to Book VII of *Paradise Lost*, when he wrote:

> Descend from heaven Urania, by that name
> If rightly thou art called, whose voice divine
> Following, above the Olympian hill I soar,
> Above the flight of Pegasean wing.[55]

Here the human imagination soars above the realm of the winged horse; in Blake's design, the human rider is about to ride and control the horse's energy, the two becoming virtually one in the process. Both works carry similar meaning, but express it in differing appropriations of the myth.

The descriptive and identifying texts that Blake has written into his *Catalogue* read an allegory of poetic and epistemological creation into the design. Blake in writing that the barren rock is *"the Barren Waste of Locke and Newton"* specifies a meaning that can in no way be said to reside *in* the rock, but is attached to it as a metaphoric name. The rock has been semiotically shifted from representation to icon, and in that mode can mean more or less anything that a text declares it to mean: Humpty Dumpty Blake once more.

There remains, however, a connection with Shakespeare's text; Vernon's account of the reborn Hal's easy rise into a newly energized power and freedom of movement on horseback is an image of new self-control and focus. Blake's design, articulating its action through a focus on Vernon's "Pegasus," moves Vernon's images to the sphere of the sublime without being unfaithful to their basic gesture. Poetic invention has achieved a genuine response to the underlying thrust of an image-filled passage, has achieved originality without denying the power and significance of the text in which it incarnates its "Vision."

These readings of a few of Blake's designs show that within the varying structures produced by Blake's creative process there is a constant playing with something like Le Bossu's theory of epic invention. There are large differences between the two in how that theory is to be understood and applied, but both see it as affirming the artist's freedom to invent around and over the text that provides the body for the action. Understanding that theory helps to give us a way of describing what we find in these designs, of entering their way of incarnating new meaning within existing structures, and bending those structures in the process. The next chapters will pursue these themes in a variety of Blake's work, exploring aspects of the ever-varying relationship between Blake's art and the world of texts.

"12 Large Prints… Historical & Poetical"

Nearly two centuries have passed since William Blake used his newly invented process of color printing to produce the twelve designs generally known as the large color prints, but despite being beyond question a high point of his pictorial invention, they continue to puzzle as well as stir viewers. Other than technical questions, with which I am not primarily concerned, the key issues at stake are the interpretation of the individual designs, and the continuing attempts to find ways of binding the twelve into unity.

The assumption that the prints form a narrative series seems to have originated with Blunt, who states that:

> There are good reasons for supposing that these colour-prints were planned by Blake as a single series. They were all produced in a very short period of time, and they are more or less identical in format and technique. Moreover, all the subjects can be shown to bear on themes connected with Blake's interpretation of the early history of the world as it is set forth in the Lambeth Books.[1]

Some version of that view has become the standard way of looking at these prints; Butlin, for instance, who has done more than any other single person to inform us about these prints, writes in his recent revision of the catalogue of the Tate Gallery's Blake collection:

> the twelve designs… make up what seems to be a unified series despite the subjects being at first sight an apparently haphazard collection including events from the Old Testament and the life of Christ, illustrations to Shakespeare and Milton, designs previously used in Blake's prophetic books, and the completely unprecedented appearance of Newton as a figure of universal significance, all raised by Blake's genius to an equal level of importance. As yet there has been no fully convincing analysis of the meaning of the series as a whole, but it seems likely that Blake is draw- ing indiscriminately on a number of sources to find images to express vari- ous aspects of his own universal philosophy.[2]

"Various aspects" suggests a looser model than "unified series," and one with which I am more comfortable.

Since Blunt's statement there have been several attempts to formulate a program to give narrative coherence to the prints, including those by Anne

Kostelanetz Mellor and Jenijoy La Belle.[3] However, the rather thin reasons originally given by Blunt are open to question. Recent research has demonstrated that some of the extant copies were made no earlier than 1804, though no copy with a date other than 1795 has yet been traced. There were changes in technique over this period, since at least one print involved a relief-etched plate, of which there are no signs on the others.[4] Running contrary to the assumption of their being a narrative series is Blake's reference to them simply as "Prints" in the accounts with Butts,[5] and elsewhere as "12 Large Prints Size of Each about 2 feet by 1 & ½ Historical & Poetical Printed in Colours," with the price quoted as "Each 5.5.0"; the repetition of "Each" seems to imply that he would be perfectly happy to sell individual prints (letter 9 June 1818, E 771). Blake seems to have considered these prints as a group only on the grounds of their technique, and seems to imply a generic distinction in describing them as "Historical" and "Poetical," which could be read as further evidence that they do not constitute a single narrative. When Blake created a true series, he advertised it as such, as in the case of *The History of England, a small book of Engravings* and *The Gates of Paradise, a small book of Engravings*, both offered only in complete form in his "Prospectus" (E 693).

There is another theory that sees the prints as organized in pairs, Butlin being the figure most closely associated with this view,[6] though it is David W. Lindsay who has made the most determined effort to interpret the prints in the light of this theory.[7] This view is capable of providing an ordering of the prints, or most of them, but must be examined for its true content – does it illuminate the meaning of the prints so coupled, or simply point to formal relationships?

The attempt to read the prints as forming a series has usually been associated with Hagstrum's view that Blake "usually illustrates, not his source, but his own myth."[8] That statement may contain an element of truth, but it is also potentially misleading. Blake referred to the prints in 1818 as "unaccompanied by any writing" to distinguish them explicitly from the prints taken from the Prophetic Books to make up what are known as *The Large* and *The Small Book of Designs*, which are described very differently: "they when Printed perfect accompany Poetical Personifications & Acts without which Poems they never could have been Executed" (E 771). Blake recognized the difference between illustrations to his own poems, and prints designed to go into the world without texts other than the titles which

seem to have accompanied the prints originally, most though not all of which survive either as inscriptions upon the prints themselves or in the accounts with Butts.

All the extant titles point to known texts or to historical figures like Newton; the argument of the last chapter implies that the public stories and names under which the inventions have been "placed" must be taken into account in any interpretation, though we should expect a Blakean "Vision" to govern each design. The following readings will further that view, and will reconsider the argument that the prints are arranged in pairs, looking not at all of them but at enough to give an overview.

II

Lamech and his Two Wives and *Naomi Entreating Ruth and Orpah to Return to the Land of Moab* have been twinned on the grounds that one copy of each has its corners cut off in what for Blake is a unique pattern, and that there is a similarity in tone and number of figures, though Butlin acknowledges that "it is difficult to see any connection in subject beyond the fact that each deals with a family relationship."9

The subject of *Lamech* (B 297; illus. 37) is very rare in post-medieval art, but the episode attracted an extraordinary quantity of commentary by

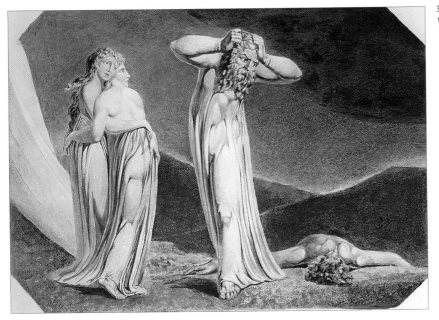

37. William Blake, *Lamech and his Two Wives* (B 297), color print

virtue of its obscurity. Here is the account given in Genesis 4: 19–24:

> 19. And Lamech took unto him two wives: the name of the one was Adah, and the name of the other Zillah.
> 20. And Adah bare Jabal: he was the father of such as dwell in tents, and of such as have cattle.
> 21. And his brother's name was Jubal: he was the father of all such as handle the harp and organ.
> 22. And Zillah, she also bare Tubal-cain, an instructer of every artificer in brass and iron: and the sister of Tubal-cain was Naamah.
> 23. And Lamech said unto his wives, Adah and Zillah, Hear my voice; ye wives of Lamech, hearken unto my speech: for I have slain a man to my wounding, and a young man to my hurt.
> 24. If Cain shall be avenged sevenfold, truly Lamech seventy and sevenfold.

The obvious obscurity prompted much speculation. One apocryphal interpretation had it that Lamech was blind, and while out hunting, guided by a boy, accidentally killed Cain with his arrow, whereupon he killed the boy too in his anger at discovering what he had done. Most commentators, however, dismiss this as a foolish fable. Some interpret the words as meaning that Lamech has actually killed one or two people, others see merely a boastful threat. Many focus on the two wives in order to read a homily on the corruption of the institution of monogamous marriage. A few, notably including Boehme and Swedenborg, create a contrast between the wives, naming Adah as the superior, Rachel-like figure, and Zillah as the inferior, Leah-like one.

Robert Lowth singled the episode out as "the first instance" of the "vestiges of poetic language extant in the writings of Moses," and the English translation of Lowth that Blake probably knew well included a note by Michaelis with which Blake's design appears to agree: "The truth is, Lamech has committed a murder [the "man" and "the young man" are the same person]: he repents of the fact, but hopes, after the example of Cain, to escape with impunity, and with that hope cheers his two wives, who are anxious for his fate."[10]

Blake, like Michaelis, views Lamech as having actually killed a single man. We are not to understand this man to be Cain, since in that case the mark on Cain's forehead would have been made visible. He has the short, curly hair that, as we shall see in the discussion of *Hecate*, indicates a young man. Lamech's hands pull at his hair in anguish, and his face expresses the

same feeling; both gesture and expression are close to those of Cain in *The Body of Abel Found by Adam and Eve* (B 806). His two wives clasp each other in fear. There are dark hills in the background, outlined with light, and a heavy, dark cloud overhead.

To the left is part of a white tent. Genesis 4: 20 couples tents with the ownership of cattle; Lamech in the first account given in Genesis is descended from Cain, which would make him a member of an agricultural society – "Cain was a tiller of the ground" (Genesis 4: 2). The tent is therefore puzzling; are we to understand that Cain changed his mode of life after discovering that God, an unrepentant carnivore, preferred the offerings of herders like Abel? More probably Blake is using the tent as a sign of God's continuing presence to Lamech; Cruden glosses "Tent" as both "the covering of the tabernacle," citing Exodus 26: 11, and "The Church," with The Song of Solomon 1: 8 as his reference; Blake writes of "Jerusalem in every Man / A Tent & Tabernacle of Mutual Forgiveness" (E 203).

The print shows the effects upon Lamech and his wives of a sudden act of violence, with an act of protection symbolized by the tent brought into play: "If Cain shall be avenged sevenfold, truly Lamech seventy and sevenfold." Lamech is a kind of super-Cain, and the design simply confronts us with the fact and problem of guilt; Lamech has been betrayed, the print does not show how, into an act which horrifies him, and appalls his wives. His head-clutching and hair-tearing do not mend matters, but the tent acts as a guarantee of divine forgiveness.

In Genesis there are two accounts of the story of Lamech, one of the victims of that book's complicated editorial history. In the first, Lamech is the descendent of Cain; immediately after Cain's murder of Abel, we have the account of Cain's fathering of Enoch, from whom Lamech descends. In the second, Lamech is a descendent of Seth, and becomes in turn the father of Noah, of whose birth Lamech prophesies that "This same shall comfort us concerning our work and toil of our hands, because of the ground which the Lord hath cursed" (Genesis 5: 29). This makes him an ancestor of Jesus (Luke 3: 36).

In the first account, Lamech is closely associated with Cain, and his murder is almost a duplication of Cain's act; in the second account, Lamech is a key part of the mechanism through which the first covenant between God and man broken by the Fall is replaced by the new covenant made with Noah, in which the earth is restored to Noah by God in all its fertility (Genesis 8: 17).

110

Lamech's crime is thus doubly taken up into a pattern of restitution; he plays a role in confirming the divine forgiveness of sins, and also a role in moving humanity forwards beyond the blockage represented by the Fall. Blake's later use of Lamech is in accord with this. He is listed as the last of the group of "Giants mighty Hermaphroditic" who constitute the first nine of "the Twenty-seven Heavens & their Churches," and also as the father of Noah, the first of the "Female-Males" (E 138). Whatever the exact meaning of these distinctions, Lamech at this later point in Blake's career still represents a key moment in humanity's development of representations of divinity. The choice of this particular story makes sense in terms of Blake's reading of the biblical narrative; the path forwards is through transgression and forgiveness.

The print usually coupled with *Lamech* is *Naomi Entreating Ruth and Orpah to Return to the Land of Moab* (B 299; illus. 38). There is no title or inscription on the two extant copies of the print, but the later and similar watercolor (B 456) has the title "The dutiful Daughter-in-law," with a reference to "Ruth ch. Ist: v. 16th" followed by three lines of that text: "And Ruth said, Intreat me not to leave thee, or to return from following after thee: for whither thou goest, I will go; and where thou lodgest, I will lodge: thy

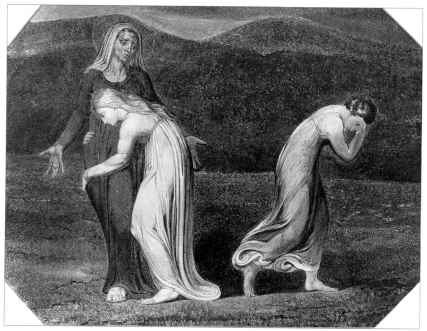

38. William Blake, *Naomi Entreating Ruth and Orpah to Return to the Land of Moab* (B 299), color print

people shall be my people, and thy God my God." In his entry on the water-color in *A Descriptive Catalogue*, Blake calls it *"Ruth. – A Drawing,"* and cites part of that text, apparently from memory (E 549). Blake uses the title "Ruth and her mother in Law & Sister" in referring to the watercolor in a letter to Butts (E 729); all the titles and texts that come from Blake highlight Ruth rather than Naomi.

The Biblical episode had an unproblematic history in commentary. Most focus on the significance of Ruth, a gentile, becoming an ancestor of Christ through her decision to remain with Naomi and adopt her religion. The Geneva Bible put it this way: "By this wonderful providence of God Ruth became one of Gods housholde, of whom Christ came" (gloss on Ruth 1: 4).

Blake's print sharpens the opposed choices by making the bodies of Ruth and Orpah almost mirror images of each other, though there is difference within the similarity of the arm gestures to distinguish between Ruth's em-brace of another and Orpah's self-enclosure. The hair is also different, Ruth's long and fair, Orpah's short and black; the differences of gesture and hair mark opposed approaches to the same problem by two different people.

Orpah's hand gesture is like Gestus XLIX in Bulwer's *Chirologia*, which is glossed *"Pudeo* [I am ashamed]"[11]; her hand is raised to her face in an attempt at concealment reminiscent of Joseph's gesture in *Joseph's Brethren Bowing before him*. Ruth's gesture shows her literal as well as figurative embracing of her mother-in-law, an embrace which includes a new religion and culture. The text from which Blake quotes in the watercolor focuses that identification in all its parameters. We of course know the distant con-sequences of that choice, as Ruth could not; Ruth in allowing personal love to overcome tribal loyalty became a true ancestor of Christ.

Naomi demands attention too, particularly since she has a halo in the Victoria and Albert Museum copy. The halo is a sign of the power to per-form the divine work of pushing history forwards to its conclusion, as in *The Spiritual Form of Nelson Guiding Leviathan* (B 649) and *The Spiritual Form of Pitt Guiding Behemoth* (B 651), in which the despised heroes both wear halos. Naomi's halo denotes her agency in Ruth's momentous decision; although she has lost her plea, in retrospect that plea can be interpreted as a test, which Ruth has just passed and Orpah has failed. Though Naomi, unlike Ruth, is not a direct ancestor of Christ, she had an essential part to play in the process which led to the incarnation. Naomi's sad face and widow's dark dress and shawl express her sorrow: "Call me not Naomi, call

me Mara: for the Almighty hath dealt very bitterly with me" (Ruth 1: 20). Her spread arms and open hands show both pleading and sorrow, and distantly recall the crucifixion; only we as spectators know the final joyful outcome of the narrative. Naomi's act is a sacrifice of her own interests; the story as it continues makes it clear that daughters-in-law could be expected to help support a mother-in-law (Ruth as she gleans brings back the gathered food to Naomi), and the offered sacrifice of her own interest in favor of the future of her daughters-in-law calls forth the answering self-sacrifice of Ruth. Naomi also becomes the nurse of Ruth's child Obed (Ruth 4: 16), giving of the substance of her own body to become a foster parent of the line from Obed to Jesus. There is a relationship to Jesus in both her life and gesture; her halo has been legitimately earned, and expresses the point of view of an implicit narrator, who knows the whole story, and redresses Naomi's grief: "Sorrows bring forth" (E 36).

This print and *Lamech* are the most obviously paired of the colored prints with their cut corners, similar landscapes, and the three figures present in each design, placed one against two in both cases. But the relationships between the figures are quite different. In *Lamech* the two similar figures of the wives are twinned, both in their physical resemblance to each other and in their function in the narrative. Lamech is the isolated and very different figure, standing beside the body he has killed. In *Naomi*, the two figures of the daughters-in-law are strongly contrasted in meaning though almost mirror images in form, while the bodies of Naomi and Ruth, strongly contrasted in appearance, are entwined together in deep sympathy. The surface resemblance is not duplicated in the underlying syntax.

Blake's comments on and titles for *Naomi* show that its relationship to the biblical text is the key to the meaning of the design, not its relation to *Lamech*; to argue with Lindsay that "Orpah's elbow and hand echo those of Lamech" or that "the mutually imprisoning arms of Adah and Zillah reveal by contrast Ruth's voluntary and total commitment to Naomi and the journey to Bethlehem"[12] is to short-circuit consideration of the true meaning of Orpah's gesture, and to load Adah and Zillah with undeserved and irrelevant censure. Lindsay's search for analogies results in commentary that is unhelpful and even misleading; I much prefer Butlin's frank statement that it is difficult to find much to connect these two prints in content beyond family concerns. The two prints may have been designed to hang together, but each must be read separately for what it contains.

III

Pity (B 310; plate i) has traditionally been coupled with *Hecate*, on such grounds as the "Blake" signature incised bottom left on the Tate copy of *Hecate* and bottom right on the Tate copy of *Pity*, and the female protagonists of both, so that these prints offer another occasion on which to consider the pairs hypothesis. *Pity* is also a good design in which to pursue Blake's practice in illustrating poetic imagery, a subject begun in the reading of *A Spirit vaulting from a cloud* in the previous chapter.

The text from which the print originates is established by the inscriptions "Pity from Shakespeare's Macbeth" and "Pity..." recorded by Butlin as on the copy at the Metropolitan Museum of Art in New York, and confirmed by Tatham's note on the first sketch for the design (B 314r), which reads "Shakespeares Pity. And pity like a newborn Babe & & F. Tatham—." Here is the passage referred to as it appears in Samuel Johnson's edition:

> Besides, this *Duncan*
> Hath borne his faculties so meek, hath been
> So clear in his great office, that his virtues
> Will plead, like angels, trumpet-tongu'd aga in [*sic*]
> The deep damnation of his taking off;
> And Pity, like a naked new-born babe,
> Striding the blast, or heav'n's cherubin hors'd
> Upon the sightless couriers of the air,
> Shall blow the horrid deed in ev'ry eye;
> That tears shall drown the wind – I have no spur
> To prick the sides of my intent, but only
> Vaulting ambition, which o'er leaps itself,
> And falls on th'other.[13]

I do not know if this was the edition read by Blake, but it well might have been; most later editions dropped the capitalization of "Pity," as the personification lost its vividness.

In addition to the text, Johnson's note is worth giving in full, beginning with his quotation from Warburton: "But the cherubin is the *courier*; so that he can't be said to be *hors'd* upon another *courier*. We must read, therefore, coursers. WARBURTON. *Courier* is only runner. *Couriers of air* are *winds*, air in motion. *Sightless* is *invisible* [Johnson]." Whether or not Blake read this note, he visualized the phrase "hors'd/Upon the sightless couriers of the air" in the concrete form suggested by Warburton, and then had no

option but to interpret "sightless" as meaning "blind," rather than "invisible" as Johnson had persuasively suggested. The theater can accommodate invisibility with the famous cloak, but the artist has no such trick to play.

Critics have given generally rather negative interpretations of this print. Most commentators, for instance, have presumed that the woman on the ground is dead,[14] often identifying her as Enitharmon, and have further presumed that the pity represented in the print is an example of Blake's negative view of pity, or even an act of betrayal.[15]

To my eyes, the woman lying on the ground demonstrates nothing analogous to the "perverse and cruel delight" with which Enitharmon fled from Los in the act which establishes the negative version of Blake's view of pity (E 78–79), but is rather the image of defenseless vulnerability. She is alive: her eyes are open, her head strained back in distress, her hands clasped over her breast, and her skin color healthily pink. In the pencil sketches (B 314 and 315) she is naked, and twisting as in agony from having given birth. She needs to be explained, and two interpreters have attempted to connect her with Shakespeare's text. Mellor suggests that the division of mother from child in the process of sexual reproduction imposed upon man by the Fall brings with it separation and death, and the print therefore includes an indirect reference to "Macbeth's 'horrid deed,' the murder of Duncan and the breaking of all familial ties and social bonds."[16] Paley adapts this idea in suggesting that the figure "may represent the 'horrid deed'... the murder of Duncan."[17] These suggestions are helpful in making a connection to Shakespeare's text, but Mellor's suggestion is too elliptical to be altogether clear, and the suggestion that the woman represents either the deed of murder or the dead Duncan is unpersuasive. Paley's suggestion is also very succinct, but again the apparent suggestion that a living woman represents the murder (the act rather than the dead body?) of Duncan is unconvincing.

I read the woman as the personified image of Duncan's "virtues... [that] plead, like angels" against the "deep damnation of his taking off." In Macbeth's imagery, there is no hint of a mother, but it is implicitly Duncan's pleading virtues that give birth to the babe of Pity, and the mother in the print is indeed pleading. The mother represents not the murder of Duncan, but a consequence of his murder; Blake as so often has personified a simile[18] (the personification is already present in the language) in order to visualize it and bring it into action in a dramatized situation.

The babe himself and the figures on horseback arise directly from Macbeth's next lines:

And Pity, like a naked new-born babe,
Striding the blast, or heav'n's cherubin hors'd
Upon the sightless couriers of the air.

Shakespeare develops his simile in two parts separated by an "or." This surface logic, however, is undermined by the high degree of conflation between seemingly distinct alternatives. The naked babe gives rise very naturally to the image of "heav'n's cherubin," since cherubin were often represented as children in art,[19] and the babe's "Striding the blast" is simply made concrete and metaphorically more powerful in "hors'd/Upon the sightless couriers of the air," giving an air of apocalyptic mystery to what had begun in a simpler though still striking image. The alternative images catch with wonderful power the improvisatory quality of Macbeth's thought.

Blake has taken these partly alternative, partly conflated images and visualized them quite separately, putting them into dynamic interaction with each other. The babe's gesture originates in Shakespeare's "striding," and keeps something of the perilous mastery implied in the word. The babe is full of energy – it looks as if it has leaped across the space between mother and rescuing rider – and recalls the new-born Jesus in Blake's *Nativity* (B 401). The babe has sprung up in a version of the gesture that Warner has described as "Form II. The flying figure, back view, springing upward, one leg bent, one arm higher, usually nude, female, and wingless," which she defines as "one of Blake's favorite means of depicting forces of spiritual or physical energy."[20] The gesture is emphatic and articulate, "a firm determinate outline" (E 693). The expression on the babe's face is difficult to read,[21] but appears almost indignant, as if he were still suffering from the shock of recent entry into this dark and stormy world, like Los, who "indignant/first in wrath threw his limbs, like the babe/New born into our world" (E 92).

Pity as imaged in Blake's babe combines the vulnerability that inspires pity with the energetic response aroused in a pitying spectator; the visual image retains the almost paradoxical quality of the verbal image. It also participates in what is a frequent form of ambiguity in allegorical imagery, the fusing together of the cause of an emotion and the quality of the aroused emotion itself to create a single, complex, and often self-contradic-

tory image. A case in point is Spenser's Fear, who "feard each shadow mouing to and fro,/And his owne armes when glittering he did spy,/Or clashing heard, he fast away did fly."[22]

Simultaneously, the second, more developed image of pity, "heav'n's cherubin hors'd/Upon the sightless couriers of the air," has been shaped by Blake into a second personification of pity, in the form of a woman who takes the babe up into her arms in a gesture of rescue and protection focused in the tenderly curving fingers. In all copies of the print the woman's eyes look at the supine mother rather than at the babe; pity is a response divided into the active help given the babe and the sympathetic feeling-with given to the mother; the mother cannot, it seems, be airlifted away with the babe. It is also true that Duncan's virtues do not need rescue; the logic of the print is as much an expression of the relationships embodied in Macbeth's words as of the action invented by Blake in which to embody his own "Fable" or implied text, which interacts with Shakespeare in complex ways.

The gesture of down-reaching arms is common in Blake's designs; the most striking parallel is in *Night Thoughts* 144, illustrating the lines: "Thou, who didst save him, snatch the smoking Brand/From out the flames, and quench it in thy Blood!" The design shows Jesus with arms reaching down to grasp the arms of a man reaching up to him from a sea of flames. That in turn may originate in the figure tagged "Pity" in the drawing of *Various Personifications* (illus. 19) discussed in Chapter 2. Analogous gestures are found in Blake's illustrations to *Pilgrim's Progress* (B 829: 6) and in his paintings of *The Finding of Moses* (B 440) and *The Agony in the Garden* (B 425). The gesture reaches down in order to raise up, a translation into visible form of "Therefore God becomes as we are, that we may be as he is" (E 3). True Pity, together with Mercy and Peace, "is the worlds release" (E 470). The negative view of Pity taken by many of Blake's critics ignores the details of the design itself, and those many situations in which Pity is for Blake associated with Jesus and the imagination.

Shakespeare's "cherubin" are plural, and Blake has accordingly paired this pitying woman with another figure, identified by Grant as male,[23] as is indicated by the heavy musculature and darker skin. The trailing robe that extends above the horses belongs to this second rider. His face is turned away from us, and from the babe and mother, and his arms are outstretched over his horse to speed it on its way. His gestures have no basis in Shake-

speare's text. Grant comments that faces turned away from us like this are particularly challenging for the interpreter, and suggests that the averted face of the rider in Blake's 1796 frontispiece for *Lenore* is Death himself. That is possible, but I think the meaning of the averted face here is best approached through the contrast with the nearer rider. One face looks down in compassion, the other turns away; one pair of arms reaches down to help, the other is extended in streamlined urging of the horses to even greater speed.

The contrast between the riders images a divided response to human suffering. Roe has interpreted the two cherubin as respectively the pitying Emanation that guards fallen man, a representative of the watchful love of God, and the materialistic Specter that "symbolizes compliance with the rule of Rational Law which governs the Natural Man in the Fallen World of Experience."[24] This catches the contrast, though it disregards any relationship to Shakespeare's text, and is very distant from the situation in Night, the first of *The Four Zoas*, where Blake first works out the symbolism of Specter and Emanation.

Macbeth's lines express a divided vision: part of him wishes to achieve the deed and with it the crown, while the other part of his soul works towards his fall, towards the o'erleaping of his ambition and its collapse. Blake has seized upon the internal dialectic within Macbeth, and has derived from it the twin but opposed riders. From this he has developed an aspect of the "action" that embodies his "Vision"; providence shows a twofold face to suffering humanity, compassion and impassivity.

This contrast brings into focus an additional aspect of the design. The further rider speeds on, robe swept back by the airflow. The nearer rider, though her horse keeps pace with the other, has let go of the reins; her robe falls loosely around her, and her hair rises upward at a striking angle. Blunt interprets this detail as a borrowing from "a representation of Occasio such as that shown in the painting by Girolamo da Carpi of 'Chance and Penitence'";[25] that may be part of its meaning here, but there is also a narrative component to that meaning. The slackly draped robe implies that the compassionate act has for a moment, for a "pulsation of the artery" (E 127), stopped or slowed the rush of time. Even the lighting, which spotlights the rider, babe, and mother, suggests a creative moment snatched from the onward rush.

The loose reins of the nearer horse emphasize that the flight of these

horses is not easily subject to human control. They seem to represent blind agents of providential intervention, as Shakespeare's words imply. Their "sightless"-ness is part of this freedom from supervisory power; they perform their work on their own, and the best that human or even cherubic agency can do is snatch the moment and perform the work of rescue while providence permits.

The horses are borne on dark, low clouds, that release a forwards-falling rain from their leading edge. Such clouds are often used by Blake to separate realms of existence from each other, following a widely used tradition. Here the clouds separate the tyranically usurped realm of nature below, in which virtue lies vulnerable and pleading, from the upper world of providential action. In Shakespeare's lines, the cherubin's imagined act is to "blow the horrid deed in ev'ry eye" with the result that "tears shall drown the wind." Blake has visualized this in the rain which falls at a wind-driven angle; Pity has a propaganda job to do in addition to its active helping of the victimized.

The blowing rain angles forwards in the pencil sketches and the Tate and Yale copies, and backwards in the Metropolitan copy. In all copies it appears to stop when it hits the line of hills in the background, as if falling at some distance, well behind the plane of the woman; Blake was unwilling to allow the rain actually to fall on her. In Blake's reworking of Shakespeare's text, the rain represents tears that fall in response to the propagandizing of the cherubin, and is therefore working on behalf of the abandoned woman. At the level of visualized narrative, however, the rain would appear as the natural enemy of the woman, and thus Blake has had to avoid allowing it to fall on her. Metaphorical/allegorical and narrative modes of meaning are here awkwardly spliced together in a way that very narrowly escapes a threatened direct collision.

Moments such as these show how Blake's mode of invention straddles the space between an emblematic or metaphorical mode of signifying, and a more immediate mode based on feelings and meanings that arise from a dramatic or narrative situation. The mixed space thus created is not always comfortable for either artist or interpreter.

Blake's design illustrates Macbeth's words, or more precisely the vehicles of his images. Blake focuses on both the explicit and latent personifications in Shakespeare's language, while ignoring completely the immediate dramatic situation in which the words are spoken, as in the case of *A Spirit*

vaulting from a cloud. Shakespeare's language invites us to see an implicit narrative linking the two parts of his either/or similes, the emotion aroused in a person ("babe") leading to an activity that puts that emotion to work ("heav'n's cherubin hors'd"). The two sequential similes for Pity in Macbeth's lines are separated simply by an "or," but there is no way in which a single design can easily render verbal negation, or sequential hypotheses which replace each other; there is no visual equivalent of that "or." What Blake can do, however, is construct a narrative that uses the personified images of energies he finds in the text, and put them into an interactive dramatic situation that still contains something of the field of meaning created by the poetic imagery from which it arises.[26] In accepting the challenge of basing a design on a passage of poetic imagery, Blake has no alternative but to construct an implicit narrative of his own that will bring figures into intelligible relation with each other.

Pity builds a world of meaning on the basis of Shakespeare's imagery. Macbeth's lines are uttered as he contemplates the act of murder, and represent a last attempt by his conscience to image the true situation to him before the deed is done. The pity evoked through simile is potentially within himself, but being rejected there becomes the agent of a providence that is capable of immediate expression in feeling, but cannot act until the time is ripe. The lines project powerfully a vision of the world as fallen, in that it contains helpless and innocent victims – suffering cannot be abolished in the present – but also as capable of final redemption, in that divine elements within it can submit to taking on the human form of "a naked new-born babe," and yet can finally become "heav'n's cherubin" acting on a cosmic scale eventually to transform the situation, in a process of liberation which will free even the time itself.

Blake's print expresses an analogous vision of a world in which Pity is a cherub with a human face, and suffering is projected onto a cosmic screen:

> For a Tear is an Intellectual thing;
> And a Sigh is the Sword of an Angel King
> And the bitter groan of a Martyrs woe
> Is an Arrow from the Almighties Bow!
>
> (E 202)

These lines offer a bridge between Macbeth's images and the structure of Blake's print. Like Shakespeare's play, the print suggests a world in which pain is not avoidable, but can eventually be transformed; perhaps Blake

even had this design in mind when he later wrote these lines in "Auguries of Innocence":

> Every Tear from Every Eye
> Becomes a Babe in Eternity
> This is caught by Females bright
> And returnd to its own delight[.]

<div align="right">(E 491)</div>

Blake found in Macbeth's words images that he could visualize and reshape in a way that would focus the human vision that is about to die in Macbeth himself, only to re-emerge elsewhere in the play to have the final word. More specifically, it is the sacrifice of an innocent mother and her children which is the turning point in *Macbeth*; it is the news of the murder of his wife and children at the end of Act IV that transforms Macduff into the avenging and restoring arm of providence in Act V. This sense of the empowering sacrifice of innocence survives in the changed world of Blake's print. It is a deep structure in all of Shakespeare's tragedies[27], and a perception of this was probably one of the forms in which "Shakespeare in riper years gave me his hand," as Blake wrote in the mini-autobiography he sent to Flaxman (E 707).

Blake's print is simultaneously both profoundly original and deeply shaped by Shakespeare's imagery. It has its own structure, with an implicit narrative that we must recreate in interpreting the design, as I have attempted to do here. As in the examples discussed in Chapter 4, we have a story or poem that provides the body, so to speak, of the imagery and/or narrative, and a soul or reorganizing structure that recasts the body into a new form, and gives it a new though related meaning; in this case, the informing "Vision" is profoundly indebted to the originary text. When Blake wrote that "All but Names of Persons & Places is Invention both in Poetry & Painting" (E 650) he was countering Reynolds's apparent subjection of the painter to literature, but his claim of independence for the painter does not cancel the deep relation to Shakespeare in this print.

IV

Hecate (B 316; plate ii), the print usually coupled with *Pity*, has a title that can be traced no further back than Rossetti, who refers to it as "the triple Hecate... three separate figures, close together, exceedingly grand."[28] However, the one known reference to the print before Rossetti calls it "the

owls,"[29] and the iconography of triple figures such as Hecate never follows that of the print, with three dissimilar bodies turned inwards upon each other. There are two traditional ways of representing Hecate; one is the three heads or faces that Ovid describes: "Thou seest Hecate's faces turned in three directions that she may guard the crossroads where they branch three several ways."[30] This is the model followed by such triform figures as that in Titian's *Allegory of Prudence*, and by Blake himself, textually in the "Two Beings each with three heads they Represent Vegetative Existence" (E 558), and graphically in the design on page 14 of *The Four Zoas*.[31] The other tradition is to describe or show three separate bodies, again with faces turned away from each other.[32] I know of no triple figure handled in the way in which Blake handles the three figures in this print, and it is a tribute to the power of a text to organize and control perception that this interpretation lasted as long as it did.

My own moment of recognition came while standing before the print at the 1978 Blake exhibition at the Tate Gallery, though I afterwards discovered that Jean Hagstrum had made the same recognition many years ago, but had put it in a footnote where it had been overlooked by most subsequent interpreters. That note marks a large recovery from the error begun by Rossetti:

> Blake is thought to have illustrated *Macbeth* III, v, or IV, i, or *Midsummer Night's Dream*, V, i, 391. But he usually illustrates, not his source, but his own myth. The landscape of this color-print is Urizenic – like that of all the others in the series done for Butts in 1795. The figure on the right is a male (Los?) and on the left a female (Enitharmon?), separated by the goddess of jealousy. The print is an allegory of love and marriage under Urizen.[33]

Though I do not agree with everything in this note, much of the basic subject of the print becomes visible for the first time in a century.

The figure cannot be Hecate, but is almost certainly a witch; the naked shoulders and arms, bare feet and long, dark, and untied hair also characterize the witch in Blake's earlier *The Witch of Endor Raising the Spirit of Samuel* (B 144; 1783), and with some variation the witch in the later *The Ghost of Samuel Appearing to Saul* (B 458; c. 1800).[34] These features were widely used characterizations of witches, based on Ovid's description of Medea as she leaves home to seek help from Hecate: "her haire / Untrest, her garments loose, her ankles bare."[35]

The witch hypothesis is supported by the creature hovering above the central figure's head. Its membranous wings are quite different from those of the smaller, "real" bat below it, and its face is grotesque, with something of the cat in the ears and whiskers, and something of the pig in the nose; the scowling frown is almost a caricature of the human. This creature falls readily into place as the witch's familiar, the feline aspects suggesting something like Graymalkin from the opening scene of *Macbeth*.

The witch sits on the ground with raised knees, left foot crossed over right, right arm passive at her side while her left forefinger points at an open book with an illegible but heavily marked text. She appears to be naked from the waist up, while a long, blue-black robe covers her lower body. We see her left profile as she looks away and down; her look seems to express her internal feeling rather than a response to what is before her. The face is handsome, even sensual, particularly in the Tate Gallery copy, with large eyes, a strong and long nose, and full red lips. Her eyebrows are lowered, there are two frown marks on the forehead, and her lips are closed.

If we compare her expression with the passions illustrated by Le Brun, both Jealousy and Sadness offer possible identifications, with the description of Jealousy particularly suggestive:

> Jealousy is expressed by the Forehead wrinkled, the Eye-brow quite depressed and knit; the Eye flashing fire; the Pupil hid under the Brows and turned towards the object that inspires the Passion, looking awry upon it, distorted from the situation of the Face, and appearing restless and fiery... the Mouth may be shut so as to denote that the Teeth are too; the Under-Lip pouts out beyond the Upper one, and the corners of the Mouth are drawn back and hanging down.[36]

It seems that the "awry" look, whether interpreted as turned away eyes or an averted face, was a well understood sign of Jealousy; one remembers "My Pretty Rose Tree" from *Songs of Experience*, where "my Rose turnd away with jealousy" (E 25).

Hagstrum is clearly correct in stating that the small figure on our left is female, that on our right male. The boy – the small size and physical tenderness of both suggest adolescence, or the years preceding it – has heavier musculature, almost flat buttocks, noticeably ruddier skin, and shorter, more curly hair. The sexual differentiation is even clearer in the preliminary sketch (B 319), which shows a distinctly feminine curve to the outline

of the breast of the female figure. A youthful couple distinguished in some or all of these terms is almost a constant in Blake's iconography, present in the *Songs*, in *Night Thoughts*, in the pair of children in *Christ Baptising* (B 485), the Adam and Eve of the *Paradise Lost* illustrations, *The Angel of the Divine Presence Clothing Adam and Eve with Coats of Skins* (B 436), and elsewhere. Blake is using a conventional system of markers, the differentiation of skin colors being recorded in his comment on "Rubens, Titian, Correggio, and all of that class" that "their men are like leather, and their women like chalk" (E 545).

The conventional nature of these distinctions is confirmed by a popular manual of the eighteenth century, *The Art of Painting* by Gerard de Lairesse:

> Boys may very well sometimes be allowed Hair, and that frequently curled: Girls may have theirs twisted and wound on their Heads, with flying Locks, serving not only for Ornament, but Distinction of Sexes.
>
> Boys of 5 or 6 Years old may have their Hair finely curl'd; Girls more thick and displayed; another Difference in the Sexes may be this, that Girls Hair is more soft and long, Boys more curl'd and short.[37]

The hair in Blake's youthful figures is modeled upon these instructions, contained in a book which will appear again as one of the sources of Blake's knowledge of the traditions of painting.

The other participants in the action, apart from the witch's familiar, are the owl, the rather odd animal immediately below, and the ass. The owl has an extraordinarily wide range of possible connotations, from night and death to patient self-control and wisdom, to take the meanings given by just one emblem book.[38] None of these, except perhaps night and death, is an obvious fit in Blake's print, but an appropriate story can be found in one of Blake's favorite books, Ovid's *Metamorphosis*. In Book five, Ascalaphus is transformed into a "Screech–owle" for having informed on Proserpine's unwitting theft of pomegranate seeds, and Sandys comments that this agreed well "with the nature of an Informer."[39] An even darker view is taken by Sandys in his commentary on the story of Medea and Jason in Book Seven: "infamous Screech–owles: so branded, in that they were thought to suck the blood of infants as they lay in the cradle."[40]

The animal below is usually interpreted as a toad, traditionally associated with envy and injustice.[41] However, the long jaw of the animal in the Tate copy is more suggestive of a newt or salamander. Newts had a bad

press in Blake's time, and Blake himself regarded them as venomous (E 124), at least for poetic purposes.[42] Again there is a good story in Ovid: Ceres turns Abas into a "Stellion" or "Evet,"[43] a creature "Though lesse, yet like a Lizard" which "presently into a crevise runnes." Sandys comments that it is an "envious creature... proverbially taken for one that is subtill and envious," and cites Alciati's Emblem 49 as an example:

> The little Stellion starr'd with black, that crawles
> In hollow sepulchers, and ruin'd walls,
> The Embleme of deceit and envy showes.[44]

Sandys's comment and citation correspond exactly with the placement of the animal in Blake's print. These two animals fit well into a narrative of envy or jealousy and witchcraft.

The ass is handled differently. It could be associated with witchcraft through its role in *The Golden Ass*, to which Blake refers elsewhere (E 556), but that possibility is outweighed by others. The design of the ass, as C. H. Collins Baker notes, is taken from an engraving of the *Repose* in Browne's *Ars Pictoria*,[45] and was used again by Blake in *The Repose of the Holy Family in Egypt* (B 472), where it has almost exactly the form of the ass in *Hecate*, and yet again, though this time as a horse, in Blake's etching of the story of the Good Samaritan for Young's *Night Thoughts*.[46] In both these cases the grazing animal is simply resting on a journey, and it is thus likely that the ass in the print is an element in the implied narrative rather than the container of an allegorical function. The way in which it minds its own business differentiates it from the other animals in the print, which all gaze at something or someone: the owl and familiar stare disconcertingly at us, the newt directly at the witch. In contrast the ass looks down with insouciance at the thistles it is eating, mindless of the imminent event.

Hagstrum reads the print as an allegory of "the goddess of jealousy" engaged in separating the children, whom he tentatively identifies as Los and Enitharmon. Lindsay, while accepting my argument that the central figure is a witch and not Hecate, also accepts much of Hagstrum's argument, describing her as revealing "a Vala-like envy which eclipses vitality by impeding the union of Cupid and Psyche."[47] Gert Schiff has recently written that the print represents Enitharmon's scheme to enslave humanity through sexual repression, enforcing her ban on sex by means of Urizen's repressive book. He reads the print as an "allegoriz[ation]" or

"visualization" of the text of *Europe* 5: 1–9 (E 62).[48] Hagstrum had identified the young girl as Enitharmon; now Schiff identifies the witch as Enitharmon. Though I believe both these views contain a partial truth, the two together show that attempts to read Blake's designs as direct articulations of his own myth produce disturbingly unstable identifications.

These interpretations all describe the woman as separating the children, though that is not a persuasive description of the interaction depicted. The print demands an interpretation that uncovers and deals with the implicit narrative content more adequately than do any of the interpretations offered so far. Hagstrum's perception that jealousy is at work is not so much wrong as incomplete. Jealousy must be interpreted as a motive operating within a story; a feeling must become incarnate in an intended action before it can be realized in a picture, and the details of the design should make that intention both visible and intelligible.

In the case of *Hecate*, the moment chosen is that in which the witch points to her book.[49] A book can be merely a text, but a witch pointing at a book becomes a version of *How to Do Things with Words*, and the pointing finger becomes the gestural equivalent of a performatory utterance.[50] If the central figure is a witch, she is about to cast a spell; it is not enough to refer to Urizen's book of brass, as if all the books shown in Blake's pictures were identical, regardless of the context. This is a witch's book, full of magic.

We must also deal with the implications of the expressive bodies and face in the print. The children kneel submissively, waiting for the event that will decide their fate. There is sadness in the woman, as well as possibly jealousy: jealousy, of course, is an emotion triggered by the loss, or fear of the loss, of a loved person. None of the three copies leaves me comfortable with Schiff's proposed title, "The Night of Enitharmon's Joy," nor with his comment that "The woman's demeanor is expressive of the most perfect indifference." Besides the feelings registered in the several faces and bodies, the figures are very close, held together in a profound complicity in the unnamed action about to be triggered by the finger pointing at the open book.

In my earlier essay, I made a few uncertain guesses at the nature of that action: the dedication of the children to an underworld deity of whom the woman is the unwilling agent, or a premature marriage ceremony conducted under powerful and unfavorable auspices, in a manner hinted at in *Visions of the Daughters of Albion*: "Till the child dwell with one he hates. and

do the deed he loaths / And the impure scourge force his seed into its unripe birth / E'er yet his eyelids can behold the arrows of the day" (E 49). I also suggested that just possibly we have a situation analogous to the stories of Circe or Hansel and Gretel, and the children are about to be transformed into animals like the others visible in the print. I now have a better interpretation to offer.

Witches became very popular in the later eighteenth century. Salvator Rosa had made a famous painting of *Saul and the Witch of Endor*, which had a part in stimulating Mortimer to paint *An Incantation* in 1770; the painting is now lost, but the design is extant in a mezzotint published in 1773.[51] The print shows an elderly witch with a wand standing before a cave, a kneeling young woman, and a flaming altar. This prompted William Julius Mickle's poem "The Sorceress; or, Wolfwold and Ulla," published in 1794 "as a story to the painting[,]" a reminder that texts can occasionally follow designs in a reversal of the more usual relationship. This has a moonlit scene at the "dreary mouth, half under ground," of a cell that "Yawn'd like the gate of Hell." The cavern has an altar and tomb, and around these are "forms of various mien, / And efts, and foul-wing'd serpents," while

> Eyeless a huge and starv'd toad sat
> In corner murk aloof,
> And many a snake and famish'd bat
> Clung to the crevic'd roof.[52]

Much of Blake's iconography of witchcraft was common property.

More particularly, one of the subjects popular among the artists of Blake's circle was the story of Jason and Medea, especially the moment of her contemplating the murder of their children out of ungovernable jealousy over his new love for Glauce. Medea was the niece of Circe, and a follower of Hecate; she was at the very center of classical witchcraft. The renewed interest in Medea was triggered by several events. One was Lessing's singling out of the description of a classical painting of Medea as an example of his argument that the painter should never show the moment of climax: "Timomachus did not represent Medea at the moment when she was actually murdering her children, but a few moments before, when a mother's love was still struggling with her vengefulness."[53] Further stimuli came from Richard Glover's stage version of 1761 and Robert Potter's translation of Euripides' play in 1781.[54]

Barry was one of those interested in Medea. In 1772 he exhibited a painting at the Royal Academy of *Medea Making Her Incantation after the Murder of Her Children*, and later wrote an account of a possible design of the subject, for which he made two oil sketches (now lost):

> something might be made of the children worth taking notice of: while
> the mother is in all this agitation, with the preparations for a sacrifice
> around her, the youngest and most loved child may be playing at her feet;
> and with an infantine innocence and joy calling the attention of his
> mother to a butterfly (or psyche) which he is laughingly holding up to her;
> whilst the elder, terrified at the agitation of his mother, and ignorant of
> the cause of it, is seeking shelter under her chlamys or mantle. – Indica-
> tions of the marriage in the distance, &c.[55]

This account was published in Barry's 1783 *Account of a Series of Pictures*, a book that Blake owned.[56]

Romney made numerous studies of the subject, including a drawing of *Medea Contemplating the Murder of Her Children c.* 1776–77, and a cartoon of the same subject (illus. 39) dated *c.* 1777–78.[57] Fuseli made an interesting

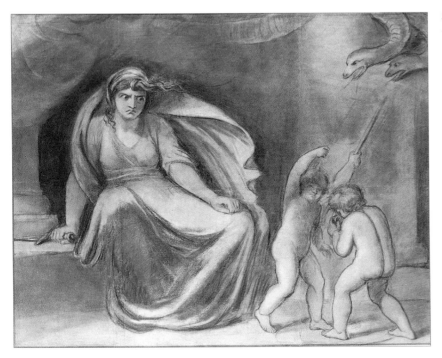

39. George Romney, cartoon,
Medea Contemplating the Murder of Her Children, c. 1777–78

128

drawing around 1808 of a different but related subject, *Circe absolving Medea and Jason of the killing of Medea's brother Absyrtos.*[58] This shows a tall, proud woman sprinkling something from a bowl over two bowed-down young people; one almost wonders if this might not be the subject of Blake's print, but Circe was associated with wolves, lions, and bears rather than owls and newts and such small creatures.

This establishes that there was a high degree of interest in the Medea story among artists close to Blake, and that the moment found most promising for pictorial invention was Medea's contemplation of the murder, rather than the act itself. It shows further that the animals in the print, particularly the screech owl, have strong associations with witchcraft as imagined by Blake's artistic circle.

The assumption that the print is based on the story of Medea about to murder her children clarifies some features of the design. The submissiveness of the children is a recognition of the maternal authority of the central figure, who does not separate the children but brings them together to face a common fate, while partially occluding or eclipsing them. The relation between the figures is close, and is analogous to that between Abraham and Isaac in Blake's early version of the story (B 109; illus. 40), which shows Isaac in a position similar to that of the children in the print, also naked – a sign of

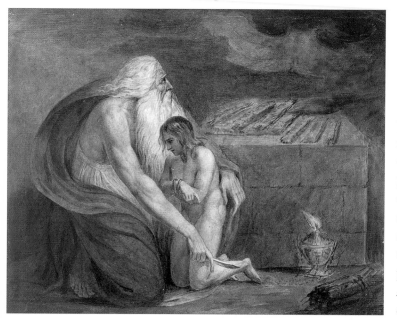

40. William Blake, *Abraham and Isaac, c.* 1780 (B 109)

vulnerability – and very close to his parent, though with bound hands. The pathos of childhood underlies both situations, the vulnerability of those who are not yet fully independent beings.

The print represents a sacrifice of youth and beauty to some powerful negating force; Medea was a follower of Hecate, from whom she gained her powers. A ceremony is about to be enacted that will change forever the status of the two young people; they are about to be "bound / In spells of law," to borrow a singularly appropriate phrase from *Visions of the Daughters of Albion* (E 49). Medea's killing of her children represents a sacrifice to the

power of Eros within her, since her love for Jason was triggered by an arrow from that deity as part of a plan cooked up by Hera and Athene to help Jason win the golden fleece.[59]

There are two features of Blake's print that differentiate it from other representations of Medea's murder of her children, and make one hesitate. One is that the other versions all focus on the passion and fury of Medea, and show her with a dagger or short sword; Ovid refers to the "impious steele" with which she "her childrens blood had shed";[60] Blake's figure seems about to kill her children through baleful magic alone. That is certainly a change, but one in accord with Blake's emphasis on spiritual rather than material agency.

The other problematical feature is that nearly all versions of the story state or show that Medea's two children were both boys,[61] and I am too convinced by my argument that the children in the print are boy and girl to reverse myself now. But there was at least one version of the story that identified Medea's children as boy and girl, and it was in a book with explicit connections to Blake. Erasmus Darwin wrote an account of the story of Medea in his *The Loves of the Plants*, usually published together with his *The Economy of Vegetation* in a joint volume called *The Botanic Garden*.[62] The former contained several engravings by Blake. I do not know the source, if any, of Darwin's version of the story, but here are the key lines:

> So when MEDÆA left her native soil
> Unaw'd by danger, unsubdued by toil;
> Her weeping fire and beckoning friends withstood,
> And launch'd enamour'd on the boiling flood;
> One ruddy boy her gentle lips caress'd,
> And one fair girl was pillow'd on her breast.[63]

Darwin's sexing of the children does not appear to be motivated by anything in his description of *Impatiens*, or "touch me not," the plant that prompts the analogy with Medea. This account differs substantially from Blake's design, but the essential elements of a "ruddy boy" and a "fair girl" accord perfectly with the print, even to echoing the traditional painterly way of distinguishing the sexes.

I propose the following interpretation. Blake wanted to show the destructive effects that jealousy and parental oppression could have on the free growth of youthful love-energy. He thought of the story of Medea and

Jason, and decided that he could work on the story of two children murdered as the expression of the jealous love / rage of a woman for her unfaithful husband – "torments of Love & Jealousy" (E 300). The hypothesis that Blake's print shows Medea about to murder her children explains the feeling visible on the woman's face – jealous rage and maternal love in conflict. Blake took Darwin's unusual, possibly unique description of Medea's children rather than the standard account, and changed Medea's dagger into a book of magic, because these changes allowed him to introduce into the story something like the meaning that Hagstrum and Schiff in their different ways have proposed. He also made the children older than the usual accounts suggested in order to strengthen the erotic resonance of the situation. Blake's Medea is killing not just two children, but a boy and girl who, though they are apparently brother and sister, had within them the capacity to become lovers; the Romantic period generally, and Blake's poetry specifically, is full of brother and sister incest.

The mythical story becomes allegorical through Blake's restructuring, and as in the process of epic invention described by Le Bossu, the meaning that Blake wished to communicate controlled and reshaped the story he chose for its incarnation. Jealousy, vengeance, and parental oppression kill the future loves and graces of humanity. The animals come into focus as emblematic of envy and jealousy. Darwin's retelling of the story gave him the public text that he required for recognition of his subject, the names under which he could place his version of the story, or so he optimistically supposed.

Blake is not illustrating his own myth directly, but is shaping the story he has taken as his cover or mask in a Blakean direction; or, to return again to Le Bossu, he has placed his moral under the name of Medea as representing most appropriately the forces he wishes to show at play. Given the popularity of the theme in the art of his time, he expected his viewers to recognize his subject, even though he changed significant elements in the story. Quite apart from the naming of prints in the accounts with Butts, no less than eight of the prints owned by Butts still have titles written upon them, and it is just bad luck that we have no such help here. That title, I believe, would have pointed to the story of Medea. On the basis of that story, Blake has built his own version of a narrative illustrating the destructive power of erotic love. Even without a recognition of the names of the actors, the print retained some communicative power, but that recognition brings a new focus and intelligibility.

To return to the question of the pairing of these prints, the similarity in color between this print and *Pity*, and the focus on female central figures, turn out to be no more helpful in interpreting the designs than were the apparent similarities between *Lamech* and *Naomi*; Lindsay's remark that the two "are connected by similarities in color and tone, by the obscurity and complexity of their iconography, and by a nightmare-imagery reminiscent of Fuseli"[64] offers no help at all to the interpreter, and to say that "One has to experience the darkly bewitched and distorted atmosphere of *Hecate* to appreciate the new light and movement through which *Pity* communicates its feeling of energy, mercy, and release"[65] is to say no more than that the two prints are very different, while contradicting the statement quoted above about their sharing a "nightmare-imagery." The prints may have been designed to hang in pairs by virtue of surface similarities in color or number of figures, but as in the case of *Lamech* and *Naomi* that hypothesis has not produced illuminating commentary.

V

The Good and Evil Angels presents rather different problems. Here we have a title that comes from Blake, but no obvious text to which it refers, though Kathleen Raine has nominated Boehme, citing *Mysterium Magnum*: "Thus we are to understand that the *Evil* and *Good* Angels dwell near one another, and yet there is the greatest immense Distance between them... and although the Devil should go many Millions of Miles, desiring to enter into Heaven, and to see it, yet he would be still in Hell, and not see it."[66] The suggestion is interesting but not totally persuasive, in part because it ignores the child in the print.

The design came into being, as far as we know, as an illustration in *The Marriage of Heaven and Hell* (illus. 41). That shows a dark male figure on the right, manacled by one ankle, lunging forwards with a sea of flames as background. On our left, at some little distance, is a lighter figure, who, though interpreted as female by Erdman, is probably male, as Keynes sees him;[67] he holds a small child who reacts in terror to the apparition of the dark figure. Erdman records that in "unretouched copies" the figure on the right has open eyes, but that in copy 1 the man "has eyes shut or looking downward."

The design is placed at the bottom of Plate 4, which it seems to illustrate:

41. William Blake, *The Marriage of Heaven and Hell*, Plate 4

The voice of the Devil

All Bibles or sacred codes. have been the causes of the following Errors.

1. That Man has two real existing principles Viz: a Body & a Soul.

2. That Energy. calld Evil. is alone from the Body. & that Reason calld Good. is alone from the Soul.

3. That God will torment Man in Eternity for following his Energies.

But the following Contraries to these are True

1. Man has no Body distinct from his Soul for that calld Body is a portion of Soul discernd by the five Senses. the chief inlets of Soul in this age

2. Energy is the only life and is from the Body and Reason is the bound or outward circumference of Energy.

3. Energy is Eternal Delight[.]

(E 34)

The design appears directly below the words "Energy is Eternal Delight." The plate as a whole provides an interpretive context for the figures: the dark, chained Devil represents Energy, and the lighter Angel standing before the sun represents Reason. The previous plate comments that "Without Contraries is no progression. Attraction and Repulsion, Reason and Energy, Love and Hate, are necessary to Human existence" (E 34); we could infer that the babe is "Human existence" itself, kidnapped by Reason/Love, which has restrained Energy/Hate as Plate 5 describes, the chains being the instrument of that restraint. In the copy which shows the Devil with closed eyes there is an added suggestion of the blind Milton of Plate 6 who "wrote in fetters… because he was a true Poet and of the Devils party without knowing it" (E 35).

The text asks us to sympathize with the Devil of Energy, who represents the impulse to break free into an unrestrained enjoyment of desire, and to reinterpret "Hate" as prophetic anger. The text invites us to view the design ironically, as representing the perspective of the "Good" which has to be overcome; the Devil is not *really* bound in chains: as Blake writes, "It

indeed appear'd to Reason as if Desire was cast out. but the Devils account is, that the Messiah fell. & formed a heaven of what he stole from the Abyss" (E 34–35). Those flames may *look* like "torment and insanity," but are in truth "the enjoyments of Genius" (E 35). The Angel is not the heroic rescuer he appears, but the instigator of the oppression that chains the dark angel. The text profoundly destabilizes an innocent reading of the design, and asks us to read it in the light of the radical transvaluation performed by Blake's language. The design does not offer a finished and fixed meaning so much as a center of meaning production, in which the accompanying text plays a decisive part, though it must be recognized that the figures in the illumination do not act out the ultimately cooperative relationship defined by the words "and Reason is the bound or outward circumference of Energy," a text that has been the source of much critical debate.

Blake's text, however, is itself deeply involved with Swedenborg, as Blake has made clear even in the title of his work. It is unfortunate that Blake's copy of Swedenborg's *Heaven and Hell* is so lightly annotated, and represents an early stage of Blake's encounter with the seer, when Blake was absorbing poetic structures from him with a respect which, as the *Descriptive Catalogue* (E 546) shows, he never totally lost in spite of his later apostasy. *The Marriage of Heaven and Hell* belongs to a much more critical stage of the relationship, in which Blake allows Swedenborg's writings only the status of "a recapitulation of all superficial opinions, and an analysis of the more sublime, but no further" (E 43).

Though the intention is more to parody than flatter, Blake's language in this work follows Swedenborg closely at many points. Swedenborg's *Heaven and Hell*, for instance, states that "Heaven and Hell are to each other as two contraries in mutual opposition, from the action and reaction of which results that equilibrium by which all things subsist."[68] From hell flows "a perpetual endeavour or malignant will [*conatus*] to destroy all good and truth, joined to rage and madness at not being able to effect it... on the other hand was perceived a sphere of truth from good from Heaven opposing and restraining the fury and madness of the former, from whence proceeds an equilibrium" (538). Here is the original of the opinion that Blake satirizes in Plates 3 and 4, and I believe one major point of origin of Blake's design; one can see Swedenborg's "restraining" in Blake's manacle. Swedenborg goes on to say that "unless man stood between these two contrary attractions, he would neither have thought, will, nor liberty, these

being the effects of his equilibrium betwixt good and evil" (546), offering an analogy with the child in Blake's illustration in *The Marriage*, who is in the position of "man" in Swedenborg's sentence.

These statements outline a dynamic situation with which Blake's illustration is in general accord, though with a transformation of values. Swedenborg also provides suggestions for the specific imagery; the infernal loves of hell produce "a column of fire mixed with smoke ascending from the pit" that represents "irascible and other evil passions in this world" (571). The fire and smoke are opposed by the sun which represents the Lord (552 etc. etc.). There are also references to the blindness or obscured vision of those in hell (for example 518).

Such imagery is not peculiar to Swedenborg, but in view of the explicit relation between Blake's prophecy and the seer's work one can conclude that such passages as these – there are many more – are reflected in Blake's design. We find there the origin of the two main figures, of the sun, of the burning cloud, and perhaps of the child that they fight for. The figures emerge from a Swedenborgian subtext to take their place in Blake's transformation of *Heaven and Hell* into *The Marriage of Heaven and Hell*. The antithetical Blakean text that surrounds them turns these Swedenborg-derived figures upside down; the informing "Vision" and the chosen "names" are identical in all but value signs, and the transformation of those signs is a function of the associated text.

The color print based on this design was titled *The Good and Evil Angels*, but was otherwise "unaccompanied by any writing." The title comes from Blake, being inscribed below the design in the Tate Gallery copy and recorded in the accounts with Butts. In Blake's time, references to angels were almost guaranteed to conjure up the name of Swedenborg, who was then as famous, and notorious, as Blake himself was, in his own word, "hid" (E 636). It is also true that the idea of opposed Good and Evil Angels has a folkloric quality about it, is part of the Western tradition in ways that go too deep for full localization in any single text; one thinks of Marlowe's *Dr. Faustus*, Shakespeare's Sonnets, and numerous others. But in the context of the 1790s, it would have been natural to see a reference to Swedenborg in the image of two opposed angels, and the reference would have been confirmed by the title.

I shall take the Tate Gallery copy (B 323; plate iii) as model for a description. The Evil Angel on the left is powerfully muscled, with a shock of wavy

hair and an expression suggesting only negative emotions of anger, despair, and frustration. The face has a broad and deeply furrowed forehead, a powerful nose, and a pointed and cleft chin. The face contains a rude and unformed hostile energy; it could conceivably be read as a caricature of Fuseli.[69] The eyes are explicitly blind; in this copy, Blake has carefully drawn in both eyelids to show that the eyes are open, but only to reveal their white blankness. The eyes in the Whitney copy (B 324) do not appear to be blind; this significant detail was evidently subject to alteration. The genitals are curiously lumpy and indistinct. The figure lunges upwards and forwards, though restrained by the fetter on his left ankle, and is followed by orange and dark flames. The fetter can be read as the sign either of punished criminality, or of heroically resistive subjection to an unjust and usurping power.

The Good Angel on our right is lighter in color, with an unlined, youthful face. His hair streams back in the wind created by the rush of flames surrounding the other figure. That detail confirms that the two figures exist within the same space, but though they are both strongly imagined and drawn, the interaction between them is difficult to define exactly. The Evil Angel is usually interpreted as reaching for the child; Mellor, for instance, writes that the Evil Angel's "left arm seems to reach directly towards the child."[70] However, the perspective of the design makes that interpretation either impossible or visually irrational; the Evil Angel's left hand is already in front of the Good Angel's body, which it overlaps, so that the Evil Angel is better understood as lunging forwards blindly into the space in front of the Good Angel than as moving directly towards the child. Blake handles perspective carelessly enough that this alone would not be sufficient to rule out the possibility that the Evil Angel is reaching for the child, but his widespread arms also argue against that interpretation, for reaching is portrayed by both arms and hands stretched out together in parallel, as in Propositions II and V of *There is No Natural Religion* [*series a*].[71] The figure is listed by Janet Warner in her discussion of "The gesture of outstretched arms," and that is where he belongs.[72] He is manifesting, appearing in his characteristic shape and gesture, and it is from that act of apparition that the startled babe recoils. The blind eyes of the Tate copy make it even more improbable that the figure is reaching for a specific target.

There is a substantial issue involved in the ambiguity. Figures acting out a narrative should interact in visibly intelligible ways, since interpretation

of their meaning depends upon such interaction. But figures conceived allegorically are thought of as containing their meaning within themselves, a meaning pointed at by their names or attached attributes. Many of Blake's figures seem to participate in both modes of signification: they are involved in the implied narrative actions appropriate to history painting, but they also have an allegorical dimension, as the title of the work being discussed here indicates, though Blake usually avoids conventional attributes. Blake's typical way of imagining character and motivation is like a combination of the allegorical emblem with the *fatto*, or historical or poetical instantiation, in Hertel's eighteenth-century edition of Ripa's *Iconologia*, in which Envy, for instance, is shown in traditional emblematic manner as an old woman with snakes for hair and chewing at a human heart, accompanied by a hydra and a dog, while simultaneously the inset *fatto* represents Joseph being sold into slavery by his envious brothers.[73] Spenser did something analogous in ending the story of Malbecco with his transformation from man to abstracted personification: he, "through priuy griefe, and horrour vaine, / Is woxen so deform'd, that he has quight / Forgot he was a man, and *Gealosie* is hight."[74]

The Evil Angel's gesture is both part of a narrative and the characteristic expression of his internal nature. The spread-arms gesture implies the expression of an internal state, but the babe's startle response implies a reaction to a momentary and therefore narrative act. The two are not in contradiction: the startle response is the appropriate answer to the sudden revelation of all that the Evil Angel represents. This is in accord with Blake's theory of invention; in the account of *The Ancient Britons*, Blake claims to have "given the historical fact in its poetical vigour, so as it always happens" (E 543). Poetry has the power to perceive the permanent structures of repetition that underlie the apparently random events of history.

This in turn is analogous to the perception of the physiognomy underlying the changing accidents of pathognomy. When Blake tackles these issues directly, it is through such statements as this: "expression cannot exist without character as its stamina; and neither character nor expression can exist without firm and determinate outline" (E 549). In criticizing the art of Venice and Flanders, Blake claims that it "loses all character, and leaves what some people call expression: but this is a false notion of expression" (E 549). Physiognomy is the forming power that moulds pathognomy into its own shape, a view that privileges physiognomy over pathognomy, as alle-

gorical meaning is the foundation of narrative. When Blake describes *Malevolence* to Trusler, he writes as if that quality is perfectly incarnated in the "Two fiends" who lie in wait to "murder the mother & her infant" (E701); permanent character expresses itself in the particular but typical situation, as allegorical personification embodies itself naturally in a "characteristic" narrative.

Another sign of this relationship is the way in which gaze is handled by Blake. The figures in many of his designs, including this one, look neither at each other nor at the viewer. They look rather in directions aimed approximately at other figures with whom they interact, but at a noticeable angle of divergence. In Michael Fried's terms,[75] they are neither totally absorbed in their own consciousnesses, nor theatrically aiming their looks at the audience. They are agents caught up in a dramatic situation which expresses their eternal nature; they cannot respond totally to the present, which would involve crossing eyebeams with their fellow actors and being immersed in a changing narrative, but neither can they look directly at the viewer and acknowledge that their message is only for him/her. They look out of the frame of the design with eyes that take in but do not focus on their present entanglement, and suggest that their intentionality will continue long after the present revelatory moment has vanished, though that moment is necessary to call forth the revelation.

The original textual setting of the design from which this print was developed destabilized the terms "Good" and "Evil," revealing them as false "Angelic" terms, for which should be substituted the "Diabolic" terms "Reason" and "Energy." Both of these revised terms were validated by the text, though not equally: "Energy is the only life and is from the Body and Reason is the bound or outward circumference of Energy" (E 34). In reverting to the rejected angelic vocabulary of *The Marriage of Heaven and Hell* for the title of the color print, Blake has made interpretation difficult for knowing viewers. We may ignore the title, and read the figures in the light of our knowledge of the original context, in effect substituting "Diabolic" terms for the "Angelic" language of the title, reading the print as if Blake had titled it "Reason and Energy."

The blind eyes of the Evil Angel in the Tate copy make this difficult though not impossible; such a blind Energy would have much need of the eyes of Reason, and the opposition would be partially swallowed in an underlying cooperation, though no such cooperation is visible in the print.

It is conceivable that the blindness represents an adaptation to the owner of the print, Butts, who made the friendly complaint that he had difficulties in "discerning clearly whether your Angels are black, white, or grey."[76] This was written in 1800 in response to Blake's address to him as "Dear Friend of My Angels," and suggests that the two had had some conversation about Blake's angels, most probably over either the text of *The Marriage of Heaven and Hell* or this print, which is so closely linked to it. Butlin offers evidence that Butts's copy of this print among others may have been executed in 1804–1805,[77] just prior to purchase, and it is just possible that Blake made the Evil Angel blind in order to assuage Butts's doubts by making it clear that this was a "black" Angel. In the original context, it was relatively easy to read blindness as a sign of (Milton's) poetic genius. Cut away from that context, it becomes difficult not to read it negatively.

Mellor offers a mediating interpretation that reverts to Blake's "Diabolic" language; the dark angel represents "creative Energy [that] has been devoured by reason and perverted into an instrument of oppression," and Butlin and Lindsay accept this view.[78] This makes it difficult to interpret the title that Blake himself has given the print, which implies a strong contrast, however that contrast is to be interpreted; what Mellor offers is two versions of evil, two different oppressive forces. Though counter to the title, this provides an intelligible interpretation of the print. One could extend this interpretation to include a social or political perspective, and read the Evil Angel as an image of chained, blinded, and potentially revolutionary labor (Energy), angry and destructive in its thwarted desires, and the Good Angel as the bourgeois (Reason) who has captured the "goods" (the child) of society, and now lives in the sunlight of prosperity and social approval. Or one can confess that the print is finally undecidable, that its meaning lies to a large extent in whatever context we decide to bring to it, that the print is suspended between two perspectives and two languages, and is unable to cut itself off entirely from its title, however deeply that title has been problematized for us, and from the ambiguities of the image of fire. This possibility will be considered further in relation to the print with which it has been coupled.

VI

The print usually coupled with *The Good and Evil Angels* has had an interesting history in commentary because it was for years known by an erroneous

title. The print known as *Elijah* since Rossetti gave it that title in his cata-
logue was shown by Butlin in 1965 to be the print referred to as *God Judging
Adam* (B 294; plate iv) in the accounts with Butts, and in addition to have the
words "God speaking to Adam" written below the design.[79]

There is an earlier watercolor with a rather similar design (B 258; illus.
42), which shows Jehovah riding a cloud chariot instead of a fire chariot.
Butlin, writing after his discovery of the true subject of the color print, calls
this watercolor too *God Judging Adam*, though there is no title on the design,
and records that it was sold at Sotheby's in 1895 as "The Almighty appearing
to Moses." The cloud chariot reflects the language of Sinai, "And the Lord
said unto Moses, Lo, I come unto thee in a thick cloud" (Exodus 19: 9), and
that would appear to be the true subject of the watercolor. The long beard
and white robe of Moses are similar to those of the Moses of Blake's early
depictions of the figure (see B 111, 112, and 114). Blake has used the same basic
design, though with significant changes, for two different though related
subjects. The two episodes have in common the revelation to a human of
the power of divine will, but God in the watercolor has both hands resting
on an open book – God is using Moses as a go-between for his words – while
Moses has his eyes open and looks calmly at the ground between himself
and God. The watercolor should have its old title returned, and be known
again as *God Appearing to Moses*.

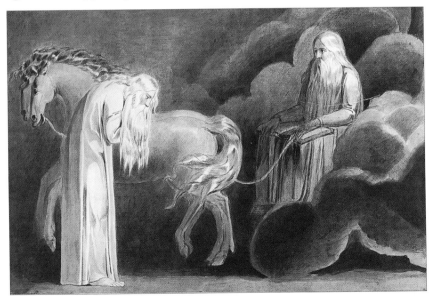

42. William Blake, *God Judging Adam*
(*God Appearing to Moses?*) (B 258)

While the color print was still known as *Elijah*, Blunt gave it a confident reading: Elijah, "the embodiment of the imagination," going up to heaven in the "chariot of inspiration," lets his mantle fall on Elisha, who reflects "the unhappy position of the poet in a world dominated by Jehovah-Urizen and a society governed by the restrictive rules of his servant Moses."[80] This is more confident than clear; there is no mantle in the print, and it seems to be Elijah who dominates the present world of Elisha, and would therefore seem the source of his despair.

With the discovery of the correct title, Butlin offered a new interpretation: "Urizen, whom Blake associated with the unillumined Jehovah of the Old Testament, imposes his law on Adam who stands before him transformed into his own image."[81] This offers a clear statement that has controlled subsequent discussion of the print. Mellor, for instance, writes that "Adam's limited vision... cannot see beyond Urizen's abstract, rational world" and this is emphasized by "the repetitions of line and color in the print."[82]

But some problems remain. Some are in the domain of the surface imagery of the design; for instance, does God hold the reins of the horses in his right hand, or a wand of command? The continuity of line between this object and the reins visible on the other side of Adam, and the analogy of the watercolor (B 258), suggest that the object is simply the reins, but in most copies Blake has given the object a lighter color, and the pointing index finger of God's hand implies an act of command more readily than it does the act of holding reins. Once more the perspective of the print is not precise enough to make clear whether the pointing hand is in the same plane as Adam, and therefore pointing at him, as the surface arrangement of forms suggests, or in a plane behind Adam and in line with the reins and the horses. The problem is related to that found in *The Good and Evil Angels*; the recurring partial collapse of perspective makes it difficult to relate bodies accurately, and therefore to understand precisely their intentionality towards each other.

Another puzzling detail is the nakedness of Adam. Adam and Eve are confronted by the voice of God (it is specifically the voice of God) in Genesis 3: 8, immediately after the discovery of their nakedness and the sewing of the fig leaf aprons. God then makes them coats of skins before sending them out of the garden (Genesis 3: 21–24), so that there may be a moment between their being dressed in fig leaves and their new skins.

Since the words actually written on the print read "God speaking to Adam," it appears that Blake has visualized that confrontation, focusing on the exact words spoken by God in the third chapter of Genesis:

17. And unto Adam he said, Because thou hast hearkened unto the voice of thy wife, and hast eaten of the tree, of which I commanded thee, saying, Thou shalt not eat of it: cursed is the ground for thy sake; in sorrow shalt thou eat of it all the days of thy life;

18. Thorns also and thistles shall it bring forth to thee; and thou shalt eat the herb of the field;

19. In the sweat of thy face shalt thou eat bread, till thou return unto the ground; for out of it wast thou taken; for dust thou art, and unto dust shalt thou return.

Blake has shown God in the act of speaking just those words, the open book visible on his lap representing his quotation from a previous utterance ("which I commanded thee"), and has imaged Adam in the act of hearing and feeling that powerful decree. Hence the deeply bowed head and, clearly visible in the Tate copy, open and staring eyes of Adam; he is looking in dismay and even horror at the ground, the earth from which he was made, as he now first learns, and as Blake shows in *Elohim Creating Adam* (B 289; illus. 24); the same ground to which he will return through the newly revealed nature of death. The ground he stares at has a virtual spotlight upon it to focus our attention there. Adam in staring at the earth confronts the whole of his newly revealed human and mortal life, from beginning to end. He is now a condemned man, and the bitter revelation shows in his face.

His nakedness is a sign of his vulnerability and openness to God's power at this moment, and/or a proleptic recognition of the about-to-occur clothing in skins, which implies a precedent nakedness. The moment Blake has chosen is placed precisely between the sewing of the fig leaf aprons and God's clothing of Adam and Eve in skins; Adam's nakedness at this moment is an appropriate intermediary state between these two states of dress. Ironically, the fig leaves are themselves the sign of the recognition of nakedness, and of the attempt to conceal it, and are associated with the attempt by Adam and Eve to hide from God: immediately after making the aprons, they hear the voice of God and "hid themselves from the presence of the Lord God amongst the trees of the garden" (Genesis 3: 8). Adam

answers God's voice with "I heard thy voice in the garden, and I was afraid, because I was naked; and I hid myself" (Genesis 3: 10). Blake has left Adam without apron to show his nakedness as his attempts to hide from God are stripped off.

Butlin's explanation of why Blake has shown Adam as an old man, a motif for which I have found no precedent in art history,[83] deserves fuller commentary. Immediately after clothing Adam and Eve in skins, God says: "Behold, the man is become as one of us, to know good and evil" (Genesis 3: 22). Blake responded to the words "as one of us" by making Adam into a mirror image of God. Moral similarity is realized as visual similarity.

The phrase "as one of us" can be read in both directions; Adam's recognition of guilt and shame and mortality reflects the nature of a judgmental and punitive God, and these qualities are immediately reflected again in the image of the God he makes or remakes for himself. Adam becomes like God, but also Adam recreates God in the image of his newly fallen state.

Adam's age may also include an allusion to the revelation to Adam in *Paradise Lost* of the ways to death: one is the lazar-house (the subject of another of these prints), and the other is old age, which Michael describes in these words:

> but then thou must outlive
> Thy youth, thy strength, thy beauty, which will change
> To withered weak and gray.[84]

The sorrows and losses of aging are part of the revelation of death made to Adam after his fall.

The flaming chariot demands interpretation. Mellor writes that "the flames of Energy are completely confined to the fixed circle of God's chariot; Energy has now become mere will to power and works as the wheels of God's carriage and the tools of his oppressive policies."[85] Perhaps; but the circles are necessary to show that these flames function as wheels, as is confirmed by their relation to the beam of the chariot. Flaming chariots are usually associated with the imagination in Blake, whether in the "Preface" to *Milton*, "Bring me my chariot of fire!" (E 95), or in *The Everlasting Gospel*, in which Christ "Became a Chariot of fire" (E 523); one should remember also *The Marriage of Heaven and Hell*, in which Blake writes, "This is shown in the Gospel, where he prays to the Father to send him the comforter or Desire that Reason may have Ideas to build on, the Jehovah of the Bible

being no other than he, who dwells in flaming fire" (E 35). Though Mellor reads the circle of the wheel as confinement, wheels, as in the vision of Ezekiel, are usually images of the power of divinity in motion, and these wheels seem to radiate beams of light. Chariots of fire do not usually bear negative connotations in Blake's work.

The closest visual analogue is the chariot representing "the Plow of Jehovah and the Harrow of Shaddai" on Plate 41 of *Jerusalem*.[86] There the image of the fiery chariot is associated with the necessary cleansing and recycling processes of apocalypse, and that meaning seems relevant to the print we are considering: the fire is something to be gone through in the path towards apocalypse, which leads through a judgment.

Another biblical text plays a major role in this design. The age preceding Blake's was very concerned with harmonizing the prophets as well as the Gospels, and Daniel had always been interpreted in the light of Revelation. Blake's figure in the chariot is modeled on the Ancient of Days from the seventh chapter of Daniel, and the God of the print is a fairly direct transcription of that figure:

> 9. I beheld till the thrones were cast down, and the Ancient of days did sit, whose garment was white as snow, and the hair of his head like the pure wool: his throne was like the fiery flame, and his wheels as burning fire.
> 10. A fiery stream issued and came forth from before him: thousand thousands ministered unto him, and ten thousand times ten thousand stood before him: the judgment was set, and the books were opened.

In the print Blake has transferred the language of *the* last judgment to this particular judgment. But since we are all included in the Fall of Adam, *his* judgment is in a sense also *the* last judgment: Adam includes those thousands of Daniel's vision.

In considering the overall meaning, we find ourselves in much the same position in which we found ourselves while considering *The Good and Evil Angels*. The print offers itself in the first place as an illustration of the text of Genesis, with even the unexpected and, as far as I know, unexampled, age of Adam explicable from that text, with significant details from Daniel. From those texts, we can understand why Adam is looking downwards with such an intense and agonized expression, even why he is shown as aged and naked. We can also explain the details of the chariot.

That, however, does not settle the question of value, of the viewer's

choice of perspective. Every commentator on the print has said, in one way or another, that it gives a negative value to this God, and that feels right. Mellor supports her interpretation from the formal details of the design itself:

> Adam's limited vision which cannot see beyond Urizen's abstract, ratio-
> nal world is emphasized by the limitations and strict repetitions of line
> and color in the print: the vertical lines of Adam's right leg and torso are
> repeated in God's back and legs and in the horse's front left leg; the hori-
> zontal line of God's knees and thighs, emphasized by the stone book upon
> his lap, are repeated in the horse's back and in Adam's bowed head and
> shoulders, the left-right diagonal of the horse's upper rein runs directly
> parallel to God's extended, judging arm and sceptre; and the entire scene
> is flatly placed against the circle of flames of God's chariot on the right.[87]

This reads perhaps too much significance into some of the surface forms of the design: the verticality of the horse's legs simply represents the way standing horses are, and it is unwise to make much of the fact. But there *is* an unattractive rigidity about God's limbs, and the bend in Adam's neck is alarming in its abrupt abjection. There is no question that an act of judgment, even condemnation, is taking place, and none of us likes to be judged.

We have been taught, by Blake as forcibly and powerfully as by anyone, that a judgmental God is a badly imagined God, and that the path to true humanity leads beyond that conception. Like Adam and Moses we make Gods in our own image, and when we bow down before those images and give them a reified power, we destroy our own capacity for freedom. This is explicitly the argument of Plate 11 of *The Marriage of Heaven and Hell* (E 38). As far as one believes that, one gives a negative valuation to the event represented in the design, as representing a badly imagined God, though this God is only a moment in the continuing history of human imaginings; he is the best that Adam can do at this moment.

It is in part their common use of the image of fire that has led to the coupling of this print with *The Good and Evil Angels*. Butlin contrasts the prints, writing that in *God Judging Adam* "'the flames of eternal fury' emit no light, whereas in 'Good and Evil Angels' the fire represents energy as 'the only Life... Eternal delight'... in 'God Judging Adam' the fire without light is part of a completely negative scene."[88] I am not fully persuaded by this

view. In *The Good and Evil Angels*, the fire is read as positive, though the print contrasts it with the sun associated with the Good Angel, and with light itself; indeed, the fire in this print threatens if it erupts much further to block our view of the sun, which emits visible rays of light. In *God Judging Adam*, the fire chariot is read as negative, despite the fact that the fire wheels radiate beams of light; *pace* Butlin, this is not "fire without light."

Lindsay gives a rather different way of linking the two prints: "the god of *Judgment* and the devil of *Angels* embody... the cooperating forces of a Urizen-Orc alliance."[89] This reads the energetically striving Evil Angel and the sternly judgmental God as members of the same team, though without making clear just what the opposed Good Angel now represents. Again, attempts to read two prints as a pair create more problems than they solve.

There is one way in which to couple these two prints, however, though it is in a very different vein. Both fall into the crevices between the layers or stages of Blake's process of invention. Both use existing texts or "names" in which to embody their "Vision," but in doing so introduce alien imagery that proves difficult to integrate into the new structure, and in both cases fire is part of that imagery. In the case of *The Good and Evil Angels*, fire is problematized in its meaning by being associated with the language of the title, and with a blind figure to whom it is difficult to respond positively, though one can recognize the positive associations of fire in Blake's work generally.

In *God Judging Adam*, fire is problematized by being associated with a figure who has the trappings of authoritarian power and is passing a clearly condemnatory judgment, with all the negative associations that act has for readers of Blake, though he is seated upon a fire-wheeled chariot that gives off rays of light and has positive associations in Blake's other work.

In both prints, the language of the imagery that comes with the chosen "cover story" projects values that run against the grain of the hypothetically embodied "Vision," and render interpretation difficult if not impossible. Once again, Blake has had problems in adapting material taken over, and has produced designs that are suspended uncomfortably between his own implicit texts, which we can only partially reconstruct, and the known texts or names associated with his chosen images. To read the two prints as a pair involves making an uncomfortable choice between reading fire as possessing opposed meanings in the two prints, and reading an Evil Angel who seems to represent something like Energy as linked with a judgmental

God, the oppressor of Adam and therefore of us all. Blake's twelve prints are difficult enough when considered separately without adding the burden of trying to reconcile their disparate images. The attempts at reconciliation have not produced genuinely helpful results so far, and have sometimes worked to obscure internal details that reveal important aspects of the act depicted. If Blake had more in mind than a visual similarity sufficient to enable an owner to hang two prints together in one room, his intentions have not yet been deciphered.

Blake and Young's *Night Thoughts*

Commentary on these illustrations has generally proposed that Blake used them as a vehicle for his own views, often criticizing Young in the process. I do not wish to deny a partial and occasional validity to this view, but I believe that it has distorted the overall picture of what Blake is doing. There is much more response to, and respect for, Young's poem than is assumed by most commentators, and in saying this I join a growing body of revisionary thinking on the whole large subject of the relationship between Blake and the poets he chose to illustrate. Bo Lindberg has modified the older view that the illustrations to the Book of Job were a re-statement of Blake's central myth, and David Fuller has questioned the views of such critics as Roe who claimed that Blake's illustrations of Dante are almost continuously critical.[1]

As an approximate model of the relationship between poet and illustrator, I shall take Blake's own words on his illustrations to Gray's poems, made shortly after the *Night Thoughts* drawings: "Around the Springs of Gray my wild root weaves / Traveller repose & Dream among my leaves" (E 482). The implication is that it is Gray's words that provide the direction for the designs, while Blake's root weaves "Around" them, producing pictorial arabesques. Certainly the two designs that open the illustrations to Gray, those of "The Pindaric Genius recieving his Lyre" and "Gray writing his Poems," suggest the highest respect for Gray's genius. I shall try to show that Blake's metaphor offers a useful paradigm for what he does in illustrating Young.

Another partial model can be derived from Blake's handling of Gray's texts. In Chapter 4, I maintained the need to think about Blake's invention within the model of a chosen text, "Historical" or "Poetical," which provided the body or historical names in which was incarnated the "Vision" that gave life to the design. I also maintained that in interpreting a design like *Pity*, we have to take seriously the relationship between the finished design and the text from which it takes its departure. In the case of a series of designs intended to be published in conjunction with the text ostensibly illustrated, we have to take that text even more seriously; Blake would have been mad to have produced a series of designs that undercut his text at every moment, producing puzzlement rather than illumination in his viewers. That view has been proposed, but I shall disagree.

148 In some of the titles he writes for his illustrations to Gray, Blake creates a secondary text that mediates between the original text and his design. Each poem is preceded by a list of designs with titles, usually written by Blake on the basis of Gray's text, but with sufficient variation from it to represent a form of "weaving" rather than direct quotation. Thus the third design for "Ode on the Spring" reads "The Purple Year awaking from the Roots of Nature. & The Hours suckling their Flowery Infants" (E 676). This is derived from the opening lines of the poem:

> Lo! where the rosy-bosom'd hours,
> Fair VENUS' train, appear,
> Disclose the long-expected flowers,
> And wake the purple year!

Blake's text in no way contradicts Gray's, but specifies detail beyond what is explicitly mandated, providing a mediation analogous to that provided for *The Ancient Britons* in the *Descriptive Catalogue*.

In the case of Young, we have only the "Explanation of the Engravings" by an unknown hand sometimes assumed to be that of Fuseli, and bound into some copies of the 1797 Edwards edition with Blake's illustrations.[2] Commentary on these illustrations has thus proceeded without guidance from Blake. It has been dominated by three critics, Morton D. Paley, Thomas H. Helmstadter, and John E. Grant. I shall try to represent their views briefly and then reinterpret some of the illustrations that figure as key examples in their positions in order to reorient discussion of the whole series, which looms as the single largest body of visual work that Blake ever produced. All my references to both text and designs will be to the numbers given to the illustrations in the Oxford edition;[3] there are differences between the text, a composite of the first and second editions of the poem, that supported Blake's watercolors, and the text as printed in the edition published in 1797 with Blake's engravings, and it is important to relate Blake's designs to the actual text that he illustrated.

II

Paley's position is that Blake read Young "as a storehouse of familiar sentiments, expressions, and attitudes" and, perhaps more importantly, of "similes and personifications"; "Young's personification becomes Blake's symbol."[4] This is accurate, but Paley goes on to claim that "Blake pictorialized his

43. William Blake, illustrations to Young's *Night Thoughts*, 35: "Oft bursts my Song"

subject in a unique way: he assimilated it into the mythological system that he was creating in his own prophetic works," and further that "certain pictures... actually satirize either the passages they are supposed to illustrate or their author." These statements become a sometimes misleading hermeneutic principle.

Let us look again at some of the illustrations upon which Paley builds his case. One is *NT* 35 (illus. 43), adduced as one of the pictures in which Blake acts as satirist: "Where Young writes 'Oft bursts my song beyond the bounds of life,' Blake shows us a leaping figure whose right foot is securely chained to earth."[5] The textual allusion in the design is not so simple. Young is comparing himself to Milton, and to Pope as the translator of Homer, and recognizes that he cannot fly so high: "ah cou'd I reach your Strain!" He tries to fly to regions unexplored by Pope – "*Man* too he sung: *Immortal* man I sing; / Oft bursts my Song beyond the bounds of Life" – but he, Young, lacks Pope's powerful wings, which would have made possible the soaring flight of which Young is incapable: "O had he mounted on his wings of fire, / Soar'd where I sink, and sung *Immortal* man!" The soaring but earth-bound poet in Blake's illustration represents Young, and is virtually identical with the figure, also a representation of Young, who has just freed himself from the briars ("Grief's sharpest Thorn") that enwrapped him on the previous page. Blake's illustration recognizes and sympathizes with Young's own honest modesty by showing that his attempt to mount "beyond the bounds of Life" is checked by limits to his power. Paley focuses on the line starred in Edwards's text, but that line is not starred in the original watercolor; as often in these designs, Blake is illustrating not just a line but a whole segment of Young's poetic argument.

Here is Paley's discussion of another illustration that he uses as an example of Blake turning Young upside down:

150

In *NT* 492, Blake provides his own answer to Young's rhetorical question "Has Matter *more* than Motion? Has it Thought, / Judgment, and Genius?" "If so," Young goes on, "how each *sage* Atom laughs at *me*, / Who think a *Clod* inferior to a *Man*?" Blake, we remember, had asked a fairy "What is the material world, and is it dead?" and had been shown "all alive / The world, when every particle of dust breathes forth its joy" (*Eur.* iii [E 60]). Therefore Blake inverted Young's meaning by illustrating his ironical conclusion as if it were literal, showing a tiny family in a green leaf pointing up in laughter at the poet.[6]

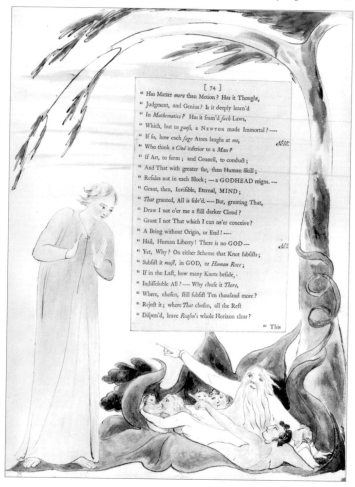

44. William Blake, illustrations to Young's *Night Thoughts*, 492: "each sage Atom laughs at me"

Again Blake's illustration (illus. 44) should be put back into its context. It follows directly upon *NT* 491, illustrating "Who bid brute *Matter*'s restive Lump assume / Such various Forms, and gave it Wings to fly?" These lines are part of Young's demonstration of the existence of God through the standard argument from design. Blake has gone along with Young's lines here, and has made "Matter" as ugly and unthinking as the poet could have desired, giving it / him the white beard often associated with sterile old men, and a blank and stupid face. I can find no trace of irony or disagreement.

To return to *NT* 492, the pointing old, white-haired man, who represents the sage and laughing atom, is very similar to the stupid *"Matter"* of the previous illustration, and the act of pointing a scornful finger is one with regularly negative associations in Blake's work. The youthful man below who points with the same gesture must represent the clod; the other members of the family are personable enough. One has to ask, given a quarrel between a poet defending the existence of God and a mocking lump of clay, whether we can really put Blake on the side of the clod? The error imputed to Young by Paley's analysis is to "think a *Clod* inferior

to a *Man*"; I think Blake would have agreed. The passage from *Europe* that is offered by Paley as a parallel is only remotely relevant, and has complex ironies of its own which can only with difficulty be brought to bear on the design under consideration.

Blake, left to himself, would doubtless have put the case for belief differently, since the notion of a universe composed of dead matter was abhorrent to him. But that is not the same thing as saying that Blake has turned Young upside down. The closest analogue to the design of *NT* 492 is not the passage from *Europe* cited by Paley, but the illumination of Plate 11 of *The Marriage of Heaven and Hell* showing another family composed of vegetable and mineral objects in the natural world, and associated with the following passage: "The ancient Poets animated all sensible objects with Gods or Geniuses. calling them by the names and adorning them with the properties of woods, rivers, mountains, lakes, cities, nations, and whatever their enlarged and numerous senses could percieve" (E 38). The life illustrated in these forms is the gift of the imaginative perception of the ancient poets, not of the world of matter. The perception of the world as "Human formd" (E 712) is not an attribute of matter itself, but an augury of a world reincorporated into the human imagination from which it originally emanated. But it is difficult, to say the least, for an illustrator to imply all of this in a single design without a supporting text, and in *NT* 492 the obviously stupid look on the old man(atom)'s face, and the unpleasantly derisive gestures of both male figures, swing the balance in the concerned poet's favor. It is better to believe with Young that "The *Course* of *Nature* is the *Art* of GOD" (*NT* 482), than to align oneself with the eighteenth-century sceptical materialists against whom Young is mounting his attack for their belief that "brute *Matter*" has created all the phenomena of the known world, including human consciousness. Blake has not inverted Young here, though he would doubtless have put the argument differently if he had been creating his own illuminated poem on the subject.

In Chapter 3, I maintained that text and context had a large power over the meaning of a design, though recognizing limits to that power. I wish to recall that argument now in order to apply it to the reading of Blake's illustrations to Young and to other poets. The first and most important context within which to read these illustrations is the text of the poets illustrated, which acts as a directing and filtering structure, foregrounding certain possibilities and suppressing others. It is always possible for a sophisticated

reader well versed in Blake's total output to invoke as a more distant but relevant context another design or poem by Blake. Set in that larger frame, the design can now be said to mean something other or more than the meaning attributed to it as an illustration. But it is a mistake to simply replace the original meaning with the second, and describe that as "the" meaning. These illustrations came into being as a response to the text being illustrated, and were designed to appear on the same page, to be part of the same visual space, explored by the same eye.[7] That relationship does not preclude the expression of difference, but it does insist that such difference be interpreted in relation to the text illustrated.

Probably the key statement in Paley's approach is that "for Blake the pictorialized trope is often a means of making a symbolic statement which depends for its meaning not on Young's text but on the myth developed in the Lambeth books and in *Vala*."[8] Paley, using this perspective as a hermeneutic program, maps Blake's myth onto the *Night Thoughts* illustrations, with results that are not always convincing. Thus he interprets the figures of Time with his scythe in the illustrations as images of Los, and then writes:

> the effect is not on the whole successful, and perhaps the reason for this is that Blake is portraying not his own conception of Time but what he regards as a common *mis*conception:
>
> > Los is by mortals nam'd Time, Enitharmon is nam'd Space:
> > But they depict him bald & aged who is in eternal youth
> > All powerful and his locks flourish like the brows of morning. [E 121][9]

This is to mark Blake down in a competition he has not entered. Blake is, for the purpose of these illustrations, "they," and accepts the conventional iconography because to portray Time as an "eternal youth" in an illustration of Young's poem is to guarantee a failure of recognition and understanding on the part of his viewers. Paley begins with the mistaken assumption that Blake's work as an illustrator is continuous with his work in the illuminated poems, and then faults him for the discontinuities that he uncovers.

In another example, Paley claims that Urizen appears as Death, as Charon, as Wealth, as Fate, and as Chaos in *NT* 20, 31, 183, 247, 473, 514–15. He explains this with the comment that "To make the same figure represent several meanings is to say they are all aspects of one meaning. Urizen is the

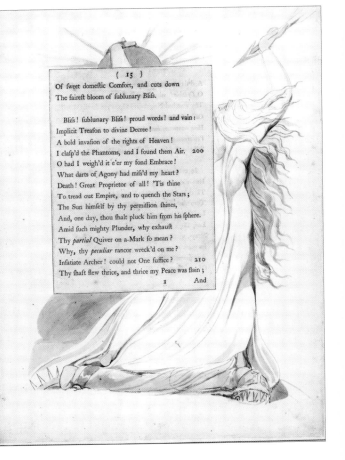

setter of limits – blighter of joy, killer of the body, schoolmaster and workmaster – and behind all his activities is a vision of the universe as a material chaos."[10] This is a statement not easily identifiable as either correct or incorrect; it operates at such a level of abstraction that it is virtually unfalsifiable. If one identifies Urizen as the sum of all bad things, one can claim to find him everywhere, but that does not bring increased intelligibility to a design made to illustrate a particular text, and may in fact lead to distortion through the overlooking of important details in the illustration.

In the examples just given, for instance, the identification of Death in *NT* 20 (illus. 45) as Urizen leads to a destructively paradoxical situation. Young describes the functions of Death:

> 'Tis thine
> To tread out Empire, and to quench the Stars;
> The Sun himself by thy permission shines,
> And, one day, thou shalt pluck him from his sphere.

45. William Blake, illustrations to Young's *Night Thoughts*, 20: "'Tis thine / To tread out Empire"

Death has his foot firmly on the neck of a crowned figure who represents Empire; but Empire is one of the functions regularly associated with Urizen, and we thus have Urizen potentially identified with both figures involved in a fatal opposition. The name Urizen brings too many uncontrollable meanings into a specific situation, and leads to a loss of the differences that produce meaning, to blindness rather than the insight of new knowledge.

III

Thomas H. Helmstadter has written several essays on the *Night Thoughts* illustrations. His general view, a softer version of Paley's metaphor of inversion, is that Blake in many cases gives "an illustration a meaning Young's text did not possess," specifying that "at least eighteen of the *Night Thoughts* illustrations depart significantly from the ideas and attitudes of their text."[11] One answer might be that 18 out of 537 is a very small number,

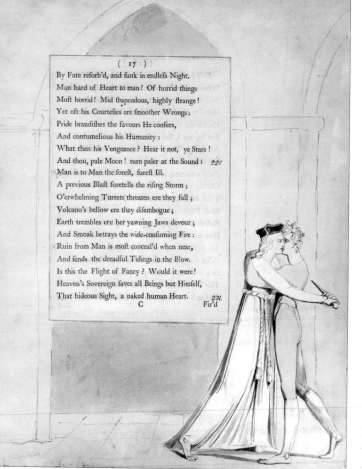

(17)

By Fate reforb'd, and funk in endlefs Night.
Man hard of Heart to man! Of horrid things
Moft horrid! Mid ftupendous, highly ftrange!
Yet oft his Courtefies are fmoother Wrongs;
Pride brandifhes the favours He confers,
And contumelious his Humanity:
What then his Vengeance? Hear it not, ye Stars!
And thou, pale Moon! turn paler at the Sound; 220
Man is to Man the foreft, fureft Ill.
A previous Blaft foretells the rifing Storm;
O'erwhelming Turrets threaten ere they fall;
Volcano's bellow ere they difembogue;
Earth trembles ere her yawning Jaws devour;
And Smoak betrays the wide-confuming Fire:
Ruin from Man is moft conceal'd when near,
And fends the dreadful Tidings in the Blow.
Is this the Flight of Fancy? Would it were!
Heaven's Sovereign faves all Beings but Himfelf,
That hideous Sight, a naked human Heart. 231.
 C Fir'd

46. William Blake, illustrations to Young's *Night Thoughts*, 92: "Man is to Man the sorest, surest Ill"

but let us look at some of the eighteen that Helmstadter picks out as departures from Young's meaning.

In an essay focused on religious themes, Helmstadter, claiming that the illustrations "express independent and original ideas, sometimes even contradicting Young's poem," singles out "ecclesiastical elements not found in Dr. Young's text in order to depict Blake's own vision of fallen religions of this world."[12] One of the illustrations chosen to exemplify this is *NT* 92 (illus. 46), showing a priest in robe and biretta stabbing in the back a man he is embracing, illustrating the text "Man is to Man the sorest, surest Ill." This takes place in Night the Third, the central situation of which is the death of Narcissa and the poet's outrage against the Catholic Church of France for refusing her burial; the preceding three pages of Young's text have included attacks on raving *"Superstition,"* "blind *Infallibility's* embrace," and "The Strife of Pontif Pride." It is precisely in the context of this drawn out and intense anger against Catholicism that Young comments that "Man is to Man the sorest, surest Ill," and Blake has done nothing more than exemplify that with an imagined incident entirely in accord with the spirit of Young's poem.

Another example from Helmstadter, *NT* 532 (illus. 47), illustrates these lines:

Gently, ah gently, lay me in my Bed,
My *Clay-cold Bed*! by Nature, now, so near;
By Nature, near; still nearer by Disease!

The end of the paragraph looks forward to the singing of "loud ETERNITY's triumphant Song!" Here is Helmstadter's commentary:

The drawing is actually another delineation... of Jude 9. The corpse being

lowered into the grave is Moses, looking very much like Urizen. Above him Christ stretches out his arm in forgiveness and puts an end to the contention between Michael and Satan for the patriarch's bones. The soldier at the upper left is Michael; the man falling headlong at the right is Satan... Moses, representing old and cruel laws, is finally being lowered into his grave. Christ appears in order to put an end to the contention for the bones of the patriarch, a struggle left unresolved in Jude.[13]

Though the design is judged "appropriate" for Young's poem, it is "far more interesting and meaningful as an example of Blake's creative use of biblical material and adaptation of Jude 9 to his own purpose."

This is good comment, but even here there is more relation to Young's poem than Helmstadter notes. Blake has chosen this passage from Jude with which to illustrate Young's text not only because it illustrates so well the human situation Young has described, but also because Young refers to the incident himself earlier in the poem. In Night the Third, he exclaims that the French Catholic Church's refusal of proper burial to Narcissa transcends the insult offered by Lucifer, "When He contended for the Patriarch's bones..." (*NT* 91). It is always a mistake to underestimate Blake's knowledge of and responsiveness to the texts he illustrated. To associate Moses with Urizen this closely is to oversimplify the complexity of Blake's response to Moses, who released water from rock and became Israel's defender against Egypt. Blake's choice of the episode here extends but does not subvert Young's meaning, and is based firmly on Young's own imagery.

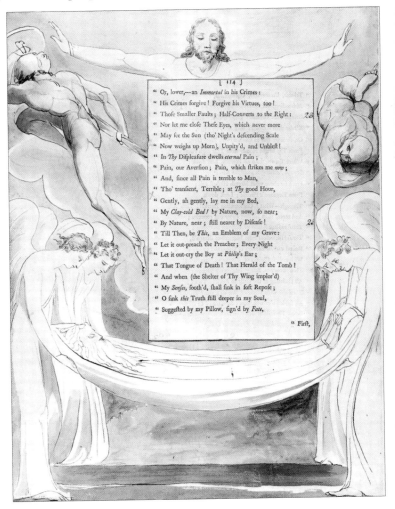

47. William Blake, illustrations to Young's *Night Thoughts*, 532: "My Clay-cold Bed!"

IV

Grant's approach to these illustrations is more complex, and has not been fully articulated yet, though enough has been published to give an overview and several detailed readings. Much of what he says is valid and perceptive; for instance, he writes that "The best immediate guides to Blake's meaning in most of the designs are to be found in Young's poem";[14] I agree. However, in spite of this, and much informed and careful comment, Grant develops a view that sees "an overall organization of the designs" and an "infrastructure of picture groups, consisting of two or more designs each, which form distinct and meaningful units within each of the Nights."[15] His later development of this thesis leads to the statement that the illustrations form "a coordinated program of visual commentary" on Young's poem;[16] the "commentary" part of this is promising, but the word "coordinated" contains in potentiality the grounds for Mitchell's accusation that Grant assumes that Blake had a full-fledged program that he imposed upon Young's poem,[17] and in practice Grant does not always do justice to his own sound advice to look for the meaning of a design first in Young's text. Mitchell's critique of Grant focuses on a reading of the design that opens Book Three, NT 78 (illus. 48), and the issues can be pursued there, with the preliminary warning that for "Grant" we should sometimes read "the editors," since the reading of this design was initially published in the Oxford edition over the names of all of them. However, since it was Grant who wrote to defend the edition, and specifically to take up the issues raised by this design, I shall simply refer to Grant as the critic responsible for the reading criticized by Mitchell.

The "Introduction" to the Oxford edition states that the title page of "Night the Third," page 43 of the 1797 engraved edition and No. 78 of the watercolors, shows Narcissa striding over the inverted crescent moon that helps identify her as the woman crowned with stars of Revelation 12; she will "deliver the Christ who will become triumphant in the title-pages to Night the first and Night the Second." She is overshadowed by the serpent, symbol of eternity or repetition, that encircles her in the next illustration, NT 79.[18] She thus becomes part of a program that Grant reads as ordering Blake's designs.

In his review, Mitchell objected to this as a particular instance of the general failure he found in the "Introduction" to pay enough attention to the text Blake was illustrating, "as if Young's poem has disappeared in favor of

48. William Blake, illustrations to Young's *Night Thoughts*, 78: title page to Night the Third

some Blakean fable which the editors are reading into the design."[19] Specifically, he finds the identification of the woman as Narcissa a mistake, since "the moon goddess depicted on the title page is clearly not the unfortunate Narcissa, but the lunar deity whom Young invokes as the muse of his song in the third Night," a figure to be identified as the Duchess of Portland, to whom Night the Third is dedicated. He adds that the design "transforms Young's Greek lunar goddess into her Christian analogue, the Virgin as Queen of Heaven, the 'woman clothed with the sun' described in Revelation 12." In sum, Blake's title page is read as a witty illumination of Young's text that transforms "his stoic, latitudinarian morality, stale Greek mythology, and urbane social flattery into a visionary, enthusiastic, and apocalyptic statement. The transformation works not against the spirit of Young's text, but as a way of freeing what is latent in it."[20]

The disagreement was continued in a reply by Grant to Mitchell and other critics, in which Grant confirms his belief that the woman of the title

page design is the Narcissa who represents Young's lost stepdaughter and, "like Eurydice alluded to in the Virgilian inscription, is a victim of the unforgiving Manes"; she can however "hardly represent the Duchess of Portland."[21] Mitchell, in responding in his turn to this, comments that the key question between them is "the programmatic theory about Blake's designs that Grant is pushing in his commentary,"[22] and there the matter rests.

I have given the disagreement in some detail because it illustrates some key questions so well, and because it offers both an opportunity and a challenge to the interpreter. The questions at play can be summarized as follows: what is the identity of the woman on the title page illustration; what, if any, is her relation to Young's text; and is Blake shaping his illustrations into discernible groups in the pursuit of a visual program of his own?

The problem of the identity of the woman in NT 78 can be approached by first considering the general issue of what Blake does in handling title pages where there is no, or virtually no, text to shape his design. All of the Nights except the Seventh and Eighth are dedicated to specific people of Young's acquaintance, and in no case, with this one possible exception of Night Three, does Blake respond to these dedications. Blake, and this should come as no surprise, disregards the social setting surrounding the writing of Young's poem in favor of the fundamental poetic metaphors at play in the text. Sometimes, as in the case of the first two Nights, he picks up the language of the subtitle and illustrates Young's allegorical personages – "Life, Death, & Immortality." If the illustration to the title page of Night the Third were based on the dedicatee, the Duchess of Portland, it would be very much an exception to the usual manner of Blake's response to Young.

It thus seems unlikely that Blake conceived the figure of the woman of the title page of Night the Third with the Duchess of Portland in mind; the latter is only referred to obliquely in Young's title page by an initial letter, and in the text of the poem by a footnote on NT 82 and by first and last initials on NT 83. Since the death of Narcissa is the central episode of Night the Third, and since her name figures as the title of the night, I shall assume, with Grant and other commentators, that the woman in the design represents Narcissa in the first instance, though she may include references to others in her total identity.

All commentators agree that the woman clothed with the sun from Revelation 12 plays a large role in the design. The references are unmistakable:

the sunny radiance surrounding her, the stars in the hair, the crescent moon under her feet, the resemblance to the woman in Blake's *The Great Red Dragon and the Woman Clothed with the Sun* (B 519 and 520), all work together to produce a clear allusion.

The allusion can be fully integrated into the meaning of the design in its context. The pregnant woman in Revelation was traditionally identified as the Church and the bride of Christ; Blake in *A Vision of The Last Judgment* identifies her as "the church Universal" (E 559), representing her as a nude woman holding her breasts and surrounded by children. In the poem, Narcissa is described as having died just at the moment before marriage and fulfillment:

> Snatch't e'er thy Prime! and in the bridal Hour!
> And when kind Fortune, with thy Lover, smil'd!
> And when high-flavour'd thy fresh-op'ning Joys! (*NT* 88)

As imminent wife and mother – motherhood is clearly implied in the "Joys" – Narcissa has a typological relationship to the woman clothed with the sun, and that extends to their having both been attacked by a powerful enemy.

Narcissa's fate in the poem is decided by two agents, death and the Catholic Church. The dragon in Revelation, the opponent of the woman clothed with the sun, is for Protestants generally an image of Papacy, the Antichrist, and Blake's designs for *NT* 345 and 349 make clear the general complex of imagery involved. The serpent is one form of the dragon: "And the great dragon was cast out, that old serpent, called the Devil, and Satan, which deceiveth the whole world" (Revelation 12: 9). Blake has chosen the serpent rather than the dragon here in order, as commentators have pointed out, to invoke the image of time as repetition and death. The serpent, in the typological analogy provided by Revelation 12, is the perfect image of the two linked enemies that attempt to destroy Narcissa: death and the Papacy. Narcissa's move towards the status of wife and mother, represented by the brave image of *NT* 78, is baffled, and she is swallowed by the serpent of *NT* 79 – in the terms of the narrative of the poem, she dies and is refused burial in sanctified ground by the inhumanity of the Papacy, imaged by Young in appropriately bestial terms:

> Their Will the *Tyger* suck't, outrag'd the Storm:
> For oh! the curst Ungodliness of Zeal!

While *sinful Flesh* relented, *Spirit* nurst
In blind *Infallibility*'s embrace,
The *Sainted Spirit* petrify'd the breast.

<div align="right">(NT 89)</div>

The analogy with Revelation holds very well. The woman clothed with the sun flees into the wilderness, "where she hath a place prepared of God" to protect her for a while ("two thousand and threescore days") until the time of resurrection: "Now is come salvation, and strength, and the kingdom of our God, and the power of his Christ" (12: 10). In Blake's design the wilderness is represented by the imminent imprisonment of the woman in the coils of the serpent, in despite of her reaching for freedom; the coils of the serpent represent the wilderness of Catholic France in which Narcissa awaits the "Christian TRIUMPH" of Night the Fourth. The image from Revelation is borrowed and put to a new use that still respects the original structure.

Blake's language in other works of the same period reflects the imagery of this design, most conspicuously in the "Annotations to Watson's *An Apology for the Bible*." There he writes that "To defend the Bible in this year 1798 would cost a man his life / The Beast & the Whore rule without controls" (E 611); subsequent comments make it clear that it is "State Religion" (E 613) and its aggressions against France and the individual that are meant by the images from Revelation. Blake is in agreement with Young on this, with the major exception that Blake has included the Anglican Church in his attacks on Priestcraft. But he certainly welcomed every opportunity given him by Young to show the Papacy in the demonic imagery of Revelation.

And the Duchess of Portland? The text of Night the Third begins by opposing *"Dreams"* to *"Reason"* and paralleling that with the opposition between *"Phoebus"* with his "Intrusions loud, and rude Assaults," and the moon, *"Day's* soft-ey'd Sister," to whom the poet will pay court. In this act he becomes *"Endymion's* Rival," and implores the aid of the moon "in succour to the *Muse*." It is at this point in the poetic argument that Young refers to the Duchess of Portland:

Thou, who didst lately borrow★ *Cynthia's* form,
And modestly foregoe thine Own! O Thou
Who didst thyself, at Midnight Hours, inspire!
Say, why not *Cynthia* Patroness of Song?

<div align="right">(NT 82)</div>

★[note] At the Duke of *Norfolk's* Masquerade.

The Duchess of Portland is simply absorbed into the structure of the poem in a way designed to pay a graceful compliment without straining the fabric of the imagery. She becomes a local and temporary home for the larger poetic identity of the goddess of the moon, who is invoked as Young's Muse. The Duchess is part of the moon/Muse complex, which Young keeps quite distinct from the woman clothed with the sun and Narcissa.

In conclusion, Mitchell is not correct in identifying the woman in NT 78 as the Duchess of Portland. However, Grant's attempt to relate the design to an assumed overall program of Blake's focused on "the Christ who will become triumphant in the title-pages of Night the first and Night the Second" has obscured the real and rich relationships between Blake's illustration and Young's text. Mitchell's critique of such programmatic usurpation of Young's text is fundamentally correct, though the alternative interpretation that Mitchell proposes does not improve matters. The point will be pursued, not on Mitchell's chosen ground this time, in another of the *Night Thoughts* designs that Grant has interpreted.

V

Grant suggests that Blake is weaving a "picture story… around the materials provided by Young's poetry,"[23] and in pursuit of this story Grant has outlined a theory about Blake's handling of the figure of Christ, maintaining that Blake depicts a Christ who changes and develops during the course of the illustrations. A key design in this program is the depiction of Christ as the Good Samaritan in NT 68 (page 37 of the engraved edition, illus. 49).

In their useful edition of *Night Thoughts*, Robert Essick and Jenijoy La Belle give both the "Explanation of the Engravings" bound into some copies of Edwards edition and a commentary of their own. The "Explanation" of the design reads as follows: "The story of the good Samaritan, introduced by the artist as an illustration of the poet's sentiment, that love alone and kind offices can purchase love."[24] The explicator, whoever it was, reads the design as illustrating the text quite straightforwardly, paraphrasing the very line starred by Blake in the text that he used for his original watercolor drawing, which reads: "Love, and love only, is the loan for love."[25]

The editorial commentary by Essick and La Belle that follows focuses on the difficulty of interpreting the cup offered by the Samaritan, which bears a serpent motif on its side. They write:

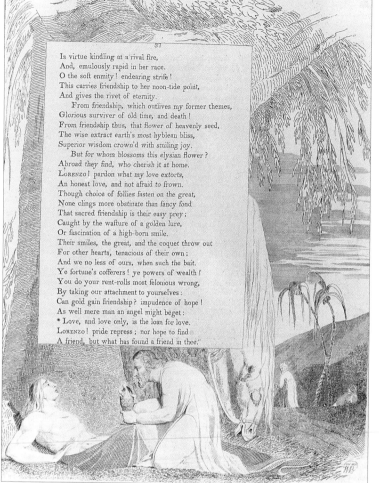

Is virtue kindling at a rival fire,
And, emulously rapid in her race.
O the soft enmity! endearing strife!
This carries friendship to her noon-tide point,
And gives the rivet of eternity.
 From friendship, which outlives my former themes,
Glorious surviver of old time, and death!
From friendship thus, that flower of heavenly seed,
The wise extract earth's most hyblean bliss,
Superior wisdom crown'd with smiling joy.
 But for whom blossoms this elysian flower?
Abroad they find, who cherish it at home.
Lorenzo! pardon what my love extorts,
An honest love, and not afraid to frown.
Though choice of follies fasten on the great,
None clings more obstinate than fancy fond
That sacred friendship is their easy prey;
Caught by the wafture of a golden lure,
Or fascination of a high-born smile.
Their smiles, the great, and the coquet throw out
For other hearts, tenacious of their own;
And we no less of ours, when such the bait.
Ye fortune's cofferers! ye powers of wealth!
You do your rent-rolls most felonious wrong,
By taking our attachment to yourselves:
Can gold gain friendship? impudence of hope!
As well mere man an angel might beget:
* Love, and love only, is the loan for love.
Lorenzo! pride repress; nor hope to find
A friend, but what has found a friend in thee."

Not only does the serpent represent mortality throughout Blake's *Night Thoughts* designs, but the cup and serpent motif is also a traditional emblem for St. John the Evangelist. The Emperor Domitian once tried to kill St. John with a cup of poisoned wine, but a serpent sprang from the cup as a miraculous warning to the intended victim. Thus the prone figure in this illustration would be quite justified in shunning, as he seems to do with his hand gesture, the offer of an ostensibly poisonous gift. The difficulties in reconciling the disparate allusions in the design are almost as great as recognizing true friendship.

49. William Blake, engraving for Young's *The Complaint, and Consolation; or, Night Thoughts* (London, 1797), 37; the Good Samaritan

This offers an explanation, while recognizing the interpretive difficulties. It also identifies two key images of uncertain meaning, the serpent on the vessel, and the victim's gesture of apparent rejection.

Discussion of this image resumes with Grant's essay.[26] His comments are framed within the thesis that Blake refocuses Young's God the father as Jesus the brother of man, and that Blake, in the course of finding ways of introducing the figure of Jesus where it is not explicitly demanded by Young's text, shows Jesus as a figure who gathers power as the illustrations to the poem progress. Blake, Grant claims, is pursuing a program of his own not based on Young's text.

After *NT*1, which does not illustrate any specific text, the first clear depiction of Jesus is as the Good Samaritan of *NT* 68. Grant notes that traditional interpretation allowed for an identification of the Good Samaritan as an image of Jesus himself. This can be confirmed from the commentators; John Gill, for instance, in referring to the Samaritan, says succinctly "By whom Christ may be meant."[27] The interpretation was commonplace.

In spite of his acceptance of this identification, Grant goes on to build a case for a rather negative view of the action depicted in the design, pointing to some of the features that troubled Essick and La Belle. He refers to the

disturbing snake, and then finds negative implications also in the interaction between the two human figures in the drama:

> The startled appearance of Jesus in the watercolor version constitutes a clear sign that he had been unprepared for rejection by the Jewish victim... Such details indicate that Blake wished to introduce doubts as to whether this Good Samaritan could have succeeded as a benefactor or "Friend of All Mankind."
>
> (E 524)

Grant's comments on the etched version modify this view just a little, suggesting that "now Jesus is represented as being masterfully composed and earnest as he proffers his cure." But his view of the general sense of the scene is unchanged, and still focused on the serpent, "the ominous but still perfectly apparent presence depicted on the cup."[28] Grant's view is summed up in this passage: "the posture of Jesus crouched beneath the text panel, holding unopened the sinister decorated cup, repelled by the victim he wishes to help, marks (at this stage) his inability to accomplish his mission."[29] The Good Samaritan shows an embryonic Jesus, not yet capable of powerful action against resistance, and offering possibly poisonous gifts.

This reading is based on an interpretation of the image of the serpent, but any reading of this serpent must first consider the nature of the representation involved. The negative interpretations are based on what would be appropriate responses to a real, living animal. But we are actually dealing with the representation of a representation of a serpent, incised on the body of the vessel. As a once well known writer on perspective put it, "we are sometimes charm'd to see that in a Picture, which would be frightful if we saw it really. A Serpent causes Fear, but its Picture, if well done, is charming."[30] Terror and horror would be merely misplaced superstition; we, and the victim, are dealing with an image, not an animal, and that image must be interpreted symbolically, as the representation of a meaning.

That symbol needs clarification. Essick and La Belle refer to the story of St. John the Evangelist. This is without much doubt the foundation of the description of Fidelia in the house of Holiness in Book I of Spenser's *The Faerie Queene*, which at first sight might appear to offer a good analogy with the design under consideration:

> She was araied all in lilly white,
> And in her right hand bore a cup of gold,
> With wine and water fild vp to the hight,

> In which a Serpent did himselfe enfold,
> That horrour made to all, that did behold.[31]

Hamilton's note on this passage tells us that "St. John the Evangelist is usually represented with a chalice out of which issues a serpent... The *Golden Legend* records the familiar story of how John drank a cup of poison to prove his faith." That story only makes sense, however, if we understand this serpent to be alive and capable of a mortal bite, so that to overcome the fear of such a death is an indication of true faith. The apparent analogy between the story of St. John and Blake's design is not in fact substantial or useful.

There is another traditional interpretation of the image of the serpent, however, of which Hamilton reminds us; it is also "the emblem of Aesculapius, the symbol of healing; also of the crucified Christ, the symbol of redemption. The serpent lifted up by Moses (Num. 21.9) is interpreted typologically as Christ lifted up on the cross (John 3.14)." This means that the story of Aesculapius can be read as a type of the story of Jesus, as is suggested by Sandys's version of Ocyroë's prophecy over the infant Aesculapius:

> Health-giver to the World, grow infant, grow;
> To whom mortalitie so much shall owe.
> Fled Soules thou shalt restore to their aboads:
> And once again the pleasure of the Gods.
> To doe the like, thy Grand-sires [Jupiter] flames denie:
> And thou, begotten by a God, must die.
> Thou, of a bloodless corps, a God shalt be:
> And Nature twice shall be renew'd in thee.

This is supported by Sandys's commentary on the account of the removal of Aesculapius to Rome in the fifteenth book: "For the Serpent was sacred unto him; not onely... for the quicknesse of his sight... But because so restorative and soveraigne in Physicke; and therefore deservedly the Character of health. So the Brasen Serpent, the type of our aeternall health, erected by *Moses*, cured those who beheld it."[32] These mythographical comments, from a source that Blake almost certainly knew,[33] provide us with an appropriate reading of the serpent image on the chalice. The reading is confirmed by the appearance of not one but two serpents on the flask carried by the foremost figure in Blake's *The Body of Christ Borne to the Tomb* (B 426; illus. 50); Blake assumes that serpents are an appropriate decoration for any flask containing medicinal or herbal potions.

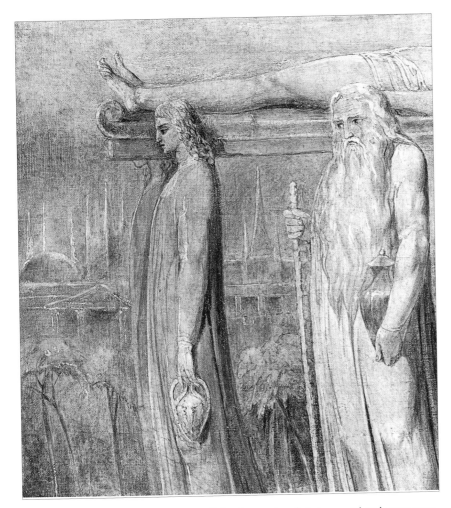

50. William Blake, *The Body of Christ Borne to the Tomb*, detail (B 426)

The explicitly medical nature of the Samaritan's intervention is not overlooked by eighteenth-century commentators. John Gill gives a heavily allegorized interpretation: the wounds of the victim represent "the morbid and diseased condition that sin has brought man into," which are "incurable by any, but the great physician of souls, the Lord Jesus Christ."[34] In the context of this offering of medical help by a figure whose face is clearly modeled on that of Jesus, one must interpret the serpent-decorated chalice as an emblem of both Aesculapius, the god of healing and medicine whose conventional attribute was the serpent or the caduceus, and of Jesus, the true healer whom Blake has made visible within the body of the Samaritan, who is also associated with the symbol of the serpent, and with a chalice filled with healing liquids. Blake is implying that any act of helping and healing is the act of a true Christian. The Good Samaritan is an incarnation of Jesus in his function as Aesculapius, the power to heal.

In *A Descriptive Catalogue*, Blake describes the Doctor of Physic as "the first of his profession; perfect, learned, completely Master and Doctor in his art," and then identifies him as "the Esculapius," one of the "eternal

Principles that exist in all ages" (E 536). Blake, however, is not illustrating his own myth, but building on public and widely known attributes.

The right hand of the Samaritan is about to lift the lid of the vessel; it contains the "oil and wine" referred to in the Gospel account, which the Samaritan poured in as he "bound up his [the victim's] wounds." The two liquids were conventionally understood as antiseptic (wine) and healing balm (oil), which, as John Wesley explains, "when well beaten together, are one of the best balsams that can be applied to a fresh wound."[35] Gill gives a more typologically oriented explanation that bridges the gap between Aesculapius and Jesus: "by *oil* may be meant, the grace of the Spirit of God… and by *wine*, the doctrines of the Gospel."[36] The implied contents of the vessel in Blake's design can thus be read as a conventional healing mixture, which in its literal form is as appropriate to Aesculapius as it is appropriate to Jesus when typologically understood, as Matthew Henry shows: "Jesus, that good Samaritan… has compassion on us, he binds up our bleeding wounds (Ps. 147. 3 Isa. 61. 1.) pours in, not *oil and wine*, but that which is infinitely more precious, *his own blood*."[37]

Matthew Henry's commentary is again useful in focusing a sometimes neglected aspect of the story: the victim "was *succoured* and *relieved* by a *stranger*, a *certain Samaritan*, of that nation which of all others the Jews most despised and detested and would have no dealings with."[38] Henry's statement is based on such texts as Matthew 10: 5, which has Jesus instructing his disciples "Go not into the way of the Gentiles, and into any city of the Samaritans enter ye not" and John 8: 48, which has the Jews say to Jesus "Say we not well that thou art a Samaritan, and hast a devil?" The victim is presumably a Jew, since he is on a journey from "Jerusalem to Jericho," and the story registers disappointment if not surprise that he is ignored by "a certain priest" and a "Levite" (Luke 10: 30–32). The victim shows astonishment and perhaps fear (the Samaritan may have a devil) because help is coming from a despised source, after two likely sources have failed him. He is not rejecting that aid.

The facial expression and the gesture made by the victim become clearer in the light of this understanding of their context. The manual gesture is almost identical with that made by Robinson Crusoe as he discovers the footprint in the sand (B 140r; illus. 2). Here is the text that Blake was illustrating: "It happen'd one Day about Noon going towards my Boat, I was exceedingly surpriz'd with the Print of a Man's naked Foot on the Shore,

which was very plain to be seen in the Sand: I stood like one Thunderstruck, or as if I had seen an Apparition."[39] Defoe's text makes plain that Crusoe's gesture is understood by Blake as meaning surprise and fear. It is described by Le Brun as proper to "Admiration [which] causes Astonishment": "this first and principal Emotion or Passion may be expressed by a person standing bolt upright, with both Hands open and lifted up, his Arms drawn near his Body, and his Feet standing together in the same situation."[40]

Martin Meisel quotes the *Thespian Preceptor* of 1810 (too late to shape the design being considered, but almost certainly derived from Le Brun) as defining Fear in the following gesture: "Fear, violent, and sudden… draws back the elbows parallel with the sides, lifts up the open hand (the fingers together) to the height of the breast, so that the palms face the dreadful object, as shields opposed to it; one foot is drawn back behind the other, so that the body seems shrinking from danger, and putting itself in a posture for flight."[41] Fear and surprise are both aspects of the root of Admiration or Astonishment coded by Le Brun. Surprise at the source of help is tinged by fear that it may conceal a hidden malevolence. A gesture which has been read as if it were a natural sign to be interpreted as meaning rejection, is in fact a conventionally coded sign meaning surprise and wonder. As in the case of the serpent, the semiotic status of a sign must be determined before it can be interpreted.

Having now focused this gesture, we can see that it is very common in Blake's work, and occurs frequently in the *Night Thoughts* illustrations. Its meaning there seems to range from joyful surprise at the resurrection (*NT* 318), through awed shock at apocalypse (*NT* 429), to fearful recognition of guilt, condemnation, and disaster (*NT* 18, 53). But through all these changes there remains the root sense of "Astonishment." The gesture seems never to mean simply rejection, though there can be an element of rejection in the shocked recognition of unwelcome news.

Blake's use of the standard gesture for rejection appears in the illustrations to Milton's *Paradise Regained* in the depiction of Christ's rejection of Satan's banquet (B 544: 6; illus. 51); rejection is signaled by the averted body and head, a gesture that reaches back at least to Quintilian: "we shall show our aversion by turning away the face and by thrusting out our hands as though to repel the thought."[42]

This interpretation of the victim as expressing profound surprise at the

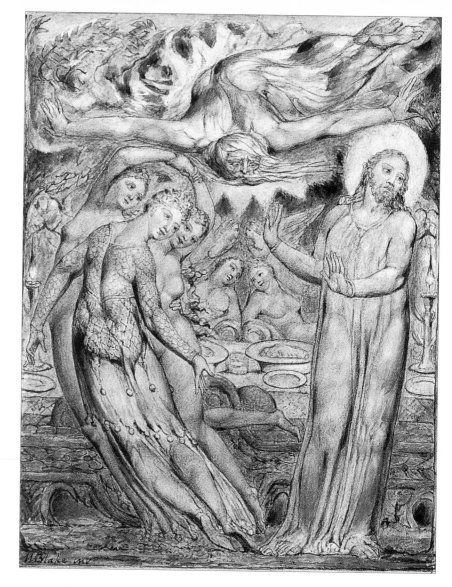

51. William Blake, illustration to
Milton's *Paradise Regained*, Christ's
rejection of Satan's banquet (B 544: 6)

source of the offered help is confirmed by another detail. The victim's eyes
fix not the allegedly threatening serpent but the eyes of the Samaritan; it is
the human source of the help that prompts the victim's response, not the
offered medicine. The face of the Samaritan shows concern and compas-
sion; nothing more complex or questionable than that.

The horse is equally innocent of ethical ambiguity or menace. Grant's
association of him with the allegedly sinister donkey "included among the
ominous familiars" of Hecate in the color print of that name is an unneces-
sary hypothesis. I have in the previous chapter suggested that the donkey in
Hecate is merely a beast of burden; all of the other associations of this ani-
mal are innocent and even benign, and I see no reason to assume any
change in Blake's version of it in the Good Samaritan.

Let us look at the design again in its context. As the asterisk beside the
text in both the original watercolor and the later etching indicates, Blake

began with the line "Love, and love only, is the loan for love." This line is set in the broader context of a musing on the theme of friendship, which blooms "abroad" for those "who cherish it at home," but resists the blandishments of power and money: "Can gold gain friendship?" Young's musing concludes with the thought that Lorenzo should not

> hope to find
> A Friend, but what has found a Friend in Thee.
> All like the Purchase, Few the price will pay;
> And this makes Friends such Miracles below.

Blake, looking for a story with which to illustrate the subject, decided upon the story of the Good Samaritan in Luke 10: 25–42. He was drawn to it in part, perhaps, because Young had already asked "For what calls *thy* Disease *Lorenzo*? not / For *Esculapean*, but for *Moral* Aid" (*NT* 41). The association (even in disjunction) of medical and moral aid may have sent his thoughts towards Luke, "the beloved physician" (Colossians 4: 14), who tells the parable of the Good Samaritan, another figure who combines medical and moral aid. The story picks up the opposition between "home" and "abroad" in Young's lines, and develops it in the direction of showing a friendship not dependent upon gold or proximity.

But the story does not exactly illustrate Young's point. The parable of the Good Samaritan is an illustration of the problem of defining just who is my neighbor, a problem opened by the lawyer's trick question to Jesus: "Master, what shall I do to inherit eternal life?" (Luke 10: 25). In response to Jesus's question about the status of the law on this point, the lawyer interprets it as saying: "Thou shalt love the Lord thy God with all thy heart, and with all thy soul, and with all thy strength, and with all thy mind; and thy neighbour as thyself." In response to Jesus's approbation, the lawyer then asks "And who is my neighbour?" It is at this point that Jesus tells the story, which he concludes by asking: "Which now of these three [priest, Levite, Samaritan], thinkest thou, was neighbour unto him that fell among the thieves?" The obvious answer comes: "He that shewed mercy on him." To which Jesus replies, "Go, and do thou likewise."

A true neighbor does not simply return love for love, or buy love by lending or giving love, but freely gives love to those most culturally remote when they are in need, even if they have shown nothing but scorn in the past, are not likely to change in the future, and may have no occasion to

return that love. Young had stated that "Love... is the loan for love," and had gone on to advise "nor hope to find / A friend, but what has found a friend in thee." Blake's chosen story goes well beyond that rather impoverished doctrine of mere monetary equivalence; the victim has just found a true friend in one towards whom he had always expressed contempt, and from whom he should expect nothing according to Young's morality.

But do these differences mean that Blake is rejecting or inverting Young's position, or that Blake is simply inscribing moral arabesques, weavings around Young's spring? Young's lines urge Lorenzo not to seek friends on the grounds of wealth: "Can Gold gain Friendship?" The story of the Good Samaritan does not cancel that morality so much as surpass it; friendship, true neighborliness in action, asks no questions, and seeks no response. Jesus as the Samaritan represents precisely the possibility of advancing beyond the position outlined by Young, though without explicit discord. Blake is playing Jesus to Young's lawyer, sending him home implicitly rebuked and pushed onwards along the path towards insight and love.

Grant's problems with this design are rooted in a desire to prove a thesis that assumes that Blake imposed a large-scale program of his own upon Young's poem. In the place of that thesis more time and thought should be spent on the relationship between the text of the story being illustrated and Blake's design, and on the details of that design in relation to the traditions of pictorial meaning as Blake knew and understood them. As I have tried to show, Blake's designs can bear Blakean meanings without being in any way direct illustrations of his own poetic mythology. There is indeed a critical distance between Blake's design and Young's text, but it is to be found not within Blake's version of the story of the Good Samaritan, which he has handled with his usual close attention to the details of the biblical story, assisted by traditionally based iconographic details, but in his choice of that particular story, which offers a subtle, sympathetic but profound critique of Young's economy of love as exposed at this moment of the poem.

If we take this design of the Good Samaritan as offering a paradigm of the relationship between Blake and Young, we could conclude that Blake respects the moral intent and the actively personifying imagination of Young, but feels free to extend his own commentary on the situations and images presented by the text, and free to extend Young's values in directions of his own. Variation and extension seem the key words rather than opposition or inversion.

Blake's Bible

Blake's work on the Bible began very early with such designs as *Saul and the Ghost of Samuel* (B 75, *c*. 1775–80) and continued to the end of his life with such works as the illustrations to Job and the illustrated manuscript of Genesis (B 828, *c*. 1826–27). A few of Blake's early Bible illustrations have been discussed in previous chapters. Roughly in the middle of this career-long involvement came the tempera and watercolor series of pictures made for Butts. This chapter will deal with aspects of those two series and the criticism they have prompted.

Blake's attitude towards the Bible can be assumed to have developed with his changing attitude to the whole Christian story, but there were some constants. One was the view that the text of the Bible was strong poetry, available for use and inspiration without any fundamentalist superstition for the text as unalterable and sacrosanct. The Bible was to be respected in the way in which all great poetry was to be respected, for the focused images of life that it presented, not as the unchangeable container of a once-and-for-always doctrine.

Blake, in an account to Butts of a now lost painting, describes himself as free, like Milton, to take over and reframe incidents from the Bible:

> I send you the Riposo which I hope you will think my best Picture in many respects. It represents the Holy Family in Egypt Guarded in their Repose from those fiends the Egyptian Gods. and tho' not directly taken from a Poem of Miltons (for till I had designd it Miltons Poem did not come into my Thoughts) Yet it is very similar to his Hymn on the Nativity... I have given in the background a building which may be supposed the ruin of a Part of Nimrods tower which I conjecture to have spread over many Countries for he ought to be reckond of the Giant brood[.]
>
> (E 729)

The Bible provides the substance of the narrative and the major images, but Blake has felt free to invent circumstances that give it an original direction. He is in a position analogous to that of Milton inventing a poem around a biblical incident, but not confined to passively illustrating the text.

This points towards Blake's understanding of typology, one of the traditional ways of drawing the manifold text of the Bible into coherence. Orthodox typology sees Christ as the antitype, the final source of the meaning of a type, which is a semi-mute striving to reach the full articulation

attendant upon the Incarnation: John Jortin defined a type as "a rough draft, a less accurate pattern or model, from which a more perfect image or work is made."[1] Typology focuses on the relationship between the two testaments, often in an attempt to overcome and explain the apparent differences between them in order to make the Old Testament more directly available for Christian use.

Blake's view is a little different. His statements imply an understanding of the historical Jesus not as the final revelation but rather as a key, but not definitive, statement that leaves room for the later and equally powerful articulations of a poet/prophet like Blake, or indeed Paine: "Christ died as an Unbeliever. & if the Bishops had their will so would Paine... but he who speaks a word against the Son of man shall be forgiven let the Bishop prove that he has not spoken against the Holy Ghost who in Paine strives with Christendom as in Christ he strove with the Jews" (E 614). Blake, since he was not a Trinitarian, can write of the Holy Ghost as the medium of the transhistorical Jesus working through time to inspire all true poetry and prophecy; the historical Jesus was one instrument of that power, as Paine and Blake are different instruments in the present. Typology therefore cannot be referred to the Jesus of the gospels for its final interpretation; a later statement may alter the ratio between type and antitype.

Interpretation must look to the inspiring power of the Poetic Genius or Holy Ghost for its justification, not to the static text of the historical Bible: "The Bible or Peculiar Word of God, Exclusive of Conscience or the Word of God Universal, is that Abomination which like the Jewish ceremonies is for ever removed & henceforth every man may converse with God & be a King & Priest in his own house" (E 615). The Bible is open to appropriation by powerful poets and painters, who as channels of the "Word of God Universal" have license to reshape and reinterpret its narratives.

That freedom, however, does not erase the value of the Bible as record of past inspiration. The Bible contains two parts, "the Jewish & Christian Testaments," which are equally "An original derivation from the Poetic Genius" which is "every where call'd the Spirit of Prophecy" (E 1). Blake is not always consistent in his statements on this issue; for instance, in the later annotations to Watson's *An Apology for the Bible*, he says that "Christ [came] to abolish the Jewish Imposture" (E 614), discarding the complexities of typology for the simplicity of replacement and cancellation. Here Blake takes a hard line on the Old Testament: "Was not Christ murderd because

he taught that God loved all Men & was their father & forbad all contention for Worldly prosperity in opposition to the Jewish Scriptures which are only an Example of the wickedness & deceit of the Jews & were written as an Example of the possibility of human beastliness in all its branches" (E 614).

However, even these portions of the Bible possess poetic power in "the Sentiments & Examples which whether true or Parabolic are Equally useful as Examples given to us of the perverseness of some & its consequent evil & the honesty of others & its consequent good" (E 618). Much of the Old Testament can be rejected as morality while simultaneously accepted as inspired, and useful, poetry.

From this perspective, there is a contrast between the historical books of the Old Testament and the utterances of the prophets, who acted as witnesses to the Holy Ghost in speaking against the wickedness they saw around them. Blake's profound respect for the prophets was shaped by, among other influences, Michelangelo's portraits and Lowth's demonstration that the prophets were poets of the first rank, especially Isaiah: "Isaiah, the first of the prophets, both in order and dignity, abounds in such transcendant excellencies, that he may be properly said to afford the most perfect model of the prophetic poetry."[2] The Old Testament includes within its structure a prophetic vision sufficiently powerful to put even its most appalling stories into a larger framework, a power reflected by Blake in his depiction of Isaiah in *The Marriage of Heaven and Hell*: "I saw no God. nor heard any, in a finite organical perception; but my senses discover'd the infinite in every thing, and as I was then perswaded. & remain confirm'd; that the voice of honest indignation is the voice of God, I cared not for the consequences but wrote" (E 38). Such prophecy unites the two testaments by pointing towards the perspective of the Jesus and Paul of the New Testament, and the final vision of Revelation; the historical books of the Old Testament belong to a different world, their stories to be understood as examples of morality to be cast out from one view, and as visionary fables about occasions for forgiveness from a deeper view.

We should therefore be prepared to find a free kind of typology in Blake. One would anticipate a respect for the actual shape of historical moments from the Old Testament, since their value depends on the example given rather than on a doctrine expressed; a prophetic perspective may be additionally implied to shape our response to the event. Traditional typology dissolves into freedom; all genuine creation is inspired, and no interpreta-

tion is final. Traditional typology demands a fixed and final reference point, prophetic poetry always makes it new.[3]

In the Bible illustrations made for Butts, Blake was commissioned by a believing Christian to produce two series of Bible illustrations for a setting we know nothing about. Neither do we know in detail such basic matters as who had responsibility for the choice of subjects. We do know, however, that Butts chose at least some of the subjects for the tempera series, because Blake writes on 2 October 1800 that "I have not got any forwarder with the three Marys or with any other of your commissions" (E 712). In another letter Blake writes of having "sent all the sketches of this subject that I ever have produced" (E 717), and again in a letter of 22 November 1802 he asks "what subject you choose to be painted on the remaining Canvas which I brought down with me" (E 720). Finally, Blake, in another letter of the same date, writes that "I now Send Two Pictures & hope you will approve of them" (E 720). This suggests that Butts had first responsibility for the choice of subject, and that Blake then made sketches for his approval, though sometimes, particularly as the project developed, Blake sent paintings without prior approval of the design, always with a power of refusal in Butts. Blake later wrote that he would "relinquish Any engagement of Designing at all unless altogether left to my own Judgment. As you My dear Friend have always left me" (6 July 1803, E 731), implying that Blake maintained independence, not necessarily in the choice of subject, but always in the handling and design.

The paintings, with virtually no exceptions other than those few not based on the text of the canonical Bible, are taken from those books of the Bible declared to have a visionary internal sense by Swedenborg, though since there is substantial overlap with the prophets that Lowth defines as the poetic parts of the Bible that may not be significant, and in any case may reflect Butts's taste more than Blake's decision.[4] I shall not attempt a survey of all the designs, but shall focus on just a few, placed in three groups, which raise questions of interpretation concerning Blake's response to the text of the Bible, and with the critical traditions that have grown up around these designs.

II

The two paintings to be considered first are from the Old Testament, and have both been seen as examples of what Blake called "Human Beastliness." Two themes will be pursued in discussing these paintings, one the sometimes problematical nature of assigning moral praise or blame in such designs, and the other the possibility that for Blake, as for Fuseli, "All ornament ought to be allegoric."[5]

Commentators on Blake's paintings have often proceeded by labeling a character good or bad, generated or regenerated. One problem with such approaches is that Blake can be quoted to support almost any valuation: one can choose, for instance, between "Energy is the only life and is from the Body" (E 34) and "the Vile Body only &... its Laws of Good & Evil & its Enmities against Mind" (E 667). In the face of such variability, one should be wary of attempting the imposition of an allegedly Blakean morality upon his illustrations of complex incidents from the Bible. One could be simultaneously both wrong and profoundly unBlakean in applying the "Laws of Good & Evil."

The tempera of *Bathsheba at the Bath* (B 390; plate v) is one design which can at first sight be assigned a place in Blake's moral scheme of the Bible with confidence; besides the explicit phrase "wickedness in David or Abraham" (E 618), there is the statement that "To Extirpate a nation by means of another nation is as wicked as to destroy an individual by means of another individual which God considers (in the Bible) as murder" (E 615), which sounds as if Blake has in mind David's use of Joab to cause the death of Uriah. But Blake also writes through Ezekiel that "we of Israel taught that the Poetic Genius (as you now call it) was the first principle... it was this. that our great poet King David desired so fervently & invokes so patheticly" (E 39), and in his own voice that "Jesus as also Abraham & David considerd God as a Man in the Spiritual or Imaginative Vision" (E 663). Can Blake really see David in both ways, and are there implications for us as viewers of this painting?

The painting shows a slender and beautiful young woman accompanied by two equally beautiful children, presumably hers from the affectionate way her hands rest on their shoulders, one a boy and the other a girl. To the right are roses and lilies: beauty, love, innocence. Another woman, with a heavier and more obviously sensual body, sits on our left on the edge of the bath holding out her hair with her left hand, and resting the right on a flask

holding oil or some other accompaniment of the bath. To the left, beside her, is a climbing flower, identified as a honeysuckle by Rodney M. Baine, and associated with fertility, perhaps "to remind us of David's line."[6] David is visible at the extreme top right, looking down from the roof of his house as 2 Samuel 11: 2 describes him: "And it came to pass in an eveningtide, that David arose from off his bed, and walked upon the roof of the king's house: and from the roof he saw a woman washing herself; and the woman was very beautiful to look upon." We can ask two questions of Blake's handling of the scene: why has he added a second woman and her two children to the biblical narrative, and why has he chosen his point of view in a way to emphasize the different kinds of sensuality of the two women, and, one could add, of the young girl?

The Bible describes Bathsheba as "washing herself," and the only figure of whom that can be said is the woman sitting on our left. That woman presents, more or less, her breasts and face to David's eye, and even seems to be looking at him, in so far as one can accurately judge the direction of her gaze. That woman is Bathsheba, who will bear David a son, Solomon, an ancestor of Jesus (Matthew 1: 6, Luke 3: 31). It was usual for artists to show Bathsheba actually washing, as the Bible describes her; Raphael's version shows her washing her hair while seated, in a posture very similar to that of Blake's figure.[7] The other woman, who presents her less explicitly sexual back to David, while favoring us with her fair front, is Maachah, the mother of Absalom and Tamar, the two children she caresses. Blake has put together two texts: 1 Chronicles 3: 2, which lists David's sons: "The third, Absalom the son of Maachah the daughter of Talmai king of Geshur"; and 2 Samuel 13: 1: "And it came to pass after this, that Absalom the son of David had a fair sister, whose name was Tamar." These texts imply that Maachah was a previous wife of David, who had already borne him two children. Blake has emphasized the infidelity of David by including in his design a previous bed companion and their two children, surrounded by the emblems of love and beauty to strengthen the implicit reproach. The honeysuckle of fertility is placed next to Bathsheba to emphasize her future pregnancy. The women's bodies reflect the difference: Bathsheba's heavily sensual and relaxed figure contrasts with the cooler, chaste slenderness of Maachah. In stylistic terms, Blake shows David being unfaithful to a slender Florentine in favor of a Venetian or even Rubenesque fleshliness.

David and Bathsheba look across the whole diagonal of the picture,

establishing an axis on which the action is articulated. A realistic assessment of sight lines would conclude that Maachah and her children would be caught in the cross fire – a symbolically appropriate position – but the impression of a direct line of vision between David and Bathsheba persists. The reading incorporates the flowers, a major ornament in the design, into the meaning of the picture; the twining honeysuckle seems almost to grow from Bathsheba's body, while the drooping lilies beside Maachah and her children echo the rather wistful, even sad, inclination of her head; they already sense the imminent betrayal.

Little Tamar steps forward bravely, but she too will be betrayed into a destructive sexual encounter; she will be raped by her half brother Amnon, who in turn will be killed by order of Absalom (2 Samuel 13). There is a partial symmetry in the stories played out by the figures in the design: both Bathsheba and Tamar are taken possession of by powerful men prepared to use dirty tricks and brute power. But justice finally avenges the betrayed women: David has Uriah killed in order to ease his possession of Bathsheba, but as Nathan tells him, "Now therefore the sword shall never depart from thine house; because thou hast despised me, and hast taken the wife of Uriah the Hittite to be thy wife" (2 Samuel 12: 10); and Amnon tricks Tamar into coming alone to his house, but is killed by order of Absalom, her brother and his own half brother, in an act of vengeance. The second story is another of the punishments that came upon the house of David because of his theft of Bathsheba, so that the two stories are deeply intertwined in the Bible account.[8] The sequence ends with the death of Absalom and David's weeping over him (2 Samuel 18: 33), a moment to which Blake refers in *The Gates of Paradise*.

Blake includes a maximum of implication in his choice of figures, with the lilies and roses there to reinforce the pathos of the betrayal and victimization of women, and the honeysuckle as a reminder of the fruitfulness of David's union with Bathsheba; their offspring Solomon was one whom "the Lord loved" (2 Samuel 12: 24). Thus a transgressive mis-step can be simultaneously an advance. The almost ostentatious display of female nudity reinforces the ambiguities of the situation; the picture suggests the motives for David's lust for possession and conquest, while recognizing that sexual pleasure and arousal have a place in the scheme of things.

Everything that Blake shows, with the exception of the flowers, is in the Bible, but not in one place. Blake has constructed his own rich composite

text from several biblical texts in order to provide an underpinning for his design, and to bring out the underlying dynamic that Blake sees at work. Blake has ornamented the story to throw into relief both the temptation undergone by David, and the pain caused by his desertion of a previous companion. The story leaves no doubt that David committed an evil act, one of the items in the Bible read as "a book of Examples" (E 618). But Blake in the same "Annotations to Watson" writes "Do or Act to Do Good or to do Evil who Dare to Judge but God alone" (E 619), and in the "Annotations to Boyd" that "The grandest Poetry is Immoral... the Poet is Independent & Wicked" and "Poetry is to excuse Vice & show its reason & necessary purgation" (E 634). We can apply this and suggest that David as poet commits a crime that transcends as well as transgresses, that the energy that creates his poetry inevitably enters into his actions also, and that the act is finally to be judged not by the standard of any human morality but by God and history; David and Solomon find their way into *An Epitome of Hervey's "Meditations among the Tombs,"* though Solomon, one of "The wisest of the Ancients" (E 702) as he was, also fell off, becoming a "Convert to the Heathen Mythology" and dropping into "the Abstract Void" where he was still followed by "the Divine Mercy" (E 666). Humanity toils in its weaknesses and strengths, and poetry and history together bring about through understanding the "necessary purgation" that moral condemnation does not assist.

Another painting that challenges us to find a response with which we can be comfortable is that of *Lot and his Daughters* (B 381; plate vi). Bindman's comments focus the ambiguities of the situation: he writes that "The story seems to imply for Blake the unnatural sexual divisions of the Fallen world, which led to the creation of Moabites and Ammonites, the enemies of Israel and inheritors of the vices of Sodom and Gomorrah." But Bindman also suggests that Lot is "clearly of the type of Strong Man described in *The Descriptive Catalogue* as acting from conscious superiority," which points to a more positive view of the action depicted,[9] though one difficult to integrate with the suggestion of "unnatural sexual divisions." Essick writes that "the scene suggests Blake's concepts of the limited senses and consciousness of the natural man and his fall into degraded forms of sexuality."[10]

If we turn to the history of visual commentary on the incident, we find generally positive responses. Réau sums up the tradition behind the early painters: "La famille de Lot, conduite par un ange hors de Sodome en

flammes, est la préfigure des Rois Mages qu'un ange invite à repartir de Bethléem par une autre route, et des Justes de l'Ancienne Loi arrachés aux Limbes par le Christ." (Lot's family, led out of a burning Sodom by an angel, is a type of the three wise men invited by an angel to leave Bethlehem by an alternative route, and of the righteous of the Old Testament covenant snatched from Limbo by Christ.) Lot's wife is a type of those who look back with longing at the goods of this world.[11] The Renaissance and Reformation bring changes, but in general the behavior exhibited is condoned. The subject was common; typical is an engraving by Goltzius of Lot and his daughters that has written at the bottom a text beginning "NE IVSTVS PEREAT," in support and explanation of the events portrayed.[12]

Blake's old favorite Boehme produced one of the most sophisticated of the written commentaries:

> In the Truth the figure was internally thus: In *Lot* and his two Daughters, the *Light* of the Understanding concerning the *Messiah* was risen in God's Truth; which *Lot's Daughters* knew very well, that it [namely, the Light of the Sun of Righteousness] in God's Truth had moved itself in their Father *Lot*: from which *Cause* afterwards when they were gone out from *Sodom*, and the Night approached, they made their *Father* drink sweet *Wine* to the full, and laid with him, that they might *receive Seed*, viz. the *holy Seed*, from him; for the Spirit, both in *Lot* and his Daughters, did also signify thus much, in their risen Light, and shewed it to them.

Lot's wife is described as "covetous in the Desire," and in love with "her *temporal Goods*." Boehme deepens his interpretation by writing that the drunkenness was a work of the Spirit of God aimed at covering "the external *Shame*," which was a figure for Jesus's taking upon himself our shame and reproach.[13] The Incarnation includes the taking on board of the full freight of human sensuality. This is close to what seems to be Blake's position, as I shall show.

Many were scandalized by the episode, and Matthew Henry is typical of rather desperate attempts to combine a moral approach with a recognition of the apparent necessity of the act:

> His daughters laid a very wicked plot to bring him to sin; and theirs was, doubtless, the greater guilt... Some think that their pretence was plausible; their father had no sons, they had no husbands, nor knew they where to have any of the holy seed... thus the learned Monsieur Allix... What-

ever their pretence was, it is certain that their project was very wicked and vile, and an impudent affront to the very light and law of nature.

Henry ends his account with a simple piece of morality: "Observe that, after this, we never read any more of Lot, nor what became of him: no doubt he repented of his sin; and was pardoned; but from the silence of the scripture concerning him henceforward, we may learn that drunkenness, as it makes men forgetful, so it makes them forgotten."[14] The episode was obviously profoundly troubling to his mind, and the final pardon does not appear to include the daughters.

It is not possible to reduce the biblical references to a single viewpoint. Bindman has pointed out that the daughters give birth to the Moabites and the Ammonites, "the enemies of Israel and inheritors of the vices of Sodom and Gomorrah." That is made explicit in 1 Kings 11: 7: "Then did Solomon build an high place for Chemosh, the abomination of Moab, in the hill that is before Jerusalem, and for Molech, the abomination of the children of Ammon." That aspect of the history of Moab and Ammon in the Bible is continued in the association of the children of Lot with the gathered enemies of Israel in Psalm 83:8, and brought to a climax by the statement in Zephaniah 2: 9: "Therefore as I live, saith the Lord of hosts, the God of Israel, Surely Moab shall be as Sodom, and the children of Ammon as Gomorrah, even the breeding of nettles, and saltpits, and a perpetual desolation." The escape seems to have been in vain: the descendents of the refugees become identical with those from whom they originally escaped. In Blake's later poetry, Moab and Ammon are reflected in Satan's bosom on the river Pison (J 89: 24–25; E 248); he seems to have accepted a dark view of these two tribes.

But the Bible also records another tradition. Abram goes to the rescue of Lot when the latter is captured (Genesis 14: 12–14), as a sign of their continued family bond, and the same three disguised angels that announce Sarah's coming pregnancy warn Lot and his family to escape the impending destruction of the cities of the plain. Lot answers their warning with an assertion of his grace: "Behold now, thy servant hath found grace in thy sight, and thou hast magnified thy mercy, which thou hast shewed unto me in saving my life" (Genesis 19: 19); his trust is answered (Genesis 19: 21–22, 29). Moses writes that the Lord instructed him not to distress or meddle with the children of Ammon, "for I will not give thee of the land of the chil-

dren of Ammon any possession; because I have given it unto the children of Lot for a possession" (Deuteronomy 2: 19).

In the New Testament both Luke (17: 26–32) and Peter (2 Peter 2: 5–9) interpret Lot, together with Noah, as single just figures saved from a righteous destruction; in Peter's words, "And [God] delivered just Lot, vexed with the filthy conversation of the wicked." In addition, as Matthew Henry notes, "the tribe of Judah, of which our Lord sprang, descended from such a birth [i.e. incestuous], and Ruth, a Moabitess, has a name in his genealogy, Matth. 1. 3, 5."[15] Thus the Bible itself is split on the question; the Old Testament largely looks upon the episode and those involved as shameful, but includes evidence that supports a counterview; the New Testament reinterprets it typologically, and sees redemption at work, though neither Luke nor Peter comment on the seduction.

The positive reading was the more influential for artists, though as in the present case it is sometimes difficult to assess exactly from what position an artist is painting the episode. Commentary descends from both traditions; some does not include Lot's daughters in any explicit fashion, saving the father by damning the daughters as wicked women repeating in act the obscene conversation from which Lot originally fled, rather than seeing them as far-sighted women trying to extract good from a difficult situation.

Blake himself has one enigmatic comment on the episode, though it is focused on Lot's wife rather than on the incest of Lot and his daughters: "Lots Wife being Changed into Pillar of Salt alludes to the Mortal Body being renderd a Permanent Statue but not Changed or Transformed into Another Identity while it retains its own Individuality" (E 556). That seems to confirm a negative view of the act of Lot's wife (the Pillar of Salt is an adequate image of her true identity), which by contrast may imply a positive view of Lot, but it leaves the daughters without commentary.

One possible clue to Blake's intention lies in the inscription on the back of the painting, which Butlin records as "Genesis XIX c. 31 & 32 v." If this inscription records Blake's thought, it suggests that the focus of the design is on the saving necessity behind the act:

31. And the firstborn said unto the younger, Our father is old, and there is not a man in the earth to come in unto us after the manner of all the earth:
32. Come, let us make our father drink wine, and we will lie with him, that we may preserve seed of our father.

Those verses, highlighting the imperatives governing the situation – "not a man in the earth" – suggest that Blake may have had a generally accepting view of the incident.

The scene is framed by the roof of the cave, from which we look out and see, absurdly reduced by the perspective, Lot's wife transformed into a tiny white pillar of salt, which retains a vaguely human form. Behind and above her are the small and distant flames that engulf the cities. In the foreground the key scene is being enacted. The daughter on our left is wearing a red sash or robe slung very low over her hips, as she reaches gently forward with her right hand to remove the loincloth covering her father's genitals. The picture catches the cloth peaked as she draws it up, in a shape reminiscent of some of the representations of the loincloth of Christ examined by Leo Steinberg in his fascinating account of the sexuality of Christ in Renaissance art.[16] The profound repose of the figure of Lot might appear to make it unlikely that he already has an erection, but perhaps that is to think too realistically, and we should forget all we know from Shakespeare and elsewhere of the sexually depressing effects of alcohol, and read the peaked loincloth as metonymy for sexual arousal. In the story, wine is assumed to possess aphrodisiac as well as tranquilizing power, and the father somehow is able to impregnate his daughters in a kind of sleep: "and he perceived not when she lay down, nor when she arose" (19:33), a state that makes it easy to exonerate him and blame only the daughters, though Lot seems to have accepted the wine without protest.

The daughter looks tenderly at the passive face of her father; no smouldering lust is apparent, though it may be doubted if Blake possessed a visual schema that would have empowered him to represent such a feeling convincingly; *Joseph and Potiphar's Wife* (B 439) shows the moment of public accusation rather than the bedroom scene, and so affords no useful comparison. The right-hand daughter is dressed in a yellow robe, slung round her waist, and looks quietly to our left, though we should perhaps think of her as intending the gaze for her father, it being simply an accident of poor perspective that she appears to look in a direction well to the front of Lot. Beside her feet is an upright wine goblet, while below Lot and to the left of her feet is an overturned goblet; she has been in charge of the wine serving, leaving the other daughter free to perform the seduction. Both daughters have beautiful long hair, and relaxedly sensuous bodies; their faces are notably calm and serene.

There is something of the traditional *pièta* in the calm tenderness of the left-hand daughter to the passive father. Bindman has suggested that "Lot is depicted as a slumbering Farnese Hercules"[17]; the face and inclination of the head, as well as the posture of the body, make that a plausible suggestion. The body of Lot also resembles the figures labeled "Dissipation" and "Luxury" in the previously discussed drawing of *Various Personifications* (illus. 20–21), but perhaps there is a justified form of dissipation,[18] and the negative implications of luxury are here neutralized by its being an image of actual unconsciousness. The figures are calm, even serene; apart from the deep relaxation of Lot himself, with the ambiguous associations noted above, there is nothing in the bodies or faces to suggest a negative view of the act portrayed.

The Genesis narrative includes the blindness and stupidity of Lot's sons-in-law: "And Lot went out, and spake unto his daughters, and said, Up, get you out of this place; for the Lord will destroy this city. But he seemed as one that mocked unto his sons in law" (Genesis 19: 14). This detail not only supports the necessity of the flight, but also allows the inference that Lot is a better protector of his daughters than are their wedded husbands, preparing the way for their choice of him as father for their children. The fact that the daughters have no names seems part of their plight – they have no stable place in the society depicted, in spite of their nominal marriages. They must make their own place with the materials at hand.

A bunch of dark grapes hangs from the tree at top right, and a sheaf of golden wheat lies at its foot, alerting us to the possibility that we are witnesses to a kind of eucharistic sacrament, that the sexual act and the taking of food and wine are both ways of participating in the energy of the divine. Blake was fond of such imagery; one remembers the lines from his poem to Anna Flaxman, in which he refers to "The Bread of sweet Thought & the Wine of Delight" (E 709). The fact that Genesis makes no mention of food or wheat renders it the more likely that Blake has added these details for a purpose, and it is difficult to see a negative implication; there may be a reflection of the biological imagery of the Genesis statement that the daughters wish to "preserve seed of our father." The grapes and wheat also more or less pick up the colors of the sashes worn by the daughters. As in the case of *Bathsheba* I take Blake's use of ornament to be allegorical.

We should return to the bodies. Nudity came to be a critical point in Renaissance painting. It offered scope for the exhibition of both human

beauty and painterly skill, but it also provoked antagonistic responses from religious spokespersons. There is a large literature on the subject, which I shall not attempt to summarize here.[19] Blake clearly followed something like the Winckelmann line on the central place of nudity in an art centered on the human body: "The nakedness of woman is the work of God" (E 36), and "Art can never exist without Naked Beauty displayed" (E 275). But that has raised questions in interpreting this particular painting. Is the sensual beauty of Lot's daughters a sign of moral decadence, related to the other side of Blake's view of the body – "the Vile Body… & its Laws of Good & Evil" (E 667) – or simply a celebration of the living human form, and its power to create life? The sensuality of the bodies is similar in style to that of the body of Bathsheba, an innocent victim of male possessive desire. All three women have a style of beauty rather different from that of most of Blake's other nudes, heavier and more quietly sensual, a style that Paley has suggested may owe something to Rubens (!), while Bindman has written that the tempera series as a whole shows the influence of the Venetians and of Rembrandt.[20] The very style of the painting seems related to what is described by Blake as a succumbing to the "temptations and perturbations… of Venetian and Flemish demons" (E 547), words that suggest an almost sexual slipping from the masculine and intellectual art of Florentine outline into the temptations of soft and colorful female flesh; Venice of course had a reputation for sexual excess. Perhaps the very subject has a metaphorical resonance, Blake as Lot seduced by the pleasures of the female body seen as an object for the artist, and falling into a Venetian mode as a consequence. Perhaps Blake's stylistic slippage has been in part responsible for the ease with which commentators have taken a negative view of the act in progress.

Both *Bathsheba* and *Lot and his Daughters* deal with situations in which transgression leads to mixed but not wholly evil results; in the case of the first, it leads to the birth of Solomon, an ancestor of Jesus, as the first chapter of the New Testament tells us. This line of descent includes other transgressors:

> Was Jesus Chaste or did he
> Give any Lessons of Chastity
> The morning blushed fiery red
> Mary was found in Adulterous bed
> Earth groaned beneath & Heaven above
> Trembled at discovery of Love[.]

(E 521)

David's theft of Bathsheba is a kind of love, however involved in crime, as is the act of Lot's daughters. Though their act lacks the explicit after-the-event justification of David's act, it too can be seen as a creative transgression made in the name of the continuation of a seed that has "found grace." One could also say that the story has been triggered by the failure of Lot's wife; the angels said to Lot "Arise, take thy wife, and thy two daughters, which are here; lest thou be consumed in the iniquity of the city" (Genesis 19: 15). It is that tiny pillar of salt, unredeemable cowardice or desire for the world's goods, that sets in motion the logic of the situation. Incest became the only way to bypass the blockage set up by human weakness, and one remembers Cain and Lamech, another ancestor of Jesus (Luke 3: 36); Blake warmed to persons conventionally interpreted as criminal who entered into the human inheritance of the Jesus who "took on Sin in the Virgins Womb" (E 524). Those were no idle words for Blake.

The Old Testament carried within it the possibility of a vision that went beyond sternly judgmental morality. Blake, I believe, read the stories of David and Bathsheba and Lot and his daughters as he thought the prophets would have read them, and as Luke and Peter seem to have read the story of Lot. David's criminal love is paid for in suffering, and leads to the wisdom of Solomon; the incest of Lot's daughters is covered by the human desire to create and continue a life freed from the brutality of promiscuous rape.

In both stories there is a conspicuous use of ornament – flowers in the case of *Bathsheba*, wheat and grapes in that of *Lot and his Daughters* – that conveys meanings that must be incorporated into a reading of the designs, and shapes and deepens our response to the events portrayed. The ornaments point us to a prophetic rather than moralistic response, to a recognition of the complexities of the situation rather than moral condemnation. The honeysuckle partially balances the lilies and roses, the grapes and wheat soften and enrich the act being performed.

III

The next group of paintings is formed by designs that have been described as showing Blake's image of the Seven Eyes of God. They raise questions of interpretation concerning the relation between Blake's mythology and his designs, and between visual and verbal structures more generally.

The Seven Eyes of God have appeared frequently in commentary on Blake's designs; indeed, one critic, Mary Lynn Johnson, has claimed that

the whole of Blake's series of watercolor illustrations of the Bible can be understood as "a pictorial anticipation of Blake's much-discussed literary symbol, the 'Seven Eyes of God,' or seven manifestations of the divine,"[21] making this structure the key to a reading of the whole series. Though Johnson has good things to say about individual paintings, I am not persuaded by this aspect of her argument. However, I shall not take up that large claim now, but focus on some specific designs in which the presence of Blake's symbol has been asserted.

In an essay on Blake's illustrations of the Psalms, Johnson has written that "The seven angelic figures between David and Christ [in *David Delivered out of Many Waters* (B 462)], as Michael J. Tolley first pointed out, are analogous to the Seven Eyes of God in Blake's later poetry." Johnson adds that the Seven appear

> in differing configurations at intervals throughout Blake's biblical watercolor series – in a mandorla, in *God Blessing the Seventh Day*… in a vortex, in *Job Confessing his Presumption to God Who Answers from the Whirlwind*… and again, with two presumed out of sight over the top of the design, in *The Conversion of Saul*… here, they are aligned in the rank and file of a matrix, or, in Bindman's words, "a continuous rhythmical row."[22]

These and a few others are the designs that I shall reconsider in this discussion, beginning with the Job engravings.

Among the most widely accepted illustrations of the Seven Eyes of God are those found in the title page and Plate 13 of the engraved *Illustrations of The Book of Job*,[23] though there is one major dissenting voice, that of Bo Lindberg, who has written of the Job engravings that "There is nothing in the plates that requires the seven eyes of God for an explanation."[24] There are substantial differences between these two designs. The seven figures in the title page (illus. 52) appear identical, with the exception that two have their backs to us and the last one has his face turned away. Because of this, it is difficult if not impossible to decide whether they are arranged in a single sequence or arranged symmetrically around the lowest angel as center, with angels ascending on both sides. The upward pointing wings on both sides suggest symmetry as the organizing structure, but the overlapping bodies and folded wings of some of the angels produce an impression of movement from top right to top left. All the angels are equally youthful. In the case of Plate 13 (illus. 53), the seven figures are all old men, and arranged

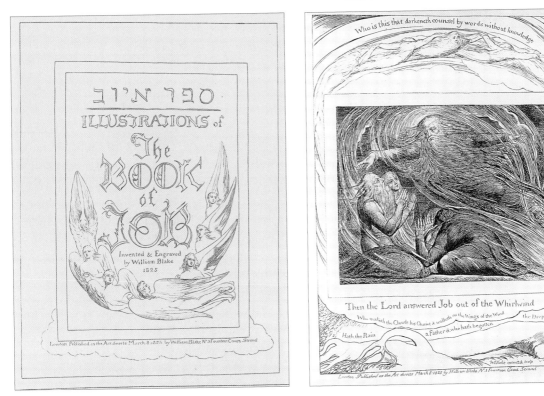

in a sequence, climaxing in the powerful figure who confronts Job within the interior frame of the design. But here too the figures are virtually identical one with another; the visual logic implies progression without change. We thus have two different visual structures that have both been identified with the same poetic myth. Clarification is needed, and it should begin with a brief account of Blake's Seven Eyes of God, the symbolic structure brought into play in these commentaries.

The Seven Eyes of God in their fully developed form are a metaphor for a historical, sequential process of revelation,[25] as the account in *Milton* shows:

52. William Blake, engraving, *Illustrations of The Book of Job*, title page

53. William Blake, engraving, *Illustrations of The Book of Job*, Plate 13

> they ratify'd
> The kind decision of Enitharmon & gave a Time to the Space,
> Even Six Thousand years; and sent Lucifer for its Guard.
> But Lucifer refus'd to die & in pride he forsook his charge
> And they elected Molech, and when Molech was impatient
> The Divine hand found the Two Limits: first of Opacity, then of Contraction
> Opacity was named Satan, Contraction was named Adam.
> Triple Elohim came: Elohim wearied fainted: they elected Shaddai.
> Shaddai angry, Pahad descended: Pahad terrified, they sent Jehovah
> And Jehovah was leprous; loud he call'd, stretching his hand to Eternity
> For then the Body of Death was perfected in hypocritic holiness,
> Around the Lamb, a Female Tabernacle woven in Cathedrons Looms
> He died as a Reprobate. he was Punish'd as a Transgressor!

 (E 107)

Blake has done his best to distinguish the Eyes, giving each not only a specific place in a historical process, but also a characteristic mode of behavior and in some cases, such as Jehovah's leprosy, a visualizable identifying mark. Though based upon the passage in Zechariah 4: 10 and its sequel in Revelation 5: 6, Blake's symbol is different; as Ferber writes, "There is nothing in the biblical passages to suggest that the Eyes emerge or descend serially in time, as they might if they were words, but it is a natural enough exegesis in view of the seven days of creation and the speculations about future intervals in Daniel and other apocalyptic writings."[26]

At other moments Blake writes and designs in a different vein. He writes of "the Seven Starry Ones" (E 116) and "the Seven Eyes of God" (E 119) in contexts implying that they are a synchronic group, as they are in the Bible. In his account of the lost *A Vision of The Last Judgment* Blake lists "the Seven Lamps of the Almighty" as "burning before the Throne," and adds the "Seven Angels with the Seven Vials of the Wrath of God" and "Seven Angels with the Seven Trumpets" as all present in the design. It is dangerous to try to identify the figures in the existing drawings with this description, though Damon has shown the high degree of isomorphism between the two designs.[27] If we assume that the "Seven Lamps" were indeed represented as lamps, as they are in the Petworth House version (B 642), then they are clearly not the sequential Seven Eyes of the account in *Milton*. In the Washington drawing reproduced by Damon (B 645), there are Seven Angels, all identical, in the place of the Seven Lamps; Damon glosses them as the "Seven Eyes of God" under his number 81 in the "Key" without referring to the fact that Blake's text refers to "Lamps." In both versions, there are seven Lamps or Angels apart from Christ, who would make an eighth.

This means that in practice Blake is ready to use the biblical imagery without any indications that he is referring to his own developed myth. The form of the symbol peculiar to Blake is a historical process of progressive revelation; it is possible to imagine that the Seven Eyes exist simultaneously in the presence of God in eternity, and only manifest themselves serially in fallen human time, but that is an interpretation we could never derive from Blake's visual images.

Returning to the Job engravings, the seven identical angels in the titlepage to the Job illustrations seem not so much a version of Blake's Seven Eyes of God as a transcription into visible form of the Bible's various references to Seven Eyes, Lamps, and other septets. The situation is not so

clear in Plate 13, where there is a suggestion of sequence in the movement, but again the total lack of individualization makes it difficult to accept these figures as a version of Blake's Seven Eyes; if they were so intended, Blake has failed totally to distinguish them in any way analogous to his poetic symbol. Lindberg's critique seems cogent.

Blake is said to have used the Seven Eyes in other designs also. In *God Blessing the Seventh Day* (B 434; plate vii), there are six angels plus God. The God represented may well be Elohim, from the evidence of the large color print. Elohim is the third in the sequence of Blake's Seven Eyes in *Milton*, where he is surrounded by other Eyes of presumably similar size though different attributes. In the painting, the six surrounding angels are all young, and very much smaller than Elohim; there is a clear category difference between Elohim and the surrounding angels. These angels are alternately fair and dark, and are thereby themselves divided into two different kinds. The best explanation for the differentiations is that Blake is here illustrating not the Seven Eyes of God, but the old classification of orders of angels that distinguished between cherubim and seraphim, and saw them, as the two highest orders, as most involved with the act of creation. Blake described them: "The Eternal Great Humanity Divine surrounded by / His Cherubim & Seraphim in ever happy Eternity" (E 140). The angels are six in number and not seven in order to keep symmetry between the two orders, and in the design as a whole.

Blake was quite capable of thinking and inventing in terms of the structures he found in the texts he was illustrating, without any anxious need to pass them all through the filter of his own myth. To identify such different structures with the same Blakean myth is to render oneself unresponsive to the differences found both within a single design and between distinct designs. The visual distinctions Blake has introduced into these designs need attention: *God Blessing the Seventh Day* has a simple binary distinction between light- and dark-haired angels; the Job illustrations show simple repetition. In neither case do we have the individualized, sequential differentiations we should expect from a visualization of the Seven Eyes of God as Blake has described them in his poetry.

Another painting identified by Johnson as including the Seven Eyes is *The Conversion of Saul* (B 506; illus. 54); there are actually five angels, but she notes that two are "presumed out of sight over the top of the design." The bodies of the visible angels overlap like those of the angels in the title page

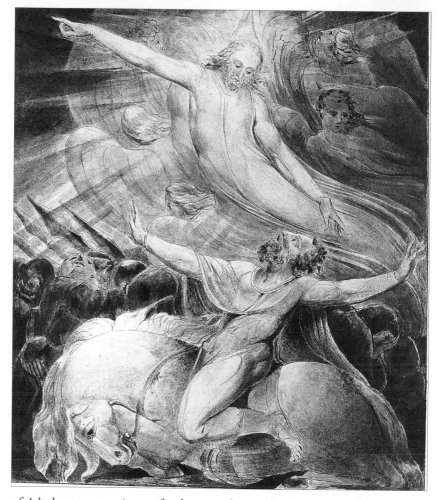

54. William Blake, *The Conversion of Saul*
(B 506)

of *Job*, but no portions of other overlapped bodies are visible; we can assume the presence of invisible angels if we wish, but there is no evidence for their existence. There are five angels.

Yet another painting. In a comment on *David Delivered out of Many Waters* (B 462, illus. 55), illustrating Psalm 18, Clyde R. Taylor claimed that the differentiated figures of the angels represented "the four-fold nature of the Eternal Man who exists vestigially in every man."[28] Grant replied by allowing that there might be "something" to Taylor's notion of the Four Zoas, but suggested that the picture could be better read as "depicting groups of beautiful men, ugly men, and strong men."[29] Tolley then followed Grant's example by allowing that though "it is quite likely that six of the cherubim form pairs of strong, ugly and beautiful types," it was even more likely that the "cherubim are the Seven Eyes or Spirits of God, who represent the ideal force of redemption when acting in concert with Christ, who controls them."[30] This view has been followed by Johnson in a passage already cited. This means that the angels in the picture have now been identified with most of the major groups of male figures available in Blake's poetry. Once more attempts to identify the figures in Blake's work with his poetic mythology reveal a disturbing instability.

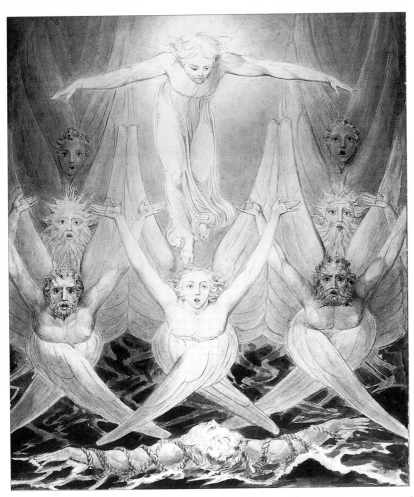

55. William Blake, *David Delivered out of Many Waters* (B 462)

David Delivered out of Many Waters shows us three or four different types of angel: the old and white-haired, at both sides in the middle row; the mature, at both sides in the front row; and the young, at the middle of the front row and perhaps at the sides at the top, though these have different hair, and the darker lighting gives them a very different appearance. There are the hands and arms of two more angels entering from the sides to cross the arms of the front row, so that there are actually five angels in that row; the arrangement implies, if we pursue the symmetry apparent in the design, an endless chain of alternating mature and young angels. We have, not the magical seven, but at least nine, and implicitly an infinite number of angels.

The presence of three or four different types of angel can be much better explained by the old doctrine of the nine orders of angels. In support of this thesis I shall quote Lairesse – whom I am sure Blake knew and used, as a previous chapter has suggested – on the manner in which angels should be painted. The quotation comes from a chapter devoted to "*Of the Representations of Angels* and *heathenish Genii*":

> The first [Seraphins], as being nearest to the Glory of the Almighty, are always represented *young and harmless, and with six Wings*, according to *Isaiah*, Ch. vi.

192

The second [Cherubins] are exhibited only for the *sake of Motion*, and to denote the Efficacy of eternal Happiness, which their *undefiled Purity* and *childish Form* give to understand.

The third [Thrones], who continually attend God's Justice …are *somewhat older, and more full-grown, and of an agreeable Sway and Motion…*

The fourth [Powers] are appointed to execute divine Vengeance in the Punishment of Sins and Wickedness… These are represented *bigger than the former, having stern Countenances*, and *violent Motions*; are *seldom or never naked*, but in *Coats of Armour, and with a flaming Sword or Thunder in their Hands, or else a Shield on their Arms*, with the *Name of God glittering thereon…*

The fifth [Arch-angels] manage great and courtly Affairs; as Guardians leading Men to the Knowledge of God; they are of *a perfect Form and modest Countenance.*

The last [Angels] protect us from all Hurt, and are particularly ordained to excite us to Virtue, and dissuade us from Evil, *Acts* xii. These, according to *Dionysius*, as being the eldest in the lowest Choir or Hierarchy, are represented of a *large Size, majestick and quick in Motion.*[31]

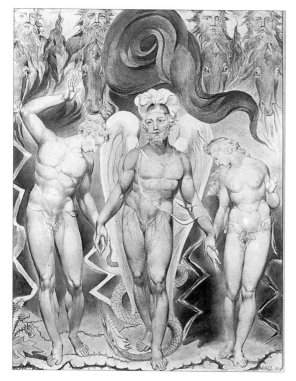

56. William Blake, "The Expulsion of Adam and Eve from the Garden of Eden," from Blake's illustrations to *Paradise Lost* (B 536: 12)

I have given this at some length because it explains so well the differences among the angels in *David Delivered out of Many Waters*. The young, apparently armless (and harmless) angels at the top are seraphim; the angry or stern old ones below are doubtless powers, and the oldish, darker ones at the front may well be angels. The single figure at center front may be an arch-angel, mediating directly between David and Christ. These identifications may not represent Blake's intention in every detail, but I am confident that they represent its essence.

Lairesse's descriptions can be applied to other designs by Blake; the description of "Powers," for instance, fits exactly the angels who ride on horseback at the top of Blake's version of "The Expulsion of Adam and Eve from the Garden of Eden" in his illustrations of *Paradise Lost* (B 536: 12; illus. 56), figures who represent the "dreadful faces… and fiery arms"[32] that Adam and Eve see as they leave Paradise. These have been explained as the Four Zoas, and also as the four horsemen of the Apocalypse;[33] again we meet the fundamental difficulty

caused by attempts to explain four visually identical figures by mapping upon them figures who are clearly distinguished in the text claimed as an origin. The whole point of the Four Zoas is that they are different from each other, and the four horsemen also have clearly differentiated functions and horses described as white, red, black, and pale in Revelation 6. A far more likely source, besides Milton's own text, is the note by Michaelis in the English translation of Robert Lowth: "the Cherubs placed at the east of the garden of Eden: under which appellation I understand to be meant, not angels, but the *Equi tonantes* of the Greek and Latin poets."[34] Blake would appear to have wanted it both ways: cherubs mounted upon "*equi tonantes*." Powers or cherubs, but not the Four Zoas.

To claim that the angels in both *God Blessing the Seventh Day* and *David Delivered out of Many Waters* represent Blake's Seven Eyes of God as articulated in *The Four Zoas* or *Milton* is to convict Blake of fundamental incompetence as an artist, of failing to transform poetic symbols into analogous and intelligible visual symbols. I have come close to suggesting this view myself at moments in this book, arguing in Chapter 3 that Blake moves towards the

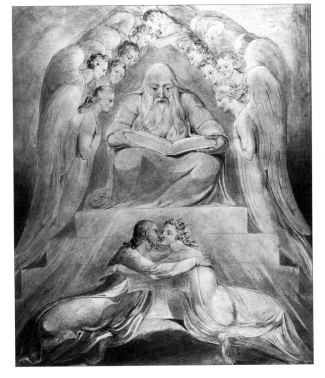

57. William Blake, *Mercy and Truth are Met Together* (B 463)

textual specification of meaning well beyond anything that can be actually shown. But the rough handling of numbers in discussions of this group of paintings shows not only the specification of meaning beyond what is conveyed by the visual evidence, but an erasure of evidence actually visible.

Let us pursue the group of designs with which Blake illustrated the Psalms. *Mercy and Truth are Met Together, Righteousness and Peace have Kissed Each Other* (B 463; illus. 57), illustrating Psalm 85: 10, shows Jesus embracing a female figure at the bottom of the design. Surrounding God seated at the center are angels arranged in an arch, the two at the top meeting in an embrace which mirrors the embrace below. The painting has been well dealt with in Johnson's essay; here I shall comment only on the number of angels. There are a round dozen, and they have been differentiated in the ways that Blake used in *God Blessing the Seventh Day*, supporting the interpretation offered of the angels in that painting.

Another design based on the Psalms is *Christ Girding Himself with Strength* (B 464), illustrating the first verse of Psalm 93, "The Lord reigneth, he is clothed with majesty." Here Blake has shown only two angels. In the painting that Johnson describes as the New Testament counterpart to this design, *The Holy Family* (B 471), there are three.

As one looks at these paintings as a group, it becomes apparent that the number of angels used by Blake is dependent upon such considerations as whether the design requires symmetry or asymmetry, one or several orders of angels, many or few. There is a visual logic at play, not the coding of a private myth. *God Blessing the Seventh Day* has six alternating angels because it requires symmetry around the central figure of God, because there are six days of creation, and because both seraphim and cherubim were involved. *David Delivered out of Many Waters* has an odd number because it presents single figures – first the central angel, then Jesus above – to confront David directly, one on one. *Christ Girding Himself with Strength* asserts symmetry around Christ at the center, as *Mercy and Truth are Met Together* needs an even number of angels to mirror the symmetry of the two embracing figures at the bottom of the design. *The Holy Family* has three angels to hover over the three large figures below. If seven is a significant number, then two, three, and twelve are significant also, and their significance must be looked for in the first instance within the visual structure of the design itself, and the way in which it articulates the text from which it takes off. Blake's designs must be fully explored for the logic and information which they contain before they are made to fit the Procrustean bed of his mythology.

IV

The last group of Bible illustrations I shall consider are those dealing with the entombment of Jesus. They form a series in their dramatic and almost monochromatic chiaroscuro and in their focus on the round arch of the door opening into the tomb. They raise interesting questions about just what it is that Blake is illustrating, and about his attitude towards the Bible as text.

Blake lived at a time when biblical study was undergoing rapid change and development. One of the key areas for this change was in the understanding of the relationship between the four gospel accounts of the ministry of Jesus. The differences between them had traditionally been handled by the process called "harmonization," which resulted in numerous "harmonies" of the four gospels designed to show that the apparent differences

were not real. That tradition came under attack from deists and others, exemplified in virulent form in a book that Blake knew very well, Paine's *The Age of Reason*. Paine speaks of "the wild and visionary doctrine" enshrined in the "fable of Jesus Christ," and of its "blasphemously obscene" character.[35] He then focuses on the differences between the gospel accounts as evidence of the falsehood of the whole story, beginning with the versions of the genealogy of Jesus given by Matthew and Luke.

One area of particular concern to Paine is the sequence of events surrounding the resurrection. Paine writes that "The book of Matthew states that when Christ was put in the sepulchre, the Jews applied to Pilate for a watch or a guard to be placed over the sepulchre, to prevent the body being stolen by the disciples; and that, in consequence of this request, the sepulchre *was made sure, sealing the stone* that covered the mouth, and setting a watch"; the other accounts have nothing of this. Paine continues his critique by focusing on the narratives of the resurrection, and I shall quote him at some length:

> The book of Matthew continues its account, and says (chap. xxviii., ver. 1) that at the end of the Sabbath, as it began to dawn toward the first day of the week, came Mary Magdalene and the other Mary, to see the sepulchre. Mark says it was sun-rising, and John says it was dark. Luke says it was Mary Magdalene and Joanna, and Mary, the mother of James, and other women, that came to the sepulchre; and John states that Mary Magdalene came alone. So well do they agree about their first evidence! they all, however, appear to have known more about Mary Magdalene; she was a woman of a large acquaintance, and it was not an ill conjecture that she might be upon the stroll.
>
> The book of Matthew goes on to say (ver. 2), "And behold there was a great earthquake, for the angel of the Lord descended from heaven, and came and rolled back the stone from the door, and sat upon it." But the other books say nothing about any earthquake, nor about the angel rolling back the stone and sitting upon it, and according to their account, there was no angel sitting there. Mark says the angel was within the sepulchre, sitting on the right side. Luke says there were two, and they were both standing up; and John says they were both sitting down, one at the head and the other at the feet.
>
> Matthew says that the angel that was sitting upon the stone on the outside of the sepulchre told the two Marys that Christ was risen, and that the women went away quickly. Mark says that the women, upon seeing

the stone rolled away and wondering at it, went into the sepulchre, and that it was the angel that was sitting within on the right side that told them so. Luke says it was the two angels that were standing up ; and John says it was Jesus Christ himself that told it to Mary Magdalene, and that she did not go into the sepulchre, but only stooped down and looked in.[36]

Paine has taken as evidence of the falsity of the claims of Christianity just those events which Blake has taken as the subject of the series of paintings under consideration here.

Watson, in replying to Paine, follows the tradition of harmonization: there is no real disagreement about the time of day; John states that Mary Magdalene went to the sepulchre, but does not say she went alone; the absence of reference to an event does not constitute a denial; and Luke and John in describing the angels in different postures are describing different moments.[37] Blake did not annotate this portion of Watson's reply, but we can take his comment on an earlier passage as representing his opinion: "I cannot concieve the Divinity of the books in the Bible to consist either in who they were written by or at what time or in the historical evidence which may be all false in the eyes of one man & true in the eyes of another but in the Sentiments & Examples which whether true or Parabolic are Equally useful." (E 618). It is in this spirit that Blake has illustrated the events surrounding the resurrection of Jesus.

Ironically, Paine and Watson share the same notion of textual authority: either a text is evidence for certain historical events, or it is not; if there are contradictions within the text, then it is disqualified as reliable testimony. Paine and Watson simply disagree on whether or not such contradictions exist. Blake's criteria are those of good poetry; does this text make powerful sense, does it arrange people and acts in meaningful conjunctions? He is not trying to make a consistent story out of the gospels, but focusing on dramatic and significant configurations of events and persons, regardless of which gospel narrates them, and of inconsistencies between the several accounts.

The narrative to be considered here can be said to begin with *The Crucifixion: "Behold Thy Mother"* (B 497), but this is outside the series proper. The first painting that truly announces the group, counting in terms of the sequence of events rather than of execution,[38] is *The Entombment* (B 498, illus. 58), which has "Luke ch: 23rd v. 53rd" inscribed on the mount, with the title "Joseph burying Jesus" written above, and the text below. That verse

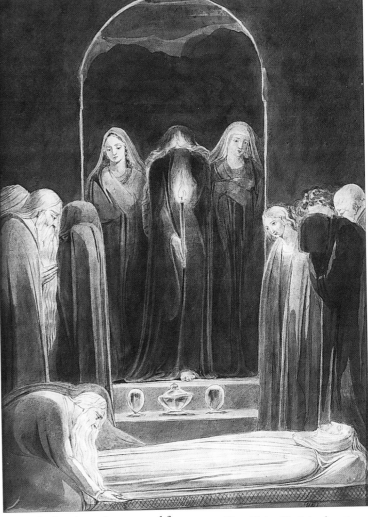

58. William Blake, *The Entombment* (B 498)

reads: "And he [Joseph of Arimathea] took it [the body of Jesus] down, and wrapped it in linen, and laid it in a sepulchre that was hewn in stone, wherein never man before was laid." The next verses describe how "the women also, which came with him from Galilee, followed after, and beheld the sepulchre, and how his body was laid." But it is only on the next day that they "returned, and prepared spices and ointments."[39] Blake's picture has telescoped these separate events into one moment that shows both Joseph laying out the body – his hands still hold the shroud that he has just placed over the body – and the spices and ointments which the women have prepared; the somewhat earlier *The Three Maries at the Sepulchre* (B 503) shows the three carrying flasks that look much like the ones in *The Entombment*. The round arch of the doorway to the tomb that is such a central feature of this group of designs is filled by the figures of three women. The woman at the center holds a long taper while covering her face with her left arm; she must be the mother of Jesus. The woman below in the tomb itself, standing to our right with uncovered hair, is almost certainly Mary Magdalene, conventionally shown with unbound hair. Apart from the collapsing of time in the account of the women's preparation of the embalming spices, Blake has been faithful to the text.

The Entombment is followed by *Christ in the Sepulchre, Guarded by Angels* (B 500, illus. 59), which has the surprising reference "Exod: CXXV. v 20" inscribed at the bottom right. Butlin's entry reads in part:

> The reference to Exodus, xxv, 20, the cherubim covering the mercy seat with their wings, is obscure but, as Michael Tolley has pointed out in a letter of 28 November 1973, Blake may be interpreting the mercy seat in the light of the New Testament as Christ in the sepulchre (see also Hebrews, ix, 5). Blake exhibited the watercolour at the Royal Academy in 1808 with

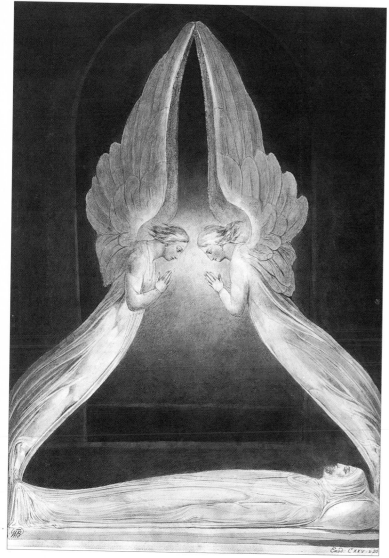

59. William Blake, *Christ in the Sepulchre, Guarded by Angels* (B 500)

the above title, and at his own exhibition the following year as "The Angels hovering over the Body of Jesus in the Sepulchre. – A Drawing."

The key to the design does indeed lie in the Epistle to the Hebrews, which is not now accepted as Pauline, though it was so accepted in Blake's time, and was clearly a text for which he had high regard.[40] The Epistle cites God as saying "I will put my laws into their mind and write them in their hearts" (8: 10), as a prelude to the distinction between the old external tabernacle and the new and internal one. The old was housed in a "worldly sanctuary" (9: 1) that had "the cherubims of glory shadowing the mercyseat" (9: 5) in the holiest tabernacle, into which "went the high priest alone once every year, not without blood, which he offered for himself, and for the errors of the people" (9: 7). The new tabernacle is "not made with hands, that is to say, not of this building" (9: 11), and is entered into only once by Christ "by his own blood… having obtained eternal redemption for us" (9: 12). Christ is the priest who enters the tabernacle of his own body and offers himself as the sacrifice, instead of sacrificing some other being on his behalf; this text must have played a key role in Blake's development of the notion of self-sacrifice.

To understand the new we must first understand the old, and we should therefore turn to Exodus 25, which in addition to being inscribed on the painting is given as a gloss in the margin of the King James translation of the passage from Hebrews just discussed. These are the relevant verses:

17. And thou shalt make a mercy seat of pure gold: two cubits and a half shall be the length thereof, and a cubit and a half the breadth thereof.
18. And thou shalt make two cherubims of gold, of beaten work shalt thou make them, in the two ends of the mercy seat.

19. And make one cherub on the one end, and the other cherub on the other end: even of the mercy seat shall ye make the cherubims on the two ends thereof.

20. And the cherubims shall stretch forth their wings on high, covering the mercy seat with their wings, and their faces shall look one to another; toward the mercy seat shall the faces of the cherubims be.

21. And thou shalt put the mercy seat above upon the ark; and in the ark thou shalt put the testimony that I shall give thee.

22. And there I will meet with thee, and I will commune with thee from above the mercy seat, from between the two cherubims which are upon the ark of the testimony, of all things which I will give thee in commandment unto the children of Israel.

Blake has read the sacrifice of Jesus in the light of the Epistle of the Hebrews' interpretation of the relation between the two testaments, including the focus on the meaning of the word "testament": "For where a testament is, there must of necessity be the death of the testator" (Hebrews 9: 16). The body of Jesus is the sacrifice or legacy (testament) that redeems man, and replaces the Old Testament mercy seat as the site of God's communing with man. Blake's reference within the frame of the painting to the Exodus text shows that he wants us to see the dead body of Jesus as creating a special place or situation which abolishes the external "Jewish imposture" and replaces it with a human body. The temple has again, as in *A Crowned Woman amid Clouds with a Demon Starting Away* (B 92) discussed in Chapter 4, become a human body. This is not a peculiarly Blakean interpretation, but is based solidly on the interpretation of typology in Hebrews, which is the logical place in which to find it, since as its title indicates it deals with the relationship between the two testaments. Cruden's *Concordance*, for instance, bases its definition of "Testament" on quotations from Hebrews and Exodus 24, making exactly the kind of connection that Blake has made in this painting. The type of the Old Testament holy place has found its true antitype in the body of Christ, the true testament that gives life to humanity.

Given all this, we can ask which text is Blake illustrating, the Exodus verses pointed at by the inscription, or the New Testament text pointed at by the presence of the body of Jesus? The depiction of the angels comes mostly from Exodus, but John's gospel has already incorporated some of the language of Exodus in describing what Mary Magdalene sees as she goes to the sepulchre early in the morning of the day after the crucifixion:

"But Mary stood without at the sepulchre weeping: and as she wept, she stooped down, and looked into the sepulchre, And seeth two angels in white sitting, the one at the head, and the other at the feet, where the body of Jesus had lain" (John 20: 11–12).

There is no New Testament authority for Blake's image of the two angels guarding the body of Jesus during the night. Matthew is clear: "In the end of the sabbath, as it began to dawn toward the first day of the week, came Mary Magdalene and the other Mary to see the sepulchre. And, behold, there was a great earthquake: for the angel of the Lord descended from heaven, and came and rolled back the stone from the door, and sat upon it" (Matthew 28:1–2). In Mark the women arrive to find the stone already rolled away and the angel sitting inside the sepulchre (Mark 16: 2–5). There the descent of the single angel is for the specified purpose of rolling back the stone, and there is thus no angelic guard during the night in the sealed sepulchre, as Blake has shown it. Luke's language makes it appear that the angels suddenly materialize around the women as they stand wondering in the sepulchre: "And they entered in, and found not the body of the Lord Jesus. And it came to pass, as they were much perplexed thereabout, behold, two men stood by them in shining garments" (Luke 24: 3–4). The same implication is present in John, since Simon Peter and "the other disciple, whom Jesus loved," enter the sepulchre first, and apparently see no sign of the angels; they see only "the linen clothes lie, And the napkin" (John 20: 6–7), and then leave; it is only when Mary arrives that, upon looking "into the sepulchre," she sees "two angels in white sitting, the one at the head, and the other at the feet, where the body of Jesus had lain" (John 20: 11-12). The angels are either invisible to all but Mary, or have just arrived to prepare her for the imminent meeting with Jesus. The accounts all differ, but in none is there an angelic guard for the body of Jesus during the night.

We recall that it was precisely these discrepancies in the gospel accounts that Paine used as ammunition against the truth of Christianity:

> Now, if the writers of those four books had gone into court of justice to prove an *alibi* (for it is of the nature of an alibi that is here attempted to be proved, namely, the absence of a dead body by supernatural means), and had they given their evidence in the same contradictory manner as it is here given, they would have been in danger of having their ears cropped for perjury, and would have justly deserved it.[41]

In no gospel is there warrant for what Blake has depicted here. His scene depends as much on Exodus as on the gospels for its invention; he is again constructing an implicit text of his own, using elements from both testaments to create a new event, a process for which typology is an only approximate title. It is not simply that the description of the mercyseat in Exodus is a type of the entombment in the sepulchre, but that Blake sees both as parts of a more comprehensive vision that he has of the real meaning of the gospel story. It is not John who is the antitype of Exodus, but both who are types of Blake's design.[42] The inscribed reference to Exodus is there to help us begin the process of following Blake's process of invention, to kickstart our imaginations.

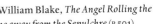

60. William Blake, *The Angel Rolling the Stone away from the Sepulchre* (B 501)

Blake's total lack of the anxiety shown in such different ways by Paine and Watson over the apparent discrepancies between the gospels can be further illustrated by the two drawings that follow *Christ in the Sepulchre* in narrative sequence, *The Angel Rolling the Stone away from the Sepulchre* (B 501, illus. 60), and *The Resurrection* (B 502, illus. 61). The two are very closely related, almost the recto and verso of the same drawing. *The Angel Rolling the Stone away from the Sepulchre* has the reference "Matw: ch:28th v.2nd," with the text "Two Angels in white the one at the head, and the other at the feet" written above and "And behold… from the door" below. The angel rolling away the stone comes directly from Matthew, but as Paine pointed out, that evangelist says nothing at all about two angels in the sepulchre; these have been imported from John, as the written text implies in specifying "the one at the head, and the other at the feet." No gospel even suggests that there might be three angels. Blake has put together differing accounts,

added features of his own, and produced not the common denominator of the harmonizers but a new invention.

A striking feature of this and several other drawings of this series is the vantage point of the artist and viewer, placed within the sepulchre with Jesus like witnesses privileged beyond the actual narrators' accounts given in the gospels. We are in the sealed tomb at night alone with the body of Jesus and the guardian angels, and we are still there in the morning when the angel comes to open it to the other viewers, who arrive after the key moment we are privileged to witness. So only we can know the effortless ease with which the angel moves away the great stone, appearing to half lift it out of the way. The light in the scene seems to come from us; it lights the side of the faces of the angels, and the bodies of Jesus and the central angel, though the shadows cast by the feet of the central angel, and the moulding of his body, suggest that Jesus, and more specifically his head, is also a source of light, despite the absence of visible light rays emanating from that source.

In the next drawing, *The Resurrection*, the light is made to emanate directly from the body of Jesus, and the body itself glows with an internal light even though Blake has kept a painterly suggestion of moulded form that again implies another light source from the direction of the viewer. Perhaps as witnesses we both receive and give light, or participate in an exchange, "meet the Lord in the Air," as Blake hopes in *A Vision of The Last Judgment* (E 560), in a passage which is itself dependent upon the description of the mercy seat quoted above: "And there I will meet with thee, and I will commune with thee from above the mercy seat, from between the two cherubims…"

On *The Resurrection*, there is the inscription "1st: Corinth ch: 15th: v.4th" at bottom right, "The Resurrection" above and "Christ died & was buried, & rose again according to the Scriptures. ecc" below. The text of I Corinthians 15: 4 actually reads "And that he was buried, and that he rose again the third day according to the scriptures"; it does no more than refer us to the gospel accounts for the details. The terrified figures of the watch in the foreground come from Matthew 28: 2–4, which describes the rolling away of the stone by an angel of the Lord whose "countenance was like lightning, and his raiment white as snow: And for fear of him the keepers did shake, and became as dead men"; the figures on the left of the design do indeed appear as dead. There is no analogous report in any other gospel, and we remember again Paine's scorn at the inconsistencies of the gospels on these crucial events.

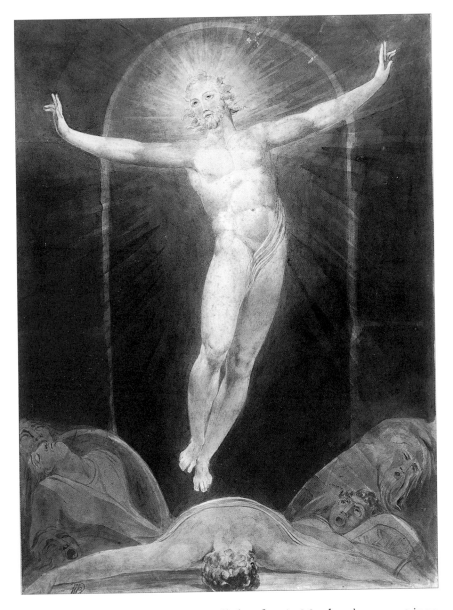

61. William Blake,
The Resurrection (B 502)

Moreover, the figure who creates all that fear in Matthew's account is an angel, whereas Blake has shown Christ at the moment of resurrection. Once more he has made his own text from the disparate fragments left by the evangelists, without concern for textual authority but with great interest in the human and dramatic effects of the events he shows.

None of the gospels describes the resurrection of Christ; all leave it as something that happens in the interstices of the narrative, between the events of the entombment and those of the morning after, when the women (or woman, in John) discover that the body has gone. Blake has used the text from I Corinthians to give textual authority for his imagining of the event, and has given that text as his primary reference because of the extraordinary silence of the gospels. Another reason for the choice may be that the verse is part of the sequence in which Paul states that "I declare unto you the gospel which I preached unto you, which also ye have received, and wherein ye stand" (15: 1); it is part of a kind of compressed gospel, a version maybe of "The Everlasting Gospel." The resurrection is a key moment unrecorded in the narratives of the gospels, and best rendered as a quotation from the mouth of Paul as he looks back from the wider view made possible by the passage of time, partly bridging the space between the evangelists and Blake's own perspective.

One striking thing has happened: we are now outside the tomb for the first time in this sequence since we entered it. From that perspective, we can note a contradiction between this design and the one previously considered. In *The Angel Rolling the Stone* we are still inside the tomb, and if the guards are outside and terrified by the moving of the great stone, as Matthew describes them, that is outside our immediate sphere of notice or interest. In *The Resurrection*, we are outside again, and there is no sign of the stone, though the guards look as if they are being crushed by a great weight. The stone has simply disappeared without trace in Blake's reimagining of the story, as if Christ himself had vaporized it in the heat of his appearing. Blake is not only unconcerned about inconsistencies in the gospel accounts, but is equally unconcerned about inconsistencies between his own designs, provided that each one tells a good story.

The last drawing in the series is *The Magdalene at the Sepulchre* (B 504, illus. 62), which shows the two angels of the entombment sitting serenely sad, still at their stations, with the linen shroud and two of the vessels containing ointments on the first step down to the tomb. Mary sits on the step above, her body facing us but her head up and back to look at Jesus as he stands in his seamless robe at the entrance above her. Behind him are rounded tombstones in the early dawn light. Both Jesus and the angels give off light, with the body of Jesus, though robed, more sculptural and three dimensional than those of the angels; whereas Jesus was floating just above

the ground in *The Resurrection*, he now stands firmly on the ground. This is Jesus incarnate, in his body as he lived.

The moment illustrated is John 20: 11–14, though it is clear, as Butlin points out, that Blake has not followed John's account in the matter of

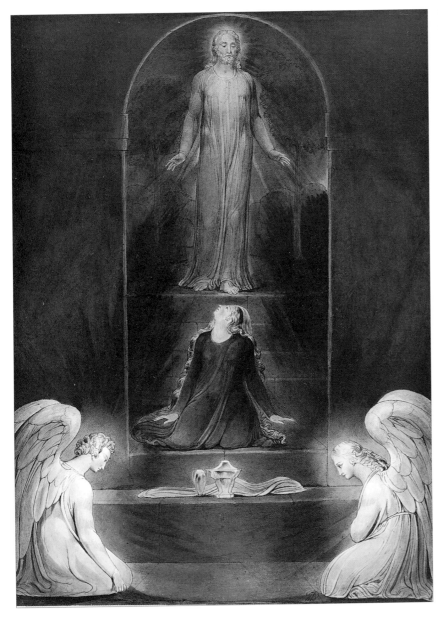

62. William Blake, *The Magdalene at the Sepulchre* (B 504)

showing Jesus in a way that would support Mary's mistake in supposing him to be the gardener. Blake had already illustrated *The Three Maries at the Sepulchre* (B 503, *c*. 1800–03), which follows the different account in Mark 16: 1–8, giving only one angel; Matthew and Luke give slightly different versions.

Once again we note Blake's absolute lack of anxiety over questions relating to discrepancies between the four evangelical accounts; they are all for him poetical texts that serve as the starting points for invention, and it is their suitability for that purpose that interests him, not their consistency as witnesses to a possibly true historical event. Each of those scandalously inconsistent accounts holds rich details that can give rise to powerful designs; truth for Blake lies in poetic fiction, not in an anxious textual apparatus designed to smooth over differences, and not in Paine's fault-finding, however well intentioned and even inspired. Blake's Bible is a poem, not history, or, to use his own words again, he aims to give the "historical fact in its poetical vigour" (B 543), bathed in the light of the imagination, not the scholar's anxiety over textual consistency or the moralist's desire to attribute blame or praise.

In all the groups of paintings considered in this chapter, illumination comes not from the imposition of simple moral judgments, or elements taken from Blake's poetic mythology, but from a readiness to respond to the marked or significant details of a design, and to consider what Blake has done in the light of the textual matrix within which the design arises. Blake's Bible is a poem, but one which he has written in close cooperation with the accepted text.

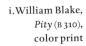
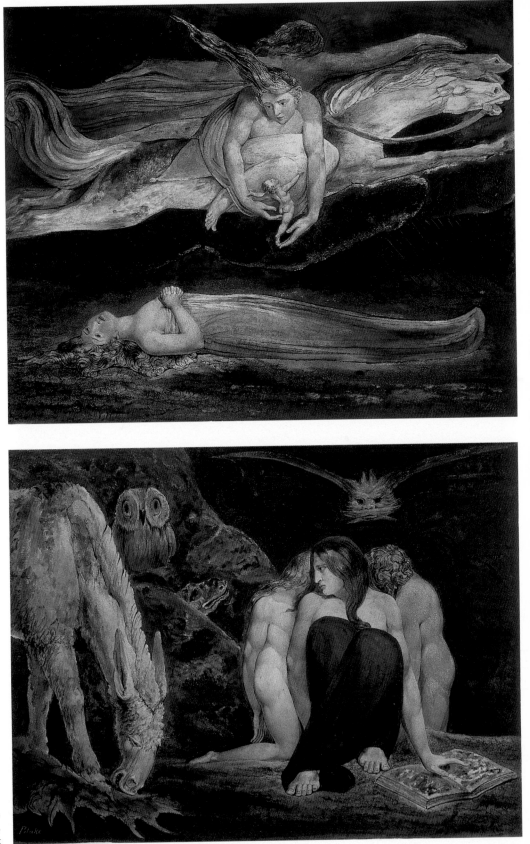

iii. William Blake,
The Good and Evil An[gels]
(B 323), color print

iv. William Blake,
God Judging Adam
(B 294), color print

liam Blake,
nsheba at the
Bath (B 390)

illiam
Blake,
and his
ughters
(B 381)

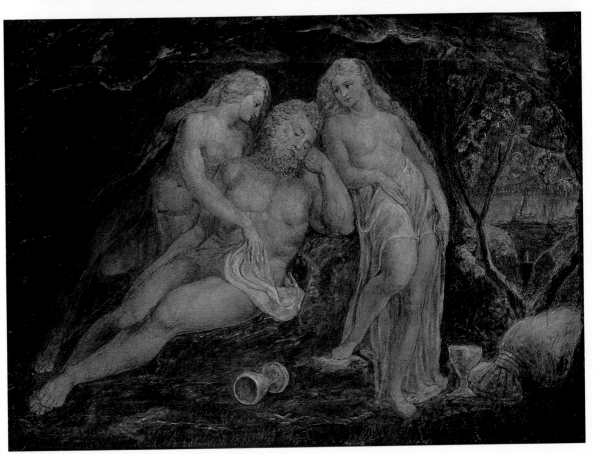

vii. William Blake, *God Blessing the Seventh Day* (B 434)

ix. William Blake, *The Sea of Time and Space* (B 803), detail: Isaiah

x. William Blake, illustrations to Milton's
Il Penseroso; "The Spirit of Plato" (B 543: 9)

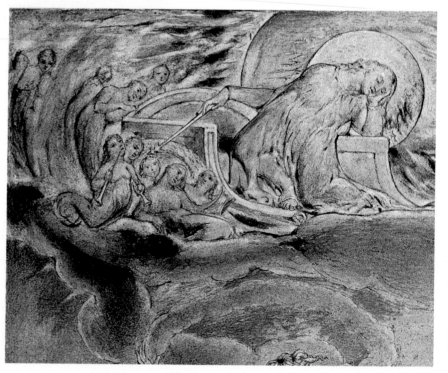

xi. William Blake,
The Sea of Time and Space (B 803),
detail: Apollo and Muses

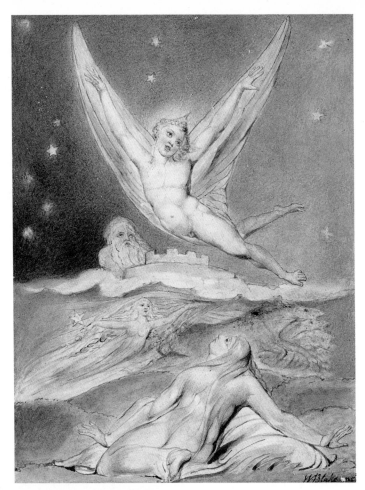

xii. William Blake, illustrations to Milton's *L'Allegro*: "Night Startled by the Lark" (B 543: 2)

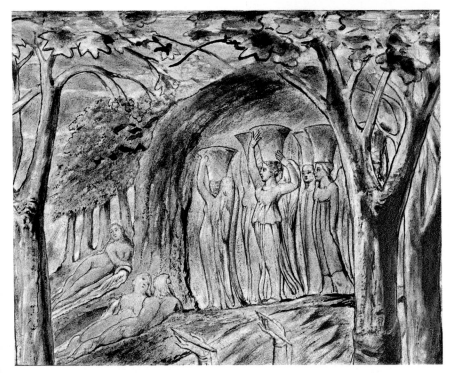

xiii. William Blake, *The Sea of Time and Space* (B 803), detail: women in cave

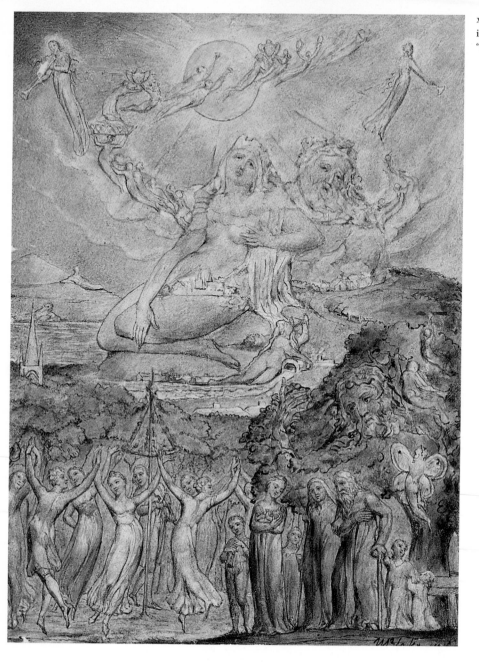

xiv. William Blake,
illustrations to Milton's *L'Allegro*:
"A Sunshine Holiday" (B 543: 4)

A "Style of Designing":
perspectives on perspective

A book focused on interactive figures must at some time consider the nature and role of the spaces in which such figures act. The question has come up from time to time, but this chapter will look at the issue broadly, taking a rather loose and metaphorical sense of the word "perspective" as the thread of continuity with which to connect those aspects of a design that control the way in which figures relate to each other, to the spaces that surround and include them, and to us as viewers.

Mitchell has written some excellent paragraphs on these issues, and I quote a key passage:

> Landscapes are schematized and perspective is flattened, or rendered in the medieval manner, as a series of horizontal strips ascending the picture like a ladder, the highest rung being the most distant. Architectural backgrounds do not provide a spacious three-dimensional container for a scene; generally they present a blank, impervious wall which lies parallel to the picture plane… rarely at an oblique angle as in post-Renaissance painting. More often no architectural background is provided, and the figure is placed in an "elemental" setting of some basic natural image such as fire, water, clouds, vegetation, or stone.[1]

To that one can add that virtually all of the designs looked at in the preceding chapters show figures in close-up; the middle ground, if present at all, is usually represented by large and rather uninformative shapes that block off any potentially more distant background. *Bathsheba* and *Lot and his Daughters* are unusual in showing significant figures in the distance, but in both cases distance is essential to the meaning. As Mitchell says, the designs usually present their figures frontally, avoiding oblique points of view. The figures exist in a partially rational space, in that there are depth clues in some, though not all, of the pictures, but it is a space which offers minimal information, and does little to either distract from or add to the viewer's focus on the figures who carry the action.

In spite of their relative lack of depth, however, Blake's pictures are not simply flat surfaces containing outlined figures, like medieval stained glass; there is depth modeling of human bodies, some movement backwards and forwards, even a little perspective recession sometimes. Though there are

208

analogies between Blake's art and Gothic art, there are also important dif-
ferences; both can be explored by tracing a little of the history of perspec-
tive.

One of the key works in the interpretation of that history is still Panof-
sky's essay, now available in English.[2] However, Panofsky's argument is
well summarized and discussed by Edgerton, and I shall borrow from his
account. According to Panofsky, after the demise of "the classical notion
that a picture should be like a window," came the early Christian idea of the
picture as decorated surface. This in turn gave way to Gothic art, in which
"the single and distinct object or body asserted itself... Gothic statues now
stood forth in the round, each encapsulated under a little baldacchino; the
enclosing space around each figure was not shared with its neighbor."
Panofsky's argument assumes a connection between the philosophical
understanding of space and the mode of its depiction; the middle ages hes-
itated to show space as continuous because Aristotle had described it as dis-
continuous and finite, a sphere existing within a surrounding void. So each
figure existed in its own separate space.

There was a further stage to pass through before perspective took over.
Here is Edgerton's account of Panofsky:

> As the metaphysic of Aristotelian space fell into disfavor in the late thir-
> teenth century, artists both north and south of the Alps began to accept
> what Panofsky... calls "psychophysiological space." This is the kind of
> space we see empirically, without theological preconceptions or mathe-
> matical structure; it is neither homogeneous, infinite, or isotropic
> (extending uniformly in all directions). In this kind of space the moon, for
> example, is perceived not as a huge body hundreds of thousands of miles
> away or as a divine being, but rather as an ordinary physical object about
> the size of a basketball which, if it were to fall, would drop within a few
> yards of the observer.[3]

This kind of space was created by making the individual spaces of late
Gothic statues flow together into a single space, paving the way for the
entry of perspective, which, early in the fifteenth century, created a space
that was mathematically ordered, infinite, homogeneous, and isotropic;[4]
the path lay open to Newtonian conceptions.

If we think of Blake in this context, we may infer that he belongs to the
two ages before perspective. His early exposure to Gothic sculpture has

often been cited as a formative influence, and Bindman's comment that
Blake tends "to isolate figures within their own space"[5] articulates that
aspect of Blake's style. We can also consider the implications of the account
of space given in *Milton*:

> The Sky is an immortal Tent built by the Sons of Los
> And every Space that a Man views around his dwelling-place:
> Standing on his own roof, or in his garden on a mount
> Of twenty-five cubits in height, such space is his Universe;
> And on its verge the Sun rises & sets. the Clouds bow
> To meet the flat Earth & the Sea in such an orderd Space:
> The Starry heavens reach no further but here bend and set
> On all sides & the two Poles turn on their valves of gold:
> And if he move his dwelling-place, his heavens also move.
>
> (E 127)

This account makes space into a movable environment that each perceiv-
ing center creates and carries around with it, as if the Gothic statues in
Panofsky's account had come alive, and were now capable of controlling
their environment, creating a "psychophysiological" space around them-
selves.

But we must never forget that Blake actually belongs to the age after
Newton; much happened between the age of Gothic sculpture and that of
Newton and Locke, and from the point of view of painting it was not simply
an unqualified advance. In addition to recognizing the close connection
between the twin Renaissance enthusiasms for perspective and mathemat-
ical science, Edgerton makes a persuasive case for understanding Alberti's
vision of perspective as uniting the physical and moral dimensions, as envi-
sioning the space it creates as an appropriate setting for noble human
action:

> Alberti's *istoria* entailed the depiction of human figures according to a code
> of decorous gesture. It called for the representation of a higher order of
> *virtù, onore,* and *nobilità.* The perspectival setting itself was to act as a kind
> of visual metaphor to this superior existence, for Alberti believed the world
> functioned best when everything in it obeyed the laws of mathematics.[6]

But even in Alberti, at the very beginning of the theorization of history
painting, there is tension within this apparent harmony. Alberti says that "A
beautiful invention has such force... that even without painting it is pleasing

in itself alone,"[7] which gives priority to the human story being told and its appeal to the intellect of the viewer. Yet he also asserts that "Bodies ought to harmonize together in the *istoria* in both size and function,"[8] which implies that the spatial layout of the bodies is as important as the story in creating the viewer's response. The key term for the area in which the possible conflicts are to be worked out is "Composition… that rule of painting by which the parts of the things seen fit together in the painting."[9] There is a profound ambiguity within those little words "parts" and "fit"; do they refer primarily to the intellectually perceived syntactical relationships of the narrative, or to the spatial relationships of form and color?

The invention of single vanishing point perspective sets up a complex situation. It does not correspond to the way in which we actually perceive the world, and its potential for illusion depends strictly upon the viewer being sited at one exact and predetermined station. It is utterly incapable of coping with our capacity for binocular vision. Without trying to decide the ongoing debate about its exact status, we can appreciate Panofsky's insistence that it is a "symbolic form," not a perfect reproduction of the real world.

Applied to painting, perspective creates a situation in which size is interpreted by the brain in response to the distance cues of the perspectival construction, while size as a purely surface phenomenon remains governed by a scale of inches on the canvas. In exploring the real world, our eyes find distance cues in the constant need to alter their focal length; such cues are missing when we explore a painting, and so the two kinds of space, flat surface and perspective illusion of depth, interact, sometimes uncomfortably, and the human action depicted is suspended between the two.

There is another related problem, pointed at by Michael Kubovy: "one should not… expect the vanishing point in Renaissance painting always to coincide with an element that is important to the narrative."[10] Construction in depth allows the possibility of a tension between the human narrative and the geometry of the space in which it occurs, and between both and the surface of the painting. The artist's problem was to decide whether to give primacy to the intelligible human relationships of the action depicted, to the creation of a consistent three-dimensional visual space, or to a pleasingly arranged surface of colored forms; the three options were not always compatible.[11]

The problems that can arise when perspective is applied to history paint-

ing became explicit with the founding of the French Academy. The 1648 petition for the establishment of an Academy of Painting and Sculpture outlined a program of education that placed geometry and perspective among the "noble" as distinct from "mechanical" arts. Abraham Bosse wrote a manual of perspective in the same year, and began teaching from it. But in 1653 Le Brun proposed the replacement of Bosse's teachings with Leonardo's *Trattato della pittura*, and a combat began which ended with Le Brun emerging as the major power around 1661.[12]

Bosse's view is grounded in the statement that "la pratique de ce noble *Art de Peinture*, doit estre fondée en la plus part de ses parties sur un raisonnement droit et reglé, qui est à dire Geometrie, & par consequent démonstratif" (the practice of this noble art of painting must be based in most of its concerns upon a strict and regular process of reasoning, that is upon geometry, whereby it achieves the force of a demonstration).[13] Bosse pursues his point to the extent of saying that painting is the art of seeing things through the power of reason, and that it would be a grave error to paint things merely as they appeared to the eye. On those grounds he criticizes Raphael for poor perspective. Raphael had committed the twin errors of privileging human interaction and pleasing surfaces over the creation of a totally consistent space. With Bosse was aligned Chambray, who attacked Michelangelo himself "as the prototype of those contemporary French painters concerned only with satisfying the eye."[14] These writers defend the early Renaissance view of painting as a form of scientific reasoning, to be judged by the accuracy of the spatial information it contained.

A counterview developed, led by Le Brun, and for a while Félibien was one of its spokespersons. Seeing two different approaches to art – "L'un est la veûë; l'autre est la raison, ou le jugement" – he tried for an accord: "il faut que le Peintre tasche, autant qu'il peut, d'accorder ensemble la veûë & la raison, afin qu'il ne fasse rien qui ne soit au gré de toutes deux" (the painter must work as best he can to bring about an accord between sight and reason, so that nothing that he does disagrees with either). Félibien summed up this stage of his thinking by asserting "que la Perspective n'est pas la principale chose qu'il faille considerer dans les grands ouvrages; Que les Peintres les plus excellens ont êu surement pour cela beaucoup de negligence" (perspective is not the chief thing to be considered in great works; the best painters were surely very careless about it). Grégoire Huret joined in and proposed that the main function of art was the representation of

figures "just as they are seen by the eye," which for him implied multiple vanishing points, not strict single vanishing point perspective. And Le Brun gave his blessing: "que tout le fin & le vray de l'Art sans tous ces raison-nemens, dépendoit de dessiner & peindre d'aprés le Relief ou Natural, comme l'oeil voyoit" (all that is fine and true in the art, forgetting all these reasonings, depends on designing and painting after low reliefs or natural forms, as the eye sees them).[15]

Here, at a critical moment in the development of history painting, is a fascinating debate which set the eye against the reasoning brain; the proponents of painting based on human action placed perspective in a secondary position, and supported the power of the eye to see and create a pictorial reality that would appeal to the feeling and appreciating mind, even if the spatially analytical brain might object. Surface values and the depths of human response joined hands against mathematics and the construction of a coherent, quasi-three-dimensional space. For a while, Michelangelo, Raphael, and Le Brun were all on the same team, playing against early Renaissance enthusiasm for painting as scientific knowledge, and there is no doubt that it was Blake's team too.

The playing field in the debate is what was called composition, and the game continued for a long time. Richardson held to a sensible middle ground, trying to balance and adjust the contrary powers at work: "The Composition of a Picture is of Vast Consequence to the Goodness of it; 'Tis what first of all presents it self to the Eye... 'tis This that directs us to the Ideas that are to be convey'd by the Painter, and in what Order; and the Eye is Delighted with the Harmony at the same time as the Understanding is Improv'd."[16] Like Alberti, he assumes the possibility of an isomorphic relationship between the surface form and the narrative structure of a painting: "And this Principal, Distinguish'd part ought (Generally speaking) to be the Place of the Principal figure, and Action: And Here every thing must be higher finish'd, the Other parts must be Less so Gradually."[17] But he does allow the possibility of a breakdown of this happy conjunction: "*And some-times the Painter happens to be Obliged to put a figure in a Place, and with a Degree of Force which does not sufficiently distinguish it. In that Case, the Attention must be awakened by the Colour of its Drapery, or a Part of it, or by the Ground on which 'tis painted, or some other Artifice.*"[18] Principal figure and principal place can sometimes become separated by the ineluctable power of perspective law ("*Obliged*"), and then the painter's skill must bridge the disruption.

Hogarth, for whom Blake had great respect, has some remarkable things to say on the question. He gives the priority for understanding the visual world to the mind, not the eye: "Experience teaches us that the eye may be subdued and forced into forming and disposing of objects even quite contrary to what it would naturally see them, by the pre-judgment of the mind from the better authority of feeling, or some other persuasive motive." Our perception of space is thus a mental act, not a passive reception of sensory stimuli: "the eye generally gives its assent to such spaces as have been first measured by the feeling, or otherwise calculated by the mind: which measurements and calculations are equally, if not more, in the power of a blind man."[19] This is truly to see through and not with the eye as Blake would say (E 492, 520), to make mind, and not perspective, the measure of space. This view puts perspective in a very minor role, and indeed Hogarth merely refers to it in a note that offers an about-to-be published book as possibly helpful.[20] Despite his comic print caricaturing the distortions created by faulty perspective, he gives priority to the representation of human feelings and to the line of beauty.

Reynolds has little of import to say, but Fuseli is full of interesting matter, as usual. His core statement is a version of Richardson's sensible balance:

> Composition has physical and moral elements: those are Perspective and Light with shade; these, Unity, Propriety and Perspicuity; without Unity it cannot span its subject; without Propriety it cannot tell the story; without Perspicuity it clouds the fact with confusion; destitute of light and shade it misses the effect, and heedless of perspective it cannot find a place.[21]

That describes the ideal; in practice, however, most paintings fall to one side or the other.

Fuseli describes some paintings in which narrative demands overpower the limited possibilities of spatial arrangement, and intelligibility is lost: "Subjects which cannot in their whole compass be brought before the eye, which appeal for the best part of their meaning to the erudition of the spectator and the refinements of sentimental enthusiasm, seem equally to defy the powers of invention."[22] Some kinds of *istoria* were just not made for representation in a painting.

On the other side are paintings in which the demands of spatial organization have drowned out narrative meaning. Sebastian del Piombo's *Resuscitation of Lazarus*, for instance,

seems to have been dictated by the back-ground. It usurps the first glance; it partly buries, everywhere throngs, and in the most important place squeezes the subject into a corner. The horizon is at the top, Jesus, Maria, and Lazarus at the bottom of the scene. Though its plan and groups recede in diminished forms, they advance in glaring opaque colour.[23]

Here is a painting in which not only does the spatial arrangement falsify and overwhelm the human drama, but even perspective and color fight each other.

In a related vein is Correggio's subjection of the human drama to the demands of spatial representation:

Correggio was no more than a Machinist. It was less the Assumption of the Virgin, less a monument of triumphant Religion he meditated to exhibit by sublimity of conception or characteristic composition, than by the ultimate powers of linear and aerial perspective at an elevation which demanded excentric and violent fore-shortening, set off and tuned by magic light and shade, to embody the medium in which the actors were to move; and to the splendour and loftiness of that he accommodated the subject, and subordinated the agents. Hence his work, though moving in a flood of harmony, is not legitimate Composition.[24]

This is a remarkable use of the metaphor of the machine to describe the full-scale working of all the painterly tricks that can recreate the sense of a virtual space, at the expense of the human drama. It is hard not to believe that this is the origin of Blake's complaint that the Venetian and Flemish demons "cause that every thing in art shall become a Machine" by means of "that infernal machine, called Chiaro Oscuro" (E 547); "Chiaro Oscuro" was peculiarly associated with Correggio. Blake characterizes Correggio's art as one of endless "manual labour" that finally hinders "all correct drawing from appearing to be correct" (E 548). Blake and Fuseli, like Le Brun and others before, reject the claim of perspective and its allied arts to absolute control over the realm of painting. Human action with its signifying power comes first, and strict perspectival construction should be subordinated to the need to foreground the chief actors in the *istoria*.

Fuseli, however, unlike Blake, does have a positive view of what perspective can do as servant and not master. The painter can use perspective to elevate, literally; the "art of giving to the principal figure the command of the horizon" is one that was not fully appreciated by earlier painters:

It does not appear that the great masters of legitimate composition in the sixteenth century attended to or understood the advantages which elevation of site and a low horizon are capable of giving to a subject. They place us in the gallery to behold their scenes; but, from want of keeping, the horizontal line becomes a perpendicular, and drops the distance on the foreground; the more remote groups do not approach, but fall or stand upon the foremost actors.[25]

Fuseli uses the trick of a "low horizon" frequently as a form of visual bullying of the spectator that creates what he identifies as a form of the sublime.

Despite this appreciation of the power that perspective is capable of wielding, the true sublime for Fuseli as well as for Blake is that created by powerful human figures acting out meaningful events. Blake is particularly explicit in defining the sublime as the power to communicate meaning: "The Beauty proper for sublime art, is lineaments, or forms and features that are capable of being the receptacles of intellect" (E 535). His neatest demonstration of the belief is in *The Marriage of Heaven and Hell*, where he accompanies the proverb "One thought. fills immensity" with a tiny landscape composed of traditionally sublime elements: the sea, a mountain, a large tree.[26] It is the mind that creates the sublime, not the senses; a design an inch long will do the trick if the perceiving mind cooperates. There is obviously a danger that this view might become ultimately destructive of the very basis of painting as an art of manipulated surfaces, a danger that Blake became increasingly ready to face.

There is thus a long tradition in the theory of history painting that questions the primacy of perspective, preferring to give first place to the demands of narrative, though acknowledging the claims of a rational ordering of the containing space. Blake belongs to this tradition, but stretches it further than most of his predecessors.

Blake is consistently negative about perspective in both theory and practice. He used specifically perspectival constructions in very few works, and upon looking them over one almost wonders whether he actually learned to draw in perspective, or whether he regarded it with such contempt that he did not even try to use it accurately. The first constructions that Blake made may be the drawings of *The Body of Edward I in his Coffin* (B 2) and *Anne of Cleve's Monument* (B 11). The first leaves the lines of the end panels simply parallel, and the second applies perspective to the side pedestals, but in such fashion that there are several distinct vanishing points in the drawing,

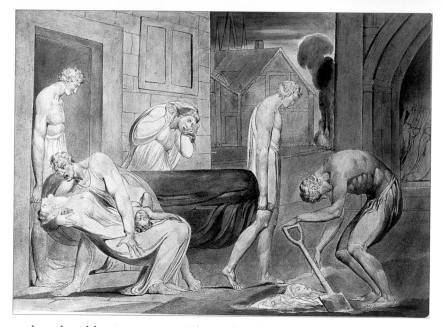

63. William Blake, *Pestilence* (B 193)

each pedestal having its own. These drawings are signed by Basire, and since Blake's responsibility for them is conjectural, it is unwise to push the evidence.

Later work points in the same direction, however. *Pestilence* (B 193; illus. 63), dated *c.* 1805 by Butlin, offers an unusually elaborate (for Blake) architectural background, placed at an angle to the viewer; but the front of the house facing us to the right of center is drawn as if head on to us, though the side of its roof states that it is at an angle to our line of vision. More common than such explicit errors is the simple avoidance of occasions for perspective drawing. Thus *Bathsheba at the Bath* (B 390; plate v), a subject that often called forth elaborately perspectival architecture, is handled by Blake with only the very corner of David's palace visible beyond the trees that cover all else.

For the most part Blake places his viewpoint at about eye height, though he occasionally plays with it in a manner that illustrates Fuseli's comments; *The Penance of Jane Shore* (B 69), for example, places the viewpoint very high, so that the implied vanishing point is above the frame of the design, and the more distant figures are open to Fuseli's critique of those masters who "drop the distance on the foreground," so that "the more remote groups do not approach, but fall or stand upon the foremost actors." *The River of Life* (B 525) also takes a high vantage point, so that we as spectators seem to float well above the river which flows beneath us. Occasionally Blake goes to the opposite extreme and takes a very low vantage point, in the manner of the Fuseli sublime, as in *God Writing upon the Tables of the Covenant* (B 448), where we look up from the perspective of Moses, and in *The Bard* (B 655), where we look up at the crazed and inspired figure above. But such images are rare; Blake is usually content to show things from a direct frontal viewpoint, and to give only the simplest, and sometimes inaccurate, indications of perspective.

Blake subjugates perspective both more carelessly and more completely than was usual in eighteenth century history painting, but that does not make his art truly medieval. Leibniz gives us a better grip than does medieval art on what Blake is doing, and the Clarke–Leibniz correspondence affords a reference point. Newton's view that space is infinite and interpenetrates bodies is summed up by Clarke: "Space is not an affection of one body, or of another body, or of any finite being; nor passes from subject to subject; but is always invariably the immensity of one only and always the same *immensum*."[27] This sounds almost like a defense of the primacy of perspective; space claims priority over body. Leibniz opposed to this the view that space is created by a synthetic process of perception: "I will here show, how men come to form to themselves the notion of space. They consider that many things exist at once and they observe in them a certain order of co-existence, according to which the relation of one thing to another is more or less simple. This order, is their *situation* or *distance*."[28] This banishes the "fiction of a material finite universe, moving forward in an infinite empty space."[29] Bodies, both perceiving and perceived, have priority over space, which becomes a plastic way of containing their interactions.

The affinities between Blake and Leibniz have been remarked before, most relevantly by Daniel Stempel, though he looks at the question in the light of an interest in identity.[30] Here I shall place the handling of space in the context of painterly and political concerns, broadly interpreted. Edgerton speculates that the "centric ray" of which Alberti makes so much, and to which Dante had given an implicitly moral aspect in the *Convivio*, was felt to have a relation with the fundamental structures of order and hierarchy.[31] As he puts it, "linear perspective came about in the early Renaissance, not in order to reveal visual 'truth' in the purely heuristic sense... but rather as a means of – literally – squaring what was seen empirically with the traditional medieval belief that God spreads His grace through the universe according to the laws of geometric optics."[32] The use of perspective as an organizing principle is linked to the articulation of powerfully centralized government, both human and divine.

Blake's opposed and more Leibnizian vision of spaces as always centered on each individual perceiving self, and on each individual pictorial entity, by contrast suggests simultaneously both the freedom and the self-centeredness of the child's view of space as described by Piaget: "Piaget's experiments show that the child's abstract comprehension of space, as a

vertical-horizontal reference system, occurs at about the same time that he begins to relate himself to a wider range of experiences in the sensory world."[33] Perspective connects with epistemology and opens up into the realm of the political organization of human life, using "political" in the widest possible sense to include all units from the family up.

Blake's profound antipathy to perspective was founded on an almost solipsistic focus on the individual self as source and center, combined with an intuitive understanding of the metaphorical and political implications of perspectival representations of reality. He never articulated this directly, but it can be traced in such comments as his riposto to Reynolds, "For Real Effect. is Making out the Parts & it is Nothing Else but That" (E 639), repeated in "Sacrifice the Parts. What becomes of the Whole" (E 650). This emphasis on the independence of parts is implicitly a powerful argument against the centralizing energy of perspectival organization, which puts parts firmly into assigned places within an overall structure. The same argument is applied to the theological and political organization of human life. Perspective is one aspect of the activity of Urizen's sons, who measure "out in orderd spaces" and "With compasses divide the deep" to produce "the heavens squared by a line" (E 318–19).

Opposed to this is the new state in which "henceforth every man may converse with God & be King & Priest in his own house" (E 615); each person becomes a perceiving and organizing center. Blake's opposition to perspective is of a piece with his views on other forms of relationship; for him it represents an unwelcome centralization of power, and a limitation upon the artist's freedom to place bodies in the positions most appropriate to their role in the story.

II

Norman Bryson's stimulating *Word and Image* provides another vocabulary with which to discuss the division we have been following. In tracing the history of Western representation, he divides the visual image into two complementary fields, which he calls the "discursive" and the "figural." He defines: "By the 'discursive' aspects of an image, I mean those features which show the influence over the image of language... By the 'figural' aspect of an image, I mean those features which belong to the image as a visual experience independent of language – its 'being-as-image'." He interprets Vasari as having read the history of Renaissance painting as "an evolu-

tionary liberation of Life from the repression of the textual," and focuses on the development of perspective as the key issue in this evolution. In an analysis of one of the first perspective paintings, Masaccio's *Rendering of the Tribute Money* in the Brancacci Chapel, Bryson finds "a marked excess of the image over the text," which he reads as a function of the movement towards realism. The characteristic mark of this excess is perspective, which "strengthens realism by greatly expanding the area on the opposite side of the threshold to the side occupied by textual function." Perspective is a means of "aggrandising the figural irrelevance" of a design.[34] Bryson goes on to suggest that painters learned to partially bridge the gap thus created by discovering that "the discursive can be disguised as the figural," that it is "just when discourse is made to feel effort, when it has to go out of its way to convert the figural into the discursive, that the effect of the real is enhanced. The subtle meanings have been planted in a difficult place, hard to reach and to absorb into language."[35]

Perspective, as a technique for converting the discursive into the apparently figural, becomes the characteristic way in which the signifying function in post-Renaissance Western art is concealed from direct view. Implicit in this language, however, is the possibility that there is something dishonest or misleading about the proceeding. Blake was always a deeply honest man, and his antipathy to perspective was part of that honesty; painting was an art intended to signify, to exist and exult "in immortal thoughts" (E 541), and that intention should appear on its surface, not lie concealed within and below an ultimately irrelevant superimposed structure.

Blake, however, was not prepared to discard perspective totally; he wished to be taken seriously as a history painter, and so worked to produce images which would be recognizable according to the governing conventions, though he was prepared to subject or distort perspective when it threatened to get in the way of the primacy of his figures. But perspective has as one of its functions the definition of the exact spatial relationship between figures; without such definition, it can become very difficult to determine exactly who is doing what to whom, the basic unit of meaning in history painting focused on human interaction. Perspective in such designs acts not only as guarantor of an excess of figural information, in Bryson's terms, but as the carrier of an essential part of the discursive or textual function. Perspective is thus a fairly close analogue to the syntax that holds together in meaningful relationship the different words that constitute a

sentence, the individual bodies being the words. Perspective does not merely hide discourse, it is a fundamental aspect of discourse itself. Unfortunately in Blake's large color prints and other designs the perspectival syntax is sometimes loose enough to permit the imagistic equivalent of comma splices and dangling participles, with the result that relationships between figures are not always adequately defined, and lie open to ambiguity and misinterpretation.

There are good examples of this in the illustrations to *Milton*, which are too interesting to pass over just because they occur in the illuminated poems, with which this book is not primarily concerned. They are the now notorious designs that, we have been told, show "drastic homoerotic implications in the direct conjunction of head and loins in Blake's union with Los … and in Milton's baptism by Urizen… implications which are certainly latent in the central concept of the loving brotherhood."[36] The illustration of Los uniting with "Blake" (Plate 21; illus. 64; I use "Blake" to designate the figure in the poem) shows Los with his right foot still within the circle of the sun he is in the act of leaving, while his forward stepping left foot is still a little way behind "Blake." "Blake"'s right hand is raised in surprise, while his head faces up awkwardly to look at the form about to enter him. What appears as conjunction on the page can, and I believe should, be interpreted as no more than proximity in three-dimensional depth; Blake has tried, not very successfully, to give the design some sense of recession. A kind of bad and unintentional pun – to keep to linguistic imagery – has occurred, in which the different implications of flat superimposition and three dimensional mere proximity have collapsed into one visually ambiguous statement. This is one instance of the difficulty discussed above; the demands of a perspectival organization of the space of an imaged action do not coincide with the demands of surface composition, with unfortunate results.

64. William Blake, *Milton*, Plate 21

Blake has not left us without guidance in the interpretation of the scene. The full-page design follows immediately upon a description of the encounter:

While Los heard indistinct in fear, what time I bound my sandals
On; to walk forward thro' Eternity, Los descended to me:
And Los behind me stood; a terrible flaming Sun: just close
Behind my back; I turned round in terror, and behold.
Los stood in that fierce glowing fire; & he also stoop'd down

And bound my sandals on in Udan-Adan; trembling I stood
Exceedingly with fear & terror, standing in the Vale
Of Lambeth: but he kissed me and wishd me health.
And I became One Man with him arising in my strength:
Twas too late now to recede. Los had enterd into my soul:
His terrors now posses'd me whole! I arose in fury & strength.

<div align="right">(E 116–17)</div>

The lines describe exactly the scene pictured; "Blake" is stooping to bind on his sandals as he turns round in terrified surprise. The gestures and relative positions of the two figures are explained better by the text than by Mitchell's hypothesis. These lines illustrate a total union more intimate than sexual conjunction. The act of fellatio we are asked to imagine by Mitchell, in the absence of any apparent reciprocity, and despite Mitchell's explanations, would be a terrified and placatory response to the fear of being totally overcome and mastered, rather than an act of "loving brotherhood." The kiss that follows "Blake's" self-protective standing up in the text is an act of reassurance from the powerful to the weak; this is a quite different act, in which Los is the initiator, not "Blake."

If one wishes (I do not) to see Blake's illumination as implying a sexual metaphor in the relative positions of the two figures, Blake's language, which describes Los as entering and possessing, would be more supportive of the interpretation that Los is approaching Blake from behind with intent to sodomize, though that would again suggest mastery / submission rather than equal brotherhood. Such readings against the grain of the text illustrated are always possible as forms of the viewer's *jouissance*, but I believe it is better to read the design in the light of the words which it illustrates, and in another context Mitchell has given that as the very good advice I believe it to be.[37]

One can always claim that unconscious motivation was at work to produce the collision between the demands of flat design and perspective recession, reading the collision as a Freudian *lapsus*, but since the evidence of the drawings in the *Four Zoas* manuscript suggests that Blake did not suffer from serious repression in the visual representation of sexual scenes, I see little to support this way of reading here, and Mitchell's case was not built on such an argument.

The other instance is the plate that shows Milton supporting Urizen (Plate 41; illus. 65). Here we are not dealing precisely with problems in per-

<div align="right">221</div>

65. William Blake, *Milton*, Plate 41

spective, but with the related and larger question of Blake's difficulties in relating figures to each other in convincing ways. Here there certainly is a "conjunction" of head and loins, but again the context of the relationship between Milton and Urizen militates against any interpretation depending on "loving brotherhood"; at this point in the narrative, Urizen is described as one who "faints in terror" (E 141), and the notion that while in this state he is fellating Milton seems radically inappropriate. In fact, the spatial relation between the two figures is similar to that between Naomi and Ruth in Blake's color print (B 299; illus. 38); though both figures there are fully clothed I suppose the same suggestion could be made about them – though I hope it will not, and certainly am not going to make it myself. There remains an awkwardness in the spatial interaction of the figures in both designs, however, and it creates sufficient ambiguity that a critic usually as perceptive and balanced as Mitchell has been drawn into interpretations which I find quite unpersuasive, though they have entered into the literature without previous challenge, where they now support assumptions about Blake's sexuality.[38]

An analogous ambiguity haunted *The Good and Evil Angels*, producing difficulty in defining exactly relationships between the bodies of the Evil Angel and the babe; again the problem was caused in part by Blake's looseness in applying perspective. We can suggest that Los in the *Milton* illumination and the Evil Angel in the color print are dangling participles, actions that cannot be exactly placed, and thus make interpretation difficult. Remove or weaken the syntax of perspective, and the statements made by bodies become equivocal where they are not completely defined by a gestural code or an attached text. Blake's fondness for codified gesture, even while he fought against it, as the first chapters of this book record, may have been grounded in a realization that it was needed in an art as inhospitable to perspective as his own.

Another point bears upon the problem. Perspective can cause ambiguity in history painting because other traditions are at work, without always being recognized. If we interpret the direction of the Evil Angel's blind head in *The Good and Evil Angels* according to strict perspective, it actually faces a point far in front of the babe. But as we saw, the history of interpretation of the print has assumed that he is more or less facing the babe. Disregarding for the moment the correctness or error of that view, it is clear that another tradition is at play, that interprets figures not in the light of

strict perspective but in that of the stage tradition in which an actor faces the audience as much as possible, while being understood to face an interlocutor. This points to a widespread ambiguity in the use of perspective: artists, like theater directors, try to keep their principal actors more or less facing the audience, even at the cost of a little trickery; I noted something of this sort in commenting on the implicit sight lines in *Bathsheba at the Bath*. The theatricality of history painting was recognized from the beginning, and is implicit in Alberti's desire to have "someone who admonishes and points out to us what is happening there; or beckons with his hand to see… or shows some danger or marvellous thing there; or invites us to weep or to laugh with them."[39] The artist's image does not actually exist in three-dimensional space, but is like a theatrical performance within a proscenium arch, and depends on various acts of mediation between its statements and the audience. Perspective, when applied to history painting, becomes such an act of mediation as much as an exact science; there are motives at play other than the desire to reproduce a portion of the world. These other motives could be termed broadly rhetorical, and perspective is one device that can be moved over from the function of representation to the rhetorical function of directing and controlling the viewer's response.

Another device closely linked with perspective is lighting, and this too has associations both with the attempt to reproduce the world with accuracy and with the theatrical and rhetorical shaping of an image to move the viewer towards a specific response. There was considerable discussion in the manuals of painting about the disposition of light, and I shall quote Lairesse to show the kind of thing Blake learned as a student. In his discussion "Of ORDONNANCE, *or* COMPOSITION" Lairesse instructs the painter to "place your *principal Object* as much as possible in the *middle*, on a *rising Ground*; fix your Point of Sight; determine your *Light*, whether it must proceed from the *left*, or the *right*, from *behind* or *before*; and whether the Story require *Sun-shine* or a *common Light*."[40] The disposition of light was a basic matter, to be settled together with the overall disposition of bodies at the very beginning of the process of design. Later, in a chapter devoted to "Lights and Shades," Lairesse discusses the question of whether there should be one or several lights, and states that according to the French academy, "no more than a single *Light* is necessary," and that double lights "are only the Inventions of *Dutch* Masters, who do not understand the *Antique*, but only follow Nature in order to please Ignorants." He refers to them as a

"diversifying Elegance," and warns that painters "must be very careful in their Disposition, that *they may not... seem forced, but natural and necessary, that there may be a general Union, and that the Principal Part have its Predominancy.*"[41] This advice threads its way between the competing demands of rhetorical clarity and pictorial verisimilitude. The language suggests the analogy between multiple lights and multiple vanishing points; both are ways of modifying the tendency of single vanishing point perspective to exert an overpowering control over the meaning of bodies placed within its frame.

Blake usually lights bodies in a way that gives enough modeling through light and shade to support the sense of there being three dimensions, but the light is often not rationally motivated, and sometimes appears to come from rather puzzling directions – often, indeed, from somewhere near the virtual position of the viewer. *God Judging Adam* (plate iv), for instance, appears to be lit from somewhere high up and to our right, despite the apparently strong light emanating from the angry red sun behind God. But this light source does not explain the light on the faces of the horses, and there is what looks like a bright spotlight illuminating the ground around Adam's feet. This is more like theatrical lighting arranged for maximal clarity of exposition than like naturally motivated lighting. Lighting, like perspective, should be considered part of the rhetorical discourse of the print as much as a function of its figural aspect.

Blake indeed suggests at one point that he understood single lighting as analogous to single vanishing point perspective in its suppression of the independent existence of parts in a design. In *A Descriptive Catalogue*, he writes that Rubens loads an original conception "with hellish brownness, and blocks up all its gates of light, except one, and that one he closes with iron bars" (E 547). Multiple "gates of light" seemed as natural to Blake as the precedence of independent bodies over a universalizing perspective. Each part of a design was to be given its own freedom to be.

III

We can learn something more and other about Blake's practice of perspective by considering a late drawing for whose subject I have recently offered an identification. The drawing known as *A Vision: The Inspiration of the Poet* (B 756, *c*. 1819–20[?]; illus. 66) represents, I believe, Elisha.[42] In 2 Kings is an account of how the prophet Elisha was regularly invited to eat bread at the

66. William Blake, *A Vision: The Inspiration of the Poet (Elisha?)* (B 756)

house of a woman of Shunem. Perceiving that he was a man of God, she said to her husband: "Let us make a little chamber, I pray thee, on the wall; and let us set for him there a bed, and a table, and a stool, and a candlestick: and it shall be, when he cometh to us, that he shall turn in thither" (4: 10). In return, Elisha, through his servant Gehazi, called the woman to him and promised her a son, in spite of the age of her husband (4: 12–16). The drawing represents Elisha seated in his "chamber... on the wall"; the phrase expresses exactly the relationship between the two spaces in the drawing, making it immediately intelligible.

The moment depicted in the drawing is probably that described in 4: 15–16, when the woman has been summoned and appears "in the door." Given the basic arrangement of the design, it would have been almost impossible for Blake to show her actually "in the door," for that would have required a view into an interior space, demanding fine detail and an elaborate perspectival scheme – not the typical strengths of Blake's drawings. It would also have been a space at variance with the implications of the phrase "on the wall." Blake would have chosen the key moment of the story, which is the announcement by Elisha to the woman that she will "embrace a son"; this son dies, but is subsequently brought back to life by Elisha (2 Kings 4: 32–37). Elisha is the inheritor of the mantle of Elijah, and the subject of the drawing can therefore be defined as the initiating moment of an act of prophetic creation, the calling into being of life.

This interpretation of the drawing makes possible an explanation of its curious perspective. Rosenblum cites the drawing in the context of a discussion of the radical "dissolution of postmedieval perspective traditions" that occurred around 1800 as part of the quest for "an artistic *tabula rasa*." He writes that the shading of the planes of the drawing contradicts the "would-be effects of recession... producing instead a series of simultaneously convex and concave planes whose shifting locations are matched in the history of art only by the comparable spatial and luminary ambiguities of early Analytic Cubism."[43] This explanation of the drawing as an attempt to represent a specific and painterly view of space, though based on an interesting and powerful argument about movements in the art of the time, is uncom-

fortably cut off from a consideration of the content of this particular draw-
ing, from its discourse. To separate style or execution from content in this
way is to run counter to Blake's doctrine that "Ideas cannot be Given but in
their minutely Appropriate Words nor Can a Design be made without its
minutely Appropriate Execution... Execution is only the result of Inven-
tion" (E 576). Artists' theories can have no monopoly over the ways in which
we discuss their work, but Blake is not the only person to argue in this vein.

Two other critics comment on the question at issue here, both of whom
point out that Blake's moment in time is characterized by the multiplicity
of available styles, so that no single style has defining power over an image.
Mitchell, in an essay significantly titled "Style as Epistemology," uses
Rosenblum's insights to develop the suggestion that Romanticism should
be defined as "that historical movement which, in inventing the notion of a
cultural history with discrete stylistic 'periods,' gathered all the possible
artistic styles to its bosom in an eclectic stylchaos."[44] From this stance
Mitchell develops the idea that Blake's particular forms of linear abstrac-
tion should be read as a kind of code, that style is indeed a part of the
specific content or "statement" of a design.[45]

More recently Bryson has suggested, in discussing eighteenth-century
French painting, that we need a history of such painting as sign as well as
the more conventional history of style. The reason he gives is that "in
France the visual arts react not only towards and against specific visual
styles, but towards and against the Académie and the high-discursive paint-
ing promoted by the Académie at different moments of its history."[46] This
reason can be generalized; Blake, for instance, is in an analogous situation,
seeing himself as one of the brave minority defending "high-discursive
painting" against an environment that he interprets as supporting "bad
(that is blotting and blurring [figural]) Art" (E 528). Bryson, like Mitchell,
asks us to see style during the Romantic period as governed by communica-
tive desire, as deliberately chosen from among the "unprecedented array
of styles" available to the painter at this time.[47] Both critics, using Rosen-
blum's original insights as part of the ground of their argument, ask us to
read style as part of the process of meaning production rather than as an
independent, purely aesthetic factor.

Looking at the drawing again from this vantage point, we can try to find
more than purely stylistic interest in the odd handling of space that inter-
ested Rosenblum. The space in the design, which relates the small chamber

to the surrounding room, and mediates between the chamber and the viewer, has the function of determining the relationship between Elisha and the world around him, including ourselves. The handling of space in the design is a form of visual rhetoric that shapes and directs information towards us, modifying it in the process; it is not simply an attempt to relate the objects and people depicted in the design to each other within the frame of a consistent visual space.

There is an obvious anomaly in the perspectival structure of the drawing. The vanishing point implied by the junction lines between the side walls and ceiling of the small chamber is radically incommensurable with that implied by the corresponding junction in the enclosing room; one hopes, though one cannot be certain, that even Blake, with his already noted ability to be careless about such things, was aware of the discrepancy – it is a large one.[48] The angle formed by the junction in the outer rooms is so steep that it is not clear whether we are looking through a room with a deeply angled roof or at a strangely marked out planar surface. The handling of perspective in the drawing contradicts the "would-be effects of recession," as Rosenblum points out, and thereby makes the apparent space virtually undecipherable as space.

There is also a conspicuous lack of the excess of figural information associated with perspectively structured architecture in post-Renaissance Western painting. The original drawing conveys a somewhat more architectural aspect than emerges from even a good photograph; the grey wash that represents the building has an almost plaster-like texture, and there are multiple very faint parallel lines that further suggest that these surfaces represent the planes of a building, not simply empty spaces. But there remains a remarkable lack of detail, and quite large surfaces remain virtually blank. Blake has subverted the conventional functions of perspective by producing something close to a parody of its usual appearance, and has thereby almost forced us to read the spaces of the drawing as discourse rather than figure; perspective has been robbed of its potential power to control perception. Read as discourse, the handling of space interprets and makes visible the relationship between the state of ordinary experience and that of prophetic inspiration; the two are related and in communication with each other, indeed one is in a sense inside the other, but they are also separated by the profound shift of gears necessary to move between them. That shift has been embodied in the distorted perspective of the drawing.

The shading – *chiaroscuro* – that Rosenblum comments on can also be read as discourse rather than simply figure. It suggests that while the light emanating from the little chamber cannot illuminate the immediately surrounding wall, it has the power to project far into the room towards us, laying down a quasi-carpet leading from the chamber towards us as spectators. The light brightens the side walls, but fades towards the corners of the room, which are darkened as if to frame the whole design. There is a curious but symmetrical imbalance in this darkening; if we let our eye travel round the frame in a counter-clockwise direction, we find that the leading edge of each surface is light toned, while the trailing edge is comparatively dark; the shading suggests a rotational effect, the beginning of a vortical movement. The result is a dynamic emphasis on the centrality and power of Elisha's chamber.

Rosenblum's analysis is a very interesting one, and his comments on the primitivist and anti-illusionist trends of Blake's art are well taken, as are those on Blake's "technical regression to the linear and planar origins of art."[49] But such commentary leaves unanswered the question why such trends find their strongest exposition in just this drawing, and indeed the larger question of why Blake is so attracted to this style. The interpretation offered above grounds the stylistic peculiarities of this drawing in its specific content, as part of the meaning of the drawing as a whole. A style can be understood as not so much the central determinant of a picture as one of several possibilities waiting in the wings to be called into action by an appropriate subject, and used for the semantic possibilities inherent within it. Blake has subordinated the potential power of perspective to give accurate spatial location in favor of its power as a form of rhetorical discourse; the perspectival distortions can in this case be read not as mere error but as deliberate shaping of information.

Blake's attitude towards perspective was complex and unstable, in short; he was capable of a disturbing lack of clarity in relating figures to each other by being careless in its use, but also capable of using it in a meaningfully distorted way as part of the signifying activity of a design. In both cases, he refused to allow to perspective the power of controlling his images, insisting instead on his right and even duty to create bodies and forms that were meaningful in themselves, and not only as points in an overall perspective structure.

IV

Associated with Blake's ambivalent treatment of perspective and the narratives it contains is his handling of the large question of the metaphorical nature of representation on the flat plane of a piece of paper. Perspective purports to open a window on a quasi-reality beyond the plane of the pictorial surface, a space in which the objects depicted exist in a virtual reality that is tantalizingly always beyond the viewer's ability actually to enter. There are a number of stories that deal with magical entry into such a separate world, and the pretense that he was actually inside the world of a painting became one of Diderot's favorite modes of description.[50] This is in accord with the late eighteenth century and Romantic focus on the experience of reading as a virtual loss of self within the world created by the artist one is encountering. Kames, for instance, wrote that "the reader's passions are never sensibly moved, till he be thrown into a kind of reverie; in which state, losing the consciousness of self, and of reading, his present occupation, he conceives every incident as passing in his presence, precisely as if he were an eye-witness."[51]

Closer to home there is the marvelous description in *Milton* (E 109–10) of the hero's descent into the world of space and time, which is described as an entry into a world of fewer dimensions than the world being left. Mitchell has commented that Blake compares both "works of arts [sic] and sensory openings to windows," and develops that perception in several very suggestive pages that focus on the image of the vortex.[52] I shall look at the notion again, seeing it in the light of the present discussion of perspective.

In *A Vision of The Last Judgment* Blake makes an appeal:

> If the Spectator could Enter into these Images in his Imagination
> approaching them on the fiery Chariot of his Contemplative Thought if
> he could Enter into Noahs Rainbow or into his bosom or could make a
> Friend & Companion of one of these Images of wonder which always
> intreats him to leave mortal things as he must know then would he arise
> from his Grave then would he meet the Lord in the Air & then he would
> be happy[.]
>
> (E 560)

This passage, developed as shown in the previous chapter from the description of the encounters of God and man over the mercy seat in Exodus 25, offers us another version of Milton's descent, encouraging us to enter into the world of a visual image in our imagination, and to meet there with both

our own imagination in its true form and with that of the artist, in a community which is the basis for the Blakean idea of a heaven. This encounter, however, is more radically metaphorical than the more usual version used by Diderot. We are asked to enter not the quasi-spatial world of a perspective construction that shows what we would see if it were indeed real, but to enter into individual images, single interpreted figures, Noah or even his rainbow, figures which have been glossed for us just before (E 559). A textually interpreted figure becomes the path through which we are invited to overcome the superficiality (a risky pun) of the plane surface of a design; it is not perspective recession, Blake suggests, that gives his pictures depth and substance, but the realms of meaning inherent within them, to which language gives the most direct access (cf. "where more is meant than meets the eye" [E 531]).

In Blake's most extended treatment of space and time in Plates 28–29 of *Milton* (E 126–27), each moment – "A Moment equals a pulsation of the artery" – and each point – "every Space smaller than a Globule of Mans blood" – becomes the organizing center of a unique experience. That is Blake's true philosophy of the spatial organization of a design, and from that stance perspective appears as another machine bent to impose a falsely hierarchical and centralized unity. The true encounter with art is semantic and imaginative, not quasi-physical, not governed by a virtual space. The picture is not really like a window, which can be passed through to gain access to another space constructed with the same dimensions as the one we left, but something much more like a text, within which the viewer is invited to encounter the creation of another mind in a mutually understood linguistic form.

Another statement to put beside this is the cry from *A Vision of The Last Judgment*: "What it will be Questiond When the Sun rises do you not see a round Disk of fire somewhat like a Guinea O no no I see an Innumerable company of the Heavenly host crying Holy Holy Holy is the Lord God Almighty I question not my Corporeal or Vegetative Eye any more than I would Question a Window concerning a Sight I look thro it & not with it" (E 565–66). When this grand statement is read in the context of a discussion of perspective, it becomes apparent that we have a major attack on the notion of a picture as a representation of the real world. To read a painting as a flattened version of reality is to question a window, to look with it; to look through the painting is to read it for its significance, to dissolve the

structure of the design into meaning, to enter the image on the chariot of contemplative thought. To take perspective seriously is to become forever entangled in the net or web of the window itself.[53]

This fundamental metaphor of the picture plane as a surface to be penetrated and dissolved in the interaction between artist and spectator-become-artist-too can be traced in several games that Blake plays. One is the pretense that the surface opens into an interiority that both represents, and is metaphorically coterminous with, the virtual space of the consciousness of a central character, usually depicted with his back towards us as he looks into his own mind. Such images can be said to address us with a particular form of rhetoric, to behave as much like language as like conventional visual images.

In 1791 Blake engraved *The Fertilization of Egypt* after a drawing by Fuseli that made dramatic use of a central character who had his back turned towards the viewer. This schema made a considerable impression on Blake, for he used it, with variations, in several subsequent designs. In *The Book of Urizen*, the figure running across the first page of the text (Plate 3) has his back to us as he looks in at the "soul-shudd'ring vacuum" that Urizen is producing through his separation, much as Urizen is pictured in Plate 27 fighting with the fire as he makes his brave new world.[54] In *Milton* there is a more dramatic use of this kind of thing in the title page (illus. 67), which shows Milton with his back to us and his right hand raised to break the title into two parts, "MIL" and "TON," thus entering the textual world of Blake's imagining of Milton's poem.

In later paintings Blake returns to the Fuseli design and creates several versions of central figures with their backs towards us as they face interior spaces that open up before them. One recurring situation is the scene of sacrifice. There is sometimes an inevitability built into the situation, as in the case of *The Sacrifice of Jephthah's*

67. William Blake, *Milton*, title page

68. William Blake, engraving, *Illustrations of The Book of Job*, Plate 18

Daughter (B 452), where the naked pathos of the daughter is directed at us, and Jephthah himself therefore, almost necessarily, has his back to us. But *Noah and the Rainbow* (B 437) and *Job's Sacrifice* (B 551: 18 and the engraved version, illus. 68)[55] show the central figure facing inwards into a new dispensation that is understood to open up into the imagined interior depth of the design; any thought of a perspectival construction of that depth is blocked off by both the figure himself and the sacrificial altar. One remembers Blake's metaphorical transposition of dimension: "[Urizen] knew that weakness stretches out in breadth & length he knew / That wisdom reaches high & deep" (E 356); the dimensions typical of perspectival organization, breadth and depth, are rejected in favor of a metaphorical verticality that can only be indirectly represented on the surface of a design by such means as the apparent opening of the space of the design into an upwards-seeking interiority. True expansion is always "inwards into the Worlds of Thought" (E 147), and "What is Above is Within" (E 225).

Blake refuses to allow to perspectival construction the status of a quasi-reality; instead, he repeatedly implies that it is an outward dissipation of form. These lines from *Jerusalem* can be read as an allegory of this view of perspective:

> The banks of the Thames are clouded! the ancient porches of Albion are
> Darken'd! they are drawn thro' unbounded space, scatter'd upon
> The Void in incoherent despair! Cambridge & Oxford & London,
> Are driven among the starry Wheels, rent away and dissipated,
> In Chasms & Abysses of sorrow, enlarg'd without dimension, terrible[.]
>
> (E 147)

Perspective builds a space without real boundaries, characterized by abysses and voids, the only control being the arbitrary limit of the chosen frame. To shape figures through perspective is to give final control of form to exteriority, to space and time visualized as the structures that define existence. To focus on the independence of figures as the definers of their own

reality and space is to give priority to being itself, to the act of creating meaning through personal agency. Those are the implications of Blake's handling of perspective, and of his comments on the construction of dimensionality. Perspective is for him a symbolic form that has only negative connotations; it is the single human form that is the foundation of his art.

That returns us to the problems of reading the narrative elements clearly present in so many of his designs. Since bodies acting in space are the basis of his art, perspective cannot be violated without at least potential losses in meaningfulness, which can only be compensated for by a textual apparatus of one kind or another, like the "necessary" account that accompanied *A Vision of The Last Judgment* (E 552). Art history has always had trouble with Blake for the very good reason that his art is in continual flight from the purely and/or merely visual towards the more explicit modes of meaning available only to language itself. The little fantasy drawing of small human forms on their way to becoming letters of the Hebrew alphabet, or, as Butlin's title reverses it, *Hebrew Characters using the Human Form* (B 199v), is a representation in the form of a miniature allegory of a powerful tendency within Blake's art.

This tendency became more directly visible after 1805 or so, and I am going to suggest an analogue and/or source for this movement. In the discussion above of Fuseli's comments on perspective and its role in composition, I omitted one important passage. Fuseli states that there is another way of painting which escapes from the potentially dictatorial power of perspective into a freedom of its own. He relates that painting "borrowed its first theory of forms," as it "probably borrowed its method of arranging them," from sculpture, and he calls this kind of arrangement "Apposition, a collateral arrangement of figures necessary for telling a single or the scattered moments of a fact." In an earlier comment, Fuseli saw this in a negative light: "Apposition, or an assemblage of figures, numerically put together, without central masses and collateral gradation, without approximation or distance, have always marked the infancy of painting."[56] But he later saw this mode as capable of the highest results: it is "in this light we ought to contemplate a great part of the Capella Sistina. Its plan was monumental, and some of its compartments were allotted to Apposition, not because M. Agnolo was a sculptor, but because it was a more comprehensive medium to exhibit his general plan than the narrower scale of composition."

The Last Judgment was conceived on the same plan:

> If collateral arrangement be the ruling plan of the Last Judgment, if point
> of sight and linear and aerial perspective in what is elevated, comes for-
> ward or recedes, if artificial masses and ostentatious roundness, on the
> whole, be absorbed by design or sacrificed to higher principles, what
> effects has the greatest power of machinery ever contrived to emulate the
> conglobation of those struggling groups where light and shade adminis-
> tered to terror or sublimity?[57]

Fuseli has found in Michelangelo something better – an art based on
"higher principles" – than composition in the conventional sense; he has
identified a form that is totally focused on the human, in which the
"machinery" of perspective and depth-rendering *chiaroscuro* ("ostentatious
roundness") has been made superfluous. The ambivalently valued drawing-
book of the heroic nude has finally found full redemption by being identi-
fied as a higher form of art, in which space and light are made subservient to
"struggling groups" of human bodies.

There is a relation between what Fuseli has described with considerable
if tortuous eloquence and the mode of organization of some of Blake's later
"epitomes," a form that includes the various versions of *The Last Judgment*
(B 639–48), *An Allegory of the Spiritual Condition of Man* (B 673), and *Epitome of
James Hervey's 'Meditations among the Tombs,'* (B 770). There are earlier designs
by Blake that point in this direction, among them the *A Spirit vaulting from a
cloud* discussed in Chapter 4, but these later designs go much further in the
direction of Fuseli's description. These works all virtually abolish depth,
and with it perspective, in favor of a presentation of figures on a non-repre-
sentational surface, all sense of a three dimensional containing space
eclipsed by a wall of bodies. The lost fresco version of *The Last Judgment*,
with its thousand figures, must have been the fullest statement of the form.
If we put Fuseli's statements here together with his description of the pro-
gramme of the Sistine Ceiling, discussed in Chapter 2, we have something
like an initial theoretical grounding of part of what Blake is doing in these
late paintings.

These paintings, and Fuseli's comments on the alleged origin of painting
from sculpture, can be associated with a rich variety of contexts. One is the
Renaissance *paragone* between sculpture and painting, in which Michelan-
gelo played a central but highly ambiguous part,[58] though most contempo-
raries interpreted him as on the side of sculpture, and it became
commonplace to say that his paintings were like sculpture.

In sympathy with this Blake developed a view that made sculpture the origin and / or archetype of the visual arts:

> All things acted on Earth are seen in the bright Sculptures of
> Los's Halls & every Age renews its powers from these Works
> With every pathetic story possible to happen from Hate or
> Wayward Love & every sorrow & distress is carved here
> Every Affinity of Parents Marriages & Friendships are here
> In all their various conbinations wrought with wondrous Art
> All that can happen to Man in his pilgrimage of seventy years
> Such is the Divine Written Law of Horeb & Sinai:
> And such the Holy Gospel of Mount Olivet & Calvary[.]
>
> (E 161)

One could spend a profitable chapter unpacking these extraordinary lines, but here I shall just point to the difficult-to-grasp nature of these carvings. They are like Lévi-Strauss's elementary structures of kinship, and they are also like both alphabetical writing and sculpted figures. They are the historical facts in their "poetical vigour; so as it always happens" (E 543), and they are the Cherubim which are the originals "from which the Greeks and Hetrurians copied Hercules, Farnese, Venus of Medicis, Apollo Belvedere, and all the grand works of ancient art" (E 531).[59]

These Cherubim are described further: "These wonderful originals seen in my visions, were some of them one hundred feet high; some were painted as pictures, and some carved as basso relievos, and some as groupes of statues, all containing mythological and recondite meaning, where more is meant than meets the eye" (E 531). These figures are imagined as in a state prior to the split between sculpture and painting, and as "containing" meanings unavailable to the observing eye, that is, linguistically coded meaning to be extracted by the informed mind, presumably through the agency of an implied or attached text. The figures as described contain many of the various and sometimes contradictory impulses we have been exploring in this and previous chapters.

When Blake attempted to base a design on figures conceived in this fashion, he produced structures like those of *A Vision of The Last Judgment*, in which there is minimal interaction between the separate figures, and maximal need for an accompanying account of meanings which are attached to each figure under the pretense that they reside within. The visual syntax connecting figures has been reduced to a remarkable degree, and replaced

by the connective and interpretive power of language. Mitchell raises many good questions about this series of drawings in the pamphlet *Blake's Visions of the Last Judgment* which accompanied the Modern Languages Association Blake Seminar, 28 December 1975 in San Francisco, and it is tempting to take up some of the many challenges there. Instead of those drawings, however, the next chapter will look at *The Sea of Time and Space*, since I can explore the issues there, and have more to say about that design that is new.

The Sea of Time and Space

Blake's visual art, like his poetry, moved towards the creation of large forms that would encompass vast areas of significance within a single structure. The impulse which had created sequences like the Joseph series and the Job illustrations of c. 1805–1806 (B 550) now turned to such projects as the focusing of the whole of the Canterbury Pilgrims or *The Faerie Queene* in one image. The striving for inclusiveness characteristic of an "epitome" increases the textual density of a design by packing into it many of the elements of a complex text, creating a need for commentary to assist the viewer's process of unpacking.

Many factors probably played a role in moving Blake in this direction. The existence of a vaguely defined but distinguishable genre had long been acknowledged; Richardson, for instance, comments that "There are Pictures representing not one particular Story, but the History of *Philosophy*, of *Poetry*, of *Divinity*, the Redemption of Man, and the like," and adds that "Such Compositions as These being of a different nature are not subject to the same Rules with Common Historical Pictures."[1] This statement can be associated with Essick's suggestion that in *The Sea of Time and Space* Blake may have been influenced by the synoptic engravings made after various painters in the sixteenth century by such as Giorgio Ghisi and Marcantonio Raimondi, designs that used subjects from classical mythology and sacred scripture to construct pictorial allegories.[2] As the previous chapters have suggested, Fuseli's account of the program of the Sistine ceiling, and his paragraphs on "Apposition," probably also captured Blake's interest. Whatever the exact influences and motives, Blake's art was moving towards allegorically conceived figures whose interaction was no longer embodied in the narratives traditional to history painting.

I shall consider Blake's handling of synoptic forms through a reading of *The Sea of Time and Space* (B 803; plate viii). The reading derives from, and is in turn designed to support, the hypotheses about Blake's art developed in previous chapters. However, since "Apposition" is associated with a movement away from figures whose meaning is defined through interactions within a space organized by perspective, and towards figures both identified and related to each other by implied texts, the interpretation of paintings such as this is difficult and uncertain, as the critical history of this

painting demonstrates. Each of its major figures has been declared to represent a wide variety of persons and ideas; not Humpty Dumpty Blake this time, but a multitude of Humpty Dumpty critics, who play the role because there is no other choice. In joining them, I can hope to avoid the merely arbitrary, but not to escape the problematical and questionable. Blake failed to provide an account of this painting, or conceivably provided one that has been lost. In its absence, the critic is condemned to provide a text that will resolve the many not always immediately identifiable and often puzzlingly independent figures into coherence and intelligibility.

One possible clue to the creation or discovery of such a text lies in Samuel Palmer's statement that there was a "finished picture from the *Metamorphoses*, after Giulio Romano" hanging in Blake's room at Fountain Court, but a problem intervenes. It seems that Palmer did not meet Blake until November 1824, which does not correlate well with the time by which the painting is assumed to have arrived at Arlington Court.[3] The history of the family records that the old house was rebuilt, but so carelessly that it had to be demolished in 1820; it was rebuilt by 1823, the year in which Colonel John Chichester died. It is said that the inscription on the back of the painting, "James Linnell framer / 3 Streatham Street Bloomsbury / One Door from Charlotte Street," was identified by an old servant as being in the hand of Colonel Chichester himself, which would imply that the painting was at Arlington Court by 1823, and therefore could not have been seen by Palmer in Blake's rooms in 1824.[4] We know nothing definite of how or when the painting arrived at Arlington, but a reasonable guess is that it was purchased during a period of redecorating that presumably followed the completion of the new house. However, the old servant's eyesight or memory may have been defective, or the report may have been mistaken, and the painting may have been acquired at a later date. It is also possible that Blake made more than one copy of the painting, just as there are several copies of *The Parable of the Wise and Foolish Virgins* (B 478–81).

Another possibility is that the painting is one of the unidentified "drawings" that Edward Denny, "son of a baronet and a man of substance," was having made for him by Blake in 1821,[5] but there is no information to connect it with him, or onwards to Arlington Court. Nothing can be proved from what is known of the painting's history, though we do know that Blake made a painting of Ovid's *Metamorphoses* that has never been identified.

II

The date of 1821, fixed by Blake's inscription on the painting, affords a more substantial clue. In 1821 Blake was invited to help with the illustration of Thornton's edition of Virgil, and it is now apparent that his involvement was more extensive than used to be thought. Essick's essay on the discovery of a sheet of relief etchings of four of Blake's illustrations gives a more detailed picture of the relationship than has been previously available,[6] but does not repeat the speculation he made some time ago that the Thornton project "may have stimulated Blake to begin the Isaiah block, *c.* 1821."[7] That block is a drawing on wood, evidently intended as the first step towards cutting the block, of *The Prophet Isaiah Foretelling the Destruction of Jerusalem* (B 773; illus. 69). It derives from a two-sided pencil drawing of Isaiah (B 772), also dated *c.* 1821 by Butlin. It is possible, even probable, that Blake was preparing the wood engraving of Isaiah for Thornton's edition, which contains a rather crude illustration of Isaiah, bearded and with a mantle over his robe, foretelling the crucifixion in a design quite similar to Blake's pencil sketch.[8] This might well be a replacement for a design originally assigned to Blake, but reassigned as a result of Thornton's discomfort with the woodblocks that Blake cut to illustrate the pastorals of Phillips.

Whatever its origin, that block and its associated sketches identify the man in red in *The Sea of Time and Space*: he is Isaiah. The broad face, the beard, and even the curious and heavily folded garment around his feet are virtually identical to those drawn on the block. The arms of Isaiah in the painting point in a gesture similar to that made by John the Baptist in the frontispiece of *All Religions are One* (illus. 70), who sits on a rock facing the viewer and pointing off to the side. That figure is identified as "The Voice of one crying in the Wilderness."[9] This phrase, spoken by John, is present in Matthew 3: 3, Mark 1: 3, Luke 3: 4, and John 1: 23; in each case except the last it is followed by the words "Prepare ye the way of the Lord, make his paths

69. William Blake, woodblock of *The Prophet Isaiah Foretelling the Destruction of Jerusalem* (B 773)

70. William Blake, *All Religions are One*, frontispiece; John the Baptist

straight." In each gospel except Mark the words are identified as those of "the prophet Esaias," as indeed they are: "The voice of him that crieth in the wilderness, Prepare ye the way of the Lord, make straight in the desert a highway for our God" (Isaiah 40: 3–4). Isaiah, in *The Sea of Time and Space*, repeats Blake's early depiction of John the Baptist, as John in that design repeats Isaiah's words. The two are linked as prophets who both point forwards to the coming of Jesus. We can even imagine the very words Isaiah is speaking through his gesture; he is not only announcing the coming of Immanuel, the Prince of Peace, his most famous prophecy, but more specifically is pointing with both arms to prepare a way across "the desert of the sea," his own phrase (12: 1).

The arm gesture is related to Le Brun's "Desire," a schema which Blake used on several occasions: "Desire may be expressed by the Arms being stretched forth towards the desired object, the whole Body inclining that way, and all the Parts appearing in an eager, perplexed and inquiet motion."[10] The gesture in the depictions of both John and Isaiah, however, is characterized by a split between the direction of the arms and that of the face; the viewer is confronted directly, but his/her attention is re-directed towards what is pointed at, as in Alberti's comment that in an *istoria* he likes to see "someone who admonishes and points out to us what is happening there; or beckons with his hand to see."[11] Prophecy addresses both what is to come and the audience towards which the prophecy is directed, and so the gesture is a divided one, face and arms pointing in different directions. The gesture made by both prophets is thus significantly different from that made by "The Evil Demon" in the drawing of that name (B 209) and his close cousin, the figure on the cloud on the title page of *Visions of the Daughters of Albion*, though both have been adduced as analogues. In those designs, the figure is looking in the direction in which he points, producing a gesture oriented towards action rather than demonstration, event rather than prophecy.

Despite the similarity of gesture, however, there is some difference between the postures of the two prophets. John sits comfortably on a rock facing the viewer, ankles crossed and both knees at the same height. Isaiah sits on some invisible object hidden by his mantle, and his body has been rotated so that it nearly faces the direction in which his arms are pointing; only his face is directed towards us. The great toe is the only part of his left foot to touch the ground, which it does with a bend, as if to suggest the pos-

sibility of an imminent push off into a dive, an interpretation which has been made, though one toe would not give much purchase. The position is less stable than John's, but there is not enough latent energy to translate into a dive. To dive in Blake's (or Isaiah's) time would surely have meant stripping off (no swimsuits), and Isaiah's right leg is stably planted: no forward propelling energy there. So prophetic yearning, yes; diving, no.

There is another difference between John and Isaiah: John points with both forefingers extended, in a gesture echoed by the figure in *NT* 60 who directs Belshazzar's gaze towards the writing on the wall, and by Truth in *NT* 156 who points our attention upwards towards last things. Isaiah in the woodblock has one hand reaching upwards with all fingers extended as he points at his text with the other hand; it is clear that he is prophesying the fall of Jerusalem, as that scene is portrayed behind him. Isaiah in *The Sea of Time and Space* points with both hands and all fingers extended in a gesture which combines the two-armed point of John the Baptist with the fingers-together gesture of the Isaiah of the woodblock, though there is a suggestion of a pointing index finger in his right hand.[12] Blake seems to have altered his schema of the prophet over the years; one can assume that Isaiah is prophesying in *The Sea of Time and Space* as he is in the woodblock, but the two-handed gesture is now more reminiscent of the schema for desire. Blake images Isaiah's prophetic spirit as desiring to reach forward to enter into the coming world as well as directing a prophetic message towards the viewer. Blake's image of the prophet has become more dynamic with the passage of some thirty years.

The garment at his feet is the prophetic mantle, as can be deduced by following the leads provided by Erdman's *Illuminated Blake*.[13] The mantle plays a key role in the story of Elijah and Elisha in 1 Kings 19, and came to be a symbol of the power of prophecy. It is a lighter, more orange scarlet than the rest of Isaiah's garb, and can be seen over his right shoulder, between his left arm and right leg, and beside his lower right leg. It has been folded in heavy layers below him, in a fashion very similar indeed to the garment visible below Isaiah in the woodblock drawing. Blake can be accused of appearing to suggest simultaneously that the mantle is an undergarment and an overgarment fastened over Isaiah's right shoulder, but its basic nature is evident. His long red tunic may represent the "garments of salvation... the robe of righteousness" (61: 10) that Isaiah wears; these are part of the prophetic garb. The intense color helps set Isaiah off from the subdued

colors of the rest of the painting in a way we shall see mirrored in the content of the work.

There is one more important detail to be noted about Isaiah's garment. There is a row of symbols running round the lower hem of Isaiah's robe that represent Hebrew letters (plate ix).[14] There are similar inscriptions running round the caps and hems of the priests in *Christ Nailed to the Cross: The Third Hour* (B 496) and *Sealing the Stone and Setting a Watch* (B 499). The letters are difficult to reproduce clearly because inadequate magnification leaves them obscure while excessive magnification breaks up the forms into fragments of pigment, but they are distinct enough in the original.

The previous identifications produced for this figure range from Albion to Luvah and Los, and outside Blake's own myth from Ulysses to Jesus.[15] As in other cases the sheer multiplicity of names produced should throw doubt on the procedure of identifying Blake's figures with those of his own mythology. The figure is utterly unlike the one certain representation of Ulysses in Blake's work, in *Philoctetes and Neoptolemus at Lemnos* (B 676), and the recognition of the Hebrew lettering on his garment rules that interpretation out of court, as it does the Jesus hypothesis. The figure is quite unlike Blake's representations of Jesus in the breadth of face and curly hair. Blake consistently shows Jesus with a central parting in his hair that leaves a high receding point of forehead; Isaiah in *The Sea of Time and Space* has a central peak of downward pointing hair, quite the opposite arrangement.

There is another reason for rejecting the Jesus hypothesis. Blake follows tradition in always showing Jesus in a seamless white robe, with the exception of the episode of the mocking of Jesus as King, for which he is naturally dressed in scarlet. There is one other moment which could justify an alternative dress, the appearance of the Word of God "clothed with a vesture dipped in blood" whose "eyes were as a flame of fire, and on his head were many crowns" (Revelation 19: 12–13), a vision based on Isaiah 63: 2–3. But that is a vision of the angry and powerful Jesus of the Last Judgment, and represents specific clothing for a specific situation.

The identification of the man in red as Isaiah raises the question whether the preliminary sketch for *The Sea of Time and Space* (B 804r; illus. 71) represents the same figure. The sketch has the title "The River of oblivion" written on the reverse, in a hand not attributed to Blake. There are differences; the figure in the sketch looks younger, and is unbearded, with long curly hair. Behind him stands a woman, above whom there appears to be a small

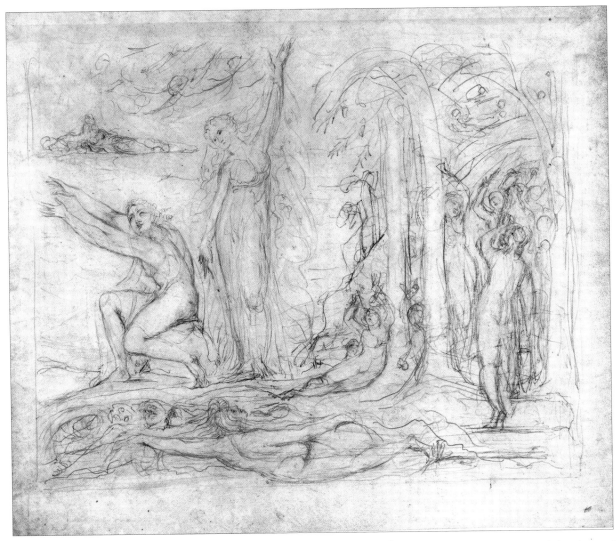

71. William Blake, sketch for *The Sea of Time and Space* (B 804r)

flying figure descending with outstretched arms; it is not clear whether it is descending towards the man or towards the more or less undecipherable figure or group just above his head.

The figure in the sketch may represent the young Milton. In the "Annotations to the Works of Sir Joshua Reynolds" Blake quotes from Milton's "Preface" to Book Two of *The Reason of Church Government*: "A Work of Genius is a Work 'Not to be obtained by the Invocation of Memory & her Syren Daughters. but by Devout prayer to that Eternal Spirit. who can

enrich with all utterance & knowledge & sends out his Seraphim with the hallowed fire of his Altar to touch & purify the lips of whom he pleases.' Milton" (E 646). Milton's reference is to Isaiah 6: 6–7: "Then flew one of the seraphims unto me, having a live coal in his hand, which he had taken with the tongs from off the altar: And he laid it upon my mouth, and said, Lo, this hath touched thy lips; and thine iniquity is taken away, and thy sin purged." The figure in the sketch may be Milton, another prophet and poet, in the process of invoking Isaiah's image of divine inspiration. The drawing may represent an earlier stage of Blake's thinking, in which the role of inspired prophet was played by Milton, before Blake settled on Isaiah as the truest incarnation of that function.

To return to the painting, the next task is to decide why Isaiah has been placed in this obviously classical setting; the situation bears some analogy to that in *A Crowned Woman amid Clouds with a Demon Starting away* (illus. 35), in which a figure from the New Testament is spliced into a scene from the Old Testament. One answer is that Blake's thoughts about Isaiah were triggered by Thornton's edition of Virgil's pastorals. That edition included a long note on the relation between classical (sibylline) and biblical prophecy, resuming the entrenched tradition of relating Virgil's Fourth Eclogue to Isaiah as parallel prophecies of the coming of Christ, of which Pope's *Messiah* was one product. Work on designing the woodblock may have prompted the desire to produce a major painting on the large theme of the relation between classical and biblical inspiration, which had long interested Blake, as the "Preface" to *Milton* shows:

> The Stolen and Perverted Writings of Homer & Ovid: of Plato & Cicero. which all Men ought to contemn: are set up by artifice against the Sublime of the Bible. but when the New Age is at leisure to Pronounce; all will be set right: & those Grand Works of the more ancient & consciously & professedly Inspired Men, will hold their proper rank, & the Daughters of Memory shall become the Daughters of Inspiration. (E 95)

A slightly more complex and positive version of the same thought is to be found in *A Vision of The Last Judgment*:

> Jupiter usurped the Throne of his Father Saturn & brought on an Iron Age & Begat on Mnemosyne or Memory The Greek Muses which are not Inspiration as the Bible is. Reality was Forgot & the Vanities of Time & Space only Rememberd & calld Reality Such is the Mighty difference

between Allegoric Fable & Spiritual Mystery Let it here be Noted that the
Greek Fables originated in Spiritual Mystery & Real Vision and Real
Visions Which are lost & clouded in Fable & Alegory <while> the Hebrew
Bible & the Greek Gospel are Genuine Preservd by the Saviours Mercy.

<div align="right">(E 555)</div>

These statements give us a good deal of the general subject of *The Sea of Time
and Space*, the relationship between "Real Vision" and "Fable & Alegory"
dealing with "the Vanities of Time & Space." Accepting Isaiah as Blake's
model of the "consciously & professedly Inspired Men" who represent
"Real Vision," we can turn to puzzle out the classical side of the painting.

III

The first interpretation of the painting was by Kathleen Raine, who read it
as based on Porphyry's treatise *Concerning the Cave of the Nymphs*.[16] Raine's
thesis has not been widely accepted because she insists, against all the evi-
dence, that Blake was a Platonist. It is also demonstrably wrong in some of
its claims; for instance, the description she reads as confirming her account
simply does not fit:

> High at the head a branching olive grows,
> And crowns the pointed cliffs with shady boughs.
> A cavern pleasant, though involv'd in night,
> Beneath it lies, the Naiades delight:
> Where bowls and urns, of workmanship divine
> And massy beams in native marble shine;
> On which the Nymphs amazing webs display,
> Of purple hue, and exquisite array.
> The busy bees, within the urns secure
> Honey delicious, and like nectar pure.
> Perpetual waters thro' the grotto glide,
> A lofty gate unfolds on either side;
> That to the north is pervious by mankind;
> The sacred south t'immortals is consign'd.[17]

The painting does not match this description. Blake shows several trees at
the foot of the mountain, not one olive at the head of a cliff; there are no
"massy beams," no bees (pace Raine's urging that the winged women in
Blake's painting represent those bees), and no "lofty gate" at each side. This
is not the place, nor this the key text Raine took it to be.

Yet some aspects of her interpretation stand; she has understood that Blake is constructing his painting as an exposition of what Blake understood as Platonic or Neo-Platonic doctrine. Though many of her specific identifications of figures are incorrect, some of her commentary is apt, and she does point us towards Thomas Taylor, whose translations of Plato play a role in the painting, though not the one she describes.

The hypothesis I shall explore is that the texts behind Blake's painting are what he took to be the basic statements of Pythagorean and Platonic philosophy, including both Taylor's translations and notes and Ovid's *Metamorphosis*, particularly Pythagoras's oration in Book Fifteen, which Blake would have taken to be the primary extant text of Pythagorean thought, though it has of course no historical authority whatsoever, containing as it does a large element of Lucretian thought. I have given Ovid's title in Blake's own spelling, which as previously indicated suggests he knew the work in Sandys's version: "Apuleius's Golden Ass & Ovids Metamorphosis & others of the like kind are Fable yet they contain Vision in a Sublime degree being derived from real Vision in More Ancient Writings" (E 556). Blake's painting expounds the world view of Pythagoras and Plato as Blake understood it, with Isaiah there to expose its fabulous, even deceptive, nature.

As one might expect, there are analogies between this painting and the design "The Spirit of Plato" (B 543: 9; plate x) in the series illustrating Milton's *Il Penseroso*, dated *c*. 1816–20 by Butlin. Blake's inscription reads as follows: "The Spirit of Plato unfolds his Worlds to Milton in Contemplation. The Three destinies sit on the Circles of Platos Heavens weaving the Thread of Mortal Life these Heavens are Venus Jupiter & Mars. Hermes flies before as attending on the Heaven of Jupiter the Great Bear is seen in the Sky beneath Hermes & The Spirits of Fire. Air. Water & Earth Surround Miltons Chair" (E 685). Blake has elaborated this from Milton's own text:

Or let my Lamp at midnight hour,
Be seen in som high lonely Towr,
Where I may oft out-watch the *Bear*,
With thrice great *Hermes*, or unsphear
The spirit of *Plato* to unfold
What Worlds, or what vast Regions hold
The immortal mind that hath forsook
Her mansion in this fleshly nook:
And of those *Dæmons* [changed by Blake to 'Spirits'] that are found

In fire, air, flood, or under ground,
Whose power hath a true consent
With Planet, or with Element.[18]

Blake has, however, added the Three Fates, appears to have (mis)understood Milton's Hermes [Trismegistus] as the god Hermes, and has specified Milton's "Worlds or... vast regions" as the three planetary divinities he lists. Pamela Dunbar suggests that the Fates may come from the myth of Er in Book Ten of the *Republic*, citing Taylor's *Works of Plato* as source;[19] it is virtually certain that Blake knew this edition, since he writes in *The Laocoön* that "The Gods of Greece & Rome were Mathematical Diagrams See Plato's Works" (E 274), and the edition gives explicit support for that view.[20]

Though Blake has not quoted the last two lines of Milton cited above, he has illustrated them by showing Mars as the god of both war and fire (a spirit bearing flaming torches descends bottom left, driving before him two terrified women – decidedly a horrors of war scene),[21] and Venus as goddess of both love and water (a watery sprite entangles a male in a net in an underwater scene at bottom right). The elements are thus shown as derived from the Greek gods, and as integrally connected with vegetative life. They are in human form, as we would expect from Blake. Milton's editors attribute these elemental daemons to a variety of hermetic and Neo-Platonic sources, agreeing that they do not come from Plato himself.[22] Taylor however had no qualms about adding Neo-Platonic interpretations to his translations of Plato, and in the notes to *The first Alcibiades* we are told that "every mundane god is the leader of a certain dæmoniacal order, to which he proximately imparts his power," so that there are a multitude of daemons who "rejoice when they are called by the names of Jupiter, Apollo, and Hermes," and mediate the creative power of the gods.[23] In other passages, Taylor's translation speaks of the elements as progressing from the demiurgus, and Blake seems to have put these accounts together, doubtless with other statements, to create an account of the Greek philosophy of the elements as daemons who emanate from the gods of the Greek pantheon. Unlike Milton's editors, Blake has been happy to accept these elemental daemons as aspects of Plato's celestial machinery.

Taylor has a consistent view of Pythagoras as a forebear of Plato, and of the two as joined in a common philosophy: he describes his mission as the restoration of "the long lost *philosophy* of *Pythagoras* and *Plato*," which is "the genuine key to the religion of Greece."[24] This is Blake's version of

Plato, whom he couples with Ovid as spokespersons for classical culture in the "Preface" to *Milton* cited above. I shall therefore refer to Taylor's translations and notes, and to Ovid's *Metamorphosis*, especially Book Fifteen, as representing together what Blake took to be Pythagorean/Platonic doctrine.

Sandys's edition of Ovid is concerned, as is Blake, to point out the priority of biblical over classical inspiration, to the point of suggesting that "[Ovid] had either seene the Bookes of *Moses*, or receaved that doctrine by tradition," while another note says "*Thus many Poeticall fables* (saith *Tertullian*) *have taken their originall from the sacred Scriptures: and what we write is not beleeved, because the same is written by the Poets.*"[25] The theory of the derivation of heathen poetry from Hebraic prophecy is as central to Sandys's interpretation of Ovid as it is to Thornton's presentation of Virgil.

IV

The woman who stands beside Isaiah shares with him the central position in the design. Like other figures in this painting, she has in the past been variously identified.[26] In the sketch, the corresponding figure has clearly visible stars in her long robe, which might suggest that she represents Night.[27] The woman in *The Sea of Time and Space* lacks the stars, and has no specific insignia other than her dark veil.

There are several ways in which to approach the problem of constructing an identity for this woman. One is to focus on attributes that might give a clue to her name, another is to interpret her gesture in order to recover her function, and a third is to construct a text to explain her. She has no specific attributes except for her veil, and the discussion of this figure in Chapter Three showed that her gesture, while obviously significant, is not sufficiently univocal to act as sole guide to an interpretation. We must seek or construct a text.

The most suggestive single text I have found is in Taylor's translation of *The Hymns of Orpheus*. The hymn "To Nature" describes her as "all parent, ancient, and divine," as an "Immortal, first-born, ever still the same,/Nocturnal, starry, shining, glorious dame."[28] Taylor's "Introduction" to the *Timæus* also includes a commentary that may help interpret her up-and-down pointing gesture: "But nature governs the whole world by her powers, by her summit comprehending the heavens, but through these ruling over the fluctuating empire of generation, and every where weaving together

partial natures in amicable conjunction with wholes."[29] The association with weaving is relevant, and the description of Nature as a "starry, shining" dame may explain why Blake gave her stars in the sketch but not in the finished painting: the description authorized stars, but Blake may have felt that they would confuse her identity with that of Night.

Another commentary can be found in Ovid. Ovid begins his account of the creation of the world in Book One with the statement that "The Sea, the Earth, all-covering Heaven unfram'd, / One face had Nature, which they *Chaos* nam'd." This language is picked up again in Book Fifteen, when Pythagoras is described as having taught "The Worlds originall, past humane thought: / What Nature was, what God[.]"[30] The speech goes on to express a desire to "unfold the booke of Fate"; as in Plato we find a conjunction of Fate with the governors of the world of nature.

Pythagoras in his oration becomes the spokesperson for Nature, the process of change and transformation that is central to the *Metamorphosis* as a whole. I shall quote the account of "The Vicissitude of Things" at some length because it affords such a useful commentary on the painting:

Th'eternall world foure bodies comprehends,
Ingendring all. The heavie Earth descends,
So Water, clog'd with weight: two light, aspire,
Deprest by none; pure Aire, and purer Fire.
And though they have their severall seates; yet all
Of these are made, to these again they fall.
Resolved Earth to Water rarifies;
To Aire extenuated Waters rise;
The Aire, when it it selfe againe refines,
To elementall Fire extracted, shines.
They in like order back again repaire:
The grosser Fire condenseth into Aire;
Aire, into Water: Water thickning, then
Growes solid, and converts to Earth againe.
None holds his owne: for Nature ever joyes
In change, and with new formes the old supplies.

It is this same Nature that "in her changes manifold, / Sends forth new fountaines; there, shuts up the old."[31] The Nature of Ovid and Pythagoras is the governor of change and transformation, of the exchanges between the elements, and of fountaines and the circulation of water.

Nature also controls the cycles of time through which those exchanges move:

> Even time, with restlesse motion, slides away
> Like living streames: nor can swift Rivers stay,
> Nor light-heel'd Howers. As billow billow drives,
> Driven by the following; as the next arrives
> To chace the former: times so flye, persue
> At once each other; and are ever new.
> What was before, is not, what was not, is:
> All in a moment change from that to this.
> See, how the Night on Light extends her shades:
> See, how the Light the gloomie Night invades.
> Nor such Heavens hew, when Mid-night crown's repose,
> As when bright *Lucifer* his taper shows:
> Yet changing, when the Harbinger of Day
> Th'inlightned World resigns to *Phoebus* sway.[32]

These passages point to much of the action of the painting, specifically the exchanges among the elements and the cycles of time; the first passage corresponds approximately to the right hand and lower portion of the painting, the second to the upper left. Together, these passages constitute a vision of Nature that is approximately in accord with what Blake means by the mythical figure he calls Vala in his poetry, and they are almost certainly one of its sources.

Nature as visible personification is central to Blake's design because she functions there as the spokesperson for Ovid and Pythagoras and Plato, for a whole culture that is in Blake's view centered on nature. She is veiled in the tradition represented, for instance, by Spenser, who images her head and face hid "with a veile that wimpled euery where,"[33] though that figure is not quite like Blake's, whose face is open to our view; in fact, one could ask whether Spenser's Mutability or Nature is closer to the figure in the painting.

She and Isaiah represent the alternative views of the world that Blake proposes to us as viewers of the painting. Isaiah and Nature do not respond to each other since each is essentially invisible to the other. The world of prophetic imagination towards which Isaiah points is outside the frame of the painting, which sets before us images that represent Blake's view of the world of Nature as expounded by Pythagoras and Plato.

The spatial relationship between Isaiah and Nature is in accord with Fuseli's concept of "Apposition"; the figures stand like statues placed beside each other, not recognizing each other's existence, though their garments actually touch. Each addresses a separate message to the viewer from their own semantic and physical space; no attempt has been made to accommodate the two to a single controlling aesthetic structure. They are as they are because of what each is and says, not because of the demands of an overall surface or spatial organization. This is equally true of the other major figures and groups of figures; each exists in a separate space, which can only approximately be related to the spaces of the other figures. Thus it is impossible to impose a clear perspective upon the various planes and areas of the mountain at right; the temple at the foot is unrealistically tucked down under its cliff, and the small lake visible between the trees at the left of the mountain is placed quite irrationally in relation to the slopes above. The elements of the painting are put together to expound a text, not to constitute a unified and coherent representation of a corner of the visual world: "Apposition" rather than composition.

As we saw in Chapter 3, Nature's gesture alone does not tell us whether her arms and hands point to a choice, or include everything above and below in one embrace. The texts drawn upon here imply that Nature is expounding a view of the world, and that her pointing hands are inclusive, reaching out to both the figures above and those below. Much of the painting is thus in virtual quotation marks, that bracket a Pythagorean/Platonic view of the world in opposition to the view represented by Isaiah, who points off to the coming of a new world. Nature's outstretched arms and pointing hands offer a whole turning world for our inspection, consideration, and, finally, rejection.

V

One of the key figures within Nature's discourse is the one at top left, clearly Apollo, though he too has been very variously identified. His chariot is surrounded by nine females, representing the Muses (plate xi); it is difficult to believe that they have not previously been so identified.[34] The Muses appear in Book five of *Metamorphosis* when Athene appears to check out the rumor of their "new Fountaine, rays'd by force/Of that swift-winged *Medusean* horse."[35] Sandys gives a long note on them. They are the daughters of Jove and Mnemosyne. Their habitation is "*Parnassus, Tempe,*

and *Helicon… Apollo* is their president: not only in that the inventor of musique, but for playing so harmoniously on the instrument of this world, moving in order and measure." There follows a general overview of their position as the possessors of the whole complex of classical culture:

> *Jupiter* the divine mind, inspires *Apollo; Apollo* the Muses; and they their legitimate issue. Who are called by *Plato* the fathers of wisdom; and interpreters of the Gods (among the Heathen the only Theologians, and therefore called by *St Paul* their Prophets) accustoming to celebrate their praises and the heroicall actions of men, inflaming the hearers with emulation: teaching the causes of things, the knowledge of the Coelestiall motions; how to order the mind, and curb the rebellious affections.[36]

This integrates the theme of the tension between classical and divine inspiration with the other major themes of Nature's speech, the building and unbuilding of the world through the interaction of the elements and the cycles of time. Apollo and the Muses are bridges between these topics; the Muses sing of the elements and the hours under the leadership of Apollo, who is also god of the sun that marks out the divisions of time that govern all change in the mortal world.

Sandys then gives a quotation from "Virgil" [i.e. Ausonius] that differentiates the "particular faculties" of the nine:

> *Clio the acts of former ages sings:*
> *Melpomene, in tragick straines, sad things:*
> *Comick Thalia joyes in amorous layes:*
> *On sweetly speaking reeds* Euterpe *playes:*
> Terpsichores *harp the rais'd affections moves:*
> Erato *musique odes, and dances loves:*
> Calliope *pens the lofty rage of warres:*
> Urania *observes the heaven-imbrodered starres:*
> *Polymnia to her words her gesture fitts:*
> Apollos *soule illuminates their wits;*
> *Who all informing, in the middle sitts.*

On the basis of this text, specific muses can be identified. The one who holds two pipes is Euterpe, the one who plays the harp or lyre Terpsichore. These attributes are also given by Spence, who quotes Ausonius in Latin and then describes the figures on a drawing of a relief of the muses.[37] The muse swaying oddly behind Apollo's chariot is Polymnia, fitting a gesture

to her words. The one to her upper right may be Melpomene, since there appears to be the ghost of a face at her side that may represent her tragic mask. The one at the right is Urania, observing the stars. Spence describes her as with "globe and radius"; Blake is here much closer to Sandys, suggesting that Ovid is indeed his primary source. Apollo's downcast wand is the sign of his function as *musagetes*. Apollo is often represented naked, but Spence has a note that "At other times he has his hair finely dressed out; all flowing down at its full length, and crowned with laurel; dressed in a long robe, that falls down to his feet: which is indeed the proper and distinguishing habit, of the Apollo Vates or Lyristes."[38] Since Apollo is not simply god of the sun, but also leader of the Muses, he may be not asleep but entranced by the music of his accompanists; his wand may represent control rather than mere collapse, though it looks singularly ineffective. Blake seems to be implying the weakness and fatigue of classical culture understood as a secondary echo of the original power of Hebrew poetry. This portion of the painting has a marked analogy with Blake's early poem "To the Muses," which begins by sketching in something very like the scene of the painting: "Whether on Ida's shady brow, / Or in the chambers of the East, / The chambers of the sun," and ends by describing a lassitude much like that of Apollo in the painting: "The languid strings do scarcely move! / The sound is forc'd, the notes are few!" (E 417).[39] Apollo with his Muses represent the "Fable or Allegory... Formd by the Daughters of Memory" which, while containing some "Vision" (E 554), are nevertheless both product and source of an allegorical and fabulous view of the world.

Apollo's horses are being unharnessed and towelled down by a group of four other women, one of whom holds a curry comb. They are the Hours, conventionally four in number to represent the seasons, and assigned the work of yoking and unyoking the horses of the sun each morning and evening. "His horses are harnised and brought forth by the houres, which are the ministers of time" is Sandys's comment on Ovid's lines on the morning:

When *Titan* saw the Dawning ruddy grew,
And how the Moone her silver hornes with-drew:
He bade the light-foote Houres, without delay
To joyn his Steeds.[40]

The time in the top left of the painting, however, is evening, and the horses descend the steps towards the sea:

> Then downe the Hill of Heaven they [the horses of Apollo] scoure amaine
> With desperate speed, and need a steady reigne;
> That *Tethys*, in whose wavy bowres I lie,
> Each evening dreads my down-fall from the skie.[41]

Sandys adds a footnote that "The Sun was feigned to descend into the Sea, (which is *Tethys*) in that it so appeared to the eye."[42] This accords with what Blake has shown, though the horses have been well managed and all danger is past.

VI

There is a strong visual connection by means of a cloud vortex between him and the woman drawn by horses over the sea, who is thereby connected with the time aspect of the exposition of the world of Pythagorean Nature. She too has been variously identified. George Wingfield Digby saw on her head the "crescent lunar horns of Artemis, the mistress in Greek mythology of the pride and strife of animal life,"[43] and subsequent commentary has found it difficult to make a fresh beginning. There are, however, no horns; her hair has simply been blown by the wind into pointed ringlets. Blake was quite prepared to use a visible crescent moon to identify a figure as Diana.[44]

Grant has pointed out that there are two barely visible chariot wheels emerging from the sea.[45] There are also two rows of converging dots leaving the woman's feet that have been interpreted as connecting her with the veiled woman standing behind Isaiah. To interpret them in this way, however, is to impose a geometrical symbolism upon Blake that is very foreign to his normal practice. There are two interpretations of the dots that are consonant with the rest of the design; one is that they indicate the movement of the woman as she is drawn to our left by the horses, as cartoonists signify speed by drawing lines in the direction from which a character moves. The other depends upon a prior identification of the woman.

Several female figures are traditionally represented as drawn by chariots, but most are not likely candidates for this figure who is so closely associated with the sea. Amphitrite, the daughter of Oceanus and Tethys and also the wife of Neptune, is sometimes said to share a chariot.[46] She is mentioned at the very opening of *Metamorphosis*, where Sandys's footnote says she "is here taken for the Sea."[47] She might thus appear a possibility, but a better candidate is at hand.

The chariot-borne woman's true identity was glanced at by Grant, though he continued to call her a sea goddess and so did not pursue his observation:

> Even more closely related to <u>ACP</u> is the figure of Dawn [in *Night Startled by the Lark* from *L'Allegro*, B 543: 2; plate xii], who, in this picture is represented as a woman drawn by a team of four horses. If the Indian lady of J 11 were combined with Jerusalem as she appears in J 57 and J 93, the composite figure would be much like the sea goddess – though this observation is not of much assistance for interpretation of <u>ACP</u>.[48]

This one certain portrayal of Aurora by Blake shows her drawn by four horses, though no chariot is visible; almost as in *The Sea of Time and Space*, the horses draw her without any visible vehicle. Both versions of Aurora have their arms stretched out before and behind in the same gesture, and both have the traditional veil curving up between Aurora's hands to represent the clouds of dawn that veil the sun. Montfaucon describes Dawn thus: "*Aurora* covered with a large Veil comes next, mounted upon a Chariot with two horses, as *Luna* generally is. The Veil upon her Head is very much turn'd up behind, which denotes that the Obscurity of the Night is considerably dissipated already by the advances of Day-light."[49] Spence also describes her, rather prettily: "Her chariot, should be of a fine rose-colour; with pearls of dew scattered here and there upon it, if the painter pleases: and the horses, I think, may be either cream-coloured, or strawberry."[50] Blake's horses are neither, but are quite dark in color; dawn may have just begun.

Aurora does not have the morning star beside her, as she does in the Milton illustration, but has two small figures, apparently male and female, who swim beside her horses, urging them on with outstretched arms that echo the arms of Aurora. Spence states that "There seem to have been some representations of this goddess [Aurora] of old, as driving Nox and Somnus from her presence; and of the Constellations as chased out of heaven, at her appproach,"[51] and Lemprière gives similar information. It seems unlikely that Blake would picture so powerful a figure as Nox in the form of this tiny female, but since Somnus is male the possibility exists that we have here an identification of these puzzling small figures. Alternatively, they may be Blake's typically humanized images of Hesperus and Lucifer, again typically transformed by Blake into a male / female pair, in disregard

of the logic of their identity as variant forms of the planetary Venus; Spence records that the two were distinguished by the fact that Lucifer preceded the chariot of the sun with a torch, and Hesperus that of the moon, and without a torch.[52]

There were several well-known images of Aurora, including a famous engraving by Marcantonio Raimondi after Raphael of *Aurora Rising* which shows a nude woman in front of a sun disc, drawn by two horses that arise from the water, a veil arched over her head and two winged girls in the water holding the horses' heads,[53] a very likely source for Blake's two small figures. Guido Reni and Guercino also made well-known paintings. Barry showed her in his *Mercury inventing the Lyre* (exhibited 1774): "Aurora precedes the horses drawing the chariot of the sun, while Night flees in the upper left-hand corner."[54]

The evidence for Aurora as the identity of the figure is strong, and the hypothesis gives meaning to the rows of dots leaving her feet: they are drops of dew scattered as she rises, an image with plentiful occurrences in poetry, including Blake's own.

If the figure is Aurora, we are dealing with the exposition of an allegory of time and space, in which dawn and sunset can be shown simultaneously as parts of a cyclical temporal structure, and not as sequential moments in a linear narrative. This is exactly consonant with the account of time in Pythagoras's "Vicissitude of Things"; "See, how the Night on Light extends her shades:/ See, how the Light the gloomie Night invades"; the interchanges of evening and morning are precisely the moments indicated by Blake's classical figures. Aurora's veil of morning clouds descends in something like a vortex from Apollo's chariot to indicate the interdependence of the two; evening will become morning and morning in turn evening in a perpetual cycle. The two figures are also connected by the symmetry of their four-horse chariots, the one descending into the sea as the other rises up from it. That cyclical symmetry is a key part of what Nature is indicating with her hands.

The major figures on the upper left side of the painting are familiar ones drawn from the Bible and classical mythology; only an insistence upon identifying Blake's figures with those of his own myth has prevented recognition. Blake has followed conventional accounts closely, as in the case of the Muses; we have not the kind of adaptation described in Blake's account of *The Ancient Britons*, but something more like direct quotation. Apart

from Isaiah, these figures are allegorical in a sense that includes a suggestion of falsity, of surface show rather than deep reality; they are "Allegoric Fable" representing "the Vanities of Time & Space." It is a mistake to look for "deep" Blakean meanings within them: they exist within implicit quotation marks, are part of a narrative in a voice other than Blake's, though that narrative implies Blake's often repeated critique of the classical world.

VII

Another key figure is the man at the bottom of the picture, swimming in the burning river with the Three Fates. He has often been identified as Tharmas, whether given a shell or horns, the two interpretations of his odd headdress.[55] The reasons for the identification are extremely tenuous; Blake describes Tharmas as "Demon of the Waters" (E 111), and as sitting "in the place of shells" (E 398), but nowhere as "shell-crowned," as Damon calls him. The identification persists, however. Simmons and Warner, for instance, comment that "the horned man has associations with Tharmas," and allege that he is "trying to integrate the divided reality of spiritual and physical existence into one body."[56] That, as Alice might have said, is a great deal to make a figure mean on slender evidence. Moreover, Simmons and Warner keep Damon's name Tharmas, which was based on the assumption that the figure was "shell-crowned," though they themselves correctly identify the headdress as horns, thereby removing the only grounds for the original association with Tharmas.

Examination of the painting shows that he bears ram's horns, not a shell headdress; the horns are even clearer in the sketch, which shows the annular rings. Blake's shells are always tapered conches, not flat whorls like the shape here. There also seems to be a filet of leaves around the head in the finished painting. We need to identify a figure who fits the context, one not based on a factitious connection to Blake's myth.

The likeliest candidate is Jupiter Hammon (as he is spelled by Sandys), a version of Jupiter traditionally depicted as bearing ram's horns, and one who appears several times in Ovid. In Book five he is called "horned *Hammon*," and associated with the "wrath of Seas."[57] Even more to the present point is Pythagoras's reference in his oration to "Hammons Fountaine": "Hornd *Hammons* at high Noone / Is cold; hot at Sun-rise, and setting Sun,"[58] a description that fits both the urn under the figure's right hand and the time indications of the painting. Sandys's note translates Lucretius 6:

861–78 as offering the "true reason" for this phenomenon: the fountain is one "Wherein the sulphurous seeds of fire reside."

There are other possibilities, such as Pan and Bacchus, both often represented as horned. Spence comments that the horns of Bacchus are seldom visible because "they are very liable to be hid, by the crown of grapes, or ivy, which is almost a constant ornament of the head of Bacchus," which correlates well with the filet of leaves worn by the figure in Blake's painting. Spence then neatly links Jupiter Hammon and Bacchus by stating that "These horns were given to Bacchus to show that he was the son of Jupiter Ammon."[59] Taylor relieves us of having to choose between father and son by providing a plethora of syncretizing information that identifies the demiurge as a being called variously Pan/Phanes/Protogonus/Bacchus/Jupiter; whatever his name, he is the "king and father of the universe."[60]

A typical statement is that in a note to Hymn X of *The Hymns of Orpheus*:

> The reason why Pan is horned is because Jove is the mingler of all things, according to Orpheus… horns are an occult symbol of the mingling and tempering power of the demiurgos of the world… We may add that Pan considered as the soul of the world is with great propriety called Jove; since that appellation is given by Orpheus to the mundane soul.[61]

This demiurgic, horned Jupiter/Pan/Bacchus is creator and ruler of the fallen and generating world of time and space; it is probably a temple dedicated to him that we see behind the figure of Nature, though Apollo as *musagetes* is also a candidate.

In the painting he holds a distaff in his right hand from which unwinds the heavy thread that is passed through the hands of the three Fates, to be finally cut by Atropos. In the myth of Er in *The Republic* Plato describes how "from the extremities [of 'a light extended as a pillar' 'through the whole heaven and earth'] the distaff of necessity is extended, by which all the revolutions were turned round." The three Fates, "daughters of Necessity," control the motion of the spheres that turn on the axis of the pillar.[62] Blake may have seized on the image of the "distaff of necessity" for its connections with the Fates, suppressing the associated cosmology. The connection between Jupiter and fate is even clearer in the *Timæus*, where Taylor's note says that "In the Politicus also he [Plato]… says that the present order of the world is under Jupiter, and that the world is governed according to fate."[63] Is it a coincidence that Blake writes in a letter dated 23 October 1804

(the year of publication of *The Works of Plato*) of having as an enemy "the Jupiter of the Greeks, an iron-hearted tyrant, the ruiner of ancient Greece"? (E 756)

Jupiter, as I shall henceforward call him for simplicity, holds under his left hand an urn from which pours a burning spring that fills the lower part of the picture, and is continued in the flames that fill the cave of the weavers above. This fire connects him with the elemental imagery that is pervasive in the design. There is a good deal about the elements in Pythagoras's speech in the *Metamorphosis*, and also in Plato, including a key discussion in the *Timæus* of how the elements subsist in and progress from the demiurgus in a system in which "fire every where prevails."[64]

Blake has taken the Jupiter of Ovid and Plato as a demiurgic god who is pure natural process, the central fire that keeps the exchange system of natural transformation energized. The river that leaves his urn is the fountain that "at high Noone/ Is cold; hot at Sun-rise, and setting Sun"; it is also "smoking *Phlegeton*," a "burning river in Hell" according to Sandys's annotation.[65] Pure natural process is Blake's vision of hell; the two statements fit together nicely. The flames are visible in the background of the second cave, behind the weavers; their activity too is part of the continual processes of the natural world, building and destroying as Sandys describes them as doing: "*Pythagoras*... declares the vicissitude of all things through alternate generation and corruption."[66] Blake picks up these terms in such imagery as that of Plate 72 of *Jerusalem*, showing a world "Continually Building. Continually Decaying because of Love & Jealousy" (E 227), with two angels weeping over it and flames surrounding the whole. Jupiter through his connection with both fire and weaving is at the center of this process.

The Three Fates are part of the destined process of natural cycles, playing much the same role that they filled in the illustration to "The Spirit of Plato"; they represent the fatality, in both senses, of natural process as Blake interprets it. Pythagoras's stated ambition was "t'unfold the booke of Fate"; Blake, as in the illustration cited above, regarded the concept as central to the classical vision. The rope or thread that the Fates handle is unwound from the great distaff held by Jupiter; he is the origin of natural life as he is of fire, and the Fates merely unwind and decree in accord with his creation. Here is the key passage of Sandys's commentary:

They are called *Parcae* of producing, in that they conferre at our births either good or evill: the one supposed to draw forth the thread of humane life; the second to twist, and the third to cut it a sunder... Yet *Plato* more divinely: how there is one God the Creator of the Universe, the Prince and Father of the Gods and coelestiall vertues: who are only his ministers, and order all things at his obeyed direction; his lawes constant and unevitable, and therefore called Fate or necessity; whose effects no force, no art, nor wisedome can impeach or alter.[67]

The Fates Blake has shown perform just these acts; Sandys's "twist" explains perfectly the gestures of both hands of the central fate, who in the illustration of "The Spirit of Plato" is represented as measuring the length of thread to be cut by her sister, while the youngest of the three is, as usual, given the distaff to hold. In *The Sea of Time and Space*, Blake has modeled his depiction of the Fates on Sandys's text, making the central fate twist the thread rather than measure it.

These figures swim in the river that flows underground; the earth beneath Isaiah has been cut through in cross-section, showing the rock layer beneath the soil. The rocks keep Jupiter and the Fates invisible to those on the surface; the machinery that runs this world is invisible save to the alerted poetic eye. It is part of Nature's function to point these things out to us, to reveal the demonic mechanics of classical philosophy as Blake understood it.

We have been looking so far at figures for whom specific identifications are possible by virtue of their functions and attributes. The correspondences between the details of Blake's painting and the sources I have quoted demonstrate that he is illustrating texts external to his own mythology, though links can be made since his myth is derived from such sources, among others. That Blake rejects the claims of the source texts to provide an adequate explanation of the world does not render them less significant as his originals for this design. Apollo does not become Los because Blake does not credit Apollo with effective divinity; Apollo can still be useful in a design aimed at putting the classical world into a wider perspective.

VIII

On the right-hand side of the painting are less specific figures, who confront us with the difficulties that arise from Blake's use of what I shall call "Human formd" (E 712) allegory, in which a human figure may represent

almost anything, from water-vapor to a human energy or a person. Some
of the problems caused by this were discussed in Chapter 3 while con-
sidering the changes Blake made to the emblem of "Aged Ignorance" from
The Gates of Paradise (E 265). It is inherent in personification allegory that
many different kinds of entity will all be represented by human figures;
Richardson's *Iconologia* differentiates between allegories of the seasons and
times, of the senses and sciences, and of moral virtues and vices: all are rep-
resented by human figures.[68] It is because of the possibility of radical cate-
gory mistakes that eighteenth century discussions of allegory betray such
anxiety over the need to maintain intelligibility; Boswell tells the story of
"a little Miss [who] on seeing a painting of Justice, with the scales...
exclaimed... 'See, there's a woman selling sweetmeats,'" to which Johnson
replied "'Painting, Sir, can illustrate, but cannot inform.'"[69] Blake was
more optimistic about the power of images to communicate without resor-
ting to traditional attributes, but as a result his designs are often difficult to
interpret.

The imagery of weaving in the painting can be approached through a
passage from *The Four Zoas*:

> And all the time in Caverns shut, the golden Looms erected
> first spun, then wove the Atmospheres, there the Spider & Worm
> Plied the winged shuttle piping shrill thro' all the list'ning threads
> Beneath the Caverns roll the weights of lead & spindles of iron
> The enormous warp & woof rage direful in the affrighted deep
> ...& many a net is netted; many a net
> Spread & many a Spirit caught, innumerable the nets
> Innumerable the gins & traps.
>
> (E 319–20)

There is a drawing on this page (29) of the manuscript that shows a nude
man or woman[70] weaving a net curtain with a needle or shuttle raised in the
left hand in a gesture related to that of the three weavers in the painting.
The image of atmospheres spun and woven on looms, that become nets to
entrap spirits, is close to the imagery of the right hand side of the painting,
and I shall explore the possibility that "spun," "wove," and "caught" can all
be linked to the process shown in the right hand side of the painting, mov-
ing from the creation of the elemental substances of the fallen world to the
embodiment of human spirits.

Weaving is a process; there are inputs, the process itself, and outputs. On

the input side, the approach to the cave of the weavers is flanked by two women who hold the dual supply needed for the weaving; Blake understood the roles of warp and woof. The woman on the right holds over her shoulder a heavy warp line, one end of which has been cut, and the other end of which goes up into the weaving frame. Since Atropos has just cut her line, the end held by the woman on the right may be the length that has been cut off; a determinate line of life is being fed into the weaving frame. This neatly ties together the two loose ends visible in the painting, and defines weaving as a process that combines the elements with a determinate time to make a mortal body.

The woman on the left holds a ball of fine woof that has been rolled from the skein held by a young girl sitting under the trees at the left. The woof will presumably be fed by the standing woman into the shuttles of the weavers, which hold a fine thread. The young girl with the skein has her eyes raised upwards meaningfully, possibly to suggest the origin of her skein from the air itself, no other source being visible; we remember the cycling of elements in Pythagoras's oration. The woof will enter the weaving frame, there to be united with the fateful warp unwound by Jupiter and the Fates.

Since there are flames on the water below, on the steps mounting up to the weaving frame, and in the frame itself, this fire must also enter the weaving process. The fabric which constitutes body combines the Necessity of Jupiter and the Fates with the processes and substances of the elements, among which fire has a natural priority. Blake's lines speak of the "Atmospheres" as themselves spun and woven, and that process includes more than the appearance as from nowhere of the fine woof; the maiden who mounts the steps towards the weavers with a bucket in her hand is also bringing something to the weavers that will enter into their process.

This figure has given rise to a wide diversity of interpretation, much of it focused on her bucket. Critics have regarded the scales visible on this bucket as ominous – and the water-carrier as morally flawed[71] – ever since Keynes wrote that the "bucket" was "strangely covered with scales, the sign of evil, whether seen on Satan's loins or on the trunk of a palm tree, symbol of suffering," and that "the water in the bucket may, therefore, be assumed to have been taken from the River of Death which flows out of a large culvert on the extreme right below."[72] The logic of this needs reconsideration. It is first of all not clear that the river is the River of Death; if it is indeed Hammon's fountain, it would be equally appropriate to call it the River of

Life, though ironically the meaning would be much the same. Keynes's view must be based on the assumption that scales refer to serpents, or to scaly armor. But to transfer this motivated dislike to a bucket made, presumably, out of the bark of a palm tree, is to interpret a surface without regard for either the context or the substance and function that underlie that surface. The situation is analogous to the serpent on the flask carried by the Good Samaritan in the illustration discussed in Chapter 6, though with a reversal: there, we had an interpretation of a response to a symbolic representation that would have been appropriate only if the object had been real and not symbolic; here we have an interpretation of a real object that would be appropriate only if the object were a symbolic representation. *Pace* Keynes, Blake did not think of palm trees as inherently evil; they appear in several of his paintings associated with rest, protection, and food (dates), as in *The Repose of the Holy Family in Egypt* (B 472) and *The Virgin and Child in Egypt* (B 669). There are no grounds for the moral condemnation that has been passed on this innocent vessel.

In addition, it has not previously been noted that there are faint hatchings on the buckets carried by the women in the topmost cave, indicating that these are also "scaly" (plate xiii); these women have usually been interpreted in a positive light, as befits their wings. Since there are thus similarities as well as differences between the water-carrier and the women in the topmost cave, one way of clarifying what the water-carrier represents is to consider first the nature of the winged women.

The question of who could be represented with wings was of enough interest that at least two essays were devoted to the subject. The first is by C. L. Junker and is included in a collection of essays by Winckelmann, Addison, Sulzer, and others called *De l'Allégorie, ou Traités sur cette Matière,* 2 vols., Paris [1799]. Junker's essay, "Des aîles, et des divinités aîlées," identifies wings as a means by which an artist can make apparent to sense the characteristics of a personified general idea, adding that they ought to be the distinctive sign of movement. Commenting that the Greeks, unlike the Etruscans, gave wings to relatively few of their divinities, he lists Diana and her nymphs, Venus, Victory, Medusa's sisters pursuing Perseus, the Gorgons, and speed. After a discussion of angels, he adds Aurora and the Hours to his list.

The other essay is the section "Des Déités ailées" of Winckelmann's *Monuments Inédits de l'Antiquité,* 2 vols. (Paris, 1808). After commenting that Nonnus made all deities winged, Winckelmann selects the ideas of speed

and power as the keys to an appropriate use of wings. He lists Jupiter, Pluto, Bacchus, Pallas, Diana, Venus, and Pudicity as all having been represented as winged. His views are close to Junker's; both agree in requiring some basic sense of movement, speed, or power to justify the representation of a being as winged. These two essays demonstrate that it was recognized that wings had to be substantially motivated to appear in a design. Though it is unlikely that Blake knew either essay, he might have had access to Winckelmann's views through Fuseli.

Blake has surprisingly few winged beings in his designs, and those are generally well motivated; he, too, did not think of wings as attributes to be given casually. Figures representing such ideas as Time, Conscience, and brooding darkness in *Night Thoughts* 24, 27, and 54 are winged, as are Elohim and Satan in the large color prints, and of course angels, particularly when imaged as on powerful missions.

Since the winged women in the cave carry what we must, in the absence of any contra-indication, assume to be water, they may represent clouds thought of as part of the whole life-giving cycle of water, and thus be analogous to the clouds in the illustrations to *L'Allegro* to be discussed below. The absence of visible handles on the buckets, and the fact that the buckets are carried on the head, suggest that the relationship between these women and the water they carry has changed from that between the water-carrier and her bucket; a possible explanation is that the water is now in vapor, not liquid, form.

If these women do represent clouds, their wings show their power to both carry and move over distance, in order to communicate with and feed the springs and streams shown high up on the hillside; indeed, the river god just outside their cave appears to look directly into the cave, as if into the source of his supply. The streams in turn feed the lake and finally find their way back to the sea.

This hypothesis leaves some problems, however, such as the fact that the women are shown in a cave, within which they appear to circle in a regular and equally spaced procession. This in turn suggests that they represent some structure of temporal division, most probably a second version of the Hours, representing hours in the modern sense. Ovid describes such Hours as companions of the sun:

> *Sol* cloth'd in purple, sits upon a Throne,
> Which cleerely with tralucent Emralds shone.

With equall-raigning Houres, on either hand,
The dayes, the Months, the Yeares, the Ages stand.[73]

A distant analogy to the figures in the painting may be found in *The Four Zoas*: "They [Los and Enitharmon] view'd the dancing Hours, quick sporting through the sky / With winged radiance scattering joys thro the ever changing light" (E 308); winged Hours scatter refreshment through the air as clouds scatter life-giving moisture. The Hours imagined as the companions of the sun's movement through the day are a natural accompaniment of the water-exchange system of the world.

There are many poetic versions of these hourly Hours, if one may call them that; Spence has a paragraph on them, describing them as placed "at pretty equal distances" and "gliding on, with a quick and easy motion," and refers to several authorities, including Ovid.[74] Spenser refers to Hours who are porters of heaven's gate, "Which they did dayly watch, and nightly wake / By even turnes, ne ever did their charge forsake,"[75] and Milton speaks of "morn, / Waked by the circling hours," and of "a cave / Within the mount of God, fast by his throne, / Where light and darkness in perpetual round / Lodge and dislodge by turns."[76] These Hours circle in a cave and are associated with day and night, attending the sun at equal distances from each other ("even turnes"), hours in our modern sense; these Hours too were associated with the palace of Helios or Apollo – one remembers Blake's early "chambers of the sun," cited above, and one can wonder for a moment whether Apollo is not after all destined to spend the night in this cave rather than in the arms of Tethys.[77] Alternatively, the women could represent the months, mentioned briefly by Spence with a note citing Statius's description of a temple representing "the Year, in his chariot; and the figures of the twelve months, in a little circle round it."[78]

Blake in this painting seems thus to have given us two images of the regular passage of time, one a band of four, representing the seasons, engaged in their traditional task of unyoking Apollo's horses, and the other a larger group representing either the Hours in the modern sense or the months, and engaged in the equally traditional activity of circling in a cave within "the mount of God." These bear water for redistribution through the universe at the appropriate times of day and season. Both groups have their hair bound up, perhaps in token of impending marriage, understood as participation in the lifegiving exchanges we are about to explore.[79]

We can now return to the water-carrier, who also has bound hair. She is about to pass into and perhaps through the weaving process, bringing to it whatever it is she bears in her bucket. As one of Blake's "Human formd" allegorical figures, she may represent simply water being brought as another essential element to the weaving process, where it will enter into the body being created, and/or be released as water-vapor. The steps she climbs rise from the burning river up to the weavers in the second burning cave, where the woman holding the ball of woof yarn arrests or hails the water-carrier. The arm and hand gestures exchanged here might offer clues to the nature of this encounter, but unfortunately the gestures are rather unspecific and used by Blake for a wide range of meanings. The yarn-holder has a calm face; her gesture seems to greet, recognize and perhaps stop; it may also denote speech. The water-carrier raises her arm as if to show her intention of mounting towards the upper caves.[80] Her face registers determination and perhaps slight consternation.

There may be a more specific key to this encounter. Erasmus Darwin advertised himself as the modern Ovid, describing his purpose with an elaborate analogy: "Whereas P. OVIDIUS NASO… did by art poetic transmute Men, Women, and even Gods and Goddesses, into Trees and Flowers; I have undertaken by similar art to restore some of them to their original animality, after having remained prisoners so long in their respective vegetable mansions; and have here exhibited them before thee."[81] His poem offers an interesting analogy – at the least – with this section of the painting:

> NYMPHS! Your bright squadrons watch with chemic eyes
> The cold-elastic vapours, as they rise;
> With playful force arrest them as they pass,
> And to *pure* AIR betroth the *flaming* GAS.[82]

This mirrors exactly the relationship in Blake's painting, where the weavers arrest "with playful force" the gentle water-carrier who bears water from the flaming river.

Darwin in these words is writing about the newly discovered composition of water:

> Mr. Lavoisier and others… have most ingeniously endeavoured to shew that water consists of pure air, called by them oxygene, and of inflammable air, called hydrogene, with as much of the matter of heat, or calorique, as is necessary to preserve them in the form of gas… In the

atmosphere inflammable air is probably perpetually uniting with vital air and producing moisture which descends in dews and showers, while the growth of vegetables by the assistance of light is perpetually again decomposing the water they imbibe from the earth.[83]

The water-carrier may represent "inflammable air" drawn from the flaming river and about to be united with the woof of "pure air" or "oxygene" produced by the young girl from the air; the mix will pass through the burning weaving frame which provides "heat" or "calorique," and the product will become the "moisture which descends in dews and showers," the water that will be distributed by the winged women above. Whether or not Darwin's account explains what we see in the painting – it fits remarkably well – Blake's phrases "first spun, then wove the Atmospheres" take on a much more focused meaning when read in this context, reminding us that the word "Atmospheres" includes water or water-vapor. Blake made "Inflammable Gas" one of the key characters of *An Island in the Moon*; he had long been interested, however ironically, in the science of the atmospheres. One of the primary products of the weaving process may thus be water itself in its most useful forms.

If I am more or less right in my reading of the allegory of these figures (the lost drawing titled *Clouds Personified* by Rossetti (B 872) might have helped), then the morally oriented critique of the water-carrier that has dominated previous discussion of the painting is an example of the kind of category error Boswell and Johnson feared. The water-carrier represents an aspect of the physical processes that produce the material world, and can bear no direct moral responsibility; to speak of her need to be purged is in Blake's language "Eating of the Tree of Knowledge" (E 563).

Besides the process of weaving, the right-hand side of the painting contains images of the circulation of water that are connected with the weaving. Some of Blake's other designs can help us here. There are examples of relevant pictorial allegory accompanied by Blake's own commentary among the illustrations of Milton's *L'Allegro*. "The Sun at his Eastern Gate" (B 543: 3), for instance, shows the Sun "Surrounded by the Clouds in their Liveries, in their various Offices at the Eastern Gate" (E 683); some of the clouds are represented as children carrying amphoras, others as women carrying fruits on platters, while pouring down water from goblets; Blake has made a distinction ("various Offices") between the rise of water-vapor in amphoras and the dispersion of water as rain in goblets. "A Sunshine Hol-

iday" (B 543: 4; plate xiv) illustrates Milton's "Mountains on whose barren breast/ The Labring Clouds do often rest"; Blake's commentary alters this to "The Clouds arise from the bosoms of Mountains" (E 683). The design shows a female mountain holding one nipple in the classical pose of Rhea expressing the milky way, giving rise in this case to a river that flows down her side; clouds leave the other side of her ample bosom. The clouds fly up across the sun carrying vessels filled with water-vapor, while one at top right empties a goblet downwards as rain. The river flows into and through a spring represented by the traditional river nymph with her urn; the nymph drinks from a goblet similar to the one emptied by the cloud nymph above. The river is being fed both by water draining down the mountain and by rain; the rain in turn is fed by water-vapor rising from the mountain. The life-giving cycle of water has been carefully articulated by Blake through the images of women bearing differentiated vessels; the whole design affords a useful comparison with the present painting.

On the grassy hillside just to the left of the winged women in the upper cave of *The Sea of Time and Space* is a river nymph with an urn that pours water down the hill; a little below her another nymph lies beside a bearded man, presumably a river god with another urn, since water pours down from just beside them, though the implied urn is hidden by their bodies. Below these three figures is a little lake halfway down the hill, visible in a space between the two large trees. The river deities are part of a total system of water circulation that Blake has allegorically personified in conventional ways similar to the imagery with which he illustrated *L'Allegro*.

Blake's poetry and designs show a continuing deep awareness of the cycle of life-giving water I am describing. *The Book of Thel* is full of it; the bright Cloud is renewed at "golden springs," and his marriage with the "fair eyed dew" results in their joint bringing of "food to all our tender flowers" (E 4–5). *The Book of Ahania* describes "a soft cloud of dew" that falls "In showers of life on [Urizen's] harvests" (E 89), and in illustrating Gray's "Ode on the Spring," Blake responds to the lines "While, whisp'ring pleasant pleasure as they fly,/ Cool Zephyrs thro' the clear blue sky / Their gather'd fragrance fling" with the image of flying (though unwinged) women, one of whom bears a large, shallow basket on her head.[84] Gathered fragrance flung by zephyrs has analogies to the condensation of dew into rain clouds; Blake shows a fondness for depicting various forms of aerial circulation by vessels borne on the heads of nymphs. The weavers are thus very probably

producing water and water-vapor – rain and mist and cloud – as part of the process that keeps the world turning and growing.

The weavers also give bodies woven from the elements to spirits that descend into matter; such imagery is used extensively in Taylor's Plato. Raine has quoted Taylor's translation of Porphyry describing how "the Nymphs weave purple webs" that represent "the flesh which is woven from blood";[85] though the woven net in this painting is not purple, it has a faint pink tinge. Metaphors of weaving are to be found in the *Timæus*, where the "Artificer of the universe" (i.e. the demiurgus) tells the generated gods that "it is your business to weave together the mortal and immortal nature; by this mean fabricating and generating animals."[86] In another passage, Taylor translates Plato's description of the circulatory systems of the body as follows:

> These, therefore [i.e. fire and air], the Divinity employed for the purpose of producing an irrigation from the belly into the veins; weaving from fire and air a certain flexible substance like a bow-net, and which possesses a twofold gibbosity at the entrance. One of these he again wove together, divided into two parts; and circularly extended these parts from the curvatures like ropes through the whole body, as far as to the extremities of the net. All the interior parts therefore of the net-work he composed from fire; but the gibbosities and the receptacle itself from air... Every animal belonging to the universe possesses a heat in the veins and the blood, like a certain fountain of fire; and this heat we compared to a bow-net, extended through the middle of the body, and wholly woven from fire; all such things as are external being composed from air.[87]

The description of a rope-like woven net asssociated with fire is suggestively close to the image of the young girl being enclosed in a woven net in the painting.

In Blake's illustration of "The Spirit of Plato" (plate x) a water sprite associated with Venus holds a shuttle in her right hand, having just woven the net in which she catches and/or drowns a male spirit; that net also is similar to the net enclosing the young girl in the painting. Venus is involved with both the capture of men and the weaving of new bodies that may result from such capture. The nets in both designs are woven, and associated with the rope passing through the hands of the Fates.

In addition, the three figures on the right of the illustration on page 5 of Blake's manuscript of Genesis (B 828: 5; illus. 72) have their arms in virtually

270

25 And God made the beast of the earth after his kind and cattle after their kind and every thing that creepeth upon the earth

26 And God said Let us make man in our image after our likeness & let them have dominion over the fish of the sea and over the fowl of the air and over the cattle and over all the earth and over every thing that creepeth upon the earth.

27 So God created man in his own image, in the image of God created he him, male and female created he them

28 And God blessed them and God said unto them: Be fruitful and multiply and replenish the earth and subdue it and have dominion over the fish of the sea and over the fowl of the air and over every living thing that moveth upon the earth.

29 And God said: Behold I have given you every herb bearing seed which is upon the face of the earth and every tree in which is the fruit of a tree yielding seed to you it shall be for meat

30 And to every beast of the earth and to every fowl of the air & to every thing that creepeth upon the earth wherein there is life I have given every green herb for meat, and it was so.

31 And God saw every thing that he had made & behold it was very good and the evening & the morning were the sixth day

72. William Blake, manuscript of
Genesis, page 5 (B 828: 5)

the same position as the three weavers in our painting, and hold objects in their upper hands that probably represent shuttles. Essick points out that the central figure is bearded like God the father, but there remains a similarity between the two groups of three, and the figures in Genesis are almost certainly weaving, since the text illustrated is the creation of Adam.[88] Weaving became one of Blake's favorite metaphors for the creation of bodies immersed in the sea of time and space.

A heavy line descends from a kind of bandage wrapped around the left-most of the two trees at the right of the picture; the line could alternatively be understood as descending from the weaving frame, but it seems to orig-inate from directly below the bandage. This line descends to become part of a net that enmeshes a young girl standing at the bottom right; the net covers her lower body, while her left hand holds or pulls on the heavy line that descends to enmesh her. The net that wraps her lower body continues into an empty extension whose end is held in the left hand of the woman over whose shoulder runs the warp line that I have speculated comes from the line held by Jupiter and Atropos.

It is difficult to be sure whether the girl is being embodied or disem-bodied. The slack and empty extension of the net may imply that she is being unwoven, undressed, the cut line signifying her death. But it is also possible that the cut line more simply implies that she has been given a determinate length of life, that we are to imagine her being clothed in the fateful web of life. The latter seems more likely, since the line that she holds descends from the weaving frame, and she seems to be pulling down on it, as if collaborating in her own incarnation.

The bandage round the tree is clear enough that we can be certain that something is there, though not so clear that we can be sure just what it is. The simplest explanation is that it fixes the weaving frame to the tree, though that would be a curiously clumsy and inadequate method of fixation – a simple nail would be more secure.

A more complex though not less likely explanation is that the earthy sub-stance of the tree is being added to the weaving through a kind of transfu-sion, to join another element to the mix. The imagery of this process may again be mediated through details taken from Erasmus Darwin, who describes two processes that may throw light on what we see. One is the emergence of buds: "The pith seems to push up or elongate the bud by its elasticity.... This medulla Linneus believes to consist of a bundle of fibres, which diverging breaks through the bark yet gelatinous producing the buds."[89] The young girl could represent a bud or a seed, a new baby plant, being produced from the tree; Darwin includes comments on "placental veins" and even a whole note on "Vegetable Placentation,"[90] a metaphor which could explain the relationship between the tree, the warp yarn, and the young girl.

Alternatively the young girl might just conceivably be a representation of the process of grafting, which Darwin describes with the phrase a "bandage put round a branch."[91] The young girl would be a new graft, illustrating Pythagoras's metamorphic doctrine of the "Transmigration of Soules" in an updated language. In either explanation, the fibrous net symbolizes her enclosure in the vegetating world of Plato and Ovid.

Blake's "Human formd" allegory means that it is extraordinarily difficult to assign a specific mode of being to the girl; we can understand the process in which she is enmeshed, without knowing for sure whether she represents a human being going through the process of incarnation, or a personified allegory of vegetable life sprouting into new existence. Blake's term "Vegetative" was not chosen lightly; in so far as humans are vegetated, they are vegetable. The difference may not be substantial.

The weavers thus produce both the elements and the bodies that are woven from those elements. The weavers themselves work with raised arms and great vigor on a rectangular frame attached to a tree; flames fill the space of the frame, unifying the metaphors of fire and weaving, and showing that both are parts of the same process. The weavers are three in number for good reason; they are a Blakean version of Taylor's terrifying Proserpine, who "first subsists in the middle of the vivific supermundane triad, which consists of Diana, Proserpine, and Minerva."[92] This figure is a version of the triform Hecate, who Lemprière states "was called Luna in heaven, Diana on earth, and Hecate or Proserpine in hell." These weavers are thus analogous to the "Two Beings each with three heads they Represent Vegetative Existence... The wreathed Torches [emblem of Hecate] in their hands represents Eternal fire which is the fire of Generation or Vegetation it is an Eternal Consummation" (E 558). The three weavers control this "Eternal fire" in the design; though rooted in classical myth, they are consonant with Blake's myth, and cousins of the Daughters of Albion. They are formidable creatures in the universality of the process they represent, and even Los

> Dare not approach the Daughters openly lest he be consumed
> In the fires of their beauty & perfection & be Vegetated beneath
> Their Looms, in a Generation of death & resurrection to forgetfulness[.]
>
> (E 161)

These lines, like the painting under discussion, connect the images of fire, weaving and vegetation.

Whatever precisely is going to happen to the water-carrier, she will lose her specific identity in the processes named in Sandys's comments on Pythagoras as "The Vicissitude of Things" and "The Transmigration of Soules," a process for which Darwin has a gloss: "The perpetual circulation of matter in the growth and dissolution of vegetable and animal bodies seems to have given Pythagoras his idea of the metempsychosis or transmigration of spirit."[93] Darwin is consciously atoning Ovid with modern science.

The two guardians of the cave of the weavers look at the carrier as if they sympathized in an objective way with the transformation about to take place. If the water-carrier continues to mount the steps, she will have to pass into and through the three weavers and what they represent; the steps lead nowhere except to their cave, the cave of the circling Hours being separate, with no steps leading into it from below. There is a degree of wildness, even fierceness, about the expression of the weavers that implies that the process of transformation will be uncomfortable from an anthropomorphic perspective; one remembers Thel's fears of being "like a faint cloud kindled at the rising sun," and her sense of difference from the Cloud's happiness at the prospect of his transformations (E 4–5).

The water-carrier and the young girl being enmeshed are at the center of the narrative of the painting, insofar as that is distinguishable from exposition, and pose the problem of identity within the world of Ovidian exchange in a way again reminiscent of Thel's fears.[94] That problem was articulated in Blake's poem "To my Friend Butts I write," which describes a fully humanized world redeemed by vision from the continual flux of metamorphosis and dissolution of identity typical of the Pythagorean world:

I each particle gazed...
For each was a Man
Human formd. Swift I ran
For they beckond to me
Remote by the Sea
Saying. Each grain of Sand
Every Stone on the Land
Each rock & each hill
Each fountain & rill
Each herb & each tree
Mountain hill Earth & Sea
Cloud Meteor & Star
Are Men Seen Afar[.] (E 712)

Pythagoras's version of transmigration, and indeed *Metamorphosis* as a whole, is a kind of parody of that, with enough real vision in Blake's view to justify his statement that it contains "Vision in a Sublime degree being derived from real Vision in More Ancient Writings" (E 556). The water-carrier could in a poem utter her thoughts as did Thel; in a painting, those thoughts can only be implied by the text that we read into her gestures, and by Isaiah's silent witness.

Blake's way of beginning the transformation of the "Allegoric Fable" of Plato and Ovid into the "Real Vision" of Isaiah is to represent those Pythagorean fables about the transformations of the created world under the form of human bodies; the particle of water or "inflammable air" becomes a young woman, not merely a personification defined by conventionally allegorical attributes, and we feel for her imminent fate; for a moment she is rescued by Blake from the anonymous cruelties of Nature's laws of vicissitude and transmigration, and visualized as a person, with all the pathos that implies.

Another such person is the drowsy or dead nymph at the extreme bottom right, with flowers round her head, draped over a large urn or culvert, which seems to respond to and oppose Jupiter Hammon's fiery urn. She is perhaps overcome by the "slow and silent stream, / Lethe the river of oblivion,"[95] or, more likely, is a representative of those who have drunk of "th'*Aethiopian* lake… for who of this, / But only tast, their wits no longer keep, / Or forthwith fall into a deadly sleep."[96] If we continue with the Pythagorean and Darwinian natural allegory I have been tracing, we can see her as representative of the process by which generated vegetative life is returned to circulation, or "decompos[es] the water they imbibe from the earth." The urn would represent the channel by which her substance is recycled and returned to the fiery stream. As Blake learned from Ovid's Pythagoras as much as from anyone, "life liv'd upon death" in an Ovidian world in which "shapes [are] / Bred" of "beast, bird, fish, serpent & element / Combustion, blast, vapour and cloud" (E 81, 70). We could insist upon imposing a moral allegory upon her, and say that she represents perhaps those who have fallen into the trap of accepting nature as reality, thereby entering into the Pythagorean world view and becoming deaf to Isaiah's call, but she looks extraordinarily innocent in her sleep / death.

IX

The painting can now be looked at as a whole, beginning with its land-scape. One probable source for that is Ovid's description of the surroun-dings of the fountain of Hippocrene as Pallas admires them:

> Then *Pallas* to the sacred Spring convay'd,
> Shee admires the waters by the horse-hoofe made;
> Survay's their high-grown groves, coole caves, fresh bowrs,
> And meadowes painted with all sorts of flowers.[97]

There are differences between the two descriptions, but the basic layout of mountain, springs, caves, and "high-grown groves" is common to both.

One of the central subjects of the Muses' inspiration in Ovid's poetry is the warring exchange among the elements. Part of that process is the sea itself, a key element in the system of water circulation. The sea in the paint-ing is unquestionably rough, but I see no justification for Simmons and Warner's statement that it "appears to be rising."[98] The roughness is rather a sign of the energy of the tides understood as part of the total processes of time and nature:

> As billow billow drives,
> Driven by the following; as the next arrives
> To chace the former: times so flye, persue
> At once each other; and are ever new.

This is very much in keeping with the spirit of the painting, in which the whole left side is focused on the cycles of time and the natural energies through which they are articulated.

One can apply as commentary upon the design as a whole Paul's words to the Galatians: "But now, after that ye have known God, or rather are known of God, how turn ye to the weak and beggarly elements, whereunto ye desire again to be in bondage? Ye observe days, and months, and times, and years" (4: 9–10). Blake's way of putting this is "What Jesus came to Remove was the Heathen or Platonic Philosophy which blinds the Eye of Imagination The Real Man" (E 664). Time and its divisions, and the exchanges between the elements, are the very stuff of that heathen philoso-phy which Paul condemns, and upon which Isaiah is turning his back in the picture.

The text which has made the painting intelligible for me is an exposition of the philosophy of Pythagoras and Plato as Blake understood it, with the crucial addition of Isaiah to represent Blake's rejection of that philosophy; the strong red of his garb sets him off visually from the rest of the design to correspond to the separateness of his point of view. Isaiah points off towards the large and open end of a sideways "U" that opens into blank sea to imply the present invisibility of the prophetic world of imagination to which he points, the world from whose perspective Nature appears as a cruel system opposed to human identity and creativity. He represents a horizontal axis of potential movement out of the frame of the picture into another and differently structured world.

The other central figure, Nature, points vertically up and down to the imagery that articulates that system. The figures of Isaiah and Nature are essentially demonstrative and static in their function. Isaiah, unlike most of Blake's figures, seems to look directly at the viewer, as if to suggest his role as spokesperson for Blake's perspective. Nature gazes at an angle, looking neither at us nor at Isaiah, as if that indirectness were a metaphor for indirect speech; she is the spokesperson for a text being handled at one remove. There is a suggestion of melancholy or calm pathos in her face, as if she were aware that the world she represents, including Jupiter's natural fire, will be consumed by the apocalyptic fire pointed at by Isaiah.

In producing this reading I have tried to be faithful to my understanding of how Blake went about inventing such a design, beginning with the argument of Chapter 4 that something like Le Bossu's version of epic invention accounts for the way in which Blake takes known tales as the cover for his inventions. The insertion of Isaiah into a design based upon Pythagorean and Platonic texts may seem to stretch the limits of this kind of invention, but the juxtaposition of figures from two radically different worlds is one certain fact about the painting, has many precedents in eighteenth century discussion, and is a fairly direct development from Blake's insertion of the New Jerusalem into a portrayal of the flight of Gog.

The logic binding these differently conceived figures into unity is that of an implicit text, not the logic of visual coherence and immediate sensory intelligibility. The painting is the work of an artist who has changed a great deal since he created the dynamic figures of the 1790s. Blake has invented a design that needs verbal commentary, and my own is a very inadequate substitute for the one he might have provided.

It is possible to argue that the need for an interpretive commentary implies that the painting has failed to communicate in the way proper to painting, that Blake has passed into a visual world ruled by texts rather than visibly intelligible forms; that possibility opens into the huge question of just what constitutes an aesthetic object. Perhaps one can simply claim that a satisfactory account can, in making the painting intelligible, also make it aesthetically viable, that the aesthetic is not truly a separable category. Blake would seem to have thought so; he writes that when "Rivers & Mount[a]ins / Are also Men; every thing is Human, mighty! sublime!"(E 180), and that "The Beauty proper for sublime art, is lineaments, or forms and features that are capable of being the receptacles of intellect" (E 544). In describing the physical processes of Pythagorean vicissitude under the form of human bodies, Blake sees himself as having achieved a victory for the human. In transforming painting into an intellectual act, Blake makes the human form into a kind of word, one of "the Words of the Mutual Covenant Divine" (E 258).

Blake's use of Ovid in the painting justifies the belief that this is the hitherto unidentified painting of *Metamorphosis* mentioned by Palmer. Butlin's recent recovery of a copy of Plate 20 of *The Marriage of Heaven and Hell* in the form of a leaf from *A Small Book of Designs* records that Blake gave it the texts "O revolving serpent" and "O the Ocean of Time and Space."[99] In as much as *The Sea of Time and Space* was a phrase used by Blake to describe the whole process of what Sandys calls "The Vicissitude of Things," it is not a bad title, though it would be good to have Isaiah's presence in the painting recognized too: "Isaiah's Prophecy of the Messiah's Coming to Redeem the Pythagorean Sea of Time and Space" would convey more of the substance of the painting. But it would also be long-winded and clumsy; the accepted title has the virtues of simplicity and familiarity, and indicates at least some of the content of the painting.

Notes

Preface

1 Cited in David Bindman, *Blake as an Artist* (Oxford: Phaidon, 1977), 29.

2 Clifford Geertz, *The Interpretation of Cultures* (New York: Basic Books, 1973), 6 and 25.

3 David V. Erdman, ed., *The Complete Poetry and Prose of William Blake* (University of California Press, 1982), 541.

4 *Ibid.*, 544.

5 See Joseph A. Wittreich, "A Note on Blake and Fuseli," *Blake: An Illustrated Quarterly*, 3:1 (1969), 3–4, and the references given there, and Carol L. Hall, *Blake and Fuseli: A Study in the Transmission of Ideas* (New York: Garland, 1979).

1 The pathos of formulae

1 E. H. Gombrich, *Art and Illusion* (London: Phaidon, 1962). The issues involved have been pursued by Gombrich and others.

2 See Victor Anthony Rudowski, "The Theory of Signs in the Eighteenth Century," *JHI* 35 (1974), 683–90. Dubos was the primary proponent of the distinction between natural and artificial signs.

3 Le Brun probably thought he was describing natural signs, as in his definition of how the "Actions" of the body "express" the passions. But he often slips into a definition of how the painter is to represent feeling so that it may be recognized, which is not the same thing; Charles Le Brun, trans. John Williams, *A Method to learn to Design the Passions*, ed. Alan T. McKenzie (Los Angeles: William Andrews Clark Memorial Library, 1980), 13, 47.

4 "Eighteenth-century manuals for the actor gave two complementary types of advice. On the one hand, they provided instructions in the artificial management of the body and voice, identifying the postures that would signify the passions of the character; on the other, they urged the actor to feel his part, because through emotional identification the appropriate gestures would follow spontaneously." Michael G. Ketcham, "The Arts of Gesture: The *Spectator* and its Relationship to Physiognomy, Painting, and the Theatre" *MLQ* 42 (1981), 147.

5 Fuseli, "Third Lecture," in *The Life and Writings of Henry Fuseli, Esq. M.A.R.A.*, ed. John Knowles,

3 vols. (London: Colburn and Bentley, 1831), II: 182.

6 Francis Haskell and Nicholas Penny, in their *Taste and the Antique* (Yale University Press, 1981), 313, confuse the identification of this sculpture by transcribing the inscription as "ΑΠΟΛΛΩΝΙΟΣ," though they refer to it in the text as "Apollodorus."

7 Anthony Blunt, *Nicolas Poussin*, 2 vols. (New York: Pantheon, 1967), I: 231.

8 *Ibid.*, I: 225, n. 15.

9 *Ibid.*, I: 222.

10 Norman Bryson, *Word and Image* (Cambridge University Press, 1981), 50; Jennifer Montagu, "Charles Le Brun's 'Conférence sur l'expression générale et particulière,'" dissertation, University of London, 1959.

11 Knowles, *Henry Fuseli*, II: 64.

12 *Ibid.*, III: 92, 94.

13 *Ibid.*, II: 85.

14 *Ibid.*, II: 161.

15 *Ibid.*, II: 148–49.

16 *Ibid.*, II: 154.

17 *Ibid.*, II: 6–7.

18 *Ibid.*, II: 11–13.

19 See, for instance, a letter to Lavater of 1773: "Nor do I know how to follow Le Brun's Passions, for these passions do not match mine – nor would they match anyone else except a Parisian"; cited by Peter Tomory in *The Life and Art of Henry Fuseli* (London: Thames and Hudson, 1972), 26.

20 Knowles, *Henry Fuseli*, II: 101.

21 *Ibid.*, II: 219–20.

22 *Ibid.*, II: 123–24.

23 E. H. Gombrich, *Aby Warburg: an Intellectual Biography* (University of Chicago Press, 1986), 63-65, 114–25.

24 *Ibid.*, 178–79.

25 *Ibid.*, 246–47. There is also a note on this in the chapter "The Maenad under the Cross" in Edgar Wind's *Hume and the Heroic Portrait* (Oxford University Press, 1986), 74–76.

26 On this, see Brewster Rogerson, "The Art of Painting the Passions," Journal of the History of *Ideas* 14 (1953), 68–94.

27 Bo Lindberg, *William Blake's Illustrations to the Book of Job* (Abo, Finland: Abo Akademi, 1973), uses the term; Janet Warner uses and

develops it in her *Blake and the Language of Art* (McGill–Queen's University Press, 1984).

28 Jenijoy La Belle, "Blake's Visions and Revisions of Michelangelo," in *Blake in his Time*, eds. Robert N. Essick and Donald Pearce (Indiana University Press, 1978), 14–15.

29 Warner, *Blake and the Language of Art*, xviii, 5, 11.

30 See Benjamin Heath Malkin, *A Father's Memoirs of His Child*, excerpted in G.E. Bentley, Jr., *Blake Records* (Oxford University Press, 1969), 421–22.

31 On this phase of Blake's life, see Bentley, *Blake Records*, and Aileen Ward, "'Sr Joshua and His Gang': William Blake and the Royal Academy," *HLQ* 52 (1989), 75–95.

32 Bentley, *Blake Records*, 17.

33 Le Brun, *A Method*, 47. Warner discusses a similar gesture in proposing the influence of John Weaver's *The History of the Mimes and Pantomimes; Blake and the Language of Art*, 65–68.

34 See Robert N. Essick, *William Blake and the Language of Adam* (Oxford University Press, 1989), 8–9, for a discussion of the gesture that means "I am speaking."

35 See Bentley, *Blake Records*, 27–28.

36 Martin Butlin, "Six New Early Drawings by William Blake and a Reattribution," *BIQ* 23 (1989), 109–11.

37 Le Brun, *A Method*, 47.

38 *Ibid.*, 48.

39 *Ibid.*

40 David Summers, *Michelangelo's Theory of Art* (Princeton University Press, 1981), 76, offers a definition: "The word *contrapposto*, now exclusively used for a figural posture in which the weight of the body is shifted to one leg with a consequent adjustment of the other parts of the body, is taken from the Latin *contrapositum*, in turn translated from the Greek *antithesis*, a rhetorical figure in which opposites were set directly against one another."

41 See Plate 14a in Gombrich, *Warburg*.

42 Anthony Blunt, *The Paintings of Nicolas Poussin: A Critical Catalogue* (London: Phaidon, 1966), No. 154.

43 Blake agrees with Reynolds that the early "dry manner" is superior to the later "softer

and richer" style, and that "no painter was ever better qualified to paint 'Ancient Fables'" (E 655). For Poussin's early use of classical figures, see Walter Friedlander, *Nicolas Poussin: A New Approach* (New York: Abrams, 1964), 19. The painting is dated 1627; Konrad Oberhuber, *Poussin: The Early Years in Rome* (New York: Hudson Hills Press, 1988), 150.

44 David Bindman, *Blake as an Artist* (Oxford: Phaidon, 1977), 34.

45 Joseph Spence, *Polymetis* (1747; reprinted New York: Garland, 1976), 111. Haskell and Penny discuss the sculpture and reproduce Perrier's print in *Taste and the Antique*, 274–79, and fig. 10.

46 David H. Solkin, *Richard Wilson* (London: Tate Gallery, 1982), 200–201.

47 Haskell and Penny, *Taste and the Antique*, 274, and *The Complete Works of Percy Bysshe Shelley*, eds. Roger Ingpen and Walter E. Peck, 10 vols. (London: Ernest Benn, 1965), VI: 330.

48 Spence, *Polymetis*, 99.

49 Perrier actually showed Apollo in his print, and both Spence (*Polymetis*, 96–99) and Shelley (*Works*, VI: 332) assume his presence.

50 Bindman, *Blake as an Artist*, 34.

51 Warner, *Blake and the Language of Art*, 54–57 and passim.

2 "Michael Angelo Blake"

1 Recorded by G. E. Bentley, Jr., *Blake Records* (Oxford University Press, 1969), 288.

2 William Aglionby, *Painting Illustrated in Three Diallogues... Together with the Lives of the Most Eminent Painters* (London, 1685; reprinted Portland: Collegium Graphicum, 1972), 294.

3 *Ibid.*, 301.

4 *Ibid.*, 81.

5 Du Fresnoy, *The Art of Painting of Charles Alphonse Du Fresnoy*, trans. William Mason, with annotations by Sir J. Reynolds (York, 1783), 132.

6 Jonathon Richardson, Sr. and Jr., *An Account of Some of the Statues, Bas-Reliefs, Drawings and Pictures in Italy* (London, 1722), 270–71.

7 *Ibid.*

8 Joshua Reynolds, *Discourses on Art*, ed. R. R. Wark (San Marino: Huntington Library, 1959), 82.

280

9 James Barry, *The Works of James Barry, Esq.*, 2 vols. (London: Cadell and Davies, 1809), II: 41.

10 John Knowles, ed., *The Life and Writings of Henry Fuseli, Esq. M.A. R.A.*, 3 vols. (London: Colburn and Bentley, 1831), II: 85.

11 *Ibid.*, II: 157–63.

12 The story is told by Cunningham; see Carol Louise Hall, *Blake and Fuseli* (New York: Garland, 1985), 68.

13 Knowles, *Henry Fuseli*, II: 161.

14 *Ibid.*, II: 172–74.

15 Ralph N. Warnum, ed., *Lectures on Painting, by the Royal Academicians* (London: Henry G. Bohn, 1848), 263.

16 Richard Duppa, *The Life and Literary Works of Michel Angelo Buonarroti* (London: Murray, 1806), 195.

17 *Ibid.*, 198–99.

18 "The Lectures of James Barry," in Warnum, *Lectures on Painting, by the Royal Academicians*, 119: "by the phrases, ability in drawing, or skilful draftsman, we are always understood to mean… the skilful delineation or drawing of the human body."

19 He might conceivably have seen original drawings in such collections as those of Sir Thomas Lawrence, but there is no record of such encounters.

20 Told by Allan Cunningham in *The Cabinet Gallery of Pictures* and cited by Bentley in *Blake Records*, 182–83.

21 British Museum Print Room, Accession No. 1867–3–9–1817.

22 Morton D. Paley, "The Truchsessian Gallery Revisited," *SiR* 16 (1977), 168.

23 *Ibid.*, 171.

24 See Jenijoy La Belle, "Blake's Visions and Re-visions of Michelangelo," in *Blake in his Time*, eds. Robert N. Essick and Donald Pearce (Indiana University Press, 1978), 13–22.

25 The Print Room of the Victoria and Albert Museum, Accession No. Dyce 1741, Press Mark DG 11. A(3).

26 Reproduced in Jenijoy La Belle, "Michelangelo's Sistine Frescoes and Blake's 1795 Color-printed Drawings: A Study in Structural Relationships," *BIQ* 14 (1980), 68–69.

27 Richardsons, *Account*, 272.

28 Engravings of many of the drawings were available, especially the famous "presentation drawings"; see Frederick Hartt, *Michelangelo Drawings* (New York: Abrams, n.d.), 249–58. These included "The Fall of Phaëthon," "The Punishment of Tityus," and "The Dream of Human Life."

29 Knowles, *Henry Fuseli*, II: 182.

30 Leo Steinberg, *Michelangelo's Last Paintings* (Oxford University Press, 1975), 58–59.

31 Robert N. Essick, *William Blake: Printmaker* (Princeton University Press, 1980), 29–30.

32 S. Foster Damon, *A Blake Dictionary* (Brown University Press, 1965), 225.

33 Charles De Tolnay, *Michelangelo V: A final Period* (Princeton University Press, 1960), 75.

34 Steinberg, *Last Paintings*, 53; see also Francis Haskell and Nicholas Penny, *Taste and the Antique* (Yale University Press, 1981), 169–72, "Farnese Captives."

35 La Belle, "Blake's Visions and Re-visions of Michelangelo," 13–22.

36 *Ibid.*, 19.

37 Reynolds, *Discourses*, 279. See the discussion in David Bindman, "Blake's Theory and Practice of Imitation," in Essick and Pearce, *Blake in his Time*, 92–95.

38 Reynolds, *Discourses*, 107.

39 Knowles, *Henry Fuseli*, II: 181.

40 No. 665 in Gert Schiff, *Johann Heinrich Füssli 1741–1825*, 2 vols. (Zürich: Verlag Berichthaus / München: Prestel-Verlag, 1973).

41 See the discussion of this and other designs in Edgar Wind, "'Borrowed Attitudes' in Reynolds and Hogarth," *JWCI* 2 (1938–39), 182–85.

42 Cited by E.H. Gombrich in "Reynolds' Theory and Practice of Imitation," *BM* 80–81 (1942), 45.

43 See Earl R. Wasserman, "The Limits of Allusion in *The Rape of the Lock*," *JEGP* 65 (1966), 439–41, for "allusive contexts" in Pope's poetry.

44 Wind, "Borrowed Attitudes," 183.

45 Leslie W. Tannenbaum, "Transformations of Michelangelo in William Blake's *The Book of Urizen*," *CLQ* 16 (1980), 20.

46 *Ibid.*, 21.

47 *Ibid.*

48 *Ibid.*, 21–24.

49 *Ibid.*, 24–25.

50 *Ibid.*, 25.

51 W. J. T. Mitchell, *Blake's Composite Art*

(Princeton University Press, 1978), 143, 146.

52 Ibid., 151.

53 I use the numbering given by David V. Erdman, *The Illuminated Blake* (New York: Anchor Books, 1974); Plate 9 represents Urizen fighting earth, Plate 12 water, Plate 14 air, and Plate 27 fire.

54 For the metaphors here, see Maggie Kilgour, *From Communion to Cannibalism* (Princeton University Press, 1990), especially 102–39.

55 See E.H. Gombrich, "The Evidence of Images: II, The Priority of Context over Expression," in *Interpretation: Theory and Practice*, ed. C. S. Singleton (Johns Hopkins University Press, 1969), 68–104.

56 There were several engravings; the one reproduced is in the Department of Prints and Drawings of the British Museum, Accession No. 1980–U–1439.

57 Irene H. Chayes, "Blake's Way with Art Sources: Michelangelo's *The Last Judgment*," *CLQ* 20 (1984), 67–71.

58 Frederick Hartt describes the drawing as "fantastic and wonderful…well known and often copied in the Renaissance": *Michelangelo Drawings*, 256; Plate 359.

59 Knowles, *Henry Fuseli*, II: 197.

60 On bald heads in Blake, see Jenijoy La Belle, "Blake's Bald Nudes," *BIQ* 24 (1990), 52–58. La Belle traces an association with madness; the powerful and destructive passions represented in the drawing may be regarded as forms of insanity. She does not refer to Michelangelo's drawing.

61 Hartt, *Michelangelo Drawings*, 251, refers to the figures at bottom right as "Sloth," but that seems too soft.

62 Janet A. Warner, "Blake's figures of Despair: Man in his Spectre's Power," in *William Blake: Essays in Honour of Sir Geoffrey Keynes*, eds. Morton D. Paley and Michael Phillips (Oxford University Press, 1973), 213, n. 14.

63 For example, "Once he had chosen his own visual vocabulary from this lexicography, Blake used it consistently…"; Janet A. Warner, *Blake and the Language of Art* (McGill–Queen's University Press, 1984), 10.

64 Janet A. Warner, "Blake's Use of Gesture," in David V. Erdman and John E. Grant, eds.,

Blake's Visionary Forms Dramatic (Princeton University Press, 1970), 188–94.

65 Warner, *Blake and the Language of Art*, 138.

66 Irene H. Chayes, "Between Reynolds and Blake: Eclecticism and Expression in Fuseli's Shakespeare Frescoes," *BRH* 85 (1982), 152–53.

67 David V. Erdman, ed., assisted by Donald K. Moore, *The Notebook of William Blake: A Photographic and Typographic Facsimile* (Oxford University Press, 1973), 51 and notes under figs. 32–33. In Butlin's catalogue, the drawing is numbered B 214r and 214v.

68 David V. Erdman, ed., with the assistance of Donald K. Moore, *The Notebook of William Blake*, revised edn. (New York: Readex Books, 1977), 51.

69 Butlin, *Paintings and Drawings of William Blake*, No. 70.

70 Robert N. Essick, review of Butlin, *The Paintings and Drawings of William Blake*, *BIQ* 16 (1982), 31.

71 Fuseli [Remarks], in R. Blair, *The Grave: A Poem* (London: Cadell and Davies, 1808), xiv.

72 G. E. Bentley, Jr., *William Blake: The Critical Heritage* (London and Boston: Routledge and Kegan Paul, 1975), 130.

73 Ibid., 132.

74 "Biographical Sketch of Robert Blair," in R. Blair, *The Grave: A Poem* (London: Cadell and Davies, 1813), xxix.

75 Charles De Tolnay, *Michelangelo: II. The Sistine Ceiling* (Princeton University Press, 1945), 136.

76 De Tolnay, *Sistine Ceiling*, 35. But see Jane Schuyler, "The Female Holy Spirit (Shekhinah) in Michelangelo's *Creation of Adam*," *Studies in Iconography* 11 (1987), 111–36; Schuyler argues that the figure represents the *Shekhinah* or female Holy Spirit of the Cabala.

77 Cited by De Tolnay in *Sistine Ceiling*, 137.

78 Ibid., 35.

79 Knowles, *Henry Fuseli*, II: 160.

80 C. H. Collins Baker, "The Sources of Blake's Pictorial Expression," reprinted in *The Visionary Hand*, ed. Robert N. Essick (Los Angeles: Hennessey & Ingalls, 1973), 124–26.

81 See figs. 2 and 35, 12–14, 18, 23, and 36–37 in Charles Le Brun, *A Method to Learn to Design the Passions*, ed. Alan T. McKenzie (1734; reprinted Los Angeles: William Andrews Clark Memorial Library, 1980).

82 Gotthold E. Lessing, *Laocoön*, trans. Edward A. McCormick (Indianapolis: Bobbs–Merrill, 1962), 7.

83 See B. H. Malkin, *A Father's Memoirs of His Child*, reprinted in Bentley, *Blake Records*, 423.

3 Humpty Dumpty Blake

1 Lewis Carroll, *Alice's Adventures in Wonderland and Through the Looking Glass* (London: Puffin, 1962), 274–75.

2 *Ibid.*, 275.

3 *The Poetical Works of William Cowper*, ed. H. S. Milford (Oxford University Press, 1959), 188; "The Task," IV: 247–50.

4 Reproduced as No. 71 in Albert S. Roe, *Blake's Illustrations to the Divine Comedy* (Princeton University Press, 1953).

5 Janet A. Warner, "Blake's Use of Gesture," in *Blake's Visionary Forms Dramatic*, eds. David V. Erdman and John E. Grant (Princeton University Press, 1970), 177.

6 The design has its roots in two illustrations (numbered 1 and 8) made by Blake for *Tiriel*, discussed and reproduced in G. E. Bentley, Jr., *William Blake: Tiriel* (Oxford University Press, 1967).

7 Bernard Mandeville, "The Grumbling Hive," in *The Fable of the Bees*, ed. F. B. Kaye, 2 vols. (Oxford University Press, 1924), I: 29.

8 David V. Erdman, *Blake: Prophet Against Empire*, 3rd edn. (Princeton University Press, 1977), 206–209.

9 For discussion of this state, see Robert N. Essick, *The Separate Plates of William Blake: A Catalogue* (Princeton University Press, 1983), 31; and Erdman, *Prophet*, 207.

10 David Hume, *The History of England*, 6 vols. (Boston: Little Brown, 1854), II: 446.

11 Essick, *The Separate Plates*, 37.

12 See *The Notebook of William Blake*, ed. David V. Erdman with the assistance of Donald K. Moore, revised edn. (New York: Readex Books, 1977), N68.

13 The phrase is also found in Psalm 8, but Job is the more likely reference.

14 Mary Lynn Johnson, "Emblem and Symbol in Blake," *HLQ* 37 (1973–74), 158–59.

15 D. H. Lawrence, *Phoenix*, ed. Edward D. McDonald (London: Heinemann, 1936), 560.

4 "What Critics call The Fable"

1 For this theory, see Rensselaer W. Lee, *Ut Pictura Poesis: The Humanistic Theory of Painting* (New York: Norton, 1967), 5 and 17–19, and the chapter on "Fable" in H. T. Swedenberg, *The Theory of the Epic in England, 1650–1800* (University of California, 1944).

2 Stuart Curran, ed., *Le Bossu and Voltaire on the Epic* (Gainesville, Florida: Scholars Facsimiles and Reprints, 1970), 15.

3 A. F. B. Clark, *Boileau and the French Classical Critics in England (1660–1800)* (Paris: Librairie Ancienne Edouard Champion, 1925), 243–44, and Swedenberg, *Theory of the Epic in England*, 166–192, are the principal sources for these references.

4 William Hayley, *An Essay on Epic Poetry*, ed. Sister M. Celeste Williamson (1782; Gainesville, Florida: Scholars Facsimiles and Reprints, 1968), 122.

5 Curran, *Le Bossu*, 15. Joseph A. Wittreich, Jr. describes Le Bossu as "helpful when it comes to explaining what Blake means when he says that 'what Critics call The Fable is Vision itself'"; Wittreich is approaching the relationship from a different angle, though he also notes that Blake's theory of epic poetry seems to have been much influenced by Fuseli; see his "'Sublime Allegory': Blake's Epic Manifesto and the Milton Tradition," *BS* 4: 2 (Spring 1972), 20–22.

6 Robert N. Essick has shown that Blake probably owned a copy of Chapman's translation of Homer: "William Blake's Copy of Chapman's Homer," *ELN* 27 (1990), 27–33. But Blake knew Pope's translation too (E 505), though Pope's version of Le Bossu does not represent the theory adequately; see the Twickenham Edition of the Poems of Alexander Pope, vol. IX, *The Odyssey of Homer Books I–XII*, ed. Maynard Mack (London: Methuen, 1967), 3–24.

7 Curran, *Le Bossu*, 178.

8 *Ibid.*, 37–38.

9 *Ibid.*, 41.

10 *Ibid.*, 40. Le Bossu says *"Engraver,"* but clearly has original rather than reproductive work in mind.

11 James Barry, *The Works of James Barry, Esq.*, 2 vols. (London: Cadell and Davies, 1809), II: 323, 318.

12 John Knowles, ed., *The Life and Writings of Henry Fuseli, Esq. M.A. R.A.*, 3 vols. (London: Colburn and Bentley, 1831), II: 157, 172.

13 Werner Hofmann, "A Captive," in *Henry Fuseli 1741–1825* (London: Tate Gallery, 1975), 33.

14 *Ibid.*

15 From a review in the *Analytical Review* in 1788, cited in Hofmann, *Henry Fuseli 1741–1825*, 41.

16 Knowles, *Henry Fuseli*, II: 142.

17 *Ibid.*, II: 193-94.

18 *Ibid.*, II: 190.

19 *Ibid.*, II: 194.

20 Francis Haskell and Nicholas Penny, *Taste and the Antique* (Yale University Press, 1981), 284.

21 See Nicolas Powell on Gert Schiff's Fuseli catalogue: "[Schiff's] painstaking identification of subjects from which it has emerged that Fuseli practically never invented with the possible exception of Ezzelin Bracciaferro"; "Recent Fuseli Studies," *BM* 116 (June 1974), 336.

22 The possibly related drawings with titular inscriptions by Blake, "Theotormon Woven" (B 575) and "Chaining of Orc" (B 584), are among the very few clear exceptions; it is likely they were offshoots of work on *The Four Zoas*.

23 Arthur Johnston, "William Blake and 'The Ancient Britons,'" *National Library of Wales Journal*, 22: 3 (Summer 1982), 309. See also Mona Wilson, *The Life of William Blake*, ed. Geoffrey Keynes (1927; Oxford University Press, 1971), 258.

24 Jonathan Richardson, *An Essay on the Theory of Painting* (1725; reprinted Menston: Scolar Press, 1971), 52.

25 Almost certainly the Apollo Belvedere, No. 8, the Farnese Hercules, No. 46, and the Dancing Faun, No. 34, in Haskell and Penny, *Taste and the Antique*.

26 It is difficult to explain the shift from Fawn to Pan; Kirkup, many years after having seen the painting, may be confusing two different though related beings.

27 Haskell and Penny, *Taste and the Antique*, 206.

28 Blake writes to Humphry of his design that "it is necessary to give some account of [it] & its various parts ought to be described for the accomodation of those who give it the honor of attention" (E 552). In the context of a commission done on the "recommendation" of

Humphry for the Countess of Egremont, it is possible to read this ironically, as a sop to inadequate aristocratic imaginations. But the fuller account in the Notebook, headed "For the Year 1810 / Additions to Blakes Catalogue of Pictures &c" (E 554), suggests that Blake was coming to realize the essential dependence of his art upon verbal commentary.

29 Louis Réau, *Iconographie de l'art Chrétien*, 3 vols. in 6 (Paris: Presses Universitaires de France, 1955–59), II: 1, 156.

30 This brief and incomplete listing depends on Réau, *Iconographie de l'art Chrétien*, Andor Pigler, *Barockthemen* (Budapest: Verlag der Ungarischen Akademie der Wissenschaften, 1956), and *Index Iconologicus* (Sanford: Microfilming Corporation of America, 1980).

31 Quotations from Luther are from Martin Luther, *Works*, eds. Jaroslav Pelikan and Helmut T. Lehmann, 55 vols. (Saint Louis: Concordia Publishing House, 1955-74).

32 *Ibid.*, vols. VII–VIII.

33 In addition to several brief references, there is the comment in the annotations to Boyd (E 634) and the conversation recorded by Crabb Robinson; see G. E. Bentley, Jr., *Blake Records* (Oxford University Press, 1969), 541.

34 This account revises my "Blake's 'The New Jerusalem Descending': A Drawing (Butlin #92) Identified," *BIQ* 20: 1 (Summer 1986), 4–11, and "The New Jerusalem Defended," *BIQ* 20: 3 (Winter 1986–87), 102–104.

35 From *The Third Book of the Works of the Pious and Profoundly-Learned Joseph Mede, B.D.* (London, 1664), 751.

36 David Pareus, *A Commentary Upon the Divine Revelation of the Apostle and Evangelist John*, trans. Elias Arnold (Amsterdam, 1644), 536.

37 Matthew Henry, *An Exposition of the Old and New Testament*, 6 vols. (New York: Robert Carter and Brothers, 1853), IV: 767. Henry published most of his commentary, including that on Ezekiel, by 1710.

38 William Lowth, *The Prophets*, vol. IV of Simon Patrick, ed., *A Commentary upon the Old and New Testaments, with the Apocrypha*, 7 vols. (London, 1809), 334–35 and 339–40. Lowth's commentary on Ezekiel was originally published in 1723, and his *A Commentary*

284

Upon the Larger and Lesser Prophets in 1727.

39 Anthony Blackwall, *The Sacred Classics Defended and Illustrated* (London, 1725), 349; cited by Paul J. Korshin in *Typologies in England 1650–1820* (Princeton University Press, 1982), 329.

40 From *Institutes of Natural and Revealed Religion*, cited by Clarke Garrett in *Respectable Folly* (Johns Hopkins University Press, 1975), 130.

41 Morton D. Paley, *The Apocalyptic Sublime* (Yale University Press, 1986), 12, 19; William L. Pressly, *James Barry: The Artist as Hero* (London: Tate Gallery, 1983), 84–85.

42 LeRoy E. Froom, *The Prophetic Faith of Our Fathers*, 4 vols. (Washington, DC: Review and Herald, 1948), II: 541, and the table of identifications, II: 528-31.

43 Conversation with John Adams, cited by Garrett in *Respectable Folly*, 133.

44 Korshin, *Typologies*, 343.

45 Nicholas P. Negroponte, "Products and Services for Computer Networks," *Scientific American* 265: 3 (September 1991), 106.

46 Butlin says conservatively of the lost painting that "It may well have been similar in composition to the watercolour of 1809" (text, B 658).

47 *The First Part of King Henry IV*, ed. A. R. Humphrey (London: Methuen, 1965), IV. i. 97–110.

48 Anthony Blunt, *The Art of William Blake* (1959; reprinted New York: Harper and Row, 1974), 19.

49 See Edmund Burke, *A Philosophical Enquiry into the Origin of our Ideas of the Sublime and Beautiful*, ed. James T. Boulton (University of Notre Dame Press, 1968), 59–62, 79.

50 *Ibid.*, 79; Boulton notes simply that Burke misquotes.

51 *Ibid.*, 78.

52 On the sublime in Blake's poetry, see Vincent A. De Luca, *Words of Eternity* (Princeton University Press, 1991).

53 See Butlin's note under B 658, and his "The Physicality of William Blake: The Large Color Prints of '1795'," *HLQ* 52 (1989), 9.

54 The *OED* gives numerous references; s.v. "Pegasus."

55 John Milton, *Paradise Lost*, ed. Alastair Fowler (New York: Longman, 1971), VII: 1–4.

5 "12 Large Prints… Historical & Poetical"

1 Anthony Blunt, *The Art of William Blake* (1959; reprinted New York: Harper and Row, 1974), 58.

2 Martin Butlin, *William Blake 1757–1827* (London: Tate Gallery, 1990), 83–84. Butlin includes a good summary of what is presently known about the prints.

3 Anne Kostelanetz Mellor, *Blake's Human Form Divine* (University of California Press, 1974), 150–65; Jenijoy La Belle, "Michelangelo's Sistine Frescoes and Blake's 1795 Color-Printed Drawings," *BIQ* 14 (1980), 66–84.

4 Martin Butlin, "The Physicality of William Blake: The Large Color Prints of '1795'," *HLQ* 52 (1989), 1–17.

5 Geoffrey Keynes, ed., *The Letters of William Blake*, third edn. (Oxford University Press, 1980), 86.

6 Butlin, "Physicality," 1–17, and *William Blake 1757–1827*, 82–103.

7 David W. Lindsay, "The Order of Blake's Large Color Prints," *HLQ* 52 (1989), 19–41.

8 Jean Hagstrum, "'The Wrath of the Lamb': A Study of William Blake's Conversions," in *From Sensibility to Romanticism*, eds. Frederick W. Hilles and Harold Bloom (Oxford University Press, 1970), 329.

9 Butlin, *William Blake 1757–1827*, 89.

10 Robert Lowth, *Lectures on the Sacred Poetry of the Hebrews*, ed. Vincent Freimarck 2 vols. (1787; reprinted Hildesheim: Georg Olms Verlag, 1969), I: 88-93. A full account of Blake's relation to this important book has yet to be written, but see John C. Villalobos, "A Possible Source for William Blake's 'The Great Code of Art'," *ELN* 26 (1988), 36–40, Murray Roston, *Prophet and Poet* (London: Faber and Faber, 1965), and Leslie Tannenbaum, *Biblical Tradition in Blake's Early Prophecies* (Princeton University Press, 1982).

11 [John Bulwer], *Chirologia* (London, 1644), 154 and Plate B.

12 Lindsay, "Order," 28.

13 *Macbeth* I. viii, in Samuel Johnson, ed., *The Plays of William Shakespeare*, 8 vols. (London, 1765), VI: 398–99.

14 Rossetti called her "dead or tranced" in Alexander Gilchrist, *Life of William Blake*, 2 vols. (London: 1863), II: 237. Anne Kostelanetz

[Mellor], in an earlier version of her essay in *Blake's Human Form Divine*, described her as "dying or dead": "Blake's 1795 Color Prints: An Interpretation," in *William Blake* (Brown University Press, 1969), 129; Morton Paley calls her "dead" in *William Blake* (Oxford: Phaidon, 1978), 38.

15 David Bindman, *Blake as an Artist* (Oxford: Phaidon, 1977), 99.

16 Mellor, *Blake's Human Form Divine*, 163.

17 Paley, *William Blake*, 38.

18 On Blake and personification, see Jean H. Hagstrum, *William Blake: Poet and Painter* (University of Chicago Press, 1964), 49–51.

19 See Grover Smith, "The Naked New-Born Babe in *Macbeth*: Some Iconographical Evidence," in Southeastern Renaissance Conference *Renaissance Papers* (1964), 25.

20 Janet A. Warner, "Blake's Use of Gesture," in David V. Erdman and John E. Grant, eds., *Blake's Visionary Forms Dramatic* (Princeton University Press, 1970), 189–90.

21 There is an enlargement in David Bindman, assisted by D. Toomey, *The Complete Graphic Works of William Blake* (London: Thames and Hudson, 1978), Plate 326.

22 Edmund Spenser, *The Faerie Queene*, ed. A. C. Hamilton (London: Longman, 1977), III. xii. 12.

23 John E. Grant, "Blake's Designs for *L'Allegro* and *Il Penseroso*, Part II: The Meaning of Mirth and Her Companions," *BN* 5: 3 (Winter 1971–72), 197.

24 A. S. Roe, *William Blake: An Annotated Catalogue* (Andrew Dickson White Museum of Art, Cornell University, 1965), 28. Grant and La Belle both have at least partially positive interpretations of the babe.

25 Anthony Blunt, "Blake's Pictorial Imagination," *JWCI* 6 (1943), 201.

26 Cf. Moelwin Merchant, *Shakespeare and the Artist* (Oxford University Press, 1959), 83: "No other drawing exists where the images from a passage of Shakespeare's dramatic poetry are isolated in this way, analysed and then recomposed into a harmonious whole." Paley sees this as resulting in failure: "Shakespeare made the two clauses parallel; it is Blake who makes the 'cherubin' receive the 'new-born babe', yet no symbolic meaning emerges from this": *William Blake*, 38. This is based on an acute observation, but one need not agree that Blake's print fails.

27 Ophelia's death triggers Laertes into action, Emilia dies in revealing the truth, and Cordelia takes the pattern even deeper.

28 Gilchrist, *Life of William Blake*, II: 238.

29 The letter in which Ruskin uses the title "the owls" is dated "1843?" by the editors; Edward T. Cook and Alexander Wedderburn, eds., *The Works of John Ruskin*, 39 vols. (London: G. Allen, 1903–12), XXXVI: 32. See G. E. Bentley, Jr., *William Blake: The Critical Heritage* (London and Boston: Routledge and Kegan Paul, 1975), 238.

30 Ovid, *Publii Ovidii Nasonis Fastorum Libri Sex: The Fasti of Ovid*, ed. and trans. James G. Frazer, 2 vols. (London: Macmillan, 1929), I: 11. The passage is Book I: 141–42. Cf. Sandys's comment that Hecate is "said to have three heads, of her three denominations…"; George Sandys, *Ovid's Metamorphosis*, eds. Karl K. Hulley and Stanley T. Vandersall (University of Nebraska Press, 1970), 334.

31 Cettina Tramonte Magno and David V. Erdman, *"The Four Zoas" by William Blake: A Photographic Facsimile of the Manuscript with Commentary on the Illuminations* (Bucknell University Press, 1987).

32 Joseph Spence, *Polymetis* (1747; reprinted New York: Garland, 1976), 102: "A Third remarkable way of representing Diana was with three bodies. This is very common among the antient figures of this goddess; and it is hence the poets call her the triple, the three-headed, and the three-bodied Diana. Her distinguishing name, under this triple appearance, is Hecate, or Trivia."

33 Jean Hagstrum, "'The Wrath of the Lamb'," 329. The following discussion is a much revised version of part of my own "Reading Blake's Designs: *Pity* and *Hecate*," *BRH* 84 (1981), 337–65.

34 The variations are largely in the color of the witch's hair, which is black in the Tate copy, medium brown in the Huntington copy, and straw in the Edinburgh copy. The witch in the early Saul design has dark hair, but in the later version has reddish hair.

35 Sandys, *Metamorphosis*, 311–12, and cf. *The Masque of Queens*, in *Ben Jonson: The Complete Masques*, ed. Stephen Orgel (Yale University Press, 1969), 125.

36 Charles Le Brun, trans. John Williams, *A Method to learn to Design the Passions*, ed. Alan T. McKenzie (Los Angeles: William Andrews Clark Memorial Library, 1980), figs. 19, 23, and p. 38.

37 Gerard de Lairesse, *The Art of Painting* (London, 1738), 44. There is little doubt that Blake knew this work well; the statement about skin color quoted above is close to Lairesse, 14–17. We know that Fuseli borrowed a copy from a letter to Roscoe dated 24 August 1786: "I am ashamed of being still in possession of Lairesse – but when You are told that the book has been of use to me You will forgive me"; David H. Weinglass, ed., *The Collected English Letters of Henry Fuseli* (Millwood, NY: Kraus International Publications, 1982), 32. Fuseli comments in the "Introduction" to his Lectures: "Of the books purely elementary, the van of which is led by Léonardo da Vinci and Albert Dürer, and the rear by Gherard Lairesse, as the principles which they detail must be supposed to be already in the student's possession, or are occasionally interwoven with the topics of the Lectures, I shall not expatiate"; John Knowles, ed., *The Life and Writings of Henry Fuseli, Esq. M.A. R.A.*, 3 vols. (London: Colburn and Bentley, 1831), II: 2.

38 George Withers, *A Collection of Emblemes, Ancient and Moderne*, intro. Rosemary Freeman, notes by Charles S. Hensley (1635; University of South Carolina Press, 1975), emblems 9, 63, 79, 168.

39 Sandys, *Metamorphosis*, 256–57.

40 *Ibid.*, 338–39.

41 For envy, see, e.g., Spenser, *The Faerie Queene*, I. i. 20 and I. x. 59; for injustice, see George Richardson, *Iconology*, 2 vols. (London, 1779), II: 21.

42 Even Goldsmith does not dismiss the possibility in a work of natural history; see *A History of the Earth, and Animated Nature*, 6 vols. (London: F. Wingrave, 1805), V: 309–12.

43 An old form of the familiar "eft," meaning a newt; the words "a newt" were formed by cor-ruption from "an ewt" according to the *OED*.

44 Sandys, *Metamorphosis*, 238–39 and 255. Rodney M. Baine characterizes Blake's newts as "symbols of envy or selfishness" without noting the Ovidian basis: Rodney M. Baine, with the assistance of Mary R. Baine, *The Scattered Portions* (Athens, GA, 1986), 102–103.

45 Charles H. Collins Baker, "The Sources of Blake's Pictorial Expression," reprinted in *The Visionary Hand*, ed. Robert N. Essick (Los Angeles: Hennessey and Ingalls, 1973), 116–19.

46 *Night Thoughts*, ed. Robert N. Essick and Jenijoy La Belle (New York: Dover, 1975), 37.

47 Lindsay, "Order," 29.

48 Gert Schiff, original English text of his entry describing No. 31, the Edinburgh copy of *Hecate*, which he renames "The Night of Enitharmon's Joy," in the catalogue of the Blake exhibition held in Japan in 1990. The English version was kindly made available to me by Robert N. Essick.

49 Schiff points out that her hand simply rests on the book in the Edinburgh and Huntington copies, but the situation remains essentially the same.

50 John L. Austin, *How to Do Things with Words* (Oxford University Press, 1962).

51 Benedict Nicolson, *John Hamilton Mortimer ARA 1740–1779* (London: Paul Mellon Foundation for British Art, 1968), 50.

52 William Julius Mickle, "The Sorceress; or, Wolfwold and Ulla," in Alexander Chalmers, ed., *The Works of the English Poets, from Chaucer to Cowper*, 21 vols. (London, 1810), XVII: 530–31.

53 Gotthold Ephraim Lessing, *Laocoön*, trans. Edward A. McCormick (Indianapolis: Bobs-Merrill, 1962), 20–21.

54 Richard Glover, *Medea* (London, 1761), and Robert Potter, trans., *The Tragedies of Euripides* (London, 1781). There is no record of Blake's knowledge of Euripides, but he did own Potter's *Tragedies of Aeschylus* (London, 1779); see G. E. Bentley, Jr., *Blake Records Supplement* (Oxford University Press, 1988), 124.

55 James Barry, *The Works of James Barry, Esq.*, 2 vols. (London: Cadell and Davies, 1809), II: 376, and Nancy L. Pressly, *The Fuseli Circle in Rome: Early Romantic Art of the 1770s* (Yale Center for British Art, 1979), 121.

56 Bentley, *Blake Records Supplement*, 124.

57 Pressly, *The Fuseli Circle in Rome*, x, 121, and Patricia Jaffé, *Drawings by George Romney* (Cambridge University Press, 1977), 9–10.

58 Peter Tomory, *The Poetical Circle: Fuseli and the British* (Florence: Centro Di, 1979), 47.

59 Opening of Book 3 of the *Argonautica*, the primary source for the earlier part of Medea's story, as Euripides is the source for Medea's feelings at the close.

60 Sandys, *Metamorphosis*, 317.

61 There are other stories about Medea, in some of which she has many children, including daughters – see Robert Graves, *The Greek Myths*, 2 vols. (Harmondsworth: Penguin, 1957), II: 254–55 – but none of these gained any currency.

62 For details of these volumes, and Blake's engravings for *The Economy of Vegetation*, see G. E. Bentley, Jr., *Blake Books* (Oxford University Press, 1977), 546–48.

63 Erasmus Darwin, *The Botanic Garden* (1791; reprinted Menston, Yorkshire: Scolar Press, 1973), *The Loves of the Plants*, 99.

64 Lindsay, "Order," 29.

65 *Ibid.*, 30.

66 Kathleen Raine, *Blake and Tradition*, 2 vols. (Princeton University Press, 1968), I: 365–66.

67 David V. Erdman, *The Illuminated Blake* (New York: Anchor Press / Doubleday, 1974), 102; Geoffrey Keynes, ed., *The Marriage of Heaven and Hell* (Oxford University Press and Trianon Press, 1975), commentary on Plate 4.

68 Emanuel Swedenborg, *A Treatise Concerning Heaven and Hell*, 2nd. edn., trans. (London, 1784), 359, para. 536. This is the edition that Blake owned and annotated. Further references will be by paragraph number.

69 See, for instance, the self-portrait that is No. 2 in the catalogue of the 1975 exhibition, *Henry Fuseli 1741–1825* (London: Tate Gallery, 1975).

70 Mellor, *Blake's Human Form Divine*, 159.

71 See Erdman, *The Illuminated Blake*, 28–29. Le Brun describes the gesture: "Desire may be expressed by the Arms being stretched forth towards the desired object, the whole Body inclining that way, and all the Parts appearing in an eager, perplexed and inquiet motion." Le Brun, *Method*, 49. Blake uses the gesture often.

72 Janet A. Warner, *Blake and the Language of Art* (McGill–Queen's University Press, 1984), 96.

73 Emblem 57 in *Cesare Ripa: Baroque and Rococo Pictorial Imagery*, ed. Edward A. Maser (New York: Dover, 1971).

74 Spenser, *The Faerie Queene*, III. x. 60.

75 Michael Fried, *Absorption and Theatricality* (University of California Press, 1980).

76 Keynes, *Letters*, 25.

77 Butlin, "Physicality," 6–8.

78 Mellor, *Blake's Human Form Divine*, 159–60; Butlin, *William Blake 1757–1827*, 102; Lindsay, "Order," 33.

79 Martin Butlin, "Blake's 'God Judging Adam' Rediscovered," reprinted in Robert N. Essick, ed., *The Visionary Hand* (Los Angeles: Hennessey & Ingalls, 1973), 303–10.

80 Blunt, *The Art of William Blake*, 61.

81 Butlin, "Blake's 'God Judging Adam' Rediscovered," 307.

82 Mellor, *Blake's Human Form Divine*, 153–55.

83 There was much discussion of the time lapse between the creation and judgment of Adam; one account made the story into a classical tragedy, consummated within 24 hours.

84 John Milton, *Paradise Lost*, ed. Alastair Fowler (New York: Longman, 1971), XI: 538–40.

85 Mellor, *Blake's Human Form Divine*, 155.

86 Erdman, *The Illuminated Blake*, 320.

87 Mellor, *Blake's Human Form Divine*, 154–55.

88 Butlin, *William Blake 1757–1827*, 103.

89 Lindsay, "Order," 33.

6 Blake and Young's *Night Thoughts*

1 Karen Ann Gabbett-Mulhallen, "Blake's *Night Thoughts*: Context, Christology and Composite Work," dissertation, University of Toronto, 1976; W. J. T. Mitchell, review of "William Blake's Designs for Edward Young's *Night Thoughts*: A Complete Edition," *MP* 80 (1982–83), 198–205; Bo Lindberg, *William Blake's Illustrations to the Book of Job* (Åbo: Acta Academiae Aboensis, 1973); David Fuller, "Blake and Dante," *AH* 11 (1988), 349–73.

2 The "Explanation of the Engravings" is at the end of vol. 2 of the Oxford edition, and is included in the edition of the *Night Thoughts* edited by Robert N. Essick and Jenijoy La Belle (New York: Dover, 1975).

3 David V. Erdman, John E. Grant, Edward J. Rose, and Michael J. Tolley, eds., *William Blake's Designs for Edward Young's "Night Thoughts,"* 2 vols. (Oxford University Press, 1980).

4 Morton D. Paley, "Blake's *Night Thoughts*: An Exploration of the Fallen World," in *William Blake: Essays for S. Foster Damon*, ed. Alvin H. Rosenfeld (Brown University Press, 1969), 135.

5 *Ibid.*, 138.

6 *Ibid.*

7 See Irene H. Chayes, "Picture and Page, Reader and Viewer in Blake's *Night Thoughts* Illustrations," *SiR* 30 (1991), 439–71, for some related issues.

8 Paley, "Blake's *Night Thoughts*," 137.

9 *Ibid.*, 145.

10 *Ibid.*, 141.

11 Thomas H. Helmstadter, "Blake's Night Thoughts: Interpretations of Edward Young," reprinted in Robert N. Essick, ed., *The Visionary Hand* (Los Angeles: Hennessey & Ingalls, 1973), 382, 384.

12 Thomas H. Helmstadter, "Blake and Religion: Iconographical Themes in the *Night Thoughts*," *SiR* 10 (1971), 200–201.

13 *Ibid.*, 207–208.

14 John E. Grant, "Envisioning the first *Night Thoughts*," in *Blake's Visionary Forms Dramatic*, ed. David V. Erdman and John E. Grant (Princeton University Press, 1970), 306.

15 *Ibid.*, 308–309.

16 John E. Grant, "A Re-View of Some Problems in Understanding Blake's *Night Thoughts*," *BIQ* 18: 3 (Winter 1984–85), 161.

17 J. W. T. Mitchell, "Reply to John Grant," *BIQ* 18: 3 (Winter 1984–85), 182.

18 Erdman et al., *Night Thoughts*, I: 36–37.

19 W. J. T. Mitchell, review of *William Blake's Designs for Edward Young's 'Night Thoughts': A Complete Edition*, *MP* 80 (1982–83), 201.

20 *Ibid.*, 202–203.

21 Grant, "Re-View," 166–68.

22 Mitchell, "Reply to John Grant," 182.

23 Grant, "Re-View," 162.

24 Essick and La Belle, *Night Thoughts*, xi. The following discussion is a revision of my "The Good (In Spite of What You May Have Heard) Samaritan," *BIQ* 25: 2 (Fall 1991), 64–69.

25 Essick and La Belle, *Night Thoughts*, 37.

26 John E. Grant, "Jesus and the Powers That Be in Blake's Designs for Young's *Night Thoughts*," in *Blake and His Bibles*, ed. David V. Erdman (West Cornwall, CT: Locust Hill Press, 1990), 77–79.

27 John Gill, *An Exposition of the New Testament*, new edn., 5 vols. (London, 1774), II: 143. *DNB* records a first edition in 1746–48, and mentions "his extensive rabbinical learning." I confess an arbitrary element in my choice of commentators – I have made no attempt to canvas the field.

28 Grant, "Jesus," 79. Because Grant's view of the thrust of the design does not change when he turns to the etched version, I have illustrated only the etched version. The differences are small, and neither Grant's interpretation nor my own depends on an exact reading of the expression on the face of Jesus.

29 *Ibid.*, 83-4.

30 Bernard Lamy, trans., *Perspective Made Easy* (London, 1710; reprinted Alburgh: Archival Facsimiles, 1987), 12.

31 Edmund Spenser, *The Faerie Queene*, ed. A. C. Hamilton (London: Longman, 1977), I. x. 13.

32 George Sandys, *Ovid's Metamorphosis*, eds. Karl K. Hulley and Stanley T. Vandersall (University of Nebraska Press, 1970), 97, 714.

33 Many sources comment on the serpent as the attribute of Aesculapius, e.g. Joseph Spence, *Polymetis* (London, 1747), 132.

34 Gill, *Exposition*, II: 142.

35 John Wesley, *Explanatory Notes upon The New Testament* (London: Charles H. Kelly, n.d.), 241.

36 Gill, *Exposition*, II: 144.

37 Matthew Henry, *An Exposition of the Old and New Testament*, 6 vols. (New York: Robert Carter and Brothers, 1853), V: 536–37. Henry was one of the most popular commentators.

38 *Ibid.*, V: 536. See also Gill, *Exposition*, II: 143.

39 Daniel Defoe, *Robinson Crusoe*, ed. M. Shinagel (New York: Norton, 1975), 121. The drawing shows either sunset or dawn, contrary to the indication of the text, but the visible footprint makes the moment illustrated definite. Rodney M. Baine suggests that Blake chose a setting sun "To heighten Crusoe's isolation and terror... For that night

the fearful Crusoe slept not at all…";
"Blake and Defoe," *BIQ* 6: 2 (Fall 1972), 52.

40 Charles Le Brun, trans. John Williams, *A Method to learn to Design the Passions*, ed. Alan T. McKenzie (Los Angeles: William Andrews Clark Memorial Library, 1980), 16, 47. Bulwer's *Chirologia* identifies two hands raised from the wrist as "Admiror." Bulwer's commentary says: "To throw up the Hands to heaven is an expression of *admiration, amazement,* and *astonishment…*" Bulwer's text appears to describe a gesture involving arms raised above the head, but since his illustration shows only the hands the core signifying element in the gesture must be the upraising of the hands at the wrist, as is clear in Le Brun. [John Bulwer], *Chirologia: or, the Naturall Language of the Hand* (London, 1644), 29.

41 Martin Meisel, *Realizations* (Princeton University Press, 1983), 6.

42 *The Institutio Oratoria of Quintilian*, trans. H. E. Butler, 4 vols. (London: Heinemann, 1922), IV: 283 (Book XI. iii. 70).

7 Blake's Bible

1 John Jortin, *Remarks on Ecclesiastical History*, 5 vols. (London, 1751–53) I: 183; cited by Paul J. Korshin in "The Development of Abstracted Typology in England, 1650–1820," in *Literary Uses of Typology from the Late Middle Ages to the Present*, ed. Earl Miner (Princeton University Press, 1977), 165.

2 Robert Lowth, *Lectures on the Sacred Poetry of the Hebrews*, 2 vols. (1787; reprinted Hildesheim: Georg Olms Verlag, 1969), II: 84–85.

3 This is a very cursory overview of the rich topic of Blake's relationship to typology. See Leslie Tannenbaum's chapter, "Sublime Allegory," in his *Biblical Tradition in Blake's Early Prophecies* (Princeton University Press, 1982); various essays in Earl Miner, ed., *Literary Uses of Typology from the Late Middle Ages to the Present* (Princeton University Press, 1977); Paul J. Korshin, *Typologies in England 1650–1820* (Princeton University Press, 1982); and Victor Harris, "Allegory to Analogy in the Interpretation of Scriptures," *PQ* 45 (1966), 1–23.

4 See G.E. Bentley, Jr., "Blake and Swedenborg," *N & Q*, 199 (n.s.I) (1954), 264–65.

5 John Knowles, ed., *The Life and Writings of Henry Fuseli, Esq. M.A. R.A.*, 3 vols. (London: Colburn and Bentley, 1831), III: 127, Aphorism 166.

6 Rodney M. Baine, with the assistance of Mary R. Baine, *The Scattered Portions* (Athens, GA, 1986), 161 and 157; the latter page has a good paragraph on the honeysuckle.

7 Bernice F. Davidson, *Raphael's Bible: A Study of the Vatican Logge* (Pennsylvania University Press, 1985), fig. 93.

8 The commentators saw the connection; see Matthew Henry, *An Exposition of the Old and New Testament*, 6 vols. (New York: Robert Carter and Brothers, 1853), II: 405: "Adultery and murder were David's sins, and those sins, among his children, (Amnon defiling his sister Tamar, and Absalom murdering his brother Amnon,) were the beginnings of his punishment."

9 David Bindman, *Blake as an Artist* (Oxford: Phaidon, 1977), 120.

10 Robert N. Essick, *The Works of William Blake in the Huntington Collections* (San Marino, CA: Huntington Library, 1985), 120.

11 Louis Réau, *Iconographie de l'art chrétien*, 3 vols. in 6 (Paris: Presses Universitaires de France, 1957), Part II, I: 117.

12 *The Illustrated Bartsch*, III: 263(80).

13 Jacob Boehme, "Mysterium Magnum," in *The Works of Jacob Behmen*, 4 vols., eds. G. Ward and T. Langcake (London, 1764–81), III: 261–66.

14 Henry, *Exposition*, I: 118–19.

15 *Ibid.*, I: 119.

16 Leo Steinberg, *The Sexuality of Christ in Renaissance Art and in Modern Oblivion* (New York: Pantheon/October Books, 1983). See particularly his figs. 238, 243–46.

17 Bindman, *Blake as an Artist*, 126.

18 "He who has Nothing to Dissipate Cannot Dissipate the Weak Man may be Virtuous Enough but will Never be an Artist" (E 643–44); this supports Bindman's reference to the Strong Man, though implying a more active form of dissipation than Lot's.

19 See Anthony Blunt, *Artistic Theory in Italy 1450–1660* (Oxford University Press, 1962), 103–36 for the effect of the Council of Trent on religious art, and Elizabeth G. Holst, ed., *A Documentary History of Art*, 2 vols. (New

York: Doubleday, 1958), II, 62–70, for relevant documents.

20 Morton D. Paley, *William Blake* (Oxford: Phaidon, 1978), 55; Bindman, *Blake as an Artist*, 126–27.

21 Mary Lynn Johnson, "Human Consciousness and the Divine Image in Blake's Watercolor Designs for the Bible: Genesis Through Psalms," in *The Cast of Consciousness: Concepts of the Mind in British and American Romanticism*, eds. Beverly Taylor and Robert Bain (New York: Greenwood Press, 1987), 22.

22 Mary Lynn Johnson, "David's Recognition of the Human Face of God in Blake's Designs for the Book of Psalms," in *Blake and His Bibles*, ed. David V. Erdman (West Cornwall, CT: Locust Hill Press, 1990), 128.

23 S. Foster Damon, *Blake's "Job"* (New York: Dutton, 1969), 10, 36.

24 Bo Lindberg, *William Blake's Illustrations to The Book of Job* (Abo: Abo Akademi, 1973) 82, and 189; the reading of the figures on the title page as the Seven Eyes of God "does not seem probable. The angels are no Gods, merely angels; and that Blake should make a print in which Lucifer and Molech cannot be distinguished from Jehovah and Jesus, is most unlikely."

25 For the Seven Eyes, see Michael Ferber, *The Social Vision of William Blake* (Princeton University Press, 198), "Appendix," 213–21, and Rachel V. Billigheimer, "Blake's 'Eyes of God': Cycles to Apocalypse and Redemption," *PQ* 66 (1987), 231–57.

26 Ferber, *Social Vision*, 214.

27 S. Foster Damon, *A Blake Dictionary* (Brown University Press, 1965), illus. 1 and "Key."

28 Clyde R. Taylor, "Iconographical Themes in William Blake," *BS* 1: 1 (Fall, 1968), 80–83.

29 John G. Grant, "You Can't Write About Blake's Pictures Like That," *BS* 1: 2 (Spring 1969), 201.

30 Michael J. Tolley, review of Martin Butlin, *William Blake: A Complete Catalogue of the Works in the Tate Gallery*, and Kathleen Raine, *William Blake*, in *BN* 6: 1 (Summer 1972), 29.

31 Gerard de Lairesse, *The Art of Painting*, trans. John F. Fritsch (London, 1738), 479.

32 John Milton, *Paradise Lost*, ed. Alastair Fowler (New York: Longman, 1971), XII: 644.

33 See Pamela Dunbar, *William Blake's Illustrations to the Poetry of Milton* (Oxford University Press, 1980), 89: she states that the four horsemen "may also be relevant"; Stephen C. Behrendt, *The Moment of Explosion* (University of Nebraska Press, 1983), 176, identifies the figures as the four horsemen; Bette Charlene Warner, *Blake's Vision of the Poetry of Milton* (Bucknell University Press, 1986), 100, calls them the Four Zoas, "mounted like the four horsemen."

34 Robert Lowth, *Lectures on the Sacred Poetry of the Hebrews*, ed. Vincent Freimarck, 2 vols. (1787; reprinted Hildesheim: Georg Olms Verlag, 1969), II: 91.

35 Thomas Paine, "The Age of Reason," in *The Complete Writings of Thomas Paine*, ed. Philip S. Foner, 2 vols. (New York: Citadel Press, 1945), I: 570.

36 Paine, "Age of Reason," I: 577–78.

37 Richard Watson, *An Apology for the Bible*, in *An Apology for Christianity 1776 and An Apology for the Bible 1796* (reprinted New York: Garland, 1977), 99–100.

38 The designs are all dated *c.* 1805 by Butlin; the only exception is *Sealing the Stone and Setting a Watch* (B 499), dated by Butlin *c.* 1800–1803, and part of the narrative sequence, but not at all in the same style.

39 Mark has essentially the same chronology (15: 43–16: 2).

40 He uses it, for instance, in creating the text he added to his early engraving of *Joseph of Arimathea*, and in the last of the *Job* engravings.

41 Paine, "Age of Reason," I: 578.

42 There are many representations of the winged cherubim guarding the mercy seat, but I know of none besides Blake's that shows them guarding the body of Jesus.

8 A "Style of Designing": perspectives on perspective

1 W. J. T. Mitchell, *Blake's Composite Art* (Princeton University Press, 1978), 58–59.

2 Erwin Panofsky, *Perspective as Symbolic Form*, trans. Christopher S. Wood (Cambridge: MIT Press, 1991).

3 Samuel Y. Edgerton, *The Renaissance Rediscovery of Linear Perspective* (New York: Basic Books, 1975), 161.

4 *Ibid.*, 158–59.

5 David Bindman, *Blake as an Artist* (Oxford: Phaidon, 1977), 16–17.

6 Edgerton, *Perspective*, 31.

7 Leon Battista Alberti, *On Painting*, ed. and trans. John R. Spencer (Yale University Press, 1966), 90.

8 Alberti, *On Painting*, 75.

9 *Ibid.*, 72.

10 Michael Kubovy, *The Psychology of Perspective and Renaissance Art* (Cambridge University Press, 1986), 3.

11 John White discusses strategies adopted to control the problem in *The Birth and Rebirth of Pictorial Space* (New York: Harper and Row, 1967), 189–201.

12 I take this account from Carl Goldstein, "Studies in Seventeenth Century French Art Theory and Ceiling Painting," *AB* 47 (1965), 231–33.

13 Cited by Goldstein in "Studies," 235.

14 *Ibid.*, 233–37.

15 *Ibid.*, 237–39.

16 Jonathan Richardson, *An Essay on the Theory of Painting* (1725; reprinted Menston, Yorkshire: Scolar Press, 1971), 118.

17 *Ibid.*, 127.

18 *Ibid.*, 131–32.

19 William Hogarth, *The Analysis of Beauty*, ed. Joseph Burke (Oxford University Press, 1955), 119.

20 *Ibid.*, 121.

21 John Knowles, ed., *The Life and Writings of Henry Fuseli, Esq. M.A. R.A.*, 3 vols. (London: H. Colburn and R. Bentley, 1831), II: 239.

22 *Ibid.*, II: 218.

23 *Ibid.*, II: 227.

24 *Ibid.*, II: 242.

25 *Ibid.*, II: 226, 253.

26 See the reproduction in Geoffrey Keynes, ed., *The Marriage of Heaven and Hell* (Oxford University Press and Trianon Press, 1975), Plate 8.

27 H. G. Alexander, ed., *The Leibniz-Clarke Correspondence* (New York: Manchester University Press and Barnes and Noble, 1976), 103.

28 *Ibid.*, 69.

29 *Ibid.*, 63.

30 Daniel Stempel, "Blake's Monadology: The Universe of Perspectives," *Mosaic* 8 (1974), 77–99.

31 Edgerton, *Perspective*, 85–86.

32 *Ibid.*, 162.

33 *Ibid.*, 23.

34 Norman Bryson, *Word and Image* (Cambridge University Press, 1981), 6–12, 19.

35 *Ibid.*, 14–15.

36 W. J. T. Mitchell, "Style and Iconography in the Illustrations of Blake's *Milton*," *BS* 6:1 (Fall 1973), 67.

37 W. J. T. Mitchell, review of the Oxford edition of *William Blake's Designs for Edward Young's "Night Thoughts,"* *MP* 80 (1982), 198–205.

38 See Brenda Webster, *Blake's Prophetic Psychology* (University of Georgia Press, 1983), 253–71, and Margaret Storch, *Sons and Adversaries* (University of Tennessee Press, 1990), 148–53.

39 Alberti, *On Painting*, 78.

40 Gerard de Lairesse, *The Art of Painting*, trans. John F. Fritsch (London, 1738), 35.

41 *Ibid.*, 220–22.

42 What follows is a revised version of my "The Chamber of Prophecy: Blake's 'A Vision' (Butlin #756) Interpreted," *BIQ* 25 :3 (Winter 1991/92), 127–31.

43 Robert Rosenblum, *Transformations in Late Eighteenth Century Art* (Princeton University Press, 1969), 189–90.

44 W. J. T. Mitchell, "Style as Epistemology: Blake and the Movement toward Abstraction in Romantic Art," *SiR* 16 (1977), 146.

45 *Ibid.*, 156.

46 Bryson, *Word and Image*, 239.

47 *Ibid.*, 240.

48 In a drawing done at about the same time Blake does much better at conveying the perspective of an interior space; see *Falconbridge Taking Leave of King John and Queen Eleanor* (B 692: 57), Plate 29 in Martin Butlin and Robin Hamlyn's catalogue, *William Blake: Paintings, Watercolors and Drawings* (New York: Salander-O'Reilly Galleries, 1992).

49 Rosenblum, *Transformations*, 154–56, 187–89.

50 Michael Fried, *Absorption and Theatricality* (University of California Press, 1980), 96, 118–30.

51 Lord Kames (Henry Home), *Elements of Criticism*, 2 vols. (1762; Hildesheim: Georg Olms Verlag, 1970), I: 112.

52 Mitchell, *Blake's Composite Art*, 61–74.

53 A net-like grid was a favorite device in teaching perspective; see the illustration in Edgerton, *Perspective*, 119.

54 Plate numbers as in David V. Erdman, *The Illuminated Blake* (New York: Anchor Press, 1974).

55 The earliest version of this design, B 550: 18, dated *c.* 1805–1806, shows Job facing us. Blake seems to have recognized the gain in significance won by turning the figure around, for he kept that orientation in later versions.

56 *Analytical Review*, October 1792; quoted from Eudo Mason, *The Mind of Henry Fuseli* (London: Routledge and Kegan Paul, 1951), 213.

57 Knowles, *Henry Fuseli*, II: 240–41.

58 There is an account in David Summers, *Michelangelo and the Language of Art* (Princeton University Press, 1981), 269–78.

59 Morton D. Paley has outlined what Blake knew of ancient sculpture: "'Wonderful Originals'– Blake and Ancient Sculpture," in *Blake in his Time*, eds. Robert N. Essick and Donald Pearce (Indiana University Press, 1978), 170–97.

9 *The Sea of Time and Space*

1 Jonathan Richardson, *An Essay on the Theory of Painting* (1725; reprinted Menston: Scolar Press, 1971), 69.

2 Robert N. Essick, "William Blake's *The Death of Hector*," *SiR* 27 (1988), 103–104.

3 G. E. Bentley, Jr., *Blake Records* (Oxford University Press, 1969), 280–82, 565, and *Blake Records Supplement* (Oxford University Press, 1988), 81.

4 Compilation from Butlin's entry, A. P. Bruce Chichester, *History of the Chichester Family* (London: John Camden Hotten, 1872), 3–8, and Geoffrey Keynes, *Blake Studies* (Oxford University Press, 1971), 196–97.

5 Bentley, *Blake Records Supplement*, 76–77.

6 Robert N. Essick, "A Relief Etching of Blake's Virgil Illustrations," *BIQ* 25: 3 (Winter 1991–92), 124–26.

7 Robert N. Essick, *The Separate Plates of William Blake: A Catalogue* (Princeton University Press, 1983), 230.

8 Robert John Thornton, *The Pastorals of Virgil*, 3rd. edn., 2 vols. (London, 1821), 1: "To face page 116."

9 John E. Grant noted the similarity of gesture, but used it only to claim a "redemptive" function: "Redemptive Action in Blake's *Arlington Court Picture*," 1971, reprinted in Robert N. Essick, ed., *The Visionary Hand* (Los Angeles: Hennessey & Ingalls, 1973), 491.

10 Charles Le Brun, *A Method to Learn to Design the Passions*, ed. Alan McKenzie (1734; reprinted Los Angeles: William Andrews Clark Memorial Library, 1980), 49.

11 Leon Battista Alberti, *On Painting*, ed. John R. Spencer (Yale University Press, 1966), 78. There are further analogues to Isaiah's gesture in *NT* 60 and *NT* 156.

12 Robert N. Essick (personal communication) drew my attention to the difference between John and Isaiah; he is not responsible for my interpretation of it.

13 David V. Erdman, *The Illuminated Blake* (New York: Anchor Books, 1974), 24 and 156.

14 The symbols were identified by Robert Simmons and Janet Warner as the "Greek key motif" in "Blake's *Arlington Court Picture*: The Moment of Truth," reprinted in *The Visionary Hand*, 463.

15 Kathleen Raine sees him as Odysseus: *Blake and Tradition*, 2 vols. (Princeton University Press, 1968), I: 75-77. John Beer, *Blake's Visionary Universe* (Manchester University Press, 1969), 289, sees him as a Jesus-like Los; Anne Mellor reads him as Albion, *Blake's Human Form Divine* (Berkeley: University of California Press, 1974), 256. Luvah is chosen by S. Foster Damon, *A Blake Dictionary* (Brown University Press, 1965), s.v. "The Circle of Life." Los as an image of Blake himself is proposed by Simmons and Warner, "Blake's *Arlington Court Picture*," 469–70. George Wingfield Digby, *Symbol and Image in William Blake* (Oxford University Press, 1957), 65–73, describes him as Albion or Jesus clothed in Luvah's Robe of Blood.

16 Raine, *Blake and Tradition*, I: 69-98.

17 *Ibid.*, I: 78.

18 *The Student's Milton*, ed. Frank A. Patterson (New York: Appleton-Century-Crofts, 1933), 27.

19 Pamela Dunbar, *William Blake's Illustrations to the Poetry of Milton* (Oxford University Press, 1980), 152.

20 See for instance the geometrical diagrams facing the "General Introduction to The Philosophy and Writings of Plato" in *The Works of Plato*, trans. Floyer Sydenham and Thomas Taylor, 5 vols. (London, 1804; reprinted New York: AMS Press, n.d.), I: n.p., and the citation from a Hymn to Jupiter that "Jove is a circle, triangle and square…" from p. xxvii of the same "General Introduction."

21 Werner seems mistaken in her interpretation of this scene: "Some of the fire genii lie dead, but two reach upwards toward freedom, and the top figure fights against his chains." Bette Charlene Werner, *Blake's Vision of the Poetry of Milton* (Lewisburg: Bucknell University Press, 1986), 159.

22 *A Variorum Commentary on The Poems of John Milton: Volume Two, The Minor English Poems*, eds. A. S. P. Woodhouse and Douglas Bush (Columbia University Press, 1972), Part One, 324–26.

23 *The Works of Plato*, I: 18.

24 Cited by George Mills Harper, *The Neoplatonism of William Blake* (University of North Carolina Press, 1961), 11, 14. *The Works of Plato* are full of such statements, e.g. the reference on I: xci to "many Pythagoric writings from which Plato himself derived most of his more sublime dogmas."

25 *Ibid.*, 49, 65.

26 Vala is a common identification; see Damon, *Dictionary*, Grant, "Redemptive Action," 468, and others. Other suggestions include Digby's Jerusalem, *Symbol and Image*, 59, negative functions based on Vala, such as "illusion," "all that must be rejected," Simmons and Warner, "Blake's *Arlington Court Picture*," 460, and a seductive version of Venus – Mellor, *Blake's Human Form Divine*, 259.

27 *NT* 501 shows Night as a woman with a veiled face and a book covered with stars. Cf. Joseph Spence, *Polymetis* (reprinted Garland: New York, 1976; London, 1747), 193: Night "is crowned with poppies; and perhaps, sometimes with stars… She had large, dark wings; and a long black robe."

28 *Thomas Taylor*, 221–22.

29 *Works of Plato*, II: 418.

30 *Ibid.*, 669.

31 *Ibid.*, 673–74.

32 *Ibid.*, 672.

33 Edmund Spenser, *The Faerie Queene*, ed. A. C. Hamilton (London: Longman, 1977), VII. vii. 5.

34 Simmons and Warner get close: "Because he [Luvah] is associated with the Greek Apollo, god of music, the musicians are appropriate as his attendants." "Blake's *Arlington Court Picture*," 468.

35 *Metamorphosis*, 232.

36 *Ibid.*, 248–49.

37 "It was very common with the musicians of old, to play two pipes at once… It was over this species of music that Euterpe presided"; Spence, *Polymetis*, 89, and Plate XII. fig. 4. He discusses the instrument of Polyhymnia on p. 91 and illustrates it in Plate XII. fig. 7.

38 *Ibid.*, 92.

39 I owe this perception to Robert N. Essick (personal communication).

40 *Metamorphosis*, 82 and 108; 80 implies that at least Winter is male – "hoary-headed" – but the general tradition made the hours female.

41 *Ibid.*, 81.

42 *Ibid.*, 81.

43 Digby, *Symbol and Image*, 58.

44 The clearest example is *NT* 500; there are others in "The Brothers Meet the Attendant Spirit in the Wood" from the *Comus* illustrations (B 528: 4), and "Melancholy" and "The Wandering Moon" from the illustrations to *Il Penseroso* (B 543: 7, 8).

45 Simmons and Warner, "Blake's *Arlington Court Picture*," 482.

46 *Ibid.*, 219: "I think she is sometimes represented with Neptune in his chariot."

47 *Metamorphosis*, 25.

48 John E. Grant, "Discussing the Arlington Court Picture: Part I: A Report on the Warner-Simmons Theory," *BN* 3: 4 (May 1970), 101.

49 Bernard de Montfaucon, *The Supplement to Antiquity Explained* (1725; reprinted New York: Garland, 1976), Tome the first, Book I, 24.

50 Spence, *Polymetis*, 194–95.

51 *Ibid.*

52 *Ibid.*, 183.

53 Konrad Oberhuber, *The Works of Marcantonio Raimondi and of his School* (New York: Abaris, 1978), 281 and no. 293 (222).

54 William L. Pressly, *The Life and Art of James Barry* (Yale University Press, 1981), 52 and Plate 38.

55 Raine identifies this figure as Phorcys; *Blake and Tradition*, I: 91–92. Damon began the Tharnas theory (*Dictionary*, s.v. "The Circle of Life"). Mellor sees the figure as "the wholly fallen man"; *Blake's Human Form Divine*, 268.

56 Simmons and Warner, "Blake's *Arlington Court Picture*," 473.

57 *Metamorphosis*, 226.

58 *Ibid.*, 675.

59 Spence, *Polymetis*, 129 and note 85.

60 See *Thomas Taylor*, "The Hymns of Orpheus," 215–17.

61 *Thomas Taylor*, 224–25.

62 *Works of Plato*, I: 471–73.

63 *Ibid.*, II: 617–18.

64 *Ibid.*, II: 422–31.

65 *Metamorphosis*, 681.

66 *Ibid.*, 697.

67 *Ibid.*, 718.

68 George Richardson, *Iconology* (London, 1779). Though Richardson's list of sources sounds Blakean – "Mythology, Poetry, the occult Philosophy, Gems, Medals, and other monuments of antiquity" ("Preface," n.p.) – there are remarkably few if any signs that Blake used this work. On Blake and personification, see Jean H. Hagstrum, *William Blake: "Poet and Painter"* (University of Chicago Press, 1978), 49–51.

69 *Boswell's Life of Johnson* (Oxford University Press, 1953), 1313.

70 G. E. Bentley, Jr., *William Blake: Vala or The Four Zoas* (Oxford University Press, 1963), 29, identifies the figure as a woman; Cettina Tramontano Magno and David V. Erdman, *The Four Zoas by William Blake* (Lewisburg: Bucknell University Press, 1987), 29, identify it as a "garlanded young man." I am frankly unsure.

71 Grant agrees with Simmons and Warner that "the scales on the bucket indicate that the water is unredeemed. [But he] would argue that the Water of Death has to be transformed by the Purgatorial fires in the lower cave before it can be carried as the Water of Life in scale-less buckets by the procession of good women in the upper cave." Grant, "Discussing: I," 102. Grant also writes that the carrier will "enter the cave where the furnaces of Los will burn the Storge scales from her bucket and her eyes"; Grant, "Discussing the *Arlington Court Picture*: Part II: Studying Blake's Iconography for Guidance in Interpreting the Picture," *Blake Newsletter* 4: 1 (1970), 19.

72 Geoffrey Keynes, *Blake Studies*, 2nd edn. (Oxford University Press, 1971), 200.

73 *Metamorphosis*, 80.

74 Spence, *Polymetis*, 195–96.

75 *Faerie Queene*, VII. vii. 45.

76 John Milton, *Paradise Lost*, ed. Alastair Fowler (New York: Longman, 1971), VI: 2–7.

77 There is a summary of the traditions of the Hours in A. Kent Hieatt, *Short Time's Endless Monument* (New York: Columbia University Press, 1960), 31–38, 111–13.

78 Spence, *Polymetis*, 193.

79 Blake describes the land as having "modest tresses bound up" in anticipation of marriage with Spring in "To Spring" (E 408).

80 Similar gestures are found in the Dante illustrations, such as No. 4, where it seems to mean "we are going there," and No. 9, where it represents either the judgment of Minos, or a greeting to the approaching Dante and Virgil. See Albert S. Roe, *Blake's Illustrations to the Divine Comedy* (Princeton University Press, 1953), 62.

81 Erasmus Darwin, *The Loves of the Plants*, printed together with *The Economy of Vegetation* in *The Botanic Garden* (1789; reprinted Menston: Scolar Press, 1973), vi.

82 Darwin, *The Economy of Vegetation*, 132.

83 *Ibid.*, 132–33. See also Darwin, *The Temple of Nature* (1803; reprinted Menston: Scolar Press, 1973), 84.

84 Irene Tayler, *Blake's Illustrations to the Poems of Gray* (Princeton University Press, 1971), Plate 3 of "Ode on the Spring."

85 Raine, *Blake and Tradition*, I: 88.

86 *Works of Plato*, II: 504–05.

87 *Ibid.*, II: 554–55.

88 See Robert N. Essick, *The Works of William Blake in the Huntington Collections* (San Marino: Huntington Library, 1985), 101 and

illus. 33. There are similar weaving gestures in *Theotormon Woven* (B 575).

89 Darwin, *Economy of Vegetation*, 194.

90 *Ibid.*, 194 and "Additional Notes," 96–97.

91 *Ibid.*, 198.

92 *Works of Plato*, V: 521.

93 Darwin, *The Economy of Vegetation*, 107. He repeats the association in *The Temple of Nature*, 46 and 163.

94 Christopher Heppner, "'A Desire of Being':

Identity in *The Book of Thel*," *CLQ* 13 (1977), 79–98.

95 *Paradise Lost*, II: 582–83.

96 *Metamorphosis*, 675.

97 *Ibid.*, 233.

98 Simmons and Warner, "Blake's *Arlington Court Picture*," 461.

99 Martin Butlin, "A New Color Print from the Small Book of Designs," *BIQ* 26: 1 (Summer 1992), 19.

Index